THE HUMAN SPIRIT

THE HUMAN SPIRIT

Sources in the Western Humanities

Volume I

Edited by
PERRY M. ROGERS

PEARSON

Prentice
Hall

Upper Saddle River, New Jersey 07458

Library of Congress Cataloging-in-Publication Data

The human spirit: sources in the Western humanities / edited by Perry M. Rogers.--1st
 ed. p. cm.
 ISBN 0-13-055891-5 (v. 1)--ISBN 0-13-048053-3 (v. 2)
 1. Humanities--History--Sources. 2. Civilization, Western--History--Sources.
 I. Rogers, Perry McAdow.

AZ231.H86 2004
001.3'09--dc21 2003049871

Executive Editor: Sarah Touborg
VP, Editorial Director: Charlyce Jones Owen
Editorial Assistant: Sasha Anderson
Marketing Manager: Chris Ruel
Marketing Assistant: Kimberly Daum
Production Editor: Laura A. Lawrie
Manufacturing Buyer: Sherry Lewis
Cover Design: Bruce Kenselaar
Cover Illustration/Photo: Bartolomé Esteban Murillo: *Two Women at a Window,*
c. 1655/1660. Widener Collection/The National Gallery of Art.
Photo Researcher: Elaine Soares
Image Permission Coordinator: Cynthia Vincenti
Composition: Laserwords
Printer/Binder: Hamilton Printing

Credits and acknowledgments borrowed from other sources and reproduced, with
permission, in this textbook appear on appropriate page within text, and on pages
317–318.

Pearson Education LTD. Pearson Education Australia PTY, Limited
Pearson Education Singapore, Pte. Ltd Pearson Education North Asia Ltd
Pearson Education, Canada, Ltd Pearson Educacìon de Mexico, S.A. de C.V.
Pearson Education—Japan Pearson Education Malaysia, Pte. Ltd

10 9 8 7 6 5 4 3 2 1
ISBN 0-13-055891-5

For Ann
Elisa, Kit, and Tyler

Brief Contents

Chapter Features:

- The Artistic Vision: A comparative focus on the work of an artist as an expression of the dominant style of the period.

- Against the Grain: Box feature of those who don't fit or are in conflict with their societies, but embody the edge of creative change and set new artistic or historical parameters; the outsider, the radical mind, the free thinker.

- The Reflection in the Mirror: Feature section on a focused ethical or philosophical topic for comparative analysis and thoughtful reflection.

- The Cultural Intersection: Comparative links with other cultures at contemporaneous or thematic moments.

- The Architectural Foundation: Architecture as an expression of culture; analysis of palace floor plans, religious shrines or other monuments.

Contents

Imperial Rome (27 B.C.E.–500 C.E.) 124

Preface

The human world is complex, full of discovery and creativity, deceit and destruction. As we each make our way through life, we learn to navigate its seemingly endless maze of contradiction. It is our human alternative to give life or take it, to appreciate the beauty of a sunset or to deprecate the mindless destruction on some lonely battlefield. It is our gift to wonder and reconcile, to fashion the buildings that house our grand ideas and to create systems of law that harness the vagaries of our human nature.

We humans wonder at our own existence, and this is the crux of it all. This is the foundation for our study of the Humanities, those disciplines of music, drama, art, dance, architecture, literature, philosophy, and history. "It is art that *makes* life, makes interest, makes importance," noted the American novelist Henry James. "And I know of no substitute whatever for the force and beauty of its process." James understood that if we seek happiness and truth, beauty and meaning in life, we must look to the many expressions of human worth that are defined through the writings and arts of our culture. Yet this is not simply the history of human progress, but also the story of its negation and defeat—the contradiction of human existence. The primary way to understand the past and to appreciate the present is through a personal examination of the writings and artwork, the music and poetry of generations.

The Human Spirit offers the student an opportunity to evaluate and interact with some of the greatest ideas and creative expressions of humanity. And interaction is the key to an analysis of the Humanities. Each piece of literature, poetry or art, each diary entry, philosophical excerpt, or religious proviso has been juxtaposed against the tapestry of history so that it can be viewed within the context of its time. This two-volume book has been conceived as more than a simple compilation of primary sources. It is meant to provide the student with thoughtful and engaging material, which is focused around individual units that encompass time periods, specific events and historical questions. Students learn from the Humanities most effectively when posed with problems that have meaning for their own lives. In evaluating the material from *The Human Spirit*, the student will discover that issues are not nearly as simple as they may appear at first glance. Historical and visual sources often contradict each other and compete for emotional engagement and primacy. Throughout these volumes, the student is confronted with basic questions regarding historical development, human nature, moral action, and practical necessity. The text is therefore broad in its scope and incorporates a wide variety of political, social, economic, religious, intellectual, and scientific issues that encompass, define, and reward the study of the Humanities. It is internally organized around **six major themes** that provide direction and cohesion to the text while allowing for originality of thought in both written and oral analysis:

1. ***The Power Structure:*** What are the institutions of authority in Western societies and how have they been structured to achieve political, social, and economic stability? Monarchy, theocracy, democracy, fascism, socialism, communism, nationalism, and imperialism form the basis of study in this section.

2. ***The Institution and the Individual:*** What is the relationship between personal, creative expression in the arts and the governing political, religious, and social institutions of the age? What gives the Humanities purpose in the eyes of Church or State? How are writers, artists, and poets variously employed through patronage systems to enhance political authority, perpetuate myths, and create heroes who embody the values of the age? What is the role of the rebel, the free thinker, who works against the grain and threatens the status quo by exploring new dimensions of thought or creative expression?

3. ***Social and Spiritual Values:*** The Judeo-Christian and Islamic heritage of Western Civilization forms the basis of this theme. How have religious values and moral attitudes affected the course of the Western Humanities? To what extent have spiritual reform movements resulted in a change of political or social policy, or artistic style? Are ideas more potent than any army? Does every society need a spiritual foundation? How do art, architecture, and literature reflect the dominant values of an era?

4. ***Revolution and Transition:*** This theme seeks to define and examine the varieties of revolution: political, intellectual, economic, social, and artistic. What are the underlying and precipitating causes of political revolution? How essential is the intellectual foundation? Does an artistic revolution stem from political change or a shifting of social realities? This theme focuses on transition through historical or artistic periods.

5. ***The Varieties of Truth:*** What is the role of propaganda in history? Many sections examine the use and abuse of information, often in connection with absolute government, revolution, imperialism, or genocide. What roles do art, architecture, poetry, and literature play in the "creation of belief," and in the successful consolidation of power? This theme emphasizes the relativity of truth and stresses the responsibility of the individual in assessing the validity of evidence.

6. ***Women in History and the Humanities:*** The text intends to develop an appreciation of the contributions of women to the intellectual, political, and artistic framework of the Western Humanities. At issue is how women have been viewed—or rendered invisible—throughout history and how individually and collectively their presence is inextricably linked with the development and progress of civilization. This inclusive approach stresses the importance of achieving a perspective that lends value and practical application to the study of the Humanities.

The **overriding theme** that provides a foundation and overall unity to the text is that of **cultural interaction.** How have the diverse cultures of the West been linked by political systems, economic contact, social and religious movements, philosophy, art, literature, and such variables as disease and war? In what ways has Western Civilization over the centuries struggled with similar challenges and themes that have contributed to cultural transition?

Structure of the Book

The main strength of the text lies in its structure and the direction given to the student through introductions to each primary source. **Study Questions** promote analysis and evoke critical response. Each chapter follows the same format:

- **Time-line Chronological Overview:** These brief time-lines are designed to give students a visual perspective of the main events, movements, and personalities discussed in the chapter.

- **Quotations:** These are statements from various historians, artists, philosophers, diplomats, literary figures, and religious spokespersons who offer insight and give perspective on the subject matter of the chapter.

- **Thematic Presentations:** The entire text is composed around six primary themes in the Humanities. Each chapter begins with a list of the relevant themes and questions that link that chapter with ideas and problems in other chapters.

- **Headnotes:** These are extensive introductions which explain in detail the historical or biographical background of each primary source. They also focus themes and discuss interrelationships with other relevant primary sources.

- **Primary Sources:** The sources provided are diverse in nature and include excerpts from drama and literature, short stories, speeches, letters, diary accounts, poems, newspaper articles, philosophical tracts, propaganda flyers, and works of art and architecture.

- **Study Questions:** A series of study questions conclude each source or chapter section and present a basis for oral discussion or written analysis. The study questions do not seek mere regurgitation of information, but demand a more thoughtful response which is based on reflective analysis of the primary sources.

Features and Integrated Format

The study of the Humanities is necessarily an integrative experience. **The Human Spirit** provides insight into the interrelationships between art, music, literature, poetry, and architecture during various historical periods. Students are linked to historical events, broader artistic movements and styles through **five unique features** included in each chapter:

1. **The Artistic Vision:** This feature emphasizes the creative processes and vision of an artist who embodies a dominant style of the period or expresses the social or spiritual values of the age.

2. **Against the Grain:** This feature focuses on those who don't fit or are in conflict with their societies, but embody the edge of creative change and set new artistic or historical parameters: the outsider, the radical mind, the free thinker. What impact does the individual have on the artistic landscape? To what extent is progress dependent on those who threaten the status quo and seek new directions outside the mainstream?

3. **The Architectural Foundation:** This feature emphasizes architecture as an expression of culture. Most often, this section includes a visual analysis of floor plans, religious shrines, theaters, or other monuments that are important cultural expressions of a particular society.

4. **The Cultural Intersection:** This is an important focus of **The Human Spirit**. It presents a primary source that emphasizes one of the themes around which the text is based, but draws from a culture outside the European Western tradition. These are comparative links with Asian, Middle Eastern, American, or African civilizations at contemporaneous or thematic moments. This

feature provides an expansive dimension to the text and offers a world perspective on the integration of the Humanities.

5. **The Reflection in the Mirror:** This feature offers an analysis of a focused moral or philosophical problem within a culture. It emphasizes the more abstract themes of progress and decline, arrogance and power, salvation, the impact of war and disease, the conflict between science and religion, the relationship of divinity and humanity, and the importance of human memory and creativity when juxtaposed with technological progress. This feature promotes thoughtful reflection and often asks the student to assess the cultural impact of artistic vision.

Use of the Book

The Human Spirit offers the instructor a wide variety of didactic applications. The chapters fit into a more or less standard lecture format and are ordered chronologically. An entire chapter may be assigned for oral discussion, or sections from each chapter may satisfy particular interests or requirements.

The chapters also may be assigned for written analysis. One of the most important concerns of both instructor and student in an introductory class is the written assignment. **The Human Spirit** has been designed to provide self-contained topics that are problem-oriented, promote reflection and analysis, and encourage responsible citation of particular primary sources. The study questions for each chapter should generally produce an eight- to ten-page paper or instructors may assign particular sections for shorter, reflective papers.

Acknowledgements

This book has evolved over the years through contact with many colleagues and friends who offered their insight and analysis of history, poetry, literature, and art. I would like to recognize in particular the influence of Marsha Ryan, whose poetic sensibilities greatly broadened the scope of the text, Nan Hadley and Diane Abel, who read drafts of some of the art sections offering sterling commentary throughout, Mary Ann Leonard, whose broader ethical perspectives are always appreciated, and Patricia Hayot, whose encouragement in the initial stages of this project proved decisive. Linda Swarlis kept me in touch with obscure sources at crucial times and Eric Hayot lent his fresh perspective at the outset. I would like to thank the following reviewers: Cortlandt Bellavance, Atlantic Cape Community College; Michael Berberich, Galveston College; David J. Califf, The Academy of Notre Dame; Charles Carroll, Lake City Community College; Jeffery Donley, Valencia Community College; Clifford Herron, Okaloosa-Walton Community College; Bobby F. Hom, Santa Fe Community College; Barbara Kramer, Santa Fe Community College; Joyce Porter, Moraine Valley Community College; and Sonia Sorell, Pepperdine University. The text has also benefitted greatly from the insight of Robert Thoresen, a long-time friend and associate at Prentice Hall, who continues to inspire creative ideas. Thanks also to the students of *Columbus School for Girls*, who continue to "test" the chapters in this book with their typical diligence and hard work; the final product has benefitted greatly from their suggestions and ideas. Finally, I owe the largest debt to my wife, Ann, whose strength and gentle confirmation of what is most valuable in life offers the greatest perspective of all, and to my children, who always help me laugh.

THE HUMAN SPIRIT

PART ONE

Foundations of Western Civilization
(3500 B.C.E. to 500 C.E.)

PART ONE

Foundations of Western Civilization

(3500 B.C.E. to 800 C.E.)

1

The Dawn of Civilization
Mesopotamia, Egypt, and Israel

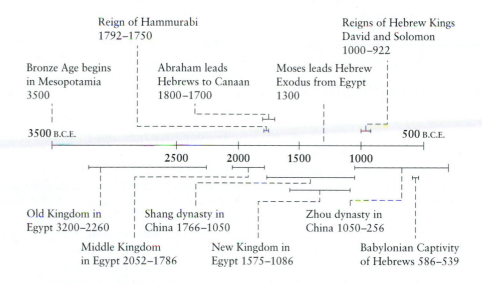

Reign of Hammurabi
1792–1750

Reigns of Hebrew Kings
David and Solomon
1000–922

Bronze Age begins
in Mesopotamia
3500

Abraham leads
Hebrews to Canaan
1800–1700

Moses leads Hebrew
Exodus from Egypt
1300

3500 B.C.E. 500 B.C.E.

2500 2000 1500 1000

Old Kingdom in
Egypt 3200–2260

Shang dynasty in
China 1766–1050

Zhou dynasty in
China 1050–256

Middle Kingdom
in Egypt 2052–1786

New Kingdom in
Egypt 1575–1086

Babylonian Captivity
of Hebrews 586–539

If a man destroy the eye of another man, they shall destroy his eye.

—Code of Hammurabi

You are a lifespan in yourself; one lives by you.

—Hymn to Aten

In the beginning, God created heaven and earth.

—Genesis 1:1

And what does the Lord require of you, but to do justly, and to love mercy,
and to walk humbly with your God.

—Micah 6:8

CHAPTER THEMES

- *The Power Structure:* How did the monarchies in Mesopotamia, Egypt, and Israel differ from one another? What is the best form of government for primitive societies?

- *Social and Spiritual Values:* How did the belief systems of the ancient Near East and China contribute to the unity of society? In what ways were these societies primarily spiritual in nature? How radical a conception is monotheism?

- *Revolution and Transition:* What were the main contributions of the early river valley societies to Western Civilization? In what specific ways did civilization progress during this time?

- *The Big Picture:* What are the most important political, social, and spiritual characteristics that each society must possess in order to lay the foundations for the transmission of culture?

Mesopotamian Civilization

Beginning about 3500 B.C.E., there was an influx of people into the region of the Fertile Crescent, the land north of the Persian Gulf that now encompasses Iran and Iraq. This area was devoid of natural barriers, such as mountain ranges, and so provided easy access for nomadic peoples. It was here that World Civilization first began, in the land watered by the flooding of the Tigris and Euphrates Rivers, whose silt allowed for abundant harvests and prosperity. The region became known as Mesopotamia ("the land between the rivers") and it fostered many distinct cultures. The Sumerians, who occupied the southern area at the confluence of the two rivers, assumed cultural leadership over the region by developing a syllabic writing script called cuneiform. Although conquerors would establish military control over the region, Sumerian literary and religious ideas and values proved a continuing influence.

Mesopotamia, at least initially, was organized on the basis of independent city-states. Each city had its own king and priests and conducted its own foreign policy, often in alliance with other city-states. The king's responsibilities included political and military leadership as well as supervision of the priests and their sacrifices to the gods. It is important to note that Mesopotamian kings were not considered to be divine themselves but, rather, acted as representatives of the gods. The independence of the city-states often gave way to conquerors like Sargon the Great, who united the area briefly about 2300 B.C.E. Because of the open geographical access to the region, Mesopotamia was overrun by a succession of invaders, such as the Babylonians, Kassites, Assyrians, and finally Persians in the sixth century B.C.E. But the insecurity of the region did not limit the development of literature and law, which were its special contributions.

The Code of Hammurabi

From 2000 to 1600 B.C.E., the city-states of Mesopotamia endured a period of nearly continuous warfare which saw shifting alliances and frequent chaos. The most dominant personality of the age, Hammurabi, established his control over the region from about 1800 to 1750 B.C.E. and ruled from the city of Babylon. His great contribution to Western Civilization

"The Code of Hammurabi" is from Robert F. Harper, trans., *The Code of Hammurabi* (Chicago: University of Chicago Press, 1904).

was a series of laws that sought to establish justice within his empire. This concept of equity, which remedied a large number of abuses, influenced law codes yet to come, most notably those of Greece and Rome. In the following passages, note the continual emphasis on fairness in the regulation of property, trade, debt, family relations, and personal injury.

When the lofty Anu, king of the Anunnaki gods, and Enlil, lord of heaven and earth, he who determines the destiny of the land . . . pronounced the lofty name of Babylon; when they made it famous among the quarters of the world and in its midst established an everlasting kingdom whose foundations were firm as heaven and earth; [they] . . . named me, Hammurabi, the exalted prince, the worshiper of the gods, to cause justice to prevail in the land, to destroy the wicked and the evil, to prevent the strong from oppressing the weak, to go forth like the sun over the black-headed people, to enlighten the land to further the welfare of the people. Hammurabi, the shepherd named by Enlil, am I, who brought about plenty and abundance; . . . the powerful king, the sun of Babylon, who caused light to go forth over the lands of Sumer and Akkad; the king who caused the four quarters of the world to render obedience; the favorite of Ishtar, am I. When Marduk sent me to rule the people and to bring help to the country, I established law and justice in the language of the land and promoted the welfare of the people. At that time [I decreed]:

1. If a man bring accusation against another man, charging him with murder, but cannot prove it, the accuser shall be put to death.

3. If a man bear false witness in a case, or does not establish the testimony that he has given, if that case be a case involving life, that man shall be put to death.

4. If he bear [false] witness concerning grain or money, he shall himself bear the penalty imposed in that case.

5. If a judge pronounce a judgment, render a decision, deliver a verdict duly signed and sealed, and afterward alter his judgment, they shall call that judge to account for the alteration of the judgment which he has pronounced, and he shall pay twelve-fold the penalty in that judgment; and, in the assembly, they shall expel him from his seat of judgment, and with the judges in a case he shall not take his seat.

22. If a man practice robbery and is captured, that man shall be put to death.

23. If the robber is not captured, the man who has been robbed shall, in the presence of god, make an itemized statement of his loss, and the city and the governor in whose province and jurisdiction the robbery was committed shall compensate him for whatever was lost.

24. If it be a life [that is lost], the city and governor shall pay one mina [about one pound] of silver to his heirs.

53. If a man neglects to maintain his dike and does not strengthen it, and a break is made in his dike and the water carries away the farmland, the man in whose dike the break has been made shall replace the grain which has been damaged.

54. If he is not able to replace the grain, they shall sell him and his goods, and the farmers whose grain the water has carried away shall divide [the results of the sale].

55. If a man opens his canal for irrigation and neglects it and the water carries away an adjacent field, he shall pay out grain on the basis of the adjacent field.

109. If bad characters gather in the house of a wine seller and he does not arrest those bad characters and bring them to the palace, that wine seller shall be put to death.

110. If a priestess who is not living in a convent opens a wine shop or enters a wine shop for a drink, they shall burn that woman.

117. If a man be in debt and sell his wife, son, or daughter, or bind them over to service, for three years they shall work in the house of their purchaser or master; in the fourth year they shall be given their freedom.

128. If a man takes a wife and does not arrange a contract for her, that woman is not a wife.

129. If the wife of a man is caught lying with another man, they shall bind them and throw them into the water.

138. If a man wishes to put away his wife who has not borne him children, he shall give her money to the amount of her marriage price and he shall make good to her the dowry which she brought from her father's house and then he may put her away.

142. If a woman hates her husband and says, "You may not have me," the city council shall inquire into her case; and if she has been careful and without reproach and her husband has been going about and greatly belittling her, that woman has no blame. She may take her dowry and go to her father's house.

143. If she has not been careful but has gadded about, neglecting her house and belittling her husband, they shall throw that woman into the water.

168. If a man set his face to disinherit his son and say to the judges, "I will disinherit my son," the judges shall inquire into his record, and if the son has not committed a crime sufficiently grave to cut him off from sonship, the father may not cut off his son from sonship.

195. If a son strike his father, they shall cut off his hand.

196. If a man destroy the eye of another man, they shall destroy his eye.

197. If he break another man's bone, they shall break his bone.

199. If he destroy the eye of a man's slave or break a bone of a man's slave, he shall pay one-half his price.

200. If a man knock out a tooth of a man of his own rank, they shall knock out his tooth.

229. If a builder build a house for a man and does not make its construction sound, and the house which he has built collapses and causes the death of the owner of the house, that builder shall be put to death.

> **"If a man destroy the eye of another man, they shall destroy his eye."**
>
> **—Hammurabi**

233. If a builder build a house for a man and does not make its construction sound, and a wall cracks, that builder shall strengthen that wall at his own expense.

[These are] the just laws which Hammurabi, the wise king, established and by which he gave the land stable support and good government. Hammurabi, the perfect king, am I. . . . The great gods called me, and I am the guardian shepherd whose scepter is just and whose beneficent shadow is spread over my city. In my bosom I carried the people of the land of Sumer and Akkad; under my protection they prospered; I governed them in peace; in my wisdom I sheltered them.

In order that the strong might not oppress the weak, that justice be given to the orphans and the widow, in Babylon, . . . for the pronouncing of judgments in the land, for the rendering of decisions for

the land, and to give justice to the oppressed, my weighty words I have written upon my monument, and in the presence of my image as king of justice have I established it.

Consider This:

- In the preface to the Code of Hammurabi, why does Hammurabi feel justified in setting forth this law code? What are some of the penalties? Do they seem too harsh to be fair? Why is a law code such as this a sign of progress in civilization?

The Epic of Gilgamesh

The Sumerians who inhabited the southern region of Mesopotamia were the first people in Western Civilization to produce epic tales about deities and human heroes. The Epic of Gilgamesh dates from about 2000 B.C.E. and is a collection of stories about the Sumerian king of Uruk. In the following passages, Gilgamesh, confronted with the reality of his friend Enkidu's death, sets out to find Utnapishtim, the only man to whom the gods have given eternal life. Gilgamesh discovers that he must accept the inevitability of his own death.

There follows the Mesopotamian tale of the Flood and the biblical account contained in the Old Testament. Flood epics were quite common in ancient literature and represented a cleansing of the community in accordance with a higher ethical law. But compare the two accounts closely, especially with regard to the attitudes and actions of the deities.

The Quest for Eternal Life

Bitterly Gilgamesh wept for his friend Enkidu; he wandered over the wilderness as a hunter, he roamed over the plains; in his bitterness he cried, "How can I rest, how can I be at peace? Despair is in my heart. What my brother is now, that shall I be when I am dead. Because I am afraid of death I will go as best I can to find Utnapishtim whom they call the Faraway, for he has entered the assembly of the gods." So Gilgamesh traveled over the wilderness, he wandered over the grasslands, a long journey, in search of Utnapishtim, whom the gods took after the deluge; and they set him to live in the land of Dilmin, in the garden of the sun; and to him alone of men they gave everlasting life . . .

Gilgamesh said to him [Utnapishtim], "Why should not my cheeks be starved and my face drawn? Despair is in my heart and my face is the face of one who has made a long journey. It was burned with heat and with cold. Why should I not wander over the pastures? My friend, my younger brother who seized and killed the Bull of Heaven and overthrew Humbaba in the cedar forest, my friend who was very dear to me and endured dangers beside me, Enkidu, my brother whom I loved, the end of mortality has overtaken him. I wept for him seven days and nights till the worm fastened on him. Because of my brother I am afraid of death; because of my brother I stray through the wilderness. His fate lies heavy upon me. How can I be silent, how can I rest? He is dust and I shall die also and be laid in the earth for ever. . . . Oh, father Utnapishtim, you who have entered the assembly of the gods, I wish to question you concerning the living and the dead, how shall I find the life for which I am searching?"

Utnapishtim said, "There is no permanence. Do we build a house to stand for ever, do we

> "There is no permanence. Do we build a house to stand forever, do we seal a contract to hold for all time?"
>
> —Utnapishtim

seal a contract to hold for all time? Do brothers divide an inheritance to keep for ever, does the flood-time of rivers endure? It is only the nymph of the dragon-fly who sheds her larva and sees the sun in his glory. From the days of old there is no permanence. The sleeping and the dead, how alike they are, they are like a painted death. What is there between the master and the servant when both have fulfilled their doom? When the Annunaki, the judges, come together, and Mammetun the mother of destinies, together they decree the fates of men. Life and death they allot but the day of death they do not disclose." . . .

The destiny was fulfilled which the father of the gods, Enlil of the mountain, had decreed for Gilgamesh: "In nether-earth the darkness will show him a light; of mankind, all that are known, none will leave a monument for generations to come to compare with his. The heroes, the wise men, like the new moon have their waxing and waning. Men will say, 'Who has ever ruled with might and with power like him?' As in the dark month, the month of

> "O Gilgamesh, you were given the kingship, such was your destiny; everlasting life was not your destiny."
>
> —Enlil

shadows, so without him there is no light. O Gilgamesh, this was the meaning of your dream. You were given the kingship, such was your destiny, everlasting life was not your destiny. Because of this do not be sad at heart, do not be grieved or oppressed; he has given you power to bind and to loose, to be the darkness and the light of mankind. He has given unexampled supremacy over the people, in victory in battle from which no fugitive returns, in forays and assaults from which there is no going back. But do not abuse this power, deal justly with your servants in the palace, deal justly with the face of the Sun."

The Story of the Flood

Then Gilgamesh said . . . "I look at you now, Utnapishtim, and your appearance is no different than mine; there is nothing strange in your features. . . . Tell me truly, how was it that you came to enter the company of the gods and to possess everlasting life?" Utnapishtim said to Gilgamesh, "I will reveal to you a mystery, I will tell you a secret of the gods."

"You know the city Shurrupak, it stands on the banks of Euphrates? That city grew old and the gods that were in it were old. There was Anu, lord of the firmament, their father, and warrior Enlil their counselor, Ninurta the helper, and Ennugi watcher over canals; and with them also was Ea. In those days the world teemed, the people multiplied, the world bellowed like a wild bull, and the great god was aroused by the clamor. Enlil heard the clamor and he said to the gods in council, 'The uproar of mankind is intolerable and sleep is no longer possible by reason of the babel.' So the gods in their hearts were moved to let loose the deluge; but my lord Ea warned me in a dream. He whispered their words to my house of reeds, . . .

'O man of Shurrupak, . . . tear down your house and build a boat, abandon possessions and look for life, despise worldly goods and save your soul alive. . . . These are the measurements of the barque as you shall build her: let her beam equal her length, let her deck be roofed like the vault that covers the abyss; then take up into the boat the seed of all living creatures.'

"When I had understood I said to my lord, 'Behold, what you have commanded I will honor and perform, but how shall I answer the people, the city, the elders?' Then Ea opened his mouth and said to me, his servant, 'Tell them this: I have learnt that Enlil is wrathful against me, I dare no longer walk in his land nor live in his city; I will go down to the Gulf to dwell with Ea my lord. But on you he will rain down abundance, rare fish and shy wild-fowl, a rich harvest-tide. In the evening the rider of the storm will bring you wheat in torrents.'

"In the first light of dawn all my household gathered round me, the children brought pitch and the men whatever was necessary. . . . On the seventh day the boat was complete. . . . "I loaded

into her all that I had of gold and of living things, my family, my kin, the beasts of the field both wild and tame, and all the craftsmen. I sent them on board, for the time that Shamash had ordained was already fulfilled when he said, 'In the evening, when the rider of the storm sends down the destroying rain, enter the boat and batten her down.' This time was fulfilled, the evening came, the rider of the storm sent down the rain. I looked out at the weather and it was terrible, so I too boarded the boat and battened her down. . . .

"With the first light of dawn a black cloud came from the horizon. . . . One whole day the tempest raged gathering fury as it went, it poured over the people like the tides of battle; a man could not see his brother nor the people be seen from heaven. Even the gods were terrified at the flood, they fled to the highest heaven, . . . they crouched against the walls, cowering like curs. . . . The great gods of heaven and of hell wept, they covered their mouths.

"For six days and six nights the winds blew, torrent and tempest and flood overwhelmed the world . . . like warring hosts. When the seventh day dawned the storm from the south subsided, the sea grew calm, the flood was stilled; I looked at the face of the world and there was silence, all mankind was turned to clay. The surface of the sea stretched as flat as a roof-top; I opened a hatch and the light fell on my face. Then I bowed low, I sat down and I wept, the tears streamed down my face, for on every side was the waste of water. . . . I threw everything open to the four winds, made a sacrifice and poured out a libation on the mountain top. . . . When the gods smelled the sweet savor, they gathered like flies over the sacrifice. . . .

"When Enlil had come, when he saw the boat, he was wrath and swelled with anger at the gods, the host of heaven, "Has any of these mortals escaped? Not one was to have survived the destruction." . . . Then Ea opened his mouth and spoke to warrior Enlil, 'Wisest of gods, hero Enlil, how could you so senselessly bring down the flood?

Lay upon the sinner his sin,
Lay upon the transgressor his transgression,
Punish him a little when he breaks loose,
Do not drive him too hard or he perishes;
Would that a lion had ravaged mankind
Rather than the flood,
Would that a wolf had ravaged mankind
Rather than the flood,
Would that famine had wasted the world
Rather than the flood,
Would that pestilence had wasted mankind
Rather than the flood.

It was not I that revealed the secret of the gods; the wise man learned it in a dream. Now take your counsel what shall be done with him.'

"Then Enlil went up into the boat, he took me by the hand and my wife and made us enter the boat and kneel down on either side, he standing between us. He touched our foreheads to bless us saying, 'In time past Utnapishtim was a mortal man; henceforth he and his wife shall live in the distance at the mouth of the rivers.' Thus it was that the gods took me and placed me here to live in the distance at the mouth of the rivers."

The Biblical Flood

God said to Noah, 'I have decided that the end has come for all living things, for the earth is full of lawlessness because of human beings. So I am now about to destroy them and the earth. Make

"The Biblical Flood" is from Genesis 6.13–9.1, from Alexander Jones, ed., *The Jerusalem Bible*, pp. 24–26. Copyright © 1966 by Darton, Longman, & Todd, Ltd., and Doubleday, a division of Random House, Inc. Used by permission of Doubleday, a division of Random House, Inc.

yourself an ark out of resinous wood. Make it of reeds and caulk it with pitch inside and out. This is how to make it: the length of the ark is to be three hundred cubits, its breadth fifty cubits, and its height thirty cubits

'For my part, I am going to send the flood, the waters, on earth, to destroy living things having the breath of life under heaven: everything on earth is to perish. But with you I shall establish my covenant and you will go aboard the ark, yourself, your sons, your wife, and your sons' wives along with you. From all living creatures, from all living things, you must take two of each kind aboard the ark, to save their lives with yours; they must be a male and a female. Of every species of bird, of every kind of animal and of every kind of creature that creeps along the ground, two must go with you so that their lives may be saved. . . .' Noah did this, exactly as God commanded him. . . .

The flood lasted forty days on earth. The waters swelled, lifting the ark until it floated off the ground. . . . The waters rose higher and higher above the ground until all the highest mountains under the whole of heaven were submerged. . . . Every living thing on the face of the earth was wiped out, people, animals, creeping things and birds; they were wiped off the earth and only Noah was left, and those with him in the ark. . . .

Then God said to Noah, 'Come out of the ark, you, your wife, your sons, and your sons' wives with you. Bring out all the animals with you, all living things. . . .' Then Noah built an altar to Yahweh and, choosing from all the clean animals and all the clean birds, he presented burnt offerings on the altar. Yahweh smelt the pleasing smell and said to himself, 'Never again will I curse the earth because of human beings, because their heart contrives evil from their infancy. Never again will I strike down every living thing as I have done. . . .' God blessed Noah and his sons and said to them, 'Breed, multiply and fill the earth.'

Compare and Contrast:

- What makes *The Epic of Gilgamesh* such an enduring story? Compare the two accounts of the Flood. Which account do you find more vivid or exciting? What are the reasons given for the Flood and what does it signify?

- Compare especially the roles of the deities. How does God of the Old Testament differ in manner and action from Enlil or Ea?

The Mesopotamian View of Death

Historians can often tell much about a civilization by the way it regards the finality of death or the existence of an afterlife. The following poems are good examples of the Mesopotamian view.

The Mother Sings

Hark the piping!
My heart is piping in the wilderness
 where the young man once went free.
He is a prisoner now in death's kingdom,
 lies bound where once he lived.
The ewe gives up her lamb
and the nanny-goat her kid.
My heart is piping in the wilderness
 an instrument of grief.
Now she is coming to death's kingdom,

Poems are from N. K. Sandars, trans., *Poems of Heaven and Hell from Ancient Mesopotamia* (Baltimore, Md., and Harmondsworth, Middlesex: Penguin Books, 1971), pp. 163–164. Copyright © 1971 by N. K. Sandars. Reprinted by permission of Penguin Books, Ltd.

she is the mother desolate
in a desolate place; where once
he was alive, now he lies
like a young bull felled to the ground.
Into his face she stares, seeing
what she has lost—his mother
who has lost him to death's kingdom.
O the agony she bears,
shuddering in the wilderness,
she is the mother suffering so much.
 'It is you,'
she cried to him,
 'but you are changed.'
The agony, the agony she bears.
Woe to the house and the inner room.

The Son's Reply

There can be no answer
 to her desolate calling,
it is echoed in the wilderness,
 for I cannot answer.
Though the grass will shoot
 from the land
I am not grass, I cannot come
 to her calling.
The waters rise for her,
I am not water to come
 for her wailing,
I am not shoots of grass
 in a dead land.

Egyptian Civilization

The second great civilization of the ancient Near East was Egypt. While Mesopotamia suffered from the uncertainties of invasion and swift transition, Egypt was generally secure and isolated because of the surrounding, prohibitive deserts. Egypt remains a land with an aura of mystery, reinforced by a fascination for the colossal statues of Ramses II at Abu Simbel, the Temple of Karnak at Luxor, the overwhelming presence of the pyramids, mummification, and the wealth of Tutankhamon's tomb. But it is perhaps the Egyptian religion with its emphasis on death and the netherworld that most reflects the endless order and regulation of life. Just as the Nile River promotes unity within the country and its annual flooding symbolizes the recurring cycle of life, so, too, did the Pharaoh serve as a unifying presence. He was a god incarnate and was worshiped as such while he was living; in death he rose to the sky to be born anew each day with the cycle of the sun. Thus the Egyptians' close connection between state and religion, a theocracy of sorts, serves as a foundation for one of the more enduring themes in history.

The Authority of the Pharaohs

The king of Egypt, or Pharaoh (meaning "Great House"), possessed an authority rarely achieved in Western Civilization. In the Old Kingdom (3200–2260 B.C.E.), pharaonic authority

was absolute and the pyramids were built to house the body of the dead king. Egyptians considered preservation of the body essential for use in the afterlife, so they perfected the art of mummification. The following selections from the Greek historian Herodotus show the great authority of the Pharaoh in the Old Kingdom. Herodotus describes the commitment demanded by Cheops, for whom the Great Pyramid is named. An account of the process of mummification follows.

Building the Pyramids
HERODOTUS

After Cheops had ascended the throne, he brought the country into every manner of evil. First closing all the temples, he forbade sacrificing there, then ordered all the Egyptians to work for him. Some he told to draw stones from the quarries in the Arabian mountains about the Nile; others were ordered to receive them after they had been carried over the river in boats, and to draw them to the Libyan mountains. And they worked in groups of 100,000 men, each group for three months continually. Ten years of oppression for the people were required for making the causeway by which they dragged the stones. This causeway which they built was not a much inferior work to the pyramid itself, as it seems to me; . . . it is made of polished stones and engraved with the figures of living beings. Ten years were required for this, and for the works on the mound, where the pyramids stand, and for the underground chambers in the island, which he intended as sepulchral vaults for his own use, and lastly for the canal which he dug from the Nile. The pyramid was built in 20 years; it is square; each side measures 800 feet and its height is the same; the stones are polished and fitted together with the utmost exactness. Not one of them is less than 30 feet in length.

The pyramid was built in steps, in the manner of an altar. After laying the base, they lifted the remaining stones to their places by means of machines, made of short pieces of wood. The first machine raised them from the ground to the top of the first step; and when the stone had been lifted thus far, it was drawn to the top of the second step by another machine; for they had as many machines as steps. . . . At any rate, the highest parts were finished first, then the next, and so on till they came to the parts resting on the ground, namely the base. It is set down in Egyptian writing on the pyramid how much was spent on radishes and leeks and onions for the workmen; and I remember well the interpreter read the sum of 1,600 talents of silver. Now if these figures are correct, how much more must have been spent on the iron with which they worked, and on the food and clothing of the workmen, considering the length of time which the work lasted, and an additional period, as I understand, during which they cut and brought the stones, and made the excavations.

Mummification
HERODOTUS

There are a set of men in Egypt who practice the art of embalming, and make it their proper business. These persons, when a body is brought to them, show the bearers various models of corpses made in wood, and painted so as to resemble nature. . . . The mode of embalming, according to the most perfect process, is the following:—They take first a crooked piece of iron, and with it draw out the brain through the nostrils, thus getting rid of a

"Building the Pyramids" is from Herodotus, *History,* 2.124, in *A Source-Book of Ancient History,* ed. George W. Botsford (New York: Macmillan, 1912), pp. 6–8.

"Mummification" is from Herodotus, *History,* 2.86, 87, 90, in *The History of Herodotus,* trans. George Rawlinson (New York: E. P. Dutton, 1910), pp. 154–156.

> "They take first a crooked piece of iron, and with it draw out the brain through the nostrils . . . while the skull is cleared of the rest by rinsing with drugs."
>
> —Herodotus

portion, while the skull is cleared of the rest by rinsing with drugs; next they make a cut along the flank with a sharp Ethiopian stone, and take out the whole contents of the abdomen, which they then cleanse, washing it thoroughly with palm wine, and again frequently with an infusion of pounded aromatics. After this they fill the cavity with the purest bruised myrrh, with cassia, and every other sort of spice, except frankincense, and sew up the opening. Then the body is placed in natron [hydrated sodium carbonate] for seventy days, and covered entirely over. After the expiration of that space of time, which must not be exceeded, the body is washed, and wrapped round, from head to foot, with bandages of fine linen cloth, smeared over with gum, which is used generally by the Egyptians in the place of glue, and in this state it is given back to the relations, who enclose it in a wooden case which they have had made for the purpose, shaped into the figure of a man. Then fastening the case, they place it in a sepulchral chamber, upright against the wall. Such is the most costly way of embalming the dead.

If persons wish to avoid expense, and choose the second process, the following is the method pursued:—Syringes are filled with oil made from the cedar-tree, which is then, without any incision or disemboweling, injected into the abdomen. The passage by which it might be likely to return is stopped, and the body laid in natron the prescribed number of days. At the end of the time the cedar-oil is allowed to make its escape; and such is its power that it brings with it the whole stomach and intestines in a liquid state. The natron meanwhile has dissolved the flesh, and so nothing is left of the dead body but the skin and the bones. It is returned in this condition to the relatives, without any further trouble being bestowed upon it.

The third method of embalming, which is practiced in the case of the poorer classes, is to rinse out the intestines and let the body lie in natron the seventy days, after which it is at once given to those who come to fetch it away. . . .

Whensoever any one, Egyptian or foreigner, has lost his life by falling prey to a crocodile, or by drowning in the river, the law compels the inhabitants of the city near which the body is cast up to have it embalmed, and to bury it in one of the sacred repositories with all possible magnificence. No one may touch the corpse, not even any of the friends or relatives, but only the priests of the Nile, who prepare it for burial with their own hands—regarding it as something more than the mere body of a man—and themselves lay it in the tomb.

Ramses the Great

Ramses II (1301–1234 B.C.E.) was one of the greatest of all Egyptian Pharaohs. His reign has been immortalized by his magnificent construction projects, such as the temple of Karnak at Luxor and the enormous statues of Abu Simbel. In addition, his fame is recorded in the Old Testament as the Pharaoh under whom the Exodus of the Hebrews took place. His mummy has been remarkably well preserved; we can tell that he died in his 90s and that he suffered from acne, tuberculosis, and poor circulation of the blood. His tomb had been plundered by ancient grave robbers, and one can only imagine its former gold and splendor. The following passage is from an inscription found on the temple at Abu Simbel. In it, the god Ptah speaks to his son, Ramses.

"Ramses the Great" is from George W. Botsford, ed., *A Source-Book of Ancient History* (New York: Macmillan, 1912), pp. 10–12. Translation modernized by the editor.

Thus speaks Ptah-Totunen with the high plumes, armed with horns, the father of the gods, to his son who loves him. . . .

Num and Ptah have nourished your childhood, they leap with joy when they see you made after my likeness, noble, great, exalted. The great princesses of the house of Ptah and the Hathors of the temple of Tem are in festival, their hearts are full of gladness, their hands take the drum with joy, when they see your person beautiful and lovely like my Majesty. . . . King Ramses, I grant you to cut the mountains into statues immense, gigantic, everlasting; I grant that foreign lands find for you precious stone to inscribe the monuments with thy name.

I give you to succeed in all the works which you have done. I give you all kinds of workmen, all that goes on two or four feet, all that flies and all that has wings. I have put in the heart of all nations to offer you what they have done; themselves, princes great and small, with one heart seek to please you, King Ramses. You have built a great residence to fortify the boundary of the land, the city of Ramses; it is established on the earth like the four pillars of the sky; you have constructed within a royal palace, where festivals are celebrated to you as is done for me within. I have set the crown on your head with my own hands, when you appear in the great hall of the double throne; and men and gods have praised your name like mine when my festival is celebrated.

You have carved my statues and built my shrines as I have done in times of old. You reign in my place on my throne; I fill your limbs with life and happiness, I am behind you to protect you; I give you health and strength; I cause Egypt to be submitted to you; and I supply the two countries with pure life. King Ramses, I grant that the strength, the vigor, and the might of your sword be felt among all coun-

tries; you cast down the hearts of all nations; I have put them under your feet; you come forth every day in order that foreign prisoners be

> "King Ramses, I grant that the fear of you be in the minds of all and your command in their hearts. . . . You give life to whomever you please."
>
> —Ptah-Totunen

brought to you; the chiefs and the great of all nations offer you their children. I give them to your gallant sword that you may do with them what you like. King Ramses, I grant that the fear of you be in the minds of all and your command in their hearts. I grant that your valor reach all countries, and that the dread of you be spread over all lands; the princes tremble at your thought, and your majesty is [evident]; they come to you as supplicants to implore your mercy. You give life to whomever you please; the throne of all nations is in your possession. . . .

King Ramses, . . . the mountains, the water, and the stone walls which are on the earth are shaken when they hear your excellent name, since they have seen what I have accomplished for you; which is that the land of the Hittites should be subjected to your rule. . . . Their chiefs are prisoners, all their property is the tribute in the dependency of the living king. Their royal daughter is at the head of them; she comes to soften the heart of King Ramses; her merits are marvelous, but she does not know the goodness which is in your heart.

Consider This:
- Kingship and authority are major themes in ancient Near Eastern civilization. What do the readings reveal as true indicators of the authority of the Egyptian Pharaoh?

The Architectural Foundation

THE GREAT PYRAMIDS OF EGYPT

The pyramid complex at Giza just outside of Cairo, Egypt was considered to be one of the Seven Wonders of the ancient world. The Great Pyramid of Cheops is over 481 feet high and its base covers about thirteen acres. It is composed of 2,300,000 stone blocks averaging 2.5 tons each and they were cut to within 1/50 of an inch. The stone was harvested from quarries miles up the Nile and floated down the river where they were then moved on log rollers and sledges and pulled up ramps by thousands of workers to be set in place. This was truly an application of mathematics on the ultimate scale.

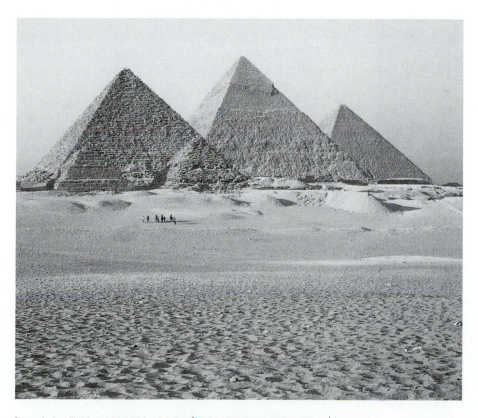

Figure 1–1 The Great Pyramids of Egypt (Dorling Kindersley Media Library).

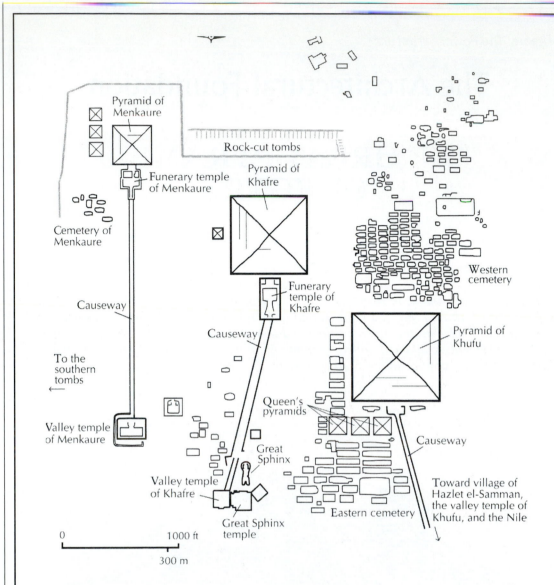

Figure 1–2 Diagram of the Pyramid Complex (Harry N. Abrams, Inc.).

Consider This:

• How were the pyramids both religious monuments and testaments to the political power of the pharaoh in the Old Kingdom? What is a theocracy? Why did the pharaohs of the later Middle and New Kingdoms have rock tombs rather than pyramids built for themselves? What had changed—the religious values of the society or the political authority of the pharaoh?

Linking the Humanities:

• In the year 1682, the illustrious French divine-right monarch, Louis XIV, commented about his new palace at Versailles: "Those who imagine that these are merely matters of ceremony are gravely mistaken. The peoples over whom we reign, being able to apprehend the basic reality of things, usually derive their opinion from what they can see with their eyes." Was Louis correct? How important was it for a pharaoh or an absolute monarch to overawe his subjects and foreign kings alike with the majesty of architecture? Would you say the same holds true for the monuments to American democracy in Washington, D.C.?

Egyptian Values

Egyptian literature abounds with didactic writings intended to instruct an individual on right action or proper conduct in life. A sense of "limit" and thoughtful discretion pervade the following suggestions to a royal administrator named Kagemni by a sage whose identity is unknown. These maxims were found on a piece of papyrus dating from the Old Kingdom. The love song in this section dates from the New Kingdom and reveals a private side to the Egyptian.

Instructions of Kagemni

The respectful man prospers,
Praised is the modest one,
The tent is open to the silent,
The seat of the quiet is spacious.
Do not chatter!
Knives are sharp against the blunderer,
Without hurry except when he faults.

When you sit with company,
Shun the food you love,
Restraint is a brief moment,
Gluttony is base and is reproved.
A cup of water quenches thirst,
A mouthful of herbs strengthens the heart,
One good thing stands for goodness,
A little something stands for much.
Vile is he whose belly covets when [meal]-time has passed,
He forgets those in whose house his belly roams.

When you sit with a glutton,
Eat when his greed has passed,
When you drink with a drunkard,
Take when his heart is content.
Don't fall upon meat by the side of a glutton,
Take when he gives you, don't refuse it,
Then it will soothe.
He who is blameless in matters of food,
No word can prevail against him;
He who is gentle, even timid,
The harsh is kinder to him than to his mother,
All people are his servants.

Let your name go forth,
While your mouth is silent,
When you are summoned,
 don't boast of strength
Among those your age, lest
 you be opposed.
One knows not what may happen,
What god does when he punishes.

> "Let your name go forth, while you mouth is silent."
> —Kagemni

"Instructions of Kagemni" is from Miriam Lichtheim, trans. and ed., *Ancient Egyptian Literature: A Book of Readings*, vol. 1 (Berkeley: University of California Press, 1973), pp. 59–60. © 1973 The Regents of the University of California. Reprinted by permission of The University of California Press.

Love Song: "I Am Your Best Girl"

I am your best girl:
I belong to you like an acre of land
which I have planted
with flowers and every sweet-smelling grass.

Pleasant is the channel through it
which your hand dug out
for refreshing ourselves with the breeze,
a happy place for walking
with your hand in my hand.

My body is excited, my heart joyful,
at our traveling together.

Hearing your voice is pomegranate wine,
for I live to hear it,
and every glance which rests on me
means more to me than eating and drinking.

Egyptian Religion

The Pyramid Texts

The Pyramid Texts date from the Old Kingdom and were carved on the walls of the sarcophagus chambers of the pyramids at Saqqara. They were discovered in 1881, and their purpose was to promote the resurrection of the Pharaoh from the dead. Each utterance is separated from the others by dividing lines and thus represents a self-contained prayer. The following incantations are from the pyramids of Pepi 1, a king in the Sixth Dynasty (ca. 2400 B.C.E.).

The Pharaoh Prays for Admittance to the Sky

Awake in peace, O Pure One, in peace!
Awake in peace, Horus-of-the-East, in peace!
Awake in peace, Soul-of-the-East, in peace!
Awake in peace, Horus-of-Lightland, in peace!
You lie down in the Night-bark,
You awake in the Day-bark,
For you are he who gazes on the gods,
There is no god who gazes on you!

"Love Song: 'I Am Your Best Girl'" is from William Kelley Simpson, ed., *The Literature of Ancient Egypt* (New Haven, Conn.: Yale University Press, 1972), pp. 308–309. Copyright © 1972 by Yale University Press. Reprinted by permission of Yale University Press.

Poems from the *Pyramid Texts* are from Miriam Lichtheim, trans. and ed., *Ancient Egyptian Literature: A Book of Readings*, vol. 1 (Berkeley: University of California Press, 1973), pp. 44, 49–50. © 1973 The Regents of the University of California. Reprinted by permission of The University of California Press.

O father of Pepi, take Pepi with you
Living, to you mother Nut!
Gates of sky, open for Pepi,
Gates of heaven, open for Pepi,
Pepi comes to you, make him live!
Command that this Pepi sit beside you,
Beside him who rises in lightland!
O father of Pepi, command to the goddess beside you
To make wide Pepi's seat at the stairway of heaven!

Command the Living One, the son of Sothis,
To speak for this Pepi,
To establish for Pepi a seat in the sky!
Commend this Pepi to the Great Noble,
The beloved of Ptah, the son of Ptah,
To speak for this Pepi,
To make flourish his jar-stands on earth,
For Pepi is one with these four gods:
Imsety, Hapy, Duamutef, Kebhsenuf,
Who live by maat [truth],
Who lean on their staffs,
Who watch over Upper Egypt.

He flies, he flies from you men as do ducks,
He wrests his arms from you as a falcon,
He tears himself from you as a kite,
Pepi frees himself from the fetter of earth,
Pepi is released from bondage!

The Pharaoh Prays to the Sky Goddess

O Great One who became Sky,
You are strong, you are mighty,
You fill every place with your beauty,
The whole earth is beneath you, you possess it!
As you enfold earth and all things in your arms,
So have you taken this Pepi to you,
An indestructible star within you!

The Book of the Dead: Negative Confession

The Book of the Dead is a collection of texts dating from the Middle and New Kingdoms that reflect a growing concern for the welfare of the dead and their search for eternal happiness. The Egyptians believed that upon death, one was judged by Osiris, god of the underworld, who

"The Book of the Dead: Negative Confession" is from E. A. Wallace Budge, trans., *The Book of the Dead According to the Theban Recension* (New York: E. P. Dutton, 1922), Ch. 125. Reprinted by permission of George Routledge and Sons, Ltd.

determined one's fate on the basis of truth (maat) and moral purity. The "negative confession" that follows was part of the summation of one's life in the presence of Osiris. The emphasis is not on one's positive accomplishments in life, but rather on the unrighteous acts that were not committed—hence the term "negative confession." The following selection is from the tomb of Nu, an administrator of the Eighteenth Dynasty (1570–1085 B.C.E.).

Homage to thee, O Great God [Osiris], . . . I have come to thee, O my Lord, I have brought myself hither that I may behold thy beauties. . . . In truth I have come to thee, and I have brought maat to thee, and I have expelled wickedness for thee.

1. I have not done evil to mankind.
2. I have not oppressed the members of my family.
3. I have not wrought evil in the place of right and truth.
4. I have had no knowledge of worthless men.
7. I have not brought forward my name for exaltation to honors.
8. I have not ill-treated servants.
9. I have not belittled a god.
10. I have not defrauded the oppressed one of his property.
11. I have not done that which is an abomination unto the gods.
14. I have made no man to suffer hunger.
15. I have made no one to weep.
16. I have done no murder.
17. I have not given the order for murder to be done for me.
18. I have not inflicted pain upon mankind.
22. I have not committed fornication.
26. I have not encroached upon the fields of others.
29. I have not carried away the milk from the mouths of children.
30. I have not driven away the cattle which were upon their pastures.
38. I have not obstructed a god in his procession. I am pure! I am pure! I am pure! I am pure!

Compare and Contrast:

- Compare the selections from the *Pyramid Texts* and *The Book of the Dead*. When were they written and what were they expected to accomplish? Can you draw any conclusions from your analysis? What do your conclusions say about Egyptian religion? Explain the term "negative confession." What is the rationale behind this practice?

- Compare Egyptian and Mesopotamian views of religion by analyzing the various selections on the nature of the gods, death, and the afterlife. What general conclusions can you draw?

The Broader Perspective:

- The geography of a region often influences the development of a civilization. In what ways did geography influence the religious outlooks of Mesopotamia and Egypt?

Against the Grain

THE AMARNA REVOLUTION

"You Are a Lifespan in Yourself"

AKHENATEN

Egyptian civilization was noted for its tradition, respect for authority, and unchanging cycles that gave unity and stability to the land for thousands of years. Yet one of the most radical changes in this pattern took place briefly during the reign of Amenhotep IV (1372–1355 B.C.E.). He changed the very essence of Egyptian religion by eliminating the several gods and goddesses that were the basis for Egyptian polytheism. He replaced them with one god, a solar disk, whom he called Aten. In accordance with these new principles, Amenhotep IV ("Amon rests") changed his name to Akhenaten ("Aten is satisfied") and constructed a new capitol at Amarna. Systematically, the names of the old gods were erased from temple walls and public inscriptions. All worship was to be directed toward Aten, a universal deity. Thus Akhenaten sacrificed his own divinity to promote himself as the son and interpreter of Aten. The following prayer to Aten is the quintessential expression of Akhenaten's devotion to his universal god.

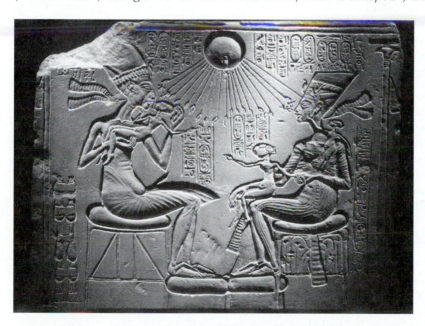

Figure 1–3 Wall carving of Akhenaten, Nefertiti, and Princesses (Corbis Bettmann).

Keep in Mind:
- Throughout this hymn, note the themes of regeneration and the regulation of life.

"'You Are a Lifespan in Yourself'" is from William Kelley Simpson, ed., "Hymn to the Aten" in *The Literature of Ancient Egypt* (New Haven, Conn.: Yale University Press, 1972), pp. 290–295. Copyright © 1972 by Yale University Press. Reprinted by permission of Yale University Press.

You rise in perfection on the horizon of the sky,
living [Aten], who started life.
Whenever you are risen upon the eastern horizon
you fill every land with your perfection.
You are appealing, great, sparkling, high over every land;
your rays hold together the lands as far as everything you
 have made.
Since you are Re, you reach as far as they do,
and you curb them for your beloved son.
Although you are far away, your rays are upon the land;
you are in their faces, yet your departure is not observed.

Whenever you set on the western horizon,
the land is in darkness in the manner of death.
They sleep in a bedroom with heads under the covers,
and one eye does not see another.
If all their possessions which are under their heads were
 stolen,
they would not know it.

Every lion who comes out of his cave and all the serpents
 bite,
for darkness is a blanket.
The land is silent now, because
he who made them
is at rest on his horizon.

But when day breaks you are
risen upon the horizon,
and you shine as the [Aten] in the daytime.
When you dispel darkness and you give forth your rays
the two lands are in festival,
alert and standing on their feet,
now that you have raised them up.
Their bodies are clean, and their clothes have been put
 on;
their arms are [lifted] in praise at your rising.

The entire land performs its works:
all the cattle are content with their fodder,
trees and plants grow,
birds fly up to their nests,
their wings [extended] in praise for your Ka.
All the kine prance on their feet;
everything which flies up and alights,
they live when you have risen for them.
The barges sail upstream and downstream too,
for every way is open at your rising.
The fishes in the river leap before your face
when your rays are in the sea.

You who have placed seed in woman
and have made sperm into man,
who feeds the son in the womb of his mother,

who quiets him with something to stop his
 crying;
you are the nurse in the womb,
giving breath to nourish all that has been begotten.

When he comes down from the womb to breathe
on the day he is born,
you open up his mouth [completely], and supply his
 needs.
When the fledgling in the egg speaks in the shell,
you give him air inside it to sustain him.
When you grant him his allotted time to break out from the
 egg,
he comes out from the egg to cry out at his fulfillment,
and he goes upon his legs when he has come forth from it.

How plentiful it is, what you have made,
although they are hidden from view,
sole god, without another beside you;
you created the earth as you wished,
when you were by yourself, [before]
mankind, all cattle and kine,
all beings on land, who fare upon their feet,
and all beings in the air, who fly with their wings.

The lands of Khor and Kush
and the land of Egypt:
you have set every man in his place,
you have allotted their needs,
every one of them according to his diet,
and his lifetime is counted out.

Tongues are separate in speech,
and their characters as well;
their skins are different,
for you have differentiated the foreigners.
In the underworld you
have made a Nile
that you may bring it
 forth as you wish
to feed the populace,
since you made them
 for yourself, their
 utter master,
growing weary on
 their account,
lord of every land.
For them the [Aten]
 of the
daytime arises,
great in awesomeness.

 All distant lands,

> **"You have set every man in his place,
> You have allotted their needs
> . . .
> And his lifetime is counted out."**
>
> **—Akhenaten**

you have made them live,
for you have set a Nile in the sky [meaning "rain"]
that it may descend for them
and make waves upon the mountains like the sea
to irrigate the fields in their towns.
How efficient are your designs,
Lord of eternity:
a Nile in the sky for the foreigners
and all creatures that go upon their feet,
a Nile coming back from the underworld for Egypt.

Your rays give suck to every field:
when you rise they live,
and they grow for you.
You have made the seasons
to bring into being all you have made:
the Winter to cool them,
the Heat that you may be felt.
You have made a far-off heaven
in which to rise
in order to observe everything you have made.

Yet you are alone,
rising in your manifestations as the Living [Aten]:
appearing, glistening, being afar, coming close;
you make millions of transformations of yourself.
Towns, harbors, fields, roadways, waterways:
every eye beholds you upon them,
for you are the [Aten] of the daytime on the face of the earth.
When you go forth
every eye [is upon you].
You have created their sight
but not to see [only] the body . . .
which you have made.

You are my desire,
and there is no other who knows you
except for your son . . .
for you have apprized him of your designs and your power.
The earth came forth into existence by your hand,
and you made it.
When you rise, they live;
when you set, they die.
You are a lifespan in yourself;
one lives by you.
Eyes are upon your perfection until you set:
all work is put down when you rest in the west.

When [you] rise, [everything] grows
for the King and [for] everyone who hastens on foot,
because you have founded the land
and you have raised them for your son
who has come forth from your body,
the King of Upper and Lower Egypt, the one Living on
 Maat,
Lord of the Two Lands . . .

son of Re, the one Living on Maat, Master of Regalia,
[Akhenaten], the long lived,
and the Foremost Wife of the King, whom he loves,
the Mistress of the Two Lands, . . .
living and young, forever and ever.

Consider This:

- What specific phrases from this Hymn to Aten reflect the regeneration and regulation of life. If Akhenaten's prayer to Aten emphasized stability and security, why was it considered so threatening to conservative Egyptian values?

- Akhenaten's monotheism has been hotly debated. Some historians have regarded it as a unique and creative approach to religion that even influenced later Hebrew monotheism; others have seen it as the development of earlier Egyptian thought with new elements included. In any event, Akhenaten's new religion was considered a heresy and did not long survive his reign. What does this tell you about the process of change in Egyptian society?

- The art produced during the reign of Akhenaten was truly revolutionary. From the various examples of art in this segment, how would you characterize it? How radical an impact did the Amarna Revolution have on Egyptian society?

Linking the Humanities:

- What is the relationship between political power and artistic style? How do political rulers use art to define their personalities, promote their policies, or to maintain their power?

Hebrew Civilization

Nowhere did religion play a greater role than in the development of Hebrew civilization. The Hebrews were a nomadic people whose wanderings and eventual establishment in the promised land of Canaan (modern-day Israel) form the narrative story of the Old Testament of the Bible. But more than this, the story concerns the relationship of Yahweh (or God) to his chosen people, the Hebrews. Many other Near Eastern conquerors held more land and ruled more people, but no one influenced the course of Western Civilization more emphatically than did the Hebrews. Their concern with moral law, right action, and adherence to monotheistic principles has formed the basis for Christianity and Islam in the modern world.

Origins, Oppression, and the Exodus of the Hebrews from Egypt

The first few pages from Genesis in the Old Testament of the Bible contain some of the most powerful and influential ideas in World Civilization. Genesis explains the origins of the universe by one omnipotent and omniscient God, who created human beings in his likeness, gave them dominion over nature, and endowed them with an inherent goodness. It is the story of the creation of woman, the origins of sin, and the fall from God's grace. This concept of monotheism and the ethical and social structure that derived from the development of these ideas were the primary contributions of the Hebrews to World Civilization.

The story of the Hebrews in the Old Testament begins with the wandering patriarch Abraham, who led his family from Ur in Sumer around 1800 B.C.E. to the promised land of Canaan by about 1700 B.C.E. A group of Hebrews led by Joseph continued south to Egypt, where they were hospitably received by the Hyksos, a Semitic people like the Hebrews, who had conquered Egypt about 1710 B.C.E. Joseph, according to the Old Testament, actually ruled Egypt for a time. But by 1570 B.C.E., a resurgent Egypt had ended the Hyksos' control, and the Pharaohs enslaved the Hebrews and forced them to build new Egyptian cities. Shortly after 1300 B.C.E., Moses was directed by God to lead his people out of Egypt, across the Red Sea, and back to the promised land of Canaan.

The Creation of the World

In the beginning, God created heaven and earth. Now the earth was a formless void, there was darkness over the deep, with a divine wind sweeping over the waters.

God said, 'Let there be light,' and there was light. God saw that light was good, and God divided light from darkness. God called light 'day,' and darkness he called 'night.' Evening came and morning came: the first day.

God said, 'Let there be a vault through the middle of the waters to divide the waters in two.' And so it was. God made the vault, and it divided the waters under the vault from the waters above the vault. God called the vault 'heaven.' Evening came and morning came: the second day.

God said, 'Let the waters under heaven come together into a single mass, and let dry land appear.' And so it was. God called the dry land 'earth' and the mass of waters 'seas,' and God saw that it was good.

God said, 'Let the earth produce vegetation: seed-bearing plants, and fruit trees on earth, bearing fruit with their seed inside, each corresponding to its own seed-bearing fruit with their seed inside, each corresponding to its own species.' And so it was. . . . God saw that it was good. Evening came and morning came: the third day.

God said, 'Let there be lights in the vault of heaven to divide day from night, and let them indicate festivals, days and years. Let them be lights in the vault of heaven to shine on the earth.' And so it was. God made the two great lights, the greater light to govern the day, the smaller light to govern the night, and the stars. . . . God saw that it was good. Evening came and morning came: the fourth day.

God said, 'Let the waters be alive with a swarm of living creatures, and let birds wing their way above the earth across the vault of heaven.' And so it was. God created great sea-monsters and all the creatures that glide and teem in the waters in their own species, and winged birds in their own species. God saw that it was good. God blessed them, saying, 'Be fruitful, multiply, and fill the waters of the seas; and let the birds multiply on land.' Evening came and morning came: the fifth day.

God said, 'Let the earth produce every kind of living creature in its own species: cattle, creeping things and wild animals of all kinds.' And so it was. . . . God saw that it was good. God said, 'Let us make man in our own image, in the likeness of ourselves, and let them be masters of the fish of the sea, the birds of heaven, the cattle, all the wild animals, and all the

> **"Be fruitful, multiply, fill the earth and subdue it. Be masters of the fish of the sea, the birds of heaven and all the living creatures that move on earth."**
> **—Genesis**

creatures that creep along the ground.' God created man in the image of himself, in the image of God he created him, male and female he created them.

God blessed them, saying to them, 'Be fruitful, multiply, fill the earth and subdue it. Be masters of the fish of the sea, the birds of heaven and all the living creatures that move on earth.' God also said, 'Look, to you I give all the seed-bearing plants everywhere on the surface of the earth, and all the trees with seed-bearing fruit; this will be your food. And to all the wild animals, all the birds of heaven and all the living creatures that creep along the ground, I give all the foliage of the plants as their food.' And so it was. God saw all he had made, and indeed it was very good. Evening came and morning came: the sixth day.

Thus heaven and earth were completed with all their array. On the seventh day God had completed the work he had been doing. He rested on the seventh day after all the work he had undertaken. God blessed the seventh day and made it holy, because on that day he rested after all his work of creating.

The Cultural Intersection

YUCATAN: 1550

Maya Origins: The Creation of the World

When Hernando Cortés had completed his conquest of Mexico in 1524, he sent his most fearless captain, Pedro de Alvarado, east to a region in modern Guatemala occupied by the descendants of the once powerful Maya civilization. These Quiché Mayans put up a vigorous defense but finally surrendered in the face of superior Spanish weaponry. Alvarado seized the kings and executed them in the presence of their people. Their city was razed to the ground and the site abandoned.

Two hundred years later in the 18th century, the Spanish friar, Father Francisco Ximénez, who had lived with the remnants of the Quiché in the area and had learned their language, was busy converting them to Christianity. In winning their confidence, these Indians offered Ximénez a sacred book that contained the stories and traditions of their ancestors. This book, called the Popul Vuh, *was written shortly after the Spanish conquest by a Quiché Indian who had learned to read and write Spanish. Father Ximénez transcribed the text and returned the book to its owners where it has been lost to history. But Ximénez's transcription still exists and it is an amazing document. It contains the Maya cosmogony, creation myths, and a chronology of their kings down to the year 1550. The following selections from the* Popul Vuh *reveal much about the Mayan conception of the world and the origins of ritual blood sacrifice.*

Keep in Mind:

• According to the *Popul Vuh*, who created the world?

• Who were the first men and why were they unacceptable to the gods? How were the first men destroyed?

This is the account of how all was in suspense, all calm, in silence; all motionless, still, and the expanse of the sky was empty.

This is the first account, the first narrative. There was neither man, nor animal, birds, fishes, crabs, trees, stones, caves, ravines, grasses, nor forests; there was only the sky.

The surface of the earth had not appeared. There was only the calm sea and the great expanse of the sky.

There was nothing brought together, nothing which could make a noise, nor anything which might move, or tremble, or could make noise in the sky.

There was nothing standing; only the calm water, the placid sea, alone and tranquil. Nothing existed.

There was only immobility and silence in the darkness, in the night. Only the Creator, the Maker, Tepeu, Gucumatz, the Forefathers, were in the water surrounded with light.

"Maya Origins" is from *The Popul Vuh* translated (from the Spanish) by Delia Goetz and Sylvanus G. Morley from the Spanish translation by Adrian Recinos, pp. 81–84. Copyright © 1950 by The University of Oklahoma Press. Reprinted by permission of The University of Oklahoma Press.

They were hidden under green and blue feathers, and were therefore called Gucumatz. By nature they were great sages and great thinkers. In this manner the sky existed and also the Heart of Heaven, which is the name of God and thus He is called.

Then came the word. Tepeu and Gucumatz came together in the darkness, in the night, and Tepeu and Gucumatz talked together. They talked then, discussing and deliberating; they agreed, they united their words and their thoughts.

Then while they meditated, it became clear to them that when dawn would break, man must appear. Then they planned the creation, and the growth of the trees and the thickets and the birth of life and the creation of man. Thus it was arranged in the darkness and in the night by the Heart of Heaven who is called Huracan. . . .

> "Let there be light, let there be dawn in the sky and on the earth! There shall be neither glory nor grandeur in our creation . . . until the human being is made, man is formed."
>
> —*Popul Vuh*

Thus let it be done! Let the emptiness be filled! Let the water recede and make a void, let the earth appear and become solid; let it be done. Thus they spoke. Let there be light, let there be dawn in the sky and on the earth! There shall be neither glory nor grandeur in our creation and formation until the human being is made, man is formed. So they spoke.

Then the earth was created by them. So it was, in truth, that they created the earth. Earth! they said, and instantly it was made.

Like the mist, like a cloud, and like a cloud of dust was the creation, when the mountains appeared from the water; and instantly the mountains grew.

Only by a miracle, only by magic art were the mountains and valleys formed; and instantly the groves of cypresses and pines put forth shoots together on the surface of the earth. . . .

First the earth was formed, the mountains and the valleys; the currents of water were divided, the rivulets were running freely between the hills, and the water was separated when the high mountains appeared. Thus was the earth created, when it was formed by the Heart of Heaven, the Heart of Earth, as they are called who first made it fruitful, when the sky was in suspense, and the earth was submerged in the water.

So it was theat they made perfect the work, when they did it after thinking and meditating upon it.

Then they made the small wild animals, the guardians of the woods, the spirits of the mountains, the deer, the birds, pumas, jaguars, serpents, snakes, vipers, guardians of the thickets. . . .

"Let us try again! Already dawn draws near: Let us make him who shall nourish and sustain us! What shall we do to be invoked, in order to be remembered on earth? We have already tried with our first creations, our first creatures; but we could not make them praise and venerate us. So, then, let us try to make obedient, respectful beings who will nourish and sustain us." Thus they spoke.

Then was the creation and the formation. Of earth, of mud, they made [man's] flesh. But they saw that it was not good. It melted away, it was soft, did not move, had no strength, it fell down, it was limp, it could not move its head, its face fell to one side, its sight was blurred, it could not look behind. At first it spoke, but had no mind. Quickly it soaked in the water and could not stand.

And the Creator and the Maker said: "Let us try again because our creatures will not be able to walk nor multiply. Let us consider this," they said.

Then they broke up and destroyed their work and their creation. And they said: "What shall we do to perfect it, in order that our worshipers, our invokers, will be successful?" . . .

Beginning the divination, they said: "Get together, grasp each other! Speak, that we may hear." They said, "Say if it is well that the wood be got together and that it be carved by the Creator and the Maker, and if this [man of wood] is he who must nourish and sustain us then there is light when it is day! . . . These were the first men who existed in great numbers on the face of the earth.

Immediately the wooden figures were annihilated, destroyed, broken up, and killed.

A flood was brought about by the Heart of Heaven; a great flood was formed which fell on the heads of the wooden creatures. . . . Those that they had made, that they had created, did not think, did not speak with their Creator, their Maker. And for this reason they were killed, they were deluged. . . .

This was to punish them because they had not thought of their mother, nor their father, the Heart of Heaven, called Huracan. And for this reason the face of the earth was darkened and a black rain began to fall, by day and by night. . . .

The desperate ones [the men of wood] ran as quickly as they could; they wanted to climb to the tops of the houses, and the houses fell down and threw them to the ground; they wanted to climb to the tree-tops, and the trees cast them far away; they wanted to enter the caverns, and the caverns repelled them.

So was the ruin of the men who had been created and formed, the men made to be destroyed and annihilated; the mouths and faces of all of them were mangled.

> "A flood was brought about by the Heart of Heaven; a great flood was formed which fell on the heads of the wooden creatures."
>
> —*Popul Vuh*

And it is said that their descendants are the monkeys which now live in the forests; these are all that remain of them because their flesh was made only of wood by the Creator and the Maker.

And therefore the monkey looks like man, and is an example of a generation of men which were created and made but were only wooden figures.

Compare and Contrast:

- Compare the sequence of creation in the Maya account with that of Genesis. How do they differ? Note the phrase used in both accounts: "Let there be light." What does this mean?

- Why are floods common in creation epics? Compare the flood narratives in the Bible and in the Epic of Gilgamesh on page 7. How are they similar?

- Why did the Mayan gods have such difficulty with the formation of human beings? What did the creator gods require of them? Why is it significant in Genesis that God made man in his own image?

The Broader Perspective:

- Why is the concept of creation so important to each culture? How does creation define the religious parameters of society?

Paradise and the Fall from Grace

At the time when Yahweh God made earth and heaven, there was as yet no wild bush on the earth nor had any wild plant yet sprung up, for Yahweh God had not sent rain on the earth, nor was there any man to till the soil. Instead, water flowed out of the ground and watered all the surface of the soil. Yahweh God shaped man from the soil of the ground and blew the breath of life into his nostrils, and man became a living being.

Yahweh God planted a garden in Eden, which is in the east, and there he put the man he had fashioned. From the soil, Yahweh God caused to grow every kind of tree, enticing to look at and good to eat, with the tree of life in the middle of the garden, and the tree of the knowledge of good and evil. . . .

Yahweh God took the man and settled him in the garden of Eden to cultivate and take care of it. Then Yahweh God gave the man this command, "You are free to eat of all the trees in the garden. But of the tree of the knowledge of good and evil you are not to eat; for, the day you eat of that, you are doomed to die."

Yahweh God said, "It is not right that the man should be alone. I shall make him a helper. . . ." Then Yahweh God made the man fall into a deep sleep. And, while he was asleep, he took one of his ribs and closed the flesh up again forthwith. Yahweh God fashioned the rib he had taken from the man into a woman, and brought her to the man. And the man said: This one at last is bone of my bones and flesh of my flesh! She is to be called Woman, because she was taken from Man.

This is why a man leaves his father and mother and becomes attached to his wife, and they become one flesh. Now, both of them were naked, the man and his wife, but they felt no shame before each other.

Now the snake was the most subtle of all the wild animals that Yahweh God had made. It asked the woman, "Did God really say you were not to eat from any of the trees in the garden?" The woman answered the snake, "We may eat the fruit of the trees in the garden. But of the fruit of the tree in the middle of the garden God said, 'You must not eat it, nor touch it, under pain of death.'" "Then the snake said to the woman, "No! You will not die! God knows in fact that the day you eat it your eyes will be opened and you will be like gods, knowing good from evil." The woman saw that the tree was good to eat and pleasing to the eye and that it was enticing for the wisdom that it could give. So she took some of the fruit and ate it. She also gave some to her husband who was with her, and he ate it. Then the eyes of both of them were opened and they realized that they were naked. So they sewed fig-leaves to make themselves loincloths.

The man and his wife heard the sound of Yahweh God walking in the garden in the cool of the day, and they hid from Yahweh God among the trees of the garden. "Where are you?" he asked. . . . "Have you been eating from the tree I forbade you to eat?" The man replied, "It was the woman you put with me; she gave me some fruit from the tree, and I ate it." Then Yahweh God said to the woman, "Why did you do that?" The woman replied, "The snake tempted me and I ate." Then Yahweh God said to the snake,

> "Because you have done this,
> Accursed be you
> of all animals wild and tame!
> On your belly you will go
> and on dust you will feed

as long as you live.
I shall put enmity
between you and the woman,
and between your offspring
 and hers;
it will bruise your head
and you will strike its heel."

To the woman he said:
I shall give you intense pain in
 childbearing,
you will give birth to your
 children in pain.
Your yearning will be for your husband,
and he will dominate you.

To the man he said:
"Because you listened to the voice of your wife
and ate from the tree of which I had forbidden you to eat,
Accursed be the soil because of you!
Painfully will you get your food from it
as long as you live. . . .
By the sweat of your face
will you earn your food,
until you return to the ground,
as you were taken from it.
For dust you are
and to dust you shall return."

> **"I shall give you intense pain in childbearing . . .**
> **Your yearning will be for your husband, and he will dominate you."**
>
> **—Genesis**

The man named his wife "Eve" because she was the mother of all those who live. Yahweh made tunics of skins for the man and his wife and clothed them. Then Yahweh God said, "Now that the man has become like one of us in knowing good from evil, he must not be allowed to reach out his hand and pick from the tree of life too, and eat and live forever!" So Yahweh God expelled him from the garden of Eden, to till the soil from which he had been taken. He banished the man, and in front of the garden of Eden he posted the great winged creatures and the fiery flashing sword to guard the way to the tree of life.

Consider This:

- After reading the selections from Genesis on the origin of the world, paradise, and the fall from grace, analyze why these have been so influential in Western Civilization. What do the Garden of Eden and the Tree of Life represent? What are the two stories about the creation of woman? What is the relative position of women to men at the biblical origin of life?

The Broader Perspective:

- How have these passages from Genesis been used to structure social attitudes and expectations throughout the centuries? Do they still have impact today?

The Hebrew Bondage

Then there came to power in Egypt a new king who knew nothing of Joseph. "Look," he said to his subjects, "these people, the sons of Israel, have become so numerous and strong that they are a threat to us. We must be prudent and take steps against their increasing any further, or if war should break out, they might add to the number of our enemies. They might take arms against us and so escape out of the country." Accordingly they put slave-drivers over the Israelites to wear them down under heavy loads. In this way they built the store-cities of Pithom and Ramses for Pharaoh. But the more they were crushed, the more they increased and spread, and men came to dread the sons of Israel. The Egyptians forced the sons of Israel into slavery, and made their lives unbearable with hard labor, work with clay and brick, all kinds of work in the fields; they forced on them every kind of labor. . . .

The Burning Bush

During this long period the king of Egypt died. The sons of Israel, groaning in their slavery, cried out for help and from the depths of their slavery their cry came up to God. God heard their groaning and he called to mind his covenant with Abraham, Isaac and Jacob. God looked down upon the sons of Israel, and he knew. . . .

Moses was looking after the flock of Jethro, his father-in-law, priest of Midian. He led his flock to the far side of the wilderness and came to Horeb, the mountain of God. There the angel of Yahweh appeared to him in the shape of a flame of fire, coming from the middle of a bush. Moses looked; there was the bush blazing, but it was not being burnt up. "I must go and look at this strange sight," Moses said, "and see why the bush is not burnt." Now Yahweh saw him go forward to look, and God called to him from the middle of the bush. "Moses, Moses!" He said. "Here I am," he answered. "Come no nearer," He said. "Take off your shoes, for the place on which you stand is holy ground. I am the God of your father," He said, "the God of Abraham, the god of Isaac and the God of Jacob." At this Moses covered his face, afraid to look at God. . . .

The Mission of Moses

God spoke to Moses and said to him, "I am Yahweh. To Abraham and Isaac and Jacob I appeared as El Shaddai; I did not make myself known to them by my name Yahweh. Also, I made my covenant with them to give them the land of Canaan, the land they lived in as strangers. And I have heard the groaning of the sons of Israel, enslaved by the Egyptians, and have remembered my covenant. Say this, then, to the sons of Israel, 'I am Yahweh. I will free you of the burdens which the Egyptians lay on you. I will release you from slavery to

"The Hebrew Bondage" is from Exodus 1, from Alexander Jones, ed., *The Jerusalem Bible*, p. 78. Copyright © 1966 by Darton, Longman, & Todd, Ltd., and Doubleday, a division of Random House, Inc. Used by permission of Doubleday, a division of Random House, Inc.

"The Burning Bush" is from Exodus 2–3, from Alexander Jones, ed., *The Jerusalem Bible*, p. 80. Copyright © 1966 by Darton, Longman, & Todd, Ltd., and Doubleday, a division of Random House, Inc. Used by permission of Doubleday, a division of Random House, Inc.

"The Mission of Moses" is from Exodus 6, from Alexander Jones, ed., *The Jerusalem Bible*, p. 84. Copyright © 1966 by Darton, Longman, & Todd, Ltd., and Doubleday, a division of Random House, Inc. Used by permission of Doubleday, a division of Random House, Inc.

them, and with my arm outstretched and my strokes of power I will deliver you. I will adopt you as my own people, and I will be your God. Then you shall know that it is I, Yahweh your God, who have freed you from the Egyptians' burdens. Then I will bring you to the land I swore that I would give to Abraham, and Isaac, and Jacob, and will give it to you for your own; I, Yahweh, will do this!" Moses told this to the sons of Israel, but they would not listen to him, so crushed was their spirit and so cruel their slavery.

Yahweh then said to Moses, "Go to Pharaoh, king of Egypt, and tell him to let the sons of Israel leave his land." But Moses answered to Yahweh's face: "Look," said he

> **"I am Yahweh. I will free you of the burdens which the Egyptians lay on you. I will release you from slavery."**
> **—Exodus**

"since the sons of Israel have not listened to me, why should Pharaoh listen to me, a man slow of speech?" Yahweh spoke to Moses and Aaron and ordered them to both go to Pharaoh, king of Egypt, and to bring the sons of Israel out of the land of Egypt.

The Departure of the Israelites

When Pharaoh had let the people go, God did not let them take the road to the land of the Philistines, although that was the nearest way. God thought that the prospect of fighting would make the people lose heart and turn back to Egypt. Instead, God led the people by the roundabout way of the wilderness to the Sea of Reeds [Red Sea]. . . .

Yahweh went before them, by day in the form of a pillar of cloud to show them the way, and by night in the form of a pillar of fire to give them light: thus they could continue their march by day and by night. The pillar of cloud never failed to go before the people during the day, nor the pillar of fire during the night. . . .

When Pharaoh, king of Egypt, was told that the people had made their escape, he and his courtiers changed their minds about the people. "What have we done," they said, "allowing Israel to leave our service?" So Pharaoh had his chariot harnessed and gathered his troops about him, taking six hundred of the best chariots and all the other chariots in Egypt, each manned by a picked team. Yahweh made Pharaoh, king of Egypt, stubborn, and he gave chase to the sons of Israel as they made their triumphant escape. So the Egyptians gave chase and came up with them where they lay encamped beside the sea—all the

horses, the chariots of Pharaoh, his horsemen, his army—near Pi-hahiroth, facing Baalzephon. And as Pharaoh approached, the sons of Israel looked round—and there were the Egyptians in pursuit of them! The sons of Israel were terrified and cried out to Yahweh. To Moses they said, "Were there no graves in Egypt that you must lead us out to die in the wilderness? What good have you done us, bringing us out of Egypt? We spoke of this in Egypt, did we not? Leave us alone, we said, we would rather work for the Egyptians! Better to work of the Egyptians than die in the wilderness!" Moses answered the people, "Have no fear! Stand firm, and you will see what Yahweh will do to save you today: the Egyptians you see today, you will never see again. Yahweh will do the fighting for you: you have only to keep still."

Yahweh said to Moses, "Why do you cry to me so? Tell the sons of Israel to march on. For yourself, raise your staff and stretch out your hand over the sea and part it for the sons of Israel to walk through the sea on dry ground. I for my part will make the heart of the Egyptians so stubborn that they will follow them. So shall I win myself glory at the expense of Pharaoh, of all his army, his chariots, his horsemen. And when I have won glory for myself, at the expense

of Pharaoh and his chariots and his army, the Egyptians will learn that I am Yahweh."

> "Why do you cry to me so? Tell the sons of Israel to march on. . . . Raise your staff and stretch out you hand over the sea and part it . . ."
> —Exodus

Then the angle of Yahweh, who marched at the front of the army of Israel, changed station and moved to their rear. The pillar of cloud changed station from the front to the rear of them, and remained there. It came between the camp of the Egyptians and the camp of Israel. The cloud was dark, and the night passed without the armies drawing any closer the whole night long. Moses stretched out his hand over the sea. Yahweh drove back the sea with a strong easterly wind all night, and he made dry land of the sea. The waters parted and the sons of Israel went on dry ground right into the sea, walls of water to right and to left of them. The Egyptians gave chase: after them they went, right into the sea, all Pharaoh's horses, his chariots, and his horsemen. . . . Yahweh said to Moses "that the waters may flow back on the Egyptians and their chariots and their horsemen." Moses stretched out his hand over the sea and, as day broke, the sea returned to its bed. The fleeing Egyptians marched right into it, and Yahweh overthrew the Egyptians in the very middle of the sea. The returning waters overwhelmed the chariots and the horsemen of Pharaoh's whole army, which had followed the Israelites into the sea; not a single one of them was left. But the sons of Israel had marched through the sea on dry ground, walls of water to right and to left of them. That day, Yahweh rescued Israel from the Egyptians, and Israel saw the Egyptians lying dead on the shore. Israel witnessed the great act that Yahweh had performed against the Egyptians, and the people venerated Yahweh; they put their faith in Yahweh and in Moses, his servant.

Consider This:
- What was Moses' mission as recorded in the Old Testament? Why is the Exodus from Egypt central to the Jewish experience? What does it say about Yahweh's relationship with the Hebrews?

Covenant and Commandments
After the Exodus of the Hebrews from Egypt, Yahweh established the nation of Israel and through Moses made a covenant with His chosen people that He would protect them in return for their obedience to His laws. The law code that God handed down to Moses on Mt. Sinai is called the Decalogue or Ten Commandments and is absolute in nature. Other laws that are less absolute and generally reflect the needs and values of Hebrew society are called the Covenant Code; they are included after the Ten Commandments and were probably written centuries later. Note the similarity between this Covenant Code and the laws of Hammurabi.

The Ten Commandments

Three months after they came out of the land of Egypt . . . on that day the sons of Israel came to the wilderness of Sinai. . . .

Moses then went up to God, and Yahweh called to him from the mountains, saying, "Say this to the House of Jacob, declare this to the

sons of Israel, 'You yourselves have seen what I did with the Egyptians, how I carried you on eagle's wings and brought you to myself. From this you know that now, if you obey my voice and hold fast to my covenant, you of all the nations shall be my very own for all the earth is mine. I will count you a kingdom of priests, a consecrated nation.' Those are the words you are to speak to the sons of Israel." . . .

Yahweh said to Moses, "Go to the people and tell them to prepare themselves today and tomorrow. Let them wash their clothing and hold themselves in readiness for the third day, because on the third day Yahweh will descend on the mountain of Sinai in the sight of all the people. You will mark out the limits of the mountain and say, 'Take care not to go up the mountain or to touch the foot of it. Whoever touches the mountain will be put to death. No one must lay a hand on him: he must be stoned or shot down by arrow, whether man or beast; he must not remain alive.' When the ram's horn sounds a long blast, they are to go up the mountain." . . .

Now at daybreak on the third day there were peals of thunder on the mountain and lightning flashes, a dense cloud, and a loud trumpet blast, and inside the camp all the people trembled. Then Moses led the people out of the camp to meet God; and they stood at the bottom of the mountain. The mountain of Sinai was entirely wrapped in smoke, because Yahweh had descended on it in the form of fire. Like smoke from a furnace the smoke went up, and the whole mountain shook violently. Louder and louder grew the sound of the trumpet, Moses spoke, and God answered him with peals of thunder. Yahweh came down on the mountain of Sinai, on the mountain top, and Yahweh called Moses to the top of the mountain; and Moses went up. . . .

Then God spoke all these words. He said, "I am Yahweh your God who brought you out of the land of Egypt, out of the house of slavery.

"You shall have no gods except me.

"You shall not make yourself a carved image or any likeness of anything in heaven or on earth beneath or in the waters under the earth; you shall not bow down to them or serve them. For I, Yahweh your God, am a jealous God and I punish the father's fault in the sons, the grandsons, and the great-grandsons of those who hate me; but I show kindness to thousands of those who love me and keep my commandments.

"You shall not utter the name of Yahweh your God to misuse it, for Yahweh will not leave unpunished the man who utters his name to misuse it.

"Remember the sabbath day and keep it holy. For six days you shall labor and do all your work, but the seventh day is a sabbath for Yahweh your God. You shall do no work that day, neither you nor your son nor your daughter nor your servants, men or women, nor your animals nor the stranger who lives with you. For in six days Yahweh made the heavens and the earth and the sea and all that these hold, but on the seventh day he rested; that is why Yahweh has blessed the sabbath day and made it sacred.

"Honor your father and your mother so that you may have a long life in the land that Yahweh your God has given to you.

"You shall not kill.

"You shall not commit adultery.

"You shall not steal.

"You shall not bear false witness against your neighbor.

"You shall not covet your neighbor's house. You shall not covet your neighbor's wife, or his servant, man or woman, or his ox, or his donkey, or anything that is his."

The Covenant Code

"This is the ruling you [Moses] are to lay before them: . . .

'Anyone who strikes a man and so causes his death, must die. If he has not lain in wait for him but God has delivered him into his hands, then I will appoint you a place where he may seek refuge. But should a man dare to kill his fellow by treacherous intent, you must

"The Covenant Code" is from Exodus 21–22, 24, from Alexander Jones, ed., *The Jerusalem Bible*, pp. 104, 106, 108. Copyright © 1966 by Darton, Longman, & Todd, Ltd., and Doubleday, a division of Random House, Inc. Used by permission of Doubleday, a division of Random House, Inc.

take him even from my altar to be put to death.

'Anyone who strikes his father or mother must die. Anyone who abducts a man—whether he has sold him or is found in possession of him—must die. Anyone who curses father or mother must die.

> ## "Anyone who strikes a man and so causes his death, must die."
>
> **—Exodus**

'If men quarrel and one strikes the other a blow with stone or fist so that the man, though he does not die, must keep his bed, the one who struck the blow shall not be liable provided the other gets up and can go about, even with a stick. He must compensate him, however, for his enforced inactivity, and care for him until he is completely cured.

'If a man beats his slave, male or female, and the slave dies at his hands, he must pay the penalty. But should the slave survive for one or two days, he shall pay no penalty because the slave is his by right of purchase.

'If, when men come to blows, they hurt a woman who is pregnant and she suffers a miscarriage, though she does not die of it, the man responsible must pay the compensation demanded of him by the woman's master; he shall hand it over, after arbitration. But should she die, you shall give life for life, eye for eye, tooth for tooth, hand for hand, foot for foot, burn for burn, wound for wound, stroke for stroke. . . .

'You must not molest the stranger or oppress him, for you lived as strangers in the land of Egypt. You must not be harsh with the widow, or with the orphan; if you are harsh with them, they will surely cry out to me, and be sure I shall hear their cry; my anger will flare and I shall kill you with the sword, your own wives will be widows, your own children orphans.

'If you lend money to any of my people, to any poor man among you, you must not play the usurer with him: you must not demand interest from him.

'If you take another's cloak as a pledge, you must give it back to him before sunset. It is all the covering he has; it is the cloak he wraps his body in; what else would he sleep in? If he cries to me, I will listen, for I am full of pity. . . .'"

Moses went and told the people all the commands of Yahweh and all the ordinances. In answer, all the people said with one voice, "We will observe all the commands that Yahweh has decreed." Moses put all the commands of Yahweh into writing.

Compare and Contrast:

- Note the Hebrew concern for moral instructions and law. Compare the Covenant Code with the Code of Hammurabi on page 4. In what ways are they similar? Were the Mesopotamians, Egyptians, and Hebrews all concerned with living a good, moral life? What values were most appreciated?

The Wisdom and Songs of Life

When the Hebrews settled in the land of Canaan (modern Israel) after the Exodus from Egypt in the early 13th century B.C.E., *it soon became apparent that the loose confederacy of Hebrew tribes was ineffective when faced with enemies. Of special concern were the Philistines, who settled in the region about 1200* B.C.E., *destroyed the Hebrew sanctuary at Shiloh about 1050* B.C.E., *and carried off the Ark of the Covenant. In response to this, the Hebrew people demanded strong leadership and elected a king named Saul. He was not a particularly effective leader and died in battle with the Philistines. His successor was the famous David (1020–1000* B.C.E.*)*

whose personal defeat of the Philistine Goliath led to security and domestic reform. David established the Hebrew capital at Jerusalem and equipped it with a central administration. At last, a united Israel was born.

David's progressive spirit was continued by his son Solomon (961–922 B.C.E.), who strengthened centralized control of the state by the king. His construction of the Temple and palace complex required frequent taxes and even oppressive forced labor. Still, Solomon developed a reputation for wisdom and fairness. It was only later in his reign that he incurred the wrath of God.

Wisdom was of particular importance to the Hebrews. The Old Testament contains five Wisdom books: Job, Proverbs, Ecclesiastes, Ecclesiasticus, and Wisdom. Together with the Psalms, which also include much wisdom, and the Song of Songs, reputedly written by Solomon the Wise himself, these books span nearly 1,000 years.

Wisdom literature, however, was certainly not particular to the Hebrews and the sages of Israel drew freely on Egyptian and Mesopotamian traditions. Hebrew wisdom focused on the practical side of life—common sense advice, the foundations of good character and right action, as well as the realization that omnipotent Yahweh was the source of all wisdom and success.

The first selection is a masterpiece of poetry from the book of Job that meditates on the relationship between sin and suffering. The logical argument that the transgression of God's laws will result in suffering and retribution is called into question as Job, a good servant of God, is visited by disaster after disaster when his oxen are stolen, his servants and children killed, his body invaded by ulcers and wasted by disease. This had been a test of Job's faith in Yahweh and throughout his ordeals, he never questioned or reproached God's action even though he was not guilty of any sin, not even unknowingly. The message was clear: Although God's plan is unknowable, human destiny is dependent on complete submission and faith in the wisdom of Yahweh.

The following selections from Job, the Psalms, and the Song of Songs seek to define faith, to acknowledge the omnipotence of Yahweh, and to celebrate the sublime wonders of nature, life, and love.

Job: "Clothed In Fearful Splendor"

Listen to this, Job, without flinching
 and reflect on the marvelous works of God.
Do you know how God controls them
 or how his clouds make the lightning flash?
Do you know how he balances the clouds—
 a miracle of consummate skill?
When your clothes are hot to your body
 and the earth lies still under the south wind,
can you, like him, stretch out the sky,
 tempered like a mirror of cast metal?
Teach me what we should say to him:
 but better discuss no further, since we are in the dark.
Does he take note when I speak?
 When human beings give orders, does he take it in?
There are times when the light vanishes,
 behind darkening clouds;

then comes the wind, sweeping them away.
 And brightness spreads from the north.
God is clothed in fearful splendor:
 he, Shaddai, is far beyond our reach.
Supreme in power, in equity,
 excelling in saving justice, yet no oppressor—
no wonder then that people fear him:
 everyone thoughtful holds him in awe!

Consider This:

- In this selection from Job, how is God's power defined? God is "clothed in fearful splendor," yet he is "no oppressor." How would you define the concept of fear in this passage?

- How do you interpret the phrase, "but better discuss no further, since we are in the dark"? What is God's relationship with human beings?

Psalm 104: "All Creatures Depend on You"

Bless Yahweh, my
 soul.
Yahweh my God, how
 great you are!
Clothed in majesty and
 glory,
wrapped in a robe of
 light!

> "Yahweh my God, how great you are! Clothed in majesty and glory, wrapped in a robe of light!"
>
> —Psalms

You stretch the
 heavens out like a tent,
you build your palace on the waters above;
using the clouds as your chariot,
you advance on the wings of the wind;
you use the winds as messengers
and fiery flames as servants.

You fixed the earth on its foundations,
unshakable for ever and ever;
you wrapped it with the deep as with a robe,
the waters overtopping the mountains.

At your reproof the waters took to flight,
they fled at the sound of your thunder,
cascading over the mountains, into the valleys,
down to the reservoir you made for them;
you imposed the limits they must never cross again,
or they would once more flood the land.

You set springs gushing in ravines,
running down between the mountains,
supplying water for wild animals,
attracting the thirsty wild donkeys;
near there the birds of the air make their nests
and sing among the branches.

From your high halls, you water the mountains,
satisfying the earth with the fruit of your works;
you make fresh grass grow for cattle
and those plants made use of by man,
for them to get food from the soil:
wine to make them cheerful,
oil to make them happy,
bread to make them strong.

The trees of Yahweh get rain enough,
those cedars of Lebanon he planted;
here the little birds build their nest
and, on the highest branches, the stork has its home.
For with the goats there are the mountains,
in the crags rock-badgers hide.

You made the moon to tell the seasons,
the sun knows when to set:
you bring darkness on, night falls,
all the forest animals come out:
savage lions, roaring for their prey,
claiming their food from God.

The sun rises, they retire,
going back to lie down in their lairs,
and man goes to work, and to labor until dusk.

Yahweh, what variety you have created,
arranging everything so wisely!
Earth is completely full of things you have made:
among them vast expanse of ocean,
teeming with countless creatures,
creatures large and small,
with the ships going to and from
and Leviathan whom you made to amuse you.

All creatures depend on you
to feed them throughout the year;
you provide the food they eat,
with generous hand you satisfy their hunger.

You turn your face away, they suffer,
you stop their breath, they die
and revert to dust.
You give breath, fresh life begins,
you keep renewing the world.

Glory for ever to Yahweh!
May Yahweh find joy in what he creates,
at whose glance the earth trembles,
at whose touch the mountains smoke!

I mean to sing to Yahweh all my life,
I mean to play for my God as long as I live.
May these reflections of mine give him pleasure,
as much as Yahweh gives me!
May sinners vanish from the earth
and the wicked exist no more!
Bless Yahweh, my soul.

Compare and Contrast:

- Compare Psalm 104 with the Egyptian "Hymn to the Aten." Are the solar deity of Akhenaten and Yahweh similar in power and purpose? Compare the vocabulary and phrasing of the two hymns.

- Both Aten and Yahweh were omnipotent and supreme in their respective societies. But the transition to one universal deity in Israel and Egypt was not without resistance. In fact, the worship of Aten did not long survive the death of the pharaoh Akhenaten. Why was monotheism such a radical concept for the time? What dangers did it pose to the authority of the various priesthoods and to the stability of society?

Psalm 8: The Power of God's Name

Yahweh our Lord,
how majestic is your name throughout the world!

Whoever keeps singing of your majesty higher than the heavens,
even through the mouths of children, or of babes in arms,
you make him a fortress, firm against your foes,
to subdue the enemy and the rebel.

I look up at your heavens, shaped by your fingers,
at the moon and the stars you set firm—
what are human beings that you spare a thought for them,
or the child of Adam that you care for him?

Yet you have made him little less than a god,
you have crowned him with glory and beauty,
made him lord of the works of your hands,
put all things under his feet,
sheep and cattle, all of them,
and even the wild beasts,
birds in the sky, fish in the sea,
when he makes his way across the ocean.

Yahweh our Lord,
how majestic your name throughout the world!

Compare and Contrast:
- Psalm 8 declares that Yahweh made human beings "little less than a god" and "the lord of the works of [Yahweh's] hands." Compare this to the contention of the Renaissance philosopher Marsilio Ficino that "man is the vicar of God." According to Ficino (see page 225, human beings were a miracle of God and through their ability to reason became "a kind of god." How legitimate is this comparison between the humanist conception during the Renaissance in 1474 and the Hebrew vision of the human relationship with Yahweh 2,000 years earlier?

- Note that the Mayan gods had great difficulty creating man, who was not made in their image (see pages 27–29). What does this say about the Mayan conception of human beings?

Song of Songs:

"I Am the Rose of Sharon"

Lover:
I am the rose of Sharon,
the lily of the valleys.

As a lily among the
 thistles,
so is my beloved among
 girls.

> "As a lily among the thistles, so is my beloved among girls."
>
> —Song of Songs

Beloved:
As an apple tree among the trees of the wood,
so is my love among young men.
In his delightful shade I sit,
and his fruit is sweet to my taste.
He has taken me to his cellar,
and his banner over me is love.
Feed me with raisin cakes,
restore me with apples,
for I am sick with love.

His left arm is under my head,
his right embraces me.

Lover:
I charge you,
daughters of Jerusalem,
by all gazelles and wild does,
do not rouse, do not wake my beloved
before she pleases.

Beloved:
I hear my love.
See how he comes

"'I Am the Rose of Sharon'" is from Song of Songs 2.1–13; 16–17; 3.1–5, from Alexander Jones, ed., *The Jerusalem Bible*, pp. 775–776. Copyright © 1966 by Darton, Longman, & Todd, Ltd., and Doubleday, a division of Random House, Inc. Used by permission of Doubleday, a division of Random House, Inc.

leaping on the mountains,
bounding over the hills.
My love is like a gazelle,
like a young stag.

See where he stands
behind our wall.
He looks in at the window,
he peers through the opening.

My love lifts up his voice,
he says to me,
'Come then, my beloved,
my lovely one, come.
For see, winter is past,
the rains are over and gone.

Flowers are appearing on the earth.
The season of glad songs has come,
the cooing of the turtledove is heard in our land.
The fig tree is forming its first figs
and the blossoming vines give out their fragrance.
Come then, my beloved,
my lovely one, come. . . .

My love is mine and I am his.
He pastures his flock among the lilies.
Before the day-breeze rises,
before the shadows flee, return!
Be, my love, like a gazelle, like a young stag,
on the mountains of Bether.

On my bed at night I sought
the man who is my sweetheart;
I sought but could not find him!
So I shall get up and go through the city;
in the streets and in the squares,
I shall seek my sweetheart.
I sought but could not find him!

I came upon the watchmen—
those who go on their rounds in the city:
'Have you seen my sweetheart?'

Barely had I passed them
when I found my sweetheart.
I caught him, would not let him go,
not till I had brought him
to my mother's house,
to the room where she conceived me!

Lover:
I charge you, daughters of Jerusalem,
by gazelles and wild does,
do not rouse, do not wake my beloved
before she pleases.

Consider This:

- Why do you think this song was included in the Old Testament of the Bible? What values of the Hebrew community does it express?

The Reflection in the Mirror

THE NEW COVENANT OF JEREMIAH

"Deep Within Them I Will Plant My Law"

Solomon's oppressive policies split the Hebrew nation into two parts after his death: Israel became the northern kingdom and Judah formed in the south. Such division made the two kingdoms vulnerable to rising new empires. Israel fell to the Assyrians in 722 B.C.E. and Judah to the Chaldeans in 586 B.C.E., whereupon the Jews were removed from the land of Canaan in what was called the Babylonian Captivity. They were finally released when the Persian Cyrus the Great conquered the Chaldean empire and liberated Babylon in 539 B.C.E.

During the years 750–550 B.C.E., when the Hebrews were trying to survive in the face of foreign invasion, they were also struggling internally. A succession of prophets arose who claimed to speak for Yahweh and condemned social injustice and the people's general disregard for the covenant they had made with God under Moses. The most influential of these prophets was Jeremiah (626–586 B.C.E.). He not only decried the faithlessness of the people of Israel and warned of the wrath of God but also offered a solution to the problem: a new covenant. God destroys, but he also builds anew. Of utmost importance was a new covenant within each individual (rather than with the nation as a whole) which would renew moral and spiritual commitment.

Keep in Mind:

- According to Jeremiah, why was Yahweh, the God of Israel, upset with the Hebrews?

The word that was addressed to Jeremiah by Yahweh, "Go and stand at the gate of the Temple of Yahweh and there proclaim this message. Say, 'Listen to the word of Yahweh, all you men of Judah who come in by these gates to worship Yahweh.' Yahweh Sabaoth, the God of Israel, says this: "Amend your behavior and your actions and I will stay with you here in this place. Put no trust in delusive words like these: This is the sanctuary of Yahweh, the sanctuary of Yahweh, the sanctuary of Yahweh! But if you do amend your behavior and your actions, if you treat each other fairly, if you do not exploit the stranger, the orphan and the widow (if you do not shed innocent blood in this place), and if you do not follow alien gods, to your own ruin, then here in this place I will stay with you, in the land that long ago I gave to your fathers for ever. Yet here you are, trusting delusive words, to no purpose! Steal, would you, murder, commit adultery, perjure yourselves, burn incense to Baal, follow alien gods that you do not know?—and then come presenting yourselves in this Temple that bears my name, saying: Now we are safe—safe to go on

"'Deep Within Them I Will Plant My Law'" is from Jeremiah 7, 31, from Alexander Jones, ed., *The Jerusalem Bible*, pp. 1264, 1304. Copyright © 1966 by Darton, Longman, & Todd, Ltd., and Doubleday, a division of Random House, Inc. Used by permission of Doubleday, a division of Random House, Inc.

committing all these abominations! Do you take this Temple that bears my name for a robbers' den? I, at any rate, am not blind—it is Yahweh who speaks. . . .

"And now, since you have committed all these sins—it is Yahweh who speaks—and have refused to listen when I spoke so urgently, so persistently, or to answer when I called you, I will treat this Temple that bears my name, and in which you put your trust, and the place I have given to you and your ancestors, just as I treated Shiloh. I will drive you out of my sight, as I drove all your kinsmen, the entire race of Ephraim.' . . .

"See, the days are coming—it is Yahweh who speaks—when I am going to sow the seed of men and cattle on the House of Israel and on the House of Judah. And as I once watched them to tear up, to knock down, to overthrow, destroy and bring disaster, so now I shall watch over them to build and to plant. It is Yahweh who speaks. In those days people will no longer say: 'The fathers have eaten unripe grapes; the children's teeth are set on edge.' But each is to die for his own sin. Every man who eats unripe grapes is to have his own teeth set on edge.

"See, the days are coming—it is Yahweh who speaks—when I will make a new covenant with the House of Israel (and the House of Judah), but not a covenant like the one I made with their ancestors on the day I took them by the hand to bring them out of the land of Egypt. They broke that covenant of mine, so I had to show them who was master. It is Yahweh who speaks. No, this is the covenant I will make with the House of Israel when those days arrive—it is Yahweh who speaks. Deep within them I will plant my Law, writing it on their hearts. Then I will be their God and they shall be my people. There will be no further need for neighbor to try to teach neighbor, or brother to say to brother, 'Learn to know Yahweh!' No, they will all know me, the least no less than the greatest—it is Yahweh who speaks—since I will forgive their inequity and never call their sin to mind."

Consider This:

- How would you define Yahweh's "new covenant" with the Hebrews? How did the Hebrews violate the original covenant with Yahweh and how did God "show them who was master?"

- How do you interpret the phrase: "But each is to die for his own sin"? How is this the crux of the "new covenant?"

2

The Glory of Greece

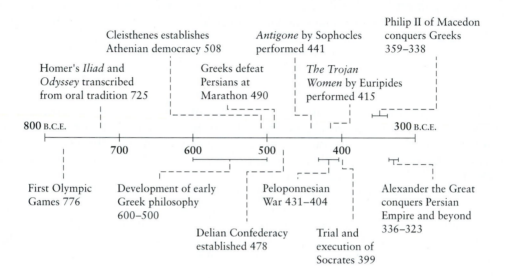

Cleisthenes establishes Athenian democracy 508

Antigone by Sophocles performed 441

Philip II of Macedon conquers Greeks 359–338

Homer's *Iliad* and *Odyssey* transcribed from oral tradition 725

Greeks defeat Persians at Marathon 490

The Trojan Women by Euripides performed 415

800 B.C.E. 300 B.C.E.

700 600 500 400

First Olympic Games 776

Development of early Greek philosophy 600–500

Peloponnesian War 431–404

Alexander the Great conquers Persian Empire and beyond 336–323

Delian Confederacy established 478

Trial and execution of Socrates 399

CHAPTER THEMES

- ***The Institution and the Individual:*** What was the relationship between Homeric kings such as Agamemnon and retainers such as Achilles and Odysseus? Is aristocracy, or "rule by the best," a workable form of government? What demands did the Athenian democracy place on the individual? Which laws were more important—those of the state or those of the gods? How were these ethical questions reflected in the works of the tragedians, Sophocles and Euripides?

- ***Social and Spiritual Values:*** What role did the gods play in the imagination of the early Greeks? How sophisticated was the pantheon of Greek gods when compared with the monotheism of the Hebrews? What was the Greek view of the afterlife? How do the stories and legends regarding the Greek gods and their interaction with humans reflect the creativity of Greek culture?

- ***Women in History and the Humanities:*** How were women portrayed in early Greek society as viewed in the *Iliad* and *Odyssey* of Homer? Is this picture consistent with the view of women during the Golden Age of Athens in the fifth century B.C.E.? Did the Athenian democracy consider women to be political equals?

- ***The Power Structure:*** How did Athens gain and maintain its empire? Can a democracy possess an empire, or is this a moral contradiction?

- *Revolution and Transition:* The history of fifth-century Greece has generally been viewed as a great success story. Is success in war or government a necessary foundation for success in the arts? How essential is arrogance to the progress of civilization? Was Athens created and then destroyed by its hubris?

- *The Big Picture:* Do the great artistic and literary creations of civilization justify the means of obtaining them? Is there a political price to pay for cultural progress?

The World of Early Greece

Zeus spoke, and nodded with his darkish brows, and immortal locks fell forward from the lord's deathless head, and he made great Olympus tremble.

—Homer

You could not step twice in the same river, for other and yet other waters are ever flowing on.

—Heraclitus

Go and be happy, but remember whom you leave shackled by love.

—Sappho

The Trojan War: Homer's Iliad

The mythology of a culture—the stories of heroism, deities, creation, moral instruction—often seems to reflect a fantasy world where reality is suspended and the pure joy of creativity is unleashed. But legends also tell us about the developing values and ideals of a civilization. The monumental narrative poems of the Iliad *and the* Odyssey *engage us with the story of the epic confrontation about 1230 B.C.E. between the Greeks and the Trojans, whose soldiers controlled the northwestern coast of Modern Turkey.*

The Trojan War stands as one of the most famous events in history. For centuries after the destruction of Troy, the tales of the struggle were preserved in an oral tradition, and amplified by several singers until they were compiled and transcribed shortly after 750 B.C.E., perhaps by one poet whom we call Homer. These are stories of rage and competition for glory and honor on the "windy plains of Troy." According to the legend, the Greeks had set out to avenge the abduction of the beautiful Helen, wife of their overlord, Menelaus, by the wily Paris, prince of Troy. The noble Agamemnon, brother of Menelaus, composed a mighty force of many warriors led by the great, Achilles, "the most violent man on the field," his friend Patroclus, the powerful Ajax, and the "quick-witted" Odysseus. The Greek gods also assumed a prominence in the conflict. They had their favorites among the mortals and intervened as their "human personalities" demanded. The story of the Iliad *and the destruction of Troy is a powerful classic of world literature.*

The story begins with Achilles' anger at Agamemnon's claim of the beautiful woman Briseis, who had been granted to Achilles as a prize. Agamemnon's own prize named Chryseis had been claimed by the god Apollo himself. The action moves to Achilles' friend, Patroclus, who fights and dies at the hands of Troy's greatest warrior, Hector, while Achilles sulks in his camp. The last passage recounts the vengeance of Achilles as he fights Hector to the death.

Rage—Goddess, sing the rage of Peleus' son Achilles,
murderous, doomed, that cost the Achaeans countless losses,
hurling down to the House of Death so many sturdy souls,
great fighters' souls, but made their bodies carrion,
feasts for the dogs and birds,
and the will of Zeus was moving toward its end.
Begin, Muse, when the two first broke and clashed.
Agamemnon lord of men and brilliant Achilles.

—Homer

The Wrath of Achilles
HOMER

King Agamemnon took him up at once. "You are a great man, Prince Achilles, but do not imagine you can trick me into that. I am not going to be outwitted or cajoled by you. 'Give up the girl,' you say, hoping, I presume, to keep your own prize safe. Do you expect me tamely to sit by while I am robbed? No; if the army is prepared to give me a fresh prize, chosen to suit my taste and to make up for my loss, I have no more to say. If not, I shall come and help myself to your prize, or that of Aias; or I shall walk off with Odysseus's. And what an angry man I shall leave behind me! However, we can deal with all that later on. For the moment, let us run a black ship down into the friendly sea, give her a special crew, embark the animals for sacrifice, and put the girl herself, Chryseis of the lovely cheeks, on board. And let some Councillor of ours go as captain—Aias, Idomeneus, the excellent Odysseus, or yourself, my lord, the most redoubtable man we could choose—to offer the sacrifice and win us back Apollo's favor."

Achilles the great runner gave him a black look. "You shameless schemer," he cried, "always aiming at a profitable deal! How can you expect any of the men to give you loyal service when you send them on a raid or into battle? It was no quarrel with the Trojan spearmen that brought me here to fight. They have never done me any harm. They have never lifted cow or horse of mine, nor ravaged any crop that the deep soil of Phythia grows to feed her men; for truth is that we joined the expedition to please

you; yes, you unconscionable cur, to get satisfaction from the Trojans for Menelaus and yourself—a fact which you utterly ignore. And now comes this threat from you of all people to rob me of my prize, my hard-earned prize, which was a tribute from the ranks. It is not as though I am ever given as much as you when the Achaeans sack some thriving city of the Trojans. The heat and burden of the fighting fall on me, but when it comes to dealing out the loot, it is you who takes the lion's share, leaving me to return exhausted from the field with something of my own, however small. So now I shall go back to Phythia. That is the best thing I can do—to sail home in my beaked ships. I see no point in staying here to be insulted while I pile up wealth and luxuries for you."

"Take to your heels, by all means," Agamemnon King of men retorted, "if you feel the

> **"What if you are a great soldier—who made you so but God? Go home now with your ships and your men-at-arms. . . . I have no use for you; your anger leaves me cold."**
>
> **—Agamemnon**

"The Wrath of Achilles" is from Homer, *The Iliad*, trans. by E. V. Rieu (Baltimore, Md., and Harmondsworth, Middlesex: Penguin Books, 1950), pp. 26–29. Copyright © 1950 by E. V. Rieu. Reproduced by permission of Penguin Books, Ltd.

urge to go. I am not begging you to stay on my account. There are others with me who will treat me with respect, and the Counselor Zeus is first among them. Moreover, of all the princes here, you are the most disloyal to myself. To you, sedition, violence and fighting are the breath of life. What if you are a great soldier—who made you so but God? Go home now with your ships and your men-at-arms and rule the Myrmidons. I have no use for you; your anger leaves me cold. But mark my words. In the same way as Phoebus Apollo is robbing me of Chryseis, whom I propose to send off in my ship with my own crew. I am going to pay a visit to your hut and take away the beautiful Briseis, your prize Achilles, to let you know that I am more powerful than you, and to teach others not to bandy words with me and openly defy their King."

This cut Achilles to the quick. In his shaggy breast his heart was torn between two courses, whether to draw his sharp sword from his side, thrust his way through the crowd, and kill Agamemnon, or to control himself and check the angry impulse. He was deep in this inward conflict, with his long sword half unsheathed, when Athena came down to him from heaven. . . . Athena stood behind him and seized him by his golden locks. No one but Achilles was aware of her; the rest saw nothing. He swung round in amazement, recognized Pallas Athena at once—so terrible was the brilliance of her eyes—and spoke out to her boldly: "And why have you come here, Daughter of aegis-bearing Zeus? Is it to witness the arrogance of my lord Agamemnon? I tell you bluntly—and I make to idle threats—that he stands to pay for this outrage with his life."

"I come from heaven," replied Athena of the Flashing Eyes, "in the hope of bringing you to your senses. . . . Come now, give up this strife and take your hand from your sword. Sting him with words instead, and tell him what you mean to do. Here is a prophecy for you–the day shall come when gifts three times as valuable as what you now have lost will be laid at your feet in payment for this outrage. Hold your hand then, and be advised by us." . . . With that he checked his great hand on the silver hilt and drove the long sword back into its scabbard, in obedience to Athena. . . . Not that Achilles was appeased. . . .

"Mark my words, for I am going to take a solemn oath. Look at this staff. . . . By this I swear (and I could not choose a better token) that the day is coming when the Achaeans one and all will miss me sorely, and you in your despair will be powerless to help them as they fall in their hundreds to Hector, killer of men. Then you will tear your heart out in remorse for having treated the best man in the expedition with contempt."

Consider This:

- After reading this selection from Homer's *Iliad* on the Trojan War, what can you say about the relationships between Agamemnon, leader of the Greek expedition, and his warriors, such as Achilles? Was Agamemnon a strong king with absolute control over his men, or was he considered "first among equals"? What does this tell you about early Greek society?

- What roles do the gods play in Homer's *Iliad*? What specific human characteristics do they exhibit, and how essential were they to the success or failure of each contesting army?

The Death of Hector

HOMER

"Hector!" the old man called, stretching out his arms to him in piteous appeal. "I beg you, my dear son, not to stand up to that man alone and unsupported. You are courting defeat and death at his hands. He is fare stronger than you, and he is savage. . . . So come inside the

"The Death of Hector" is from Homer, *The Iliad*, trans. by E. V. Rieu (Baltimore, Md., and Harmondsworth, Middlesex: Penguin Books, 1950), pp. 398; 400; 403–408; 410. Copyright © 1950 by E. V. Rieu. Reproduced by permission of Penguin Books, Ltd.

walls, my child, to be the savior of Troy and the Trojans; and do not throw away your own dear life to give a triumph to the son of Peleus. Have pity too on me, your poor father, who is still able to feel. Think of the hideous fate that Father Zeus has kept in store for my old age, the horrors I shall have to see before I die, the massacre of my sons, my daughters mauled, their bedrooms pillaged, their babies dashed on the ground by the brutal enemy, and my sons' wives hauled away by foul Achaean hands. Last of all my turn will come to fall to the sharp bronze, and when someone's javelin or sword has laid me dead, I shall be torn to pieces by ravening dogs at my own street door. . . ."

Hector thought: "If I retire behind the gate and wall, Polydamnas will be the first to cast it in my teeth that, in this last night of disaster when the great Achilles came to life, I did not take his advice and order a withdrawal into the city, as I certainly ought to have done. As it is, having sacrificed the army to my own perversity, I could not face my countrymen and the Trojan ladies in their trailing gowns. I could not bear to hear some commoner say: 'Hector trusted in his own right arm and lost an army.' But it will be said, and then I shall know that it would have been a far better thing for me to stand up to Achilles, and either kill him and come home alive or myself die gloriously in front of Troy. . . ."

While Hector stood engrossed in this inward debate, Achilles drew near him, looking like the God of War in his flashing helmet, girt for battle. Over his right shoulder he brandished the formidable ashen spear of Pelion, and the bronze on his body glowed like a blazing fire or the rising sun. Hector looked up, saw him, and began to tremble. . . .

Great Hector of the flashing helmet spoke first: "My lord Achilles, I have been chased by you three times round the great city of Priam without daring to stop and let you come near. But now I am going to run away no longer. I have made my mind to fight you man to man and kill you or be killed. But first let us make a bargain, you with your gods for witness, I with mine. . . . If Zeus allows me to endure, and I kill you, I undertake to do no outrage to your body that custom does not sanction. All I shall do, Achilles, is to strip you of your splendid armor. Then I will give up your corpse to the Achaeans. Will you do the same for me?"

> "Friendship between us is impossible, and there will be no truce of any kind till one of us has fallen and glutted the stubborn god of battles with his blood. So summon any courage you may have."
>
> —Achilles

Achilles of the nimble feet looked at him grimly and replied: "Hector, you must be mad to talk to me about a pact. Lions do not come to terms with men, nor does the wolf see eye to eye with the lamb—they are enemies to the end. It is the same with you and me. Friendship between us is impossible, and there will be no truce of any kind till one of us has fallen and glutted the stubborn god of battles with his blood. So summon any courage you may have. This is the time to show your spearmanship and daring. Not that anything is going to save you now, when Pallas Athena is waiting to fell you with my spear. This moment you are going to pay the full price for all you made me suffer when your lance mowed down my friends.". . .

Achilles saw that Hector's body was completely covered by the fine bronze armor he had taken from the great Patroclus when he killed him, except for an opening at the gullet where the collar bones lead over from the shoulders to the neck, the easiest place to kill a man. As Hector charged him, Prince Achilles drove at this spot with his lance; and the point went right through the tender flesh of Hector's neck, though the heavy bronze head did not cut his windpipe, and left him able to address his conqueror. . . .

Hector of the flashing helmet spoke to him once more at the point of death. "How well I know you and can read your mind!" He said. "Your heart is hard as iron. . . . Nevertheless, pause before you act, in case the angry gods remember how you treated me, when your turn comes and you are brought down. . . ."

Death cut Hector short and his disembodied soul took wing for the House of Hades, bewailing its lot and the youth and manhood that it

> **"Die!" He said. "As for my own death, let it come when Zeus and the other deathless gods decide."**
>
> **—Achilles**

left. But Prince Achilles spoke to him again though he was gone. "Die!" He said. "As for my own death, let it come when Zeus and the other deathless gods decide." . . .

The next thing that Achilles did was to subject the fallen prince to shameful outrage. He slit the tendons at the back of both his feet from heel to ankle, inserted leather straps, and made them fast to his chariot, leaving the head to drag. Then he lifted the famous armor into his chariot, got in himself, and with a touch of his whip started the horses, who flew off with a will. Dragged behind him, Hector raised a cloud of dust, his black locks streamed on either side, and dust fell thick upon his head, so comely once, which Zeus now let his enemies defile on his own native soil.

Thus Hector's head was tumbled in the dust. When his mother saw what they were doing to her son, she tore her hair, and plucking the bright veil from her head cast it away with a loud and bitter cry. His father groaned in anguish, the people round them took up the cry of grief, and the whole city gave itself up to despair. They could not have lamented louder if Ilium had been going up in flames, from its crowning citadel to its lowest street. . . .

Andromache, with palpitating heart, rushed out of the house like a mad woman, and her maidservants went with her. When they came to the wall, where the men had gathered in a crowd, she climbed up on the battlements, searched the plain, and saw them dragging her husband in front of the town—the powerful horses were hauling him along at an easy canter towards the Achaean ships. The world sent black as night before Andromache's eyes. She lost her senses and fell backward to the ground. . . . As she lay there in a dead faint, her husband's sisters and his brothers' wives crowded around her and supported her between them. When at length she recovered and came to herself, she burst out sobbing and made her lament to the ladies of Troy.

"Alas, Hector; alas for me!" she cried. . . . "For you are on your way to Hades and the unknown world below, leaving me behind in misery, a widow in your house. And your son is no more than a baby, the son we conceived between us, we unhappy parents. You, Hector, now that you are dead, will be no joy to him, nor he to you. Even if he escapes the horrors of the Achaean war, nothing lies ahead of him but hardship and trouble. . . . And you, by the beaked ships, far from your parents, will be eaten by the worms when the dogs have had their fill. . . ."

Thus Andromache lamented through her tears, and the women joined in her lament.

Consider This:

- Focus on Hector's struggle. Was he a coward or a hero in his confrontation with death? What inspired him to fight Achilles? And how can Achilles, unforgiving to the last, be considered the supreme realist?

Greek Values: The Odyssey of Homer

The Iliad *and the* Odyssey *were perhaps the most influential works in Greek history. Greek and Roman education was fundamentally concerned with the values expressed in these two works. Alexander the Great was even said to have slept with a copy of the* Iliad *under his pillow. And yet the* Odyssey *is very different in temperament and theme than the* Iliad. *The* Odyssey *speaks of homecoming, of love, longing, and revenge. It is the story of Odysseus, a great fighter for the Greeks at Troy whose inspired ploy of the Trojan horse resulted in the Greek victory over the Trojans. But in spite of his brilliance, or perhaps because of it, his homecoming was delayed for*

ten years as the gods conspired with monsters and witches to interrupt his life. His adventure with the one-eyed Cyclops and his dramatic visit to the underworld, where he meets the souls of Achilles and Agamemnon, are two of the most dramatic stories in literature. But Odysseus's return to his island of Ithaca, his introduction to his adult son, Telemachus, his vengeance on the suitors of his wife, Penelope, and their tearful recognition capture the brilliance of the poet history has called Homer.

I will drink life to the lees: all times I have enjoyed greatly, have suffered greatly, both with those that love me, and alone. . . . I am become a name; for always roaming with a hungry heart much have I seen and known; cities of men and manners, climates, councils, governments. . . . and drunk delight of battle, with my peers, far on the ringing plains of windy Troy. I am a part of all that I have met.

—Alfred Lord Tennyson (*Ulysses*)

Sing to me of the man, Muse, the man of twists and turns
driven time and again off course, once he had plundered
the hallowed heights of Troy.
Many cities of men he saw and learned their minds,
many pains he suffered, heartsick on the open sea,
fighting to save his life and bring his comrades home. . . .
Launch out on his story, Muse, daughter of Zeus,
start from where you will—sing for our time too.

—Homer

The Adventure of the Cyclops
HOMER

"When [the Cyclops] had done with his business and finished all his jobs, he lit up the fire, spied us, and began asking questions.

"'Strangers!' he said. 'And who may you be? Where do you hail from over the highways of the sea? Is yours a trading venture; or are you cruising the main on chance, like roving pirates, who risk their lives to ruin other people?'

"Our hearts sank within us. The booming voice and the very sight of the monster filled us with panic. Still, I managed to find words to answer him.

"'We are Achaeans,' I said, 'on our way back from Troy, driven astray by contrary winds across a vast expanse of sea. Far from planning to come here, we meant to sail straight home; but we lost our bearings, as Zeus, I suppose, intended that we should. We are proud to belong to the forces of Agamemnon, Atreus' son, who by sacking the great city of Ilium [Troy] and destroying all its armies has made himself the most famous man in the world today. We, less fortunate, are visiting you here as suppliants, in the hope that you may give us friendly entertainment or even go further in your generosity. You know the laws of hospitality: I beseech you, good sir, to remember your duty to the gods. For we throw ourselves on your mercy; and Zeus is there to avenge the suppliant and the guest. He is the travellers' god; he guards their steps and he invites them with their rights.'

"The Adventure of the Cyclops" is from Homer, *The Odyssey*, trans. by E. V. Rieu (Baltimore, Md., and Harmondsworth, Middlesex: Penguin Books, 1946), pp. 146–150; 152–153. Copyright © 1946, 1991 by E. V. Rieu. Reproduced by permission of Penguin Books, Ltd.

"So said I, and promptly he answered me out of his pitiless heart: 'Stranger, you must be a fool, or must have come from very far afield, to preach to me of fear or reverence for the gods. We Cyclopes care not a jot for Zeus with his aegis [shield], nor for the rest of the blessed gods, since we are much stronger than they. It would never occur to me to spare you or your men against my will for fear of trouble from Zeus. But tell me where you moored your good ship when you came. Was it somewhere up the coast, or near by? I should like to see her.'

"He was trying to get the better of me, but I knew enough of the world to see through him and I met him with deceit. 'As for my ship,' I answered, 'it was wrecked by the Earth-shaker Poseidon on the confines of your land. The wind had carried us onto a lee shore. He drove the ship up to a headland and hurtled it on the rocks. But I and my friends managed to escape with our lives.'

"To this the cruel brute made no reply. Instead, he jumped up, and reaching out towards my men, seized a couple and dashed their heads against the floor as though they had been puppies. Their brains ran out on the ground and soaked the earth. Limb by limb he tore them to pieces to make his meal, which he devoured like a mountain lion, never pausing till entrails and flesh, marrow and bones, were all consumed, while we could do nothing but weep and lift up our hands to Zeus in horror at the ghastly sight, paralysed by our sense of utter helplessness. When the Cyclops had filled his great belly with this meal of human flesh, which he washed down with unwatered milk, he stretched himself out for sleep among his flocks inside the cave. . . ."

" 'Here Cyclops, have some wine to wash down that meal of human flesh, and find out for yourself what kind of vintage was stored away in our ship's hold. I brought it for you by way of an offering in the hope that you would be charitable and help me on my homeward way. But your savagery is more than we can bear. Cruel monster, how can you expect ever to have a visitor again from the world of men, after such deeds as you have done?' "

"The Cyclops took the wine and drank it up. And the delicious draught gave him such exquisite pleasure that he asked me for another bowlful. . . . Three times I filled it up for him;

and three times the fool drained the bowl to the dregs. At last, when the wine had fuddled his wits, I addressed him with disarming suavity.

" 'Cyclops,' I said, 'you wish to know the name I bear. I'll tell it to you; and in return I should like to have the gift you promised me. My name is Nobody. That is what I am called by my mother and father and by all my friends.'

"The Cyclops answered me with a cruel jest. 'Of all his company I will eat Nobody last, and the rest before him. That shall be your gift.'

"He had hardly spoken before he toppled over and fell face upwards on the floor, where

> "We handled our pole with its red-hot point and twisted it in his eye till the blood boiled up round the burning wood . . . and the very roots of his eye crackled in the heat."
> —Odysseus

he lay with his great neck twisted to one side, conquered, as all men are, by sleep. His drunkenness made him vomit, and a stream of wine mixed with morsels of men's flesh poured from his throat. I went at once and thrust our pole deep under the ashes of the fire to make it hot, and meanwhile gave a word of encouragement to all my men, to make sure that no one should play the coward and leave me in the lurch. When the fierce glow from the olive stake warned me that it was about to catch alight in the flames, green as it was, I withdrew it from the fire and brought it over to the spot where my men were standing ready. Heaven now inspired them with a reckless courage. Seizing the olive pole, they drove its sharpened end into the Cyclops' eye, while I used my weight from above to twist it home, like a man boring a ship's timber with a drill which his mates below him twirl with a strap they hold at either end, so that it spins continuously. In much the same way we handled our pole with its red-hot point and twisted it in his eye till the blood boiled up round the burning wood. The fiery smoke from the blazing eyeball singed his lids and brow all round, and the very roots of his eye crackled in

the heat. I was reminded of the loud hiss that comes from a great axe . . . when a smith plunges it into cold water—to temper it and give strength to the iron. That is how the Cyclops' eye hissed round the olive stake. He gave a dreadful shriek, which echoed round the rocky walls, and we backed away from him in terror, while he pulled the stake from his eye, streaming with blood. Then he hurled it away from him with frenzied hands and raised a great shout for the other Cyclopes who lived in neighboring caves along the windy heights. These, hearing his screams, came from every quarter, and gathering outside the cave asked him what ailed him: " 'What on earth is wrong with you, Polyphemus? Why must you disturb the peaceful night and spoil our sleep with all this shouting? Is a robber driving off your sheep, or is somebody trying by treachery or violence to kill you?'

"Out of the cave came Polyphemus' great voice in reply: 'O my friends, it's Nobody's treachery, no violence, that is doing me to death.'

" 'Well then,' they answered, in a way that settled the matter, "if nobody is assaulting you in your solitude, you must be sick. Sickness comes from almighty Zeus and cannot be helped. All you can do is to pray to your father, the Lord Poseidon.'

[The next morning, Odysseus and his men escaped from the Cyclops' cave by holding on to the underside of Polyphemus' sheep. The blinded Cyclops felt the top of each sheep as they left the cave, but did not detect any of Odysseus' men.]

"When we had put a little distance between ourselves and the courtyard of the cave, I first freed myself from under my ram and next untied my men from theirs. Then, quickly, though with many a backward look, we drove our long-legged sheep right down to the ship. . . . With a nod, [I made clear my will to each man], bidding them make haste to tumble all the fleecy sheep on board and put to sea. So in they jumped, ran to the benches, sorted themselves out, and plied the grey water with their oars.

"But before we were out of earshot, I let Polyphemus have a piece of my mind. 'Cyclops!' I called. 'So he was not such a weakling after all, the man whose friends you meant to overpower and eat in that snug cave of yours! And your crimes came home to roost, you brute, who have not even the decency to refrain from devouring your own guests. Now Zeus and all his fellow-gods have paid you out.'

"My taunts so exasperated the angry Cyclops that he tore the top off a great pinnacle of rock and hurled it at us. The rock fell just ahead of our blue-painted bows. As it plunged in, the water rose and the backwash, like a swell from the open sea, swept us landward and nearly drove us on the beach. . . . After I roused my crew with urgent nods, . . . they buckled to and rowed with a will . . . and brought us across the water to twice our previous distance. . . . My spirit was up, and in my rage I called to him once more:

" 'Cyclops, if anyone ever asks you how you came by your unsightly blindness, tell him your eye was put out by Odysseus, Sacker of Cities, the son of Laertes, who lives in Ithaca.' "

Odysseus in the Underworld

HOMER

[I saw the soul of Agamemnon, which] burst into tears, stretching his arms out in my direction in his eagerness to reach me. But this he could not do, for all the strength and vigor had gone forever from those once supple limbs. Moved to compassion at the sight, I too gave way to tears and spoke to him from my heart:

" 'Illustrious son of Atreus, Agamemnon, King of men, tell me what mortal stroke of fate it was that laid you low. Did Poseidon rouse the winds to fury and overwhelm your ships? Or did you fall to some hostile tribe on land as you were rounding up their cattle and their flocks or fighting with them for their town and women?'

"Odysseus in the Underworld" is from Homer, *The Odyssey*, trans. by E. V. Rieu (Baltimore, Md., and Harmondsworth, Middlesex: Penguin Books, 1946), pp. 182–184. Copyright © 1946, 1991 by E. V. Rieu. Reproduced by permission of Penguin Books, Ltd.

" 'Royal son of Laertes, Odysseus of the nimble wits,' he answered me at once, 'Poseidon did not wreck my ships; nor did I fall to any hostile tribe on land. It was Aegisthus who plotted my destruction and with my accursed wife put me to death. He invited me to the palace, he feasted me, and he killed me as a man fells an ox at its manger. That was my most miserable end. And all around me my companions were cut down in ruthless succession, like white-tusked swine slaughtered in the mansion of some great and wealthy lord, for a wedding, a club banquet, or a sumptuous public feast. You, Odysseus, have witnessed the deaths of many men in single combat or the thick of battle, but none with such horror as you would have felt had you seen us lying there by the wine-bowl and the laden tables in the hall, while the whole floor swam with our blood. Yet the most pitiable thing of all was the cry I heard from Cassandra, daughter of Priam, whom that foul traitress Clytemnestra [Agamemnon's wife] murdered at my side. As I lay on the ground, I raised my hands in a dying effort to grip Clytemnestra's sword. But the harlot turned her face aside, and had not even the grace, though I was on my way to Hades, to shut my eyes with her hands or to close my mouth. And so I say that for brutality and infamy there is no one to equal a woman who can contemplate such deeds. Who else could conceive so hideous a crime as her deliberate butchery of her husband and her lord? Indeed, I had looked forward to a rare welcome from my children and my servants when I reached home. But now, in the depth of her villainy, she has branded not herself alone but the whole of her sex and every honest woman for all time to come.'

" 'Alas!' I exclaimed. 'All-seeing Zeus has indeed proved himself a relentless foe to the House of Atreus, and from the beginning he has worked his will through women's crooked ways. It was for Helen's sake that so many of us met our deaths, and it was Clytemnestra who hatched the plot against her absent lord.'

" 'Let this be a lesson to you also,' replied Agamemnon. 'Never be too gentle even with your wife, nor show her all that is in your mind. Reveal a little of your counsel to her, but keep the rest of it to yourself. Not that *your*

wife, Odysseus, will ever murder you. Icarius' daughter is far too sound in heart and brain for that. The wise Penelope! She was a young bride when we said goodbye to her on our way to the war. She had a baby son at her breast. And now, I suppose, he has begun to take his seat among the men. The lucky lad! His loving father will come home and see him, and he will kiss his father. That is how things should be. Whereas that wife of mine refused me even the satisfaction of setting eyes on my son. She could not wait so long before she killed his father. And now let me give you a piece of advice which I hope you will take to heart. Do not sail openly into port when you reach your home-country. Make a secret approach. Women, I tell you, are no longer to be trusted. . . .'

"Such was the solemn conversation that we two had as we stood there with our sorrows and the tears rolled down our cheeks. And now there came the souls of Peleus' son Achilles, of Patroclus, of the noble Antilochus, and of Aias. . . . It was the soul of Achilles, the great runner, who recognized me. In mournful, measured tones he greeted me by my titles, and went on: 'What next, Odysseus, dauntless heart? What greater exploit can you plan to cap your voyage here? How did you dare to come below to Hades' realm, where the dead live on without their wits as disembodied ghosts?'

" 'Achilles,' I answered him, 'son of Peleus and flower of Achaean chivalry, I came to consult with Teiresias in the hope of finding out from him how I could reach my rocky Ithaca. For I have not managed to come near Achaea yet, nor set foot on my own island, but have been dogged by misfortune. How different from you, Achilles, the most fortunate man that ever was or will be! For in the old days when you were on earth, we Argives honored you as though you were a god; and now, down here, you are a mighty prince among the dead. For you, Achilles, Death should have lost his sting.'

" 'My lord Odysseus,' he replied, 'spare me your praise of Death. Put me on earth again, and I would rather be a serf in the house of some landless man, with little enough for himself to live on, than king of all these dead men that have done with life.' "

The Return of Odysseus
HOMER

Odysseus Strings His Bow

Amid all the Suitors' banter, the cool-headed Odysseus had poised the great bow and given it a final inspection. And now . . . he strung the great bow without effort or haste and with his right hand proved the string, which gave a lovely sound in answer like a swallow's note. The Suitors were confounded. The color faded from their cheeks; while to mark the signal moment there came a thunderclap from Zeus, and Odysseus' long-suffering heart leapt up for joy at this sign of favor from the son of Chronos. . . .

One arrow lay exposed on the table beside him, the rest, which the Achaean lords were soon to feel, being still inside their hollow quiver. He picked up this shaft, set it against the bridge of the bow, drew back the grooved end and the string together, all without rising from his stool, and aiming straight ahead he shot. Not a single axe did he miss. From the first axe, right through them all and out at the last, the arrow sped with its burden of bronze. Odysseus turned to his son.

" 'Telemachus,' he said, 'the stranger sitting in your hall has not disgraced you. I scored no miss, nor made hard work of stringing the bow. My powers are unimpaired, and these gentlemen were mistaken when they scornfully rated them so low. . . .'

"As he finished, Odysseus gave a nod. Whereupon his son and heir, Prince Telemachus, slung on his sharp-edged sword and gripping his spear took his stand by the chair at his father's side, armed with resplendent bronze.

Slaughter in the Hall

"Shedding his rags, the indomitable Odysseus leapt onto the great threshold with his bow and his full quiver, and poured out the winged arrows at his feet.

" 'That match is played and won!' he shouted to the Suitors. 'Now for another target! No man has hit it yet; but with Apollo's help I'll try.' And with that he levelled a deadly shaft straight at Antinous.

"Antinous had just reached for his golden cup to take a draught of wine, and the rich,

> "Shedding his rags, the indomitable Odysseus leapt onto the great threshold with his bow and his full quiver, and poured out the winged arrows at his feet."
> —Homer

two-handled beaker was balanced in his hands. No thought of bloodshed had entered his head. For who could guess, there in that festive company, that one man, however powerful he might be, would bring calamity and death to him against such odds? Yet Odysseus shot his bolt and struck him in the throat. The point passed clean through the soft flesh of his neck. Dropping the cup as he was hit, he lurched over to one side. His life-blood gushed from his nostrils in a turbid jet. His foot lashed out and kicked the table from him; the food was scattered on the ground, and his bread and meat were smeared with gore. . . .

"The unconquerable Odysseus looked down on the Suitors with a scowl. 'You curs!' he cried. 'You never thought to see me back from Troy. So you ate me out of house and home; you raped my maids; you wooed my wife on the sly though I was alive—with no more fear of the gods in heaven than of the human vengeance that might come. I tell you, one and all, your doom is sealed.'

[Odysseus and his son Telemachus then killed all of the suitors who were trapped in the Great Hall. After the battle, Odysseus met his wife, Penelope, for the first time in nineteen years. Penelope, who had resisted all overtures from the suitors, decided to confirm Odysseus' identity by subjecting him to a test.]

The Great Rooted Bed

" 'What a strange creature!' Odysseus exclaimed. 'Heaven made you as you are, but for sheer obstinacy you put all the rest of your sex in the shade. No other wife could have steeled herself to keep as long out of the arms of a husband she had just got back after nineteen years of misadventure. Well, nurse, make a bed for me to sleep alone in. For my wife's heart is just about as hard as iron.'

" 'You too are strange,' said the cautious Penelope. 'I am not being haughty or indifferent. I am not even unduly surprised. But I have too clear a picture of you in my mind as you were when you sailed from Ithaca in your long-oared ship. Come, Eurycleia, make him a comfortable bed outside the bedroom that he built so well himself. Place the big bed out there, and make it up with rugs and blankets, and with laundered sheets.'

"This was her way of putting her husband to the test. But Odysseus flared up at once and rounded on his loyal wife. 'Penelope,' he cried, 'you exasperate me! Who, if you please, has moved my bed elsewhere? Short of a miracle, it would be hard even for a skilled workman to shift it somewhere else, and the strongest young fellow alive would have a job to budge it. For a great secret went into the making of that complicated bed; and it was my work and mine alone. Inside the court there was a long-leaved olive tree, which had grown to full height with a stem as thick as a pillar. Round this I built my room of close-set stone-work, and when that was finished, I roofed it over thoroughly, and put in a solid, neatly fitted, double door. Next I lopped all the twigs off the olive, trimmed the stem from the root up, rounded it smoothly and carefully with my adze and trued it to the line, to make my bed-post. This I drilled through where necessary, and used as a basis for the bed itself, which I worked away at till that too was done, when I finished it off with an inlay of gold, silver, and ivory, and fixed a set of purple straps across the frame.

'There is our secret, and I have shown you that I know it. What I don't know, madam, is whether my bedstead stands where it did, or whether someone has cut the tree-trunk through and shifted it elsewhere.'

"Her knees began to tremble as she realized the complete fidelity of his description. All at

> "Penelope's surrender melted Odysseus' heart. . . . She kept her white arms round his neck and never quite let go. Dawn with her roses caught them at their tears."
>
> —Homer

once her heart melted. Bursting into tears she ran up to Odysseus, threw her arms round his neck and kissed his head. 'Odysseus,' she cried, 'do not be cross with me, you who were always the most reasonable of men. All our unhappiness is due to the gods, who couldn't bear to see us share the joys of youth and reach the threshold of old age together. But don't be angry with me now, or hurt because the moment when I saw you first I did not kiss you as I kiss you now. For I had always had the cold fear in my heart that somebody might come here and bewitch me with his talk. There are plenty of rogues who would seize such a chance. . . . But now all's well. You have faithfully described our token, the secret of our bed, which no one ever saw but you and I. . . . You have convinced your unbelieving wife.'

"Penelope's surrender melted Odysseus' heart, and he wept as he held his dear wife in his arms, so loyal and so true. Sweet moment too for her, sweet as the sight of land to sailors struggling in the sea. . . . If that is bliss, what bliss it was for her to see her husband once again! She kept her white arms round his neck and never quite let go. Dawn with her roses caught them at their tears."

Consider This:

- In the excerpt in which Odysseus returns to Ithaca, why does he decide to kill all the suitors of Penelope? What informal law in Greek society have the suitors violated? How did the Cyclops, Polyphemus, violate this same law?

- How did Penelope "test" Odysseus before she would accept him as her true husband? Why is Homer's *Odyssey* considered a classic of Western literature?

Compare and Contrast:

- How are women portrayed in Homer's *Iliad* and *Odyssey*? Compare the homecoming experience of Agamemnon and his wife Clytemnestra with that of Odysseus and Penelope.

- Note also the sorrows of Hector's wife, Andromache, as she saw the body of her husband dragged around the city of Troy by the victor Achilles. What messages about war and suffering is Homer trying to convey? Compare these scenes with the agony of Andromache after the Greeks enter Troy victoriously as portrayed by Euripides in the selection entitled *The Trojan Women*.

The Heroic Age

About 750 B.C.E., the Greeks had recovered from the destruction of 1200 B.C.E. and erupted on the Mediterranean world not only with the great epics of Homer but also with goods to trade throughout the Mediterranean and colonies to found in Italy and southern France. This was an expansive time and serves as a prelude to the great political and literary achievements of fifth-century Athens. The following selections from poets of the eighth through sixth centuries B.C.E. are brilliant gems. From the conservative and stolid advice of Hesiod (ca. 700 B.C.E.) to the sensitive love lyrics of female poet Sappho (ca. 600 B.C.E.) to the heroic celebrations of athletic achievement in the Olympics by Pindar (ca. 500 B.C.E.), Greek values and a special spirit of life emerge.

Works and Days

HESIOD

Pandora's Box of Evil

> The gods desire to keep the stuff of life
> Hidden from us. If they did not, you could
> Work for a day and earn a year's supplies;
> You'd pack away your rudder, and retire
> The oxen and the laboring mules. But Zeus
> Concealed the secret, angry in his heart
> At being hoodwinked by Prometheus,
> And so he thought of painful cares for men.

"Works and Days" is from Hesiod, *Works and Days*, trans. by Dorothea Wender (Baltimore, Md., and Harmondsworth, Middlesex: Penguin Books, 1973), pp. 60–62, 69–72. Copyright © by Dorothea Wender. Reprinted by permission of Penguin Books, Ltd.

First he hid fire. But the son of Iapetos
Stole it from Zeus the Wise, concealed the flame
In a fennel stalk, and fooled the Thunderer.

Then, raging, spoke the Gatherer of Clouds [Zeus]:
'Prometheus, most crafty god of all,
You stole the fire and tricked me, happily,
You, plague on all mankind and on yourself.
They'll pay for fire: I'll give another gift
To men, an evil thing for their delight,
And all will love this ruin in their hearts.'
So spoke the father of men and gods, and laughed.

He told Hephaistos quickly to mix earth
And water, and to put in it a voice
And human power to move, to make a face
Like an immortal goddess, and to shape
The lovely figure of a virgin girl.
Athena was to teach the girl to weave,
And golden Aphrodite to pour charm
Upon her head, and painful, strong desire,
And body-shattering cares. Zeus ordered, then,
The killer of Argos, Hermes, to put in
Sly manners, and the morals of a bitch.
The son of Kronos [Zeus] spoke, and was obeyed.
The Lame God [Hephaistos] molded earth as Zeus decreed
Into the image of a modest girl,
Grey-eyed Athena made her robes and belt,
Divine Seduction and the Graces gave
Her golden necklaces, and for her head
The Seasons wove spring flowers into a crown.
Hermes the Messenger put in her breast
Lies and persuasive words and cunning ways;
The herald of the gods then named the girl
Pandora, for the gifts which all the gods
Had given her, this ruin of mankind.
The deep and total trap was now complete . . .

Before this time men lived upon the earth
Apart from sorrow and from painful work,
Free from disease, which brings the Death-gods in.
But now the woman opened up the cask,
And scattered pains and evils among men.
Inside the cask's hard walls remained one thing,
Hope, only, which did not fly through the door.
The lid stopped her, but all the others flew,
Thousands of troubles, wandering the earth.
The earth is full of evils, and the sea.
Diseases come to visit men by day
And, uninvited, come again at night
Bringing their pains in silence, for they were
Deprived of speech by Zeus the Wise. And so
There is no way to flee the mind of Zeus.

Advice for the Wise

Invite your friend, but not your enemy,
To dine; especially, be cordial to
Your neighbor, for if trouble comes at home,
A neighbor's there, at hand; while kinsmen take
Some time to arm themselves. It is a curse
To have a worthless neighbor; equally,
A good one is a blessing; he who is
So blest possesses something of great worth.
No cow of yours will stray away if you
Have watchful neighbors. Measure carefully
When you must borrow from your neighbor, then
Pay back the same, or more, if possible,
And you will have a friend in time of need.

Shun evil profit, for dishonest gain
Is just the same as failure. Love your friends;
Approach the men who come to you, and give
To him who gives, but not, if he does not.

We give to generous men, but no one gives
To stingy ones. Give is a lovely girl,
But Grab is bad, and she gives only death.
The man who gives ungrudgingly is glad
At heart, rejoicing in his gift, but if
A man forgets his shame and takes something,
However small, his heart grows stiff and cold.

Add to your stores, and Famine, burning-eyed,
Will stay away. Even if your supply
Is small, and if you add a little bit,
And do it often, soon it will be big.
Less worry comes from having wealth at home;
Business abroad is always insecure.

Think about this: to draw on what you have
Is fine; to need and have not pains the heart.

Be sparing of the middle of a cask,
But when you open it, and at the end,
Drink all you want; it's not worth saving dregs.

Let wages promised to a friend be fixed
Beforehand; even with your brother, smile
And have a witness, for too much mistrust
And too much trust can both be ruinous.

Don't let a woman, wiggling her behind,
And flattering and coaxing, take you in;
She wants your barn: woman is just a cheat.

An only son preserves his
 father's name
And keeps the
 fortune
 growing in
 one house;
If you have
 two, you'll
 need to have
 more wealth
And live a
 longer time.
 But Zeus can find
Ways to enrich a larger family;
More children mean more help and greater gains.

> **"Don't let a woman, wiggling her behind / And flattering and coaxing, take you in / She wants your barn: woman is just a cheat."**
>
> **—Hesiod**

If in your heart you pray for riches, do
These things; pile work on work, and still more work. . . .

First, get a house, a woman, and an ox
For ploughing—let the woman be a slave,
Unmarried, who can help you in the fields,
Make ready in your house the things you'll need,
So you won't have to try to borrow tools
And be refused, and do without, and let
The ripe time pass and all your work be lost.

Don't put off work until another day,
Or even till tomorrow; lazy men
Who put things off always have unfilled barns.
Constant attention makes the work go well;
Idlers wrestle with ruin all their days.

Consider This:

- What advice does Hesiod offer regarding hope, evil, and profit in the excerpts from *Works and Days*? What does he think of women and "lazy men"? Note especially the passage that presents the world as "free from disease" until woman opened up the cask (Pandora's box) and "scattered pains and evils among men."

Compare and Contrast:

- Compare this with the section in Genesis from the Old Testament of the Bible in the previous chapter in which the world is free from evil until Eve tempts Adam with the fruit of the Tree of Life and paradise vanishes. What image of women was often cultivated in antiquity? Is this image alive today?

Love Poetry from Lesbos
SAPPHO

It's no use

Mother dear, I
can't finish my
weaving

You may
blame Aphrodite
soft as she is

she has almost killed me with
love for that boy.

• • •

We drink your health

Lucky bridegroom!
Now the wedding you
asked for is over

And your wife is the
girl you asked for;
she's a bride who is

charming to look at,
with eyes as soft as
honey, and a face

that Love has lighted
with his own beauty.
Aphrodite has surely

outdone herself in
doing honor to you!

• • •

I have had not one word from her

Frankly I wish I were dead.
When she left, she wept

a great deal; she said to
me, "This parting must be
endured, Sappho. I go unwillingly."

"Love Poetry from Lesbos" is from *Sappho*, trans. by Mary Barnard (Berkeley and Los Angeles: University of California Press, 1958), nos. 12, 30, 42. Copyright © 1958 by The Regents of the University of California. Reprinted by permission of The University of California Press.

I said, "Go, and be happy
but remember (you know well)
whom you leave shackled by love.

"If you forget me, think
of our gifts to Aphrodite
and all the loveliness that we shared

"all the violet tiaras,
braided rosebuds, dill and
crocus twined around your young neck

"myrrh poured on your head
and on soft mats girls with
all that they most wished for beside them

"while no voices chanted
choruses without ours,
no woodlot bloomed in spring
without song. . . ."

Consider This:

• In contrast to Hesiod, what values and emotions are expressed by Sappho? Which is your favorite stanza from her poetry and why?

The Celebration of Olympic Athletes
PINDAR

PYTHIAN X: For Hippokleas of Thessaly, Winner in the Boys' Double Foot-Race

He is tasting the Games.
To the host of the dwellers around
That vale in Parnassos
Proclaimed him, first of the boys
In the double foot-race.
Apollo, sweet is the end of endeavor
(Sweet too its beginning)
When a God speeds its growing.
I think you planned that he should win this;
And the blood in him follows his father's tracks,
Who won at Olympia twice
In the armor of Ares which takes the shock of war;
And the Games under the rocks of Krisa,
In that deep meadow, put
Phrikias first in the runners' race.
May their luck hold, and keep in the days to come
Their lordly wealth aflower!

So great a share of the lovely thing of Hellas
Is theirs, let God not envy them
And change their fortune.
Though God alone never tastes woe,
Yet that man is happy and poets sing of him,
Who conquers with hand or swift foot
And wins the greatest of prizes
By steadfastness and strength
And lives to see
His young son, in turn, get garlands at Pytho.

ISTHMIAN V: For Phylakidas of Aegina, Winner in the Trial of Strength

In the struggle of games he has won
The glory of his desire,
Whose hair is tied with thick garlands
For victory with his hands
Or swiftness of foot.
Men's valor is judged by their fates,
But two things alone
Look after the sweetest grace of life
Among the fine flower of wealth.

If a man fares well and hears his good name spoken,
Seek not to become Zeus!
You have everything, if a share
Of these beautiful things comes to you.

Mortal ends befit mortal men.
For you Phylakidas, at the Isthmus
A double success is planted and thrives,
And at Nemea for you and your brother Pytheas
In the Trial of Strength. My heart tastes song.

PYTHIAN V: For Arkesilas of Cyrene, Winner in the Chariot Race

Now that from Pytho comes
The sweet of Triumph, the ransoming of cost,
This music of delight!
Lo, there is a man who the wise praise.
I will say what is said:
He pastures a mind and a tongue beyond his youth:
With the long wings of his courage
He is an eagle among the birds:
He is the strength of victory like a wall.
The Muses know him
Winged from his mother's lap.
He is proved a right charioteer:

He has entered the lists of the noble arts of this land
Boldly. Now God is kind to him

And establishes his power.
And in years to come, you blessed sons of Kronos,
In his acts and his counsels
Grant him the like. Let no stormy wind
Of autumn overwhelm his days.
The great mind of Zeus
Is pilot of the doom of men whom he loves.
I pray Him at Olympia
To add His glory to the House of Battos.

Consider This:

- What qualities does Pindar admire in his celebration of Olympic athletes? How are these reflective of some of the values you found in excerpts from Homer's *Iliad* and *Odyssey*? How would you interpret Pindar's advice, "If a man fares well and hears his good name spoken, seek not to become Zeus"? Can you apply this to Achilles?

Early Greek Philosophy

The Greeks were the originators of philosophy in the Western historical tradition. Philosophy means "love of wisdom," and in this the Greeks had no rivals in Western Civilization for originality of thought and beauty of expression. The Greek language is endowed with a formidable vocabulary that allows for an expressive discussion of abstract thoughts. This amazing civilization, which produced the likes of Plato and Aristotle, began its intellectual journey with Thales of Miletus (ca. 600 B.C.E.), who asked the simple question, "What are things made of?" The inspiration of the question alone reveals much about the inquiring nature of the Greeks, but its answer would lead Thales and other "monists" like Anaximenes to reduce the world to one primary element around which all others existed. For Thales, it was water; for Anaximenes, air. For others, like Pythagoras (ca. 550 B.C.E.), the world could best be explored through numerical ratios and resulting harmonies. Indeed, life itself, through the transmigration of the soul, was a cycle of rebirth.

Thales of Miletus: Water Is the Primary Element
ARISTOTLE

Some say that the earth rests on water. This in fact is the oldest view that has been transmitted to us, and they say that it was advanced by Thales of Miletus who thought that the earth rests because it can float like a log or something else of that sort (for none of these things can rest on air, but they can rest on water)—as though the same must not hold of the water supporting the earth as holds of the earth itself.

Most of the first philosophers thought that principles in the form of matter were the only principles of all things. For they say that the element and first principle of the things that exist is that from which they all are and from which they first come into being and into which they are finally destroyed, its substance remaining and its properties changing. . . . There must be some nature—either one or more than one—from which the other things come into being, it being preserved. But as to the number and form of this sort of principle, they do not all agree. Thales, the founder of this kind of philosophy, says that it is water (that is why he declares that the earth rests on water). He perhaps came to

acquire this belief from seeing that the nourishment of everything is moist and that heat itself comes from this and lives by this (for that from which anything comes into being is its first principle)—he came to his belief both for this reason and because the seeds of everything have a moist nature, and water is the natural principle of moist things.

Anaximenes: "The First Principle Is Infinite Air"
HIPPOLYTUS

Anaximenes, son of Eurystratus, was also a Milesian. He said that the first principle is infinite air, from which what is coming into being and what has come into being and what will exist and gods and divinities come into being, while everything else comes into being from its offspring. The form of the air is this: when it is most uniform it is invisible, but it is made apparent by the hot and the cold and the moist and the moving. It is always in motion; for the things that change would not change if it were not in motion. For as it is condensed and rarefied it appears different: when it dissolves into a more rarefied condition it becomes fire; and winds, again, are condensed air, and cloud is produced from air by compression. Again, when it is more condensed it is water, when still further condensed it is earth, and when it is as dense as possible it is stones. Thus the most important factors in coming into being are opposites—hot and cold.

The earth is flat and rides on air; in the same way the sun and the moon and the other heavenly bodies, which are all fiery, ride the air because of their flatness. The heavenly bodies have come into being from earth, because mist rose from the earth and was rarefied and produced fire, and the heavenly bodies are composed of this fire when it is aloft. There are also some earthy substances in the region of the heavenly bodies which orbit with them. He says that the heavenly bodies move not under the earth, as others have supposed, but round the earth—just as a felt cap turns on the head. And the sun is hidden not because it goes under the earth but because of its greater distance from us. The heavenly bodies do not heat us because of their great distance.

Winds are generated when the air is condensed and driven along. As it collects together and is further thickened, clouds are generated and in this way it changes into water. Hail comes about when the water falling from the clouds solidifies, and snow when these same things solidify in a more watery form. Lightning occurs when the clouds are parted by the force of winds; for when they part a bright and fiery flash occurs. Rainbows are generated when the sun's rays fall on compacted air; earthquakes when the earth is considerably altered by heating and cooling.

These are the views of Anaximenes. He flourished in the first year of the 58th Olympiad [548/547 B.C.E.].

Pythagoras on the Transmigration of the Soul
DIODORUS

Pythagoras believed in metempsychosis [transmigration of the soul] and thought that eating meat was an abominable thing, saying that the souls of all animals enter different animals after death. He himself used to say that he remembered being, in Trojan times, Euphorbus, Panthus's son, who was killed by Menelaus. They say that once when he was staying at Argos he saw a shield from the spoils of Troy nailed up, and burst into tears. When the Argives asked him the reason

" 'The First Principle Is Infinite Air' " is from *Early Greek Philosophy*, trans. Jonathan Barnes (Baltimore, Md., and Harmondsworth, Middlesex: Penguin Books, 1969), pp. 77–78. Copyright © 1987 by Jonathan Barnes. Reprinted by permission of Penguin Books, Ltd.

"Pythagoras on the Transmigration of the Soul" is from *Early Greek Philosophy*, trans. Jonathan Barnes (Baltimore, Md., and Harmondsworth, Middlesex: Penguin Books, 1969), p. 87. Copyright © 1987 by Jonathan Barnes. Reprinted by permission of Penguin Books, Ltd.

for his emotion, he said that he himself had borne that shield at Troy when he was Euphorbus. They did not believe him and judged him to be mad, but he said he would provide a true sign that it was indeed the case; on the inside of the shield there had been inscribed in archaic lettering EUPHORBUS. Because of the extraordinary nature of his claim they all urged that the shield be taken down—and it turned out that on the inside the inscription was found.

Consider This:

- What were the main ideas of Thales of Miletus? Why is his fundamental question about the composition of things in the world so expressive of the Greek spirit of inquiry? What were the contributions of Anaximenes and Pythagoras? Why has it been proposed that the Greeks invented philosophy?

The Classical Era: The Golden Age of Athens

Of all the wondrous things on earth, the greatest of these is man.

—Sophocles

Democracy is based on the conviction that man has the moral and intellectual capacity, as well as the inalienable right, to govern himself with reason and justice.

—Harry S Truman

Excessive freedom leads to anarchy, which in turn results in despotism, the most burdensome and most brutal slavery.

—Plato

In the strict sense of the term, a true democracy has never existed and never will exist.

—Jean Jacques Rousseau

When the Athenians finally wanted not to give to society, but for society to give to them, when the freedom they wished for was freedom from responsibility, then Athens ceased to be free.

—Edward Gibbon

The city-state of Athens has been widely admired for its contributions to Western Civilization during the fifth century B.C.E. This was a time of great intellectual energy, producing enduring works of art, architecture, philosophy, drama, and history. The confidence necessary to achieve such heights was granted early in the century when the Greek city-states united to repel two invasions by the mighty Persian empire in 490 and 480 B.C.E. On this note of triumph, the Golden Age of Athens began.

During the period from 480 to 430 B.C.E., leaders such as Pericles extolled the superiority of Athenian democratic government and the freedom essential to Athenian greatness. All citizens were expected to vote, serve in public office, and offer themselves as jurors. Active participation in political affairs was demanded, and one who shunned such responsibility was called "idiotes," or "private person"; the word has come down to us as "idiot," with all its pejorative connotations. Yet, critics of the time pointed out the shortcomings of the democracy

and of its leadership. At root, it might be argued that the greatness of Athenian civilization was dependent on her "allies," or fellow members of the Delian Confederacy. This Confederacy was established in 478 B.C.E., after the Persian wars, to ensure that the Greeks would not be attacked by Persia again. Theoretically, Athens had no greater vote than any of her Confederates, but almost from the outset she held the keys to power, contributing both the administrators of the treasury on the island of Delos and the commanders of the military expeditions. By 466 B.C.E., after several Confederate victories, it became evident that Persia no longer posed a threat to the city-states of Greece or the islands in the Aegean Sea. Some members wished to secede, but they were opposed and militarily crushed by Athens. Secession from the Confederacy would not be tolerated. In 454 B.C.E., the treasury was moved from the island of Delos to Athens. The patron goddess, Athena, supervised the protection of all tribute that came into Athens and took a piece of the action (called the "first fruits") for her trouble. The great Athenian orator Pericles maintained the Athenian Empire (as the Delian Confederacy came to be called) partly to counter Spartan land power, and managed it efficiently so as to produce revenues essential to the glorification of Athens. By 447 B.C.E., work on the Parthenon had begun, and several other building projects, artists, and sculptors would be financed by funds contributed by Athenian "allies."

The historical problem at issue here involves the compatibility of democracy and empire. From a moral standpoint, should a state that espouses freedom for all of its citizens control an empire that is maintained by fear and force? Is it even possible for a democratic government to rule an empire effectively? Finally, do the beauty and cultural worth of the monuments of a civilization justify the means of obtaining them? In other words, what price civilization?

Figure 2–1 The rocky plateau of the ancient Acropolis overlooks the city of Athens. The Parthenon (center), temple of the patron goddess Athena, was built with funds garnered from the Athenian Empire. What price civilization? (Photo Researchers, Inc.)

Greek Tragedy

The greatness of Athenian civilization in the fifth century B.C.E. *was evident in many ways. Not only was the city decorated with temples such as the Parthenon and other monuments on the Acropolis, but Athens also was glorified by the splendor of her intellectual accomplishment. During the century, three dramatists emerged who are comparable in quality to Shakespeare: Aeschylus, Sophocles, and Euripides. Aeschylus, a true patriot, wanted to be remembered only as having fought at the battle of Marathon. Sophocles, a commander in the Athenian navy, won first place in dramatic competition for his play about Oedipus, an unfortunate king of Thebes who unwittingly killed his father (Laius) and married his mother. Such sin, even if unintended and unperceived, cannot go unpunished by the gods: When the truth is revealed Jocasta (his mother/wife) commits suicide and Oedipus blinds himself. The Athenians loved the "no-win" situation, both for the problems it presented and for the moral choices it demanded. In the following selection, note the importance of self-discovery and truth, no matter the outcome.*

Oedipus the King (430 B.C.E.)
SOPHOCLES

Attendant: O you most honourable lords of the city of Thebes,
Weep for the things you shall hear, the things you must see,
If you are true sons and loyal to the house of Labdacus.
Not all the water of Ister, the waters of Phasis,
Can wash this dwelling clean of the foulness within,
Clean of the deliberate acts that soon shall be known,
Of all horrible acts most horrible, wilfully chosen.

Chorus: Already we have wept enough for the things we have known,
The things we have seen. What more will your story add?

Attendant: First, and in brief—Her Majesty is dead.

Chorus: Alas, poor soul: what brought her to this end?

Attendant: Her own hand did it. You that have not seen,
And shall not see, this worst, shall suffer the less.
But I that saw, will remember, and will tell what I remember
Of her last agony.
You saw her cross the threshold
In desperate passion. Straight to her bridal-bed
She hurried, fastening her fingers in her hair.
There in her chamber, the doors flung sharply to,
She cried aloud to Laius long since dead,
Remembering the son she bore long since, the son
By whom the sire was slain, the son to whom
The mother bore yet other children, fruit
Of luckless misbegetting, there she bewailed

"Oedipus the King" is from Sophocles, *Oedipus the King*, in *The Theban Plays*, trans. E. F. Watling (Baltimore, Md., and Harmondsworth, Middlesex: Penguin Books, 1947), pp. 59–61 (lines 1125–1318). Copyright © 1947 by E. F. Watling. Reprinted by permission of Penguin Books, Ltd.

The twice confounded issue of her wifehood—
Husband begotten of husband, child of child.
So much we heard. Her death was hidden from us.
Before we could set out her tragedy,
The King broke in with piercing cries, and all
Had eyes only for him. This way and that
He strode among us. 'A sword, a sword!' he cried;
'Where is that wife, no wife of mine—that soil
Where I was sown, and whence I reaped my harvest!'
While thus he raved, some demon guided him—
For none of us dare to speak—to where she was.

As if in answer to some leader's call
With wild hallooing cries he hurled himself
Upon the locked doors, bending by main force
The bolts out of their sockets—and stumbled in.
We saw a knotted pendulum, a noose,
A strangled woman swinging before our eyes.
The King saw too, and with heart rending groans
Untied the rope, and laid her on the ground.
But worse was yet to see. Her dress was pinned

> **"Eyes that should see no longer his shame, his guilt, No longer see those they should never have seen. . . . Henceforth seeing nothing but night. . . .**
> **—Oedipus**

With golden brooches, which the King snatched out
And thrust, from full arm's length, into his eyes—
Eyes that should see no longer his shame, his guilt,
No longer see those they should never have seen,
Nor see, unseeing, those he had longed to see,
Henceforth seeing nothing but night. . . . To this wild tune
He pierced his eyeballs time and time again,
Till bloody tears ran down his beard—not drops

But in full spate a whole cascade descending
In drenching cataracts of scarlet rain.
Thus two have sinned; and on two heads, not one—
On man and wife—falls mingled punishment.
Their old long happiness of former times
Was happiness earned with justice; but to-day
Calamity, death, ruin, tears, and shame,
All ills that there are name for—all are here.

Antigone (441 B.C.E.)

SOPHOCLES

Sophocles continued the story of Oedipus in Antigone, *a play about Oedipus' tainted children. The play won first prize in the dramatic competition and again demonstrates the tragedy of those who are not guilty but are condemned by the misdeeds of others. In the following excerpt, Antigone and her sister Ismene must decide whether to bury the body of their brother, thus satisfying the laws of the gods, or to leave it unburied as the king (Creon) has decreed.*

Scene: Before the Palace at Thebes

Enter Ismene from the central door of the Palace. Antigone follows, anxious and urgent; she closes the door carefully, and comes to join her sister.

Antigone: O sister! Ismene dear, dear sister Ismene!
You know how heavy the hand of God is upon us;
How we who are left must suffer for our father, Oedipus.
There is no pain, no sorrow, no suffering, no dishonour
We have not shared together, you and I.
And now there is something more. Have you heard this order,
This latest order that the King has proclaimed to the city?
Have you heard how our dearest are being treated like enemies?

Ismene: I have heard nothing about any of those we love,
Neither good nor evil—not, I mean, since the death
Of our two brothers, both fallen in a day.
The Argive army, I hear, was withdrawn last night.
I know no more to make me sad or glad.

Antigone: I thought you did not. That's why I brought you out here,
Where we shan't be heard, to tell you something alone.

Ismene: What is it, Antigone? Black news, I can see already.

Antigone: O Ismene, what do you think? Our two dear brothers. . . .
Creon has given funeral honours to one,
And not to the other; nothing but shame and ignominy.
Eteocles has been buried, they tell me, in state,
With all honourable observances due to the dead.
But Polynices, just as unhappily fallen—the order
Says he is not to be buried, not to be mourned;
To be left unburied, unwept, a feast of flesh
For keen-eyed carrion birds. The noble Creon!
It is against you and me he has made this order.
Yes, against me. And soon he will be here himself
To make it plain to those that have not heard it,
And to enforce it. This is not idle threat;

"Antigone" is from Sophocles, *Antigone*, in *The Theban Plays*, trans. E. F. Watling (Baltimore, Md., and Harmondsworth, Middlesex: Penguin Books, 1947), pp. 126–129, 135–136 (lines 1–112, 339–370, 1262–1353). Copyright © 1947 by E. F. Watling. Reprinted by permission of Penguin Books, Ltd.

The punishment for disobedience is death by stoning.
So now you know. And now is the time to show
Whether or not you are worthy of your high blood.

Ismene: My poor Antigone, if this is really true,
What more can I do, or undo, to help you?

Antigone: Will you help me? Will you do something with me? Will you?

Ismene: Help you do what, Antigone? What do you mean?

Antigone: Would you help me lift the body . . . you and me?

Ismene: You cannot mean . . . to bury him? Against the order?

Antigone: Is he not my brother, and yours, whether you like it
Or not? I shall never desert him, never.

Ismene: How could you dare, when Creon has expressly forbidden it?

Antigone: He has no right to keep me from my own.

Ismene: O sister, sister, do you forget how our father
Perished in shame and misery, his awful sin
Self-proved, blinded by his own self-mutilation?
And then his mother, his wife—for she was both—
Destroyed herself in a noose of her own making.
And now our brothers, both in a single day
Fallen in an awful exaction of death for death.
Blood for blood, each slain by the other's hand.
Now we two left; and what will be the end of us,
If we transgress the law and defy our king?
O think, Antigone; we are women; it is not for us
To fight against men; our rulers are stronger than we,
And we must obey in this, or in worse than this.
May the dead forgive me, I can do no other
But as I am commanded; to do more is madness.

Antigone: No; then I will not ask for your help.
Nor would I thank you for it, if you gave it.

> "**We have only a little time to please the living, But all eternity to love the dead. There I shall lie for ever. Live, if you will; Live, and defy the holiest laws of heaven.**"
>
> **—Antigone**

Go your own way; I will bury my brother;
And if I die for it, what happiness!
Convicted of reverence—I shall be content

To lie beside a brother whom I love.
We have only a little time to please the living,
But all eternity to love the dead.
There I shall lie for ever. Live, if you will;
Live, and defy the holiest laws of heaven.

Ismene: I do not defy them; but I cannot act
Against the State. I am not strong enough.

Antigone: Let that be your excuse, then. I will go
And heap a mound of earth over my brother.

Ismene: I fear for you, Antigone; I fear—

Antigone: You need not fear for me. Fear for yourself.

Ismene: At least be secret. Do not breathe a word.
I'll not betray your secret.

Antigone: Publish it
To all world! Else I shall hate you more.

Ismene: Your heart burns! Mine is frozen at the thought.

Antigone: I know my duty, where true duty lies.

Ismene: If you can do it; but you're bound to fail.

Antigone: When I have tried and failed, I shall have failed.

Ismene: No sense in starting on a hopeless task.

Antigone: Oh, I shall hate you if you talk like that!
And he will hate you, rightly. Leave me alone
With my own madness. There is no punishment
Can rob me of my honourable death.

Ismene: Go then, if you are determined, to your folly.
But remember that those who love you. . . . love you still.

[Condemned to death for defying the king and burying her brother, Antigone explains her actions]

Antigone: So to my grave,
My bridal-bower, my everlasting prison,
I go, to join those many of my kinsmen
Who dwell in the mansions of Persephone,
Last and unhappiest, before my time.
Yet I believe my father will be there
To welcome me, my mother greet me gladly,
And you, my brother, gladly see me come.
Each one of you my hands have laid to rest,
Pouring the due libations on your graves.
It was by this service to your dear body, Polynices,
I earned the punishment which now I suffer,
Though all good people know it was for your honour.

O but I would not have done the forbidden thing
For any husband or for any son.
For why? I could have had another husband
And by him other sons, if one were lost;
But, father and mother lost, where would I get

Another brother? For thus preferring you,
My brother, Creon condemns me and
 hales me away,

Never a bride, never a mother, unfriended,
Condemned alive to solitary death.
What law of heaven have I transgressed?
 What god
Can save me now? What help or hope
 have I,
In whom devotion is deemed sacrilege?
If this is God's will, I shall learn my lesson
In death; but if my enemies are wrong,
I wish them no worse punishment than
 mine. . . .

> "What law of heaven have I transgressed? What god can save me now? What help or hope have I, in whom devotion is deemed sacrilege?
> If this is God's will, I shall learn my lesson in death."
> —Antigone

[*Antigone, thus condemned by Creon, commits suicide, as does her intended husband, Haemon, son of Creon. In this passage, Creon realizes that he was blind to wisdom and that his laws have defied the gods and cost him the lives of his son and also his wife.*]

Enter Creon with the body of Haemon.

Creon: The sin, the sin of the erring soul
Drives hard unto death.
Behold the slayer, the slain,
The father, the son.
O the curse of my stubborn will!
Son, newly cut off in the newness of youth,
Dead for my fault, not yours.

Chorus: Alas, too late you have seen the truth.

Creon: I learn in sorrow. Upon my head
God has delivered this heavy punishment,
Has struck me down in the ways of wickedness,
And trod my gladness under foot.
Such is the bitter affliction of mortal man.
Enter the Messenger from the palace.

Messenger: Sir, you have this and more than this to bear.
Within there's more to know, more to your pain.

Creon: What more? What pain can overtop this pain?

Messenger: She is dead—your wife, the mother of him that is dead—
The death-wound fresh in her heart. Alas, poor lady!

Creon: Insatiable Death, wilt thou destroy me yet?
What say you, teller of evil?
I am already dead,
And there is more?
Blood upon blood?
More death? My wife?

The central doors open, revealing the body of Eurydice.

Chorus: Look then, and see; nothing is hidden now.

Creon: O second horror!
What fate awaits me now?
My child here in my arms . . . and there, the other. . . .
The son . . . the mother. . . .

Messenger: There at the altar with the whetted knife
She stood, and as the darkness dimmed her eyes
Called on the dead, her elder son and this,
And with her dying breath cursed you, their slayer.

Creon: O horrible. . . .
Is there no sword for me,
To end this misery?

Messenger: Indeed you bear the burden of two deaths.
It was her dying word.

Creon: And her last act?

Messenger: Hearing her son was dead, with her own hand
she drove the sharp sword home into her heart.

Creon: There is no man can bear this guilt but I.
It is true, I killed him.
Lead me away, away. I live no longer.

Chorus: 'Twere best, if anything is best in evil times.
What's soonest done, is best, when all is ill.

Creon: Come, my last hour and fairest,
My only happiness . . . come soon.
Let me not see another day.
Away . . . away. . . .

Chorus: The future is not to be known; our present care
Is with the present; the rest is in other hands.

Creon: I ask no more than I have asked.

Chorus: Ask nothing.
What is to be, no mortal can escape.

Creon: I am nothing. I have no life.
Lead me away. . . .
That have killed unwittingly
My son, my wife.
I know not where I should turn,
Where look for help.

My hands have done amiss, my head is bowed
With fate too heavy for me.

Chorus: Of happiness the crown
And chiefest part
Is wisdom, and to hold
The gods in awe
This is the law
That, seeing the stricken heart
Of pride brought down,
We learn when we are old.

> [*The last excerpt from Antigone is the famous choral passage that expresses the Greek view of man.*]

Chorus: Wonders are many on earth, and the greatest of these
Is man, who rides the ocean and takes his way
Through the deeps, through wind-swept valleys of perilous seas
That surge and sway.
He is master of ageless Earth, to his own will bending
The immortal mother of gods by the sweat of his brow,
As year succeeds year, with toil unending
Of mule and plough.
He is lord of all things living; birds of the air,
Beasts of the field, all creatures of sea and land
He taketh, cunning to capture and ensnare
With sleight of hand;
Hunting the savage beast from the upland rocks,
Taming the mountain monarch in his lair,
Teaching the wild horse and the roaming ox
His yoke to bear.
The use of language, the wind-swift motion of brain
He learnt; found out the laws of living together
In cities, building him shelter against the rain
And wintry weather.
There is nothing beyond his power. His subtlety
Meeteth all chance, all danger conquereth.
For every ill he hath found its remedy,
Save only death.
O wondrous subtlety of man, that draws
To good or evil ways! Great honour is given
And power to him who upholdeth his country's laws
And the justice of heaven.
But he that, too rashly daring, walks in sin
In solitary pride to his life's end.
At door of mine shall never enter in
To call me friend.

Consider This:
- In these excerpts from *Oedipus the King* and *Antigone*, what are some of Sophocles' main ideas about justice, responsibility, and law? How do these ideas reflect a prosperous civilization?

The Architectural Foundation

THE THEATER OF DIONYSUS

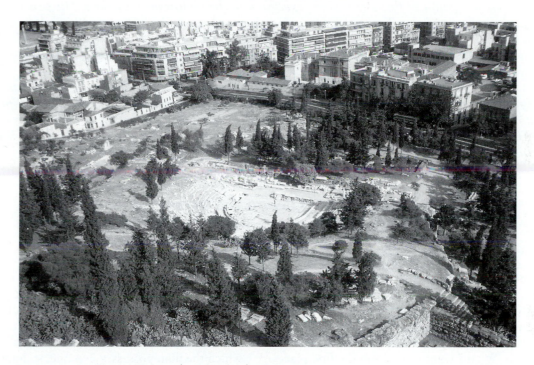

Figure 2–2 The Theater of Dionysus (Perry M. Rogers)

The Theater of Dionysus, where most of the great repertory of Athenian tragedy was premiered in the fifth century B.C.E., *was first begun in the mid-sixth century and went through many phases of construction through the Roman period. Patrons of the theater worshiped at the nearby shrine of Dionysus. The theater that survives today was basically designed between 342 and 326* B.C.E. *There were 64 tiers of seats (of which about 20 survive). The philosopher, Plato, in his dialogue,* The Symposium, *reported that it held seating for about 30,000 people.*

Consider This:
- In addition to the entertainment of comedies and satyr plays, drama also confronted the political dilemmas of the time and engaged the Athenian conscience with plays by Aeschylus, Sophocles, and Euripides on the nature of the gods, justice and retribution, hubris and the moral parameters of society. The Athenians enjoyed being painted into an ethical corner from which they could not escape the ultimate wisdom that closed in around them as the story progressed. How was the Theater of Dionysus an architectural expression of Athenian artistic creativity and political freedom?

The Peloponnesian War and the Decline of Athens (431–404 B.C.E.)

From 431 to 404 B.C.E., the Spartans and Athenians entered into a great conflict that came to be called the Peloponnesian War. This war was born of Spartan distrust for the growing Athenian power and trade influence in areas heretofore controlled by Sparta and its allies. The two city-states, so different in outlook and political orientation, fought, as the historian Thucydides noted, the greatest war "in Greek history, affecting a large part of the non-Greek world, and I might also say, the whole of mankind."

In the end, Athens lost not only the physical struggle and its empire but also the edge of confidence that had propelled its democracy and inspired its poets and statesmen. Perhaps the greatest indication of this loss was the execution of the philosopher Socrates. His penetrating questions demanded reflection on Athenian values and ideals. He considered himself a gadfly whose job it was to prod Athens to self-awareness by challenging the very foundation of its beliefs. Socrates was condemned to death in 399 B.C.E. on rather nebulous charges. His death was symbolic of the rigid defensiveness of a decaying democracy.

The leader of the Athenian democracy in the middle of the fifth century B.C.E. was the great orator Pericles. After the first year of the Peloponnesian War (430 B.C.E.), Pericles spoke to the wives and parents of those who had died in the fighting in an attempt to justify their loss. This Funeral Oration that follows was recorded by the Athenian historian Thucydides; it is the quintessential expression of the structure and values of the Athenian democracy.

"Fix Your Eyes Every Day on the Greatness of Athens": The Funeral Oration of Pericles (430 B.C.E.)
THUCYDIDES

'I have no wish to make a long speech on subjects familiar to you all: so I shall say nothing about the warlike deeds by which we acquired our power or the battles in which we or our fathers gallantly resisted our enemies, Greek or foreign. What I want to do is, in the first place, to discuss the spirit in which we faced our trials and also our constitution and the way of life which has made us great. After that I shall speak to praise of the dead, believing that this kind of speech is not inappropriate to the present occasion, and that this whole assembly, of citizens and foreigners, may listen to it with advantage.

'Let me say that our system of government does not copy the institutions of our neighbours. It is more the case of our being a model to others, than of our imitating anyone else. Our constitution is called a democracy because power is in the hands not of a minority but of the whole people. When it is a question of settling private disputes, everyone is equal before the law; when it is a question of putting one person before another in positions of public responsibility, what counts is not membership of a particular class, but the actual ability which the man possesses. No one, so long as he has it in him to be of service to the state, is kept in political obscurity because of poverty. And, just as our political life is free and open, so is our day-to-day life in our relations with each other. . . . We are free and tolerant in our private lives; but in public affairs we keep to the law. This is because it commands our deep respect.

'We give our obedience to those whom we put in positions of authority, and we obey the laws themselves, especially those which are for the protection of the oppressed, and those unwritten laws which it is an acknowledged shame to break.

'And here is another point. When our work is over, we are in a position to enjoy all kinds of

"The Funeral Oration of Pericles" is from Thucydides, *The Peloponnesian War*, 2.35–2.45, trans. Rex Warner (Baltimore, Md., and Harmondsworth, Middlesex: Penguin Books, 1954), pp. 117–121. Copyright © 1954, 1972 by Rex Warner. Reprinted by permission of Penguin Books, Ltd.

recreation for our spirits. There are various kinds of contests and sacrifices regularly throughout the year; in our own homes we find a beauty and a good taste which delight us every day and which drive away our cares. Then the greatness of our city brings it about that all the good things from all over the world flow in to us, so that to us it seems just as natural to enjoy foreign goods as our own local products.

'Then there is a great difference between us and our opponents, in our attitude towards military security. Here are some examples: our city is open to the world, and we have no periodical deportations in order to prevent people observing or finding out secrets which might be of military advantage to the enemy. This is because we rely, not on secret weapons, but on our own real courage and loyalty. There is a difference, too, in our educational systems. The Spartans, from their earliest boyhood, are submitted to the most laborious training in courage; we pass our lives without all these restrictions, and yet are just as ready to face the same dangers as they are. . . .

There are certain advantages, I think, in our way of meeting danger voluntarily, with an easy mind, instead of with a laborious training, with natural rather than with state-induced courage. We do not have to spend our time practising to meet sufferings which are still in the future; and when they are actually upon us we show ourselves just as brave as these others who are always in strict training. This is one point in which, I think, our city deserves to be admired. There are also others:

'Our love of what is beautiful does not lead to extravagance; our love of the things of the mind does not make us soft. We regard wealth as something to be properly used, rather than as something to boast about. As for poverty, no one need be ashamed to admit it: the real shame is in not taking practical measures to escape from it. Here each individual is interested not only in his own affairs but in the affairs of the state as well: even those who are mostly occupied with their own business are extremely well-informed on general politics—this is a peculiarity of ours: we do not say that a man who takes no interest in politics is a man who minds his own business; we say that he has no business here at all. We Athenians, in our persons,

> "We do not say that a man who takes no interest in politics is a man who minds his own business; we say that he has no business here at all."
> —Pericles

take our decisions on policy or submit them to proper discussions: for we do not think that there is an incompatibility between words and deeds; the worst thing is to rush into action before the consequences have been properly debated. And this is another point where we differ from other people. We are capable at the same time of taking risks and of estimating them beforehand. Others are brave out of ignorance; and, when they stop to think, they begin to fear. But the man who can most truly be accounted brave is he who best knows the meaning of what is sweet in life and of what is terrible, and then goes out undeterred to meet what is to come.

'Again, in question of general good feeling there is a great contrast between us and most other people. We make friends by doing good to the more reliable, since we want to keep alive the gratitude of those who are in our debt by showing continued good will to them. . . . We are unique in this. When we do kindnesses to others, we do not do them out of any calculations of profit or loss: we do them without afterthought, relying on our free liberality. Taking everything together then, I declare that our city is an education to Greece, and I declare that in my opinion each single one of our citizens, in all the manifold aspects of life, is able to show himself the rightful lord and owner of his own person, and do this, moreover, with exceptional grace and exceptional versatility. And to show that this is no empty boasting for the present occasion, but real tangible fact, you have only to consider the power which our city possesses and which has been won by those very qualities which I have mentioned. Athens, alone of the states we know, comes to her testing time in a greatness that surpasses what was imagined of her. In her case, and in her case alone, no invading enemy is ashamed at being

defeated, and no subject can complain of being governed by people unfit for their responsibilities. Mighty indeed are the marks and monuments of our empire which we have left. Future ages will wonder at us, as the present age wonders at us now. . . . For our adventurous spirit has forced an entry into every sea and into every land; and everywhere we have left behind us everlasting memorials of good done to our friends or suffering inflicted on our enemies.

'This, then, is the kind of city for which these men, who could not bear the thought of losing her, nobly fought and nobly died. It is only natural that every one of us who survive them should be willing to undergo hardships in her service. And it was for this reason that I have spoken at such length about our city, because I wanted to make it clear that for us there is more at stake than there is for others who lack our advantages; also I wanted my words of praise for the dead to be set in the bright light of evidence. And now the most important of these words has been spoken. I have sung the praises of our city; but it was the courage and gallantry of these men, and of people like them, which made her splendid. Now would you find it true in the case of many of the Greeks, as it is true of them, that no words can do more than justice to their deeds.

'To me it seems that the consummation which has overtaken these men shows us the meaning of manliness in its first revelation and in its final proof. Some of them, no doubt, had their faults; but what we ought to remember first is their gallant conduct against the enemy in defence of their native land. They have blotted out evil with good, and done more service to the commonwealth than they ever did harm in their private lives. . . .

'So and such they were, these men—worthy of their city. We who remain behind may hope to be spared their fate, but must resolve to keep the same daring spirit against the foe. It is not simply a question of estimating the advantages in theory. I could tell you a long story (and you know it as well as I do) about what is to be gained by beating the enemy back. What I would prefer is that you should fix your eyes every day on the greatness of Athens as she really is, and should fall in love with her. When you realize her greatness, then reflect that what made her great was men with a spirit of adventure, men who knew their duty, men who were ashamed to fall below a certain standard. If they ever failed in an enterprise, they made up their minds that at any rate the city should not find their courage lacking to her, and they gave to her the best contribution they could.

> "Make up your minds that happiness depends on being free, and freedom depends on being courageous."
> —Pericles

They gave her their lives, to her and to all of us, and for their own selves they won praises that never grow old, the most splendid of sepulchres—not the sepulchre in which their bodies are laid, but where their glory remains eternal in men's minds, always there on the right occasion to stir others to speech or to action. For famous men have the whole earth as their memorial: it is not only the inscriptions on their graves in their own country that mark them out; no, in foreign lands also, not in any visible form but in people's hearts, their memory abides and grows. It is for you to try to be like them. Make up your minds that happiness depends on being free, and freedom depends on being courageous. Let there be no relaxation in face of the perils of the war. The people who have most excuse for despising death are not the wretched and unfortunate, who have no hope of doing well for themselves, but those who run the risk of a complete reversal in their lives, and who would feel the difference most intensely, if things went wrong for them. Any intelligent man would find a humiliation caused by his own slackness more painful to bear than death, when death comes to him unperceived, in battle, and in the confidence of his patriotism.'

Consider This:

- According to Pericles in his Funeral Oration, what qualities made Athens great? How does Pericles justify Athenian imperialism? What benefits does Athens give her allies and what does she get in return? Is this equitable? Are there any weaknesses or defects in Pericles's arguments?

The Melian Dialogue (416 B.C.E.)

THUCYDIDES

The Peloponnesian War was fought primarily over the threat that Athens posed to the security and economic well-being of Sparta and her allies. After the first two years of the war, Pericles died from a plague raging in Athens. With the loss of this far-sighted statesman, the democracy fell prey to more demagogic leaders who influenced people with effective oratory but whose policies were often extreme.

The prime example of this extremism involved the island of Melos. Located off the southern tip of the Peloponnesus, Melos was a Spartan colony. Even so, the Melians maintained a strict neutrality during the Peloponnesian War. Thucydides, the Athenian historian, wrote this contrived dialogue to demonstrate the brutal force used by Athens in maintaining her empire. The ideals expounded by Pericles in the Funeral Oration are thus balanced by power politics in which logic is no defense and might makes right. Melos was conquered by Athens in 416 B.C.E.

The next summer the Athenians made an expedition against the isle of Melos. The Melians are a colony of Sparta that would not submit to the Athenians like the other islanders, and at first remained neutral and took no part in the struggle, but afterwards, upon the Athenians using violence and plundering their territory, assumed an attitude of open hostility. The Athenian generals encamped in their territory with their army, and before doing any harm to their land sent envoys to negotiate. . . . The Athenian envoys then said:

Athenians: If you have met us in order to make surmises about the future, or for any other purpose than to look existing facts in the face and to discuss the safety of your city on this basis, we will break off the conversations; otherwise, we are ready to speak.

Melians: In our position it is natural and excusable to explore many ideas and arguments. But the problem that has brought us here is our security, so, if you think fit, let the discussion follow the line you propose.

Athenians: Then we will not make a long and unconvincing speech, full of fine phrases, to prove that our victory over Persia justifies our empire, or that we are now attacking you because you have wronged us, and we ask you not to expect to convince us by saying that you have not injured us, or that, though a colony of Sparta, you did not join her. . . .

Melians: As you ignore justice and have made self-interest the basis of discussion, we must take the same ground, and we say that in our opinion it is in your interest to maintain a principle which is for the good of all—that anyone in danger should have just and equitable treatment and any advantage, even if not strictly his due, which he can secure by persuasion. This is your interest as much as ours, for your fall would involve you in a crushing punishment that would be a lesson to the world.

Athenians: We have no apprehensions about the fate of our empire, if it did fall; those who rule other peoples, like the Spartans, are not formidable to a defeated enemy. Nor is it the Spartans with whom we are now contending: the danger is from subjects who of themselves may attack and conquer their rulers. But leave that danger to us to face. At the moment we shall say we are seeking the safety of your state; for we wish you to become our subjects with least trouble to ourselves, and we would like you to survive in our interests as well as your own.

"The Melian Dialogue" is from Thucydides, *The History of The Peloponnesian War*, 5.84–116, trans. and ed. R. W. Livingstone (Oxford: The Clarendon Press, 1943), pp. 266–274. Reprinted by permission of Oxford University Press.

Melians: It may be your interest to be our masters: how can it be ours to be your slaves?

Athenians: By submitting you would avoid a terrible fate, and we should gain by not destroying you.

> "Your hostility injures us less than your friendship. That, to our subjects, is an illusion of our weakness, while your hatred exhibits our power."
> —The Athenians

Melians: Would you not agree to an arrangement under which we should keep out of the war, and be your friends instead of your enemies, but neutral?

Athenians: No: your hostility injures us less than your friendship. That, to our subjects, is an illusion of our weakness, while your hatred exhibits our power.

Melians: Is this the construction which your subjects put on it? Do they not distinguish between states in which you have no concern, and peoples who are most of them your colonies, and some conquered rebels?

Athenians: They think that one nation has as good rights as another, but that some survive because they are strong and we are afraid to attack them. So, apart from the addition of our empire, your subjection would give us security: the fact that you are islanders (and weaker than others) makes it more important that you should not get the better of the mistress of the sea.

Melians: But do you see no safety in our neutrality? Will you not make enemies of all neutral Powers when they see your conduct and reflect that some day you will attack them? Will not your action strengthen your existing opponents, and induce those who would otherwise never be your enemies to become so against their will?

Athenians: No. The mainland states, secure in their freedom, will be slow to take defensive measures against us, and we do not consider them so formidable as independent island powers like yourselves, or subjects already smarting under our yoke. These are most likely to take a thoughtless step and bring themselves and us into obvious danger.

Melians: Surely, then, if you are ready to risk so much to maintain your empire, and the enslaved peoples so much to escape from it, it would be criminal cowardice in us, who are still free, not to take any and every measure before submitting to slavery?

Athenians: No, if you reflect calmly: for this is not a competition in heroism between equals, where your honor is at stake, but a question of self-preservation to save you from a struggle with a far stronger Power.

Melians: Still, we know that in war fortune is more impartial than the disproportion in numbers might lead one to expect. If we submit at once, our position is desperate; if we fight, there is still a hope that we shall stand secure.

Athenians: Hope encourages men to take risks; men in a strong position may follow her without ruin, if not without loss. But when they stake all that they have to the last coin (for she is a spendthrift), she reveals her real self in the hour of failure, and when her nature is known she leaves them without means of self-protection. You are weak, your future hangs on a turn of the scales; avoid the mistake most men make, who might save themselves by human means, and then, when visible hopes desert them, in their extremity turn to the invisible—prophecies and oracles and all those things which delude men with hopes, to their destruction.

Melians: We too, you can be sure, realize the difficulty of struggling against your power and against Fortune if she is not impartial. Still we trust that Heaven will not allow us to be worsted by Fortune, for in this quarrel we are right and you are wrong. Besides, we expect the support of Sparta to supply the deficiencies in our strength, for she is bound to help us as her kinsmen, if for no other reason, and from a sense of honor. So our confidence is not entirely unreasonable.

Athenians: As for divine favor, we think that we can count on it as much as you, for neither our claims nor our actions are inconsistent with what men believe about Heaven or desire for themselves. We believe that Heaven, and we know that men, by a natural law, always rule where they are stronger. We did not make the law nor were we the first to act on it; we found it existing, and it will exist forever, after we are gone; and we know that you and anyone else as strong as we are would do as we do. As to your expectations from Sparta and your belief that she will help you from a sense of honor, we congratulate you on your innocence but we do not admire your folly. So far as they themselves and their natural traditions are concerned, the Spartans are a highly virtuous people; as for their behavior to others, much might be said, but we can put it shortly by saying that, most obviously of all people we know, they identify their interests with justice and the pleasantest course with honor. Such principles do not favor your present irrational hopes of deliverance.

Melians: That is the chief reason why we have confidence in them now; in their own interest they will not wish to betray their own colonists and so help their enemies and destroy the confidence that their friends in Greece feel in them.

> "Apparently you do not realize that safety and self-interest go together, while the path of justice and honor is dangerous."
> —The Athenians

Athenians: Apparently you do not realize that safety and self-interest go together, while the path of justice and honor is dangerous; and danger is a risk which the Spartans are little inclined to run. . . . Here experience may teach you like others, and you will learn that Athens has never abandoned a siege from fear of another foe. You said that you proposed to discuss the safety of your city, but we observe that in all your speeches you have never said a word on which any reasonable expectation of it could be founded. Your strength lies in deferred hopes; in comparison with the forces now arrayed against you, your resources are too small for any hope of success. You will show a great want of judgment if you do not come to a more reasonable decision after we have withdrawn. Surely you will not fall back on the idea of honor, which has been the ruin of so many when danger and disgrace were staring them in the face. How often, when men have seen the fate to which they were tending, have they been enslaved by a phrase and drawn by the power of this seductive word to fall of their own free will into irreparable disaster, bringing on themselves by their folly a greater dishonor than fortune could inflict! If you are wise, you will avoid that fate. The greatest of cities makes you a fair offer, to keep your own land and become her tributary ally: there is not dishonor in that. The choice between war and safety is given you; do not obstinately take the worse alternative. The most successful people are those who stand up to their equals, behave properly to their superiors, and treat their inferiors fairly. Think it over when we withdraw, and reflect once again that you will have only one country, and that its prosperity or ruin depends on one decision.

The Athenians then withdrew from the conference; and the Melians, left to themselves, came to a decision corresponding with what they had maintained in the discussion, and answered, Our resolution, Athenians, is unaltered. We will not in a moment deprive of freedom a city by which the gods have preserved it until now, and in the help of men, that is, of the Spartans; and so we will try and save ourselves. Meanwhile we invite you to allow us to be friends to you and foes to neither

party, and to retire from our country after making such a treaty as shall seem fit to us both.

Such was the answer of the Melians. The Athenians broke up the conference saying, To judge from your decision, you are unique in regarding the future as more certain than the present and in allowing your wishes to convert the unseen into reality; and as you have staked most on, and trusted most in, the Spartans, your fortune, and your hopes, so will you be most completely deceived.

The Athenian envoys now returned to the army, and as the Melians showed no signs of yielding the generals at once began hostilities, and drew a line of circumvallation round the Melians . . . besieged the place. . . .

Summer was now over . . . and the siege was now pressed vigorously; there was some treachery in the town, and the Melians surrendered at discretion to the Athenians, who put to death all the grown men whom they took, and sold the women and children for slaves. . . .

Consider This:

- In "The Melian Dialogue," what is the basic argument of the Athenians? of the Melians? Choose the most effective phrases from this source and explain why they are important and what they reveal about the nature of power and democracy. Is Thucydides a moralist? What is his view of human nature?

- Do you think it is possible for a democracy to rule an empire, or is this a moral contradiction? Can you apply this question to the United States in a contemporary setting?

Theme: Women in History and the Humanities

The Reflection in the Mirror

HUBRIS: THE CONCEIT OF POWER

The Trojan Women (415 B.C.E.)

EURIPIDES

One year after the destruction of Melos, the great Athenian dramatist Euripides reacted to the incident by composing The Trojan Women. *The subject of his play is the fate of the women of Troy after their husbands had been killed and their city destroyed by the Greek force in 1230 B.C.E. In the following passage, Andromache, widow of the valiant Trojan leader Hector, is informed of the fate proscribed for her young son. Note how her argument parallels that of "The Melian Dialogue."* The Trojan Women *failed to win a prize in the dramatic competition that year.*

Keep in Mind:

• What are the dominant themes in *The Trojan Women*?

Talthybius: Andromache, widow of the bravest of the Trojans: do not hate me. It is with great reluctance that I have to convey to you the decision unanimously reached by the Greeks and their two generals, the sons of Pelops.

Andromache: What is this? Your words hint at the worst.

Talthybius: It was decided that your son—how can I say it?

Andromache: He is to have a different master from mine?

Talthybius: No Greek will ever be his master.

Andromache: What? Is he to be the one Trojan left behind in Troy?

Talthybius: My news is bad. It is hard to find words.

Andromache: Thank you for your sympathy. What have you to say?

Talthybius: You must know the worst: they mean to kill your son.

Andromache: Oh, gods! His sentence is worse than mine.

Talthybius: In a speech delivered before the whole assembly Odysseus carried his point—
Andromache [sobbing passionately]: Oh, Oh! This is more than I can bear.

Talthybius: —that the son of so distinguished a father must not be allowed to attain manhood—

Andromache: May he hear the same sentence passed on his own son!

Talthybius: —but should be thrown down from the battlements of Troy. Now show yourself a sensible woman, and accept this decision. Don't cling to him, or imagine you have any chance of resisting: you have none. Bear what must be like a queen. There is no one who can help. You can see for yourself: your city and your husband are gone; you are in our hands. Shall we match our strength against one woman? We can. So I hope that you won't feel inclined to struggle, or to call down curses on the Greeks, or do anything that might lead to violent measures or resentment. If you say anything to anger the army, this child will die without rites of pity, without burial. If you are quiet, and accept the inevitable in a proper spirit, you will be allowed to lay your child in his grave, and you will find the Greeks more considerate to yourself.

> "Are you crying, little one? Do you understand? . . . No Hector will rise from the grave and step forth to save you. . . .
>
> —Andromache

Andromache: Darling child, precious beyond all price! You will die, killed by our enemies, leaving your mother to mourn. Your noble father's courage, which saved others, has condemned you; his spirit was a fatal inheritance. I thought, on that day when I entered Hector's house as a bride, on that ill-fated night, that my son would rule the teeming multitudes of the East—not die by a Greek ritual of murder.

Are you crying, little one? Do you understand? Why do you tug my hand, cling to my dress, nestling like a bird under its mother's wing? No Hector will rise from the grave and step forth to save you, gripping his glorious spear; none of your father's brothers, no army of Phrygians. You must leap from that horrible height, and fall, and break your neck, and give up your life, and be pitied by no one.

My baby, so young in my arms, and so dear! O the sweet smell of your skin! When you were newly born, how I wrapped you up and gave you my breast, and tended you day and night, and was worn out with weariness—all for nothing, for nothing! Now say good-bye to me for the last time; come close to your mother, wind your arms round my neck, and put your lips to mine.

O men of Hellas, inventors of cruelty unworthy of you! Why will you kill him? What has he done?—Helen, child of Hyndareus, you are no daughter of divine Majesty! You had many fathers, and I can name them: the Avenging Curse was one, Hate was the next, then Murder and Death and every evil that lives on earth! I will swear that Zeus never fathered you to ruin men's lives by tens of thousands through Asia and Hellas! My curse on you! With the shining glance of your beauty you have brought this rich and noble country to a shameful end.

Take him! Carry him away, throw him down, if your edict says 'Throw!' Feast on his flesh! God is destroying us! I have no power to save my child from death. Hide my miserable body, throw me on board! I go to my princely marriage, and leave behind me my dear child.

Consider This:
- In what ways does this excerpt from *The Trojan Women* by Euripides parallel the arguments of "The Melian Dialogue"?

- Why is this passage so impressive? What was Euripides trying to say about power and innocence? What does the mere production of a play critical of Athenian foreign policy say about the nature of freedom in Athens? Why do you think the play failed to win a prize that year in the competition?

The Broader Perspective:

- The Greeks believed that hubris, or the conceit of violating the limits of human action imposed by the gods, would always be punished. Eleven years after the production of this play, Athens lost the Peloponnesian War, was deprived of its empire, and lost its cultural dominance. Was this defeat retribution for the Athenian conceit of power? Had divine justice delivered the punishment for Athenian hubris?

Women and War: *Lysistrata* (411 B.C.E.)
ARISTOPHANES

Athens not only produced great tragedians such as Sophocles and Euripides but also great comic dramatists as well. The brilliant playwright Aristophanes poked fun at the major personalities of the day (Socrates included) and influenced public opinion about the most divisive political issues. Aristophanes was born about 447 B.C.E. at a time when Athens was at the height of her power and influence. He was often critical of the democracy and especially the prosecution of the Peloponnesian War. After the tragic destruction of Athenian forces at Syracuse in 413 B.C.E., and the impotent leadership in the years that followed, Aristophanes contrived his own solution for the end of the war, which he presented in 411 B.C.E. in the play Lysistrata: *The women of both Sparta and Athens would take the initiative in stopping the war by withholding sex while their husbands were on leave until the men came to their senses!*

Of special note here is the presentation of women in Athenian society. Although it is debated whether women were allowed to attend the theater (Plato gives evidence that they did), in other ways their lives were extremely restricted. They were not allowed to leave their homes unescorted, could not vote, hold public office, own property, or even attend social gatherings in their own homes. They were essentially bound to the will and decisions of their husbands or fathers. Perhaps the biggest joke in Athens after the presentation of Lysistrata *was that women could have conceived and organized such a bold and effective plan for ending the Peloponnesian War. In this scene, the leader of the Athenian women, Lysistrata, and her compatriot, Stratyllis, confront the male Athenian leadership.*

Magistrate: Anyway, what business are war and peace of yours?

Lysistrata: I'll tell you.

Magistrate [restraining himself with difficulty]:— You'd better or else.

Lysistrata: I will if you'll listen and keep those hands of yours under control.

Magistrate: I can't—I'm too livid. . . . Say what you have to say.

Lysistrata: In the last war we were too modest to object to anything you men did—and in any case you wouldn't let us say a word. But don't think we approved! We knew everything that was going on.

"Women and War: Lysistrata" is from Aristophanes, *Lysistrata and Other Plays*, trans. Alan H. Sommerstein (New York and Harmondsworth, Middlesex: Penguin Classics, 1973), pp. 200–202, 206–208. Copyright © 1973 by Alan H. Sommerstein. Reproduced by permission of Penguin Books, Ltd.

Many times we'd hear at home about some major blunder of yours, and then when you came home we'd be burning inside but we'd have to put on a smile and ask what it was you'd decided to inscribe in the pillar underneath the Peace Treaty. And what did my husband always say?—'Shut up and mind your own business!' And I did.

Stratyllis: I wouldn't have done!

Magistrate: He'd have given you one if you hadn't.

Lysistrata: Exactly—so I kept quiet. But sure enough, next thing we knew you'd make an even sillier decision. And if I so much as said, 'Darling, why are you carrying on with this silly policy?' he would glare at me and say, 'Back to your weaving, woman, or you'll have a headache for a month. Go and attend to your work; let war be the care of the menfolk.'

Magistrate: Quite right too, by Zeus.

Lysistrata: Right? That we should not be allowed to make the least little suggestion to you, no matter how much you mismanage the City's affairs? And now, look, every time two people meet in the street, what do they say? 'Isn't there a man in the country?' and the answer comes, 'Not one.' That's why we women got together and decided we were going to save Greece. What was the point of waiting any longer, we asked ourselves. Well now, we'll make a deal. You listen to us—and we'll talk sense, not like you used to—listen to us and keep quiet, as we've had to do up to now, and we'll clear up the mess you've made.

Magistrate: Insufferable effrontery! I will not stand for it!

Lysistrata [magisterially]: Silence!

Magistrate: You, confound you, a woman with your face veiled, dare to order me to be silent! Gods, let me die! . . .

Leader: Disgraceful!—women venturing to prate
In public so about affairs of State!
They even (men could not be so naive)
The blandishments of Sparta's wolves believe!
The truth the veriest child could surely see:
This is a Monarchist Conspiracy.
I'll fight autocracy until the end:
My freedom I'll unswervingly defend. . . .
And from this place
I'll give this female one upon the face!

[He slaps Stratyllis hard on the cheek.]

Stratyllis [giving him a blow in return that sends him reeling]:
Don't trifle with us, rascals, or we'll show you
Such fisticuffs, your mothers will not know you!

Chorus of Women: My debt of love today
To the City I will pay,
And I'll pay it in the form of good advice;
For the City gave me honour
(Pallas blessing be upon her!),
And the things I've had from her deserve their price. . . .

Stratyllis: See why I think I have a debt to pay?
'But women can't talk politics,' you say.
Why not? What is it you insinuate?
That we contribute nothing to the State?
Why, we give more than you! See if I lie:
We cause men to be born, you make them die.
What's more, you've squandered all the gains of old;
And now, the taxes you yourselves assess
You do not pay. Who's got us in this mess?
Do you complain? Another grunt from you,
And you will feel the impact of this shoe! . . .

Leader: If once we let these women get the semblance of a start,
Before we know, they'll be adept at every manly art!

Consider This:

- What can you discern from Aristophanes's *Lysistrata* about the treatment of women in Greek society? Note how critical the women are about how the war has been conducted. What was Aristophanes trying to do—criticize the state, or make light of the impotent status of women? Do you regard satire as a legitimate vehicle for reform?

The Trial of Socrates (399 B.C.E.)
PLATO

The Peloponnesian War came to an end in 404 B.C.E. The Athenians suffered a humiliating defeat and were divested of their empire, military forces, and dignity. A Spartan occupation force assumed control of the city and replaced Athenian democracy with the reactionary rule of the Thirty Tyrants, vindictive Athenian citizens who used the months from 404 to 403 B.C.E. to settle scores with their former political enemies. Although a democracy was reinstituted, it no longer espoused the tolerance of ideas and freedom of speech which had been such a part of former Athenian glory. A true indicator of this decline was the trial of Socrates.

Socrates, a stonecutter by trade, had dutifully served the Athenian state in a political capacity and also as a soldier in war. He disliked the advances of popular teachers called "sophists" who claimed to be able to teach anything for a fee. Socrates instead claimed that he knew nothing and set about informally teaching people to question in the hope of finding wisdom. He considered himself the gadfly whose responsibility it was to prod the democracy continually in hopes that self-reflection might produce wise policy. His "services" were free of charge, and he became quite influential among the youth of Athens. In 399 B.C.E. he was accused by various Athenian leaders of not believing in the gods of the state and of corrupting the youth. His most famous pupil, Plato, watched the proceedings in the court and wrote an account of Socrates's defense, called the Apology; *an excerpt is presented below. In the end, Socrates was condemned to death and actually insisted on drinking the poisonous hemlock. In his martyrdom lay the destruction of Athenian ideals.*

"The Trial of Socrates" is from Plato, *Apology*, in *The Dialogues of Plato*, 3rd ed., trans. Benjamin Jowett (Oxford: The Clarendon Press, 1875). Translation modernized by the editor.

This inquisition has led to my having many enemies of the worst and most dangerous kind, and has given occasion also to many injuries. . . .

There is another thing: young men of the richer classes, who have not much to do, come about me of their own accord; they like to hear the pretenders examined, and they often imitate me, and proceed to examine others; there are plenty of persons, as they quickly discover, who think they know something, but really know little or nothing; and then those who are examined by them instead of being angry with themselves are angry with me: This confounded Socrates, they say; this villainous misleader of youth!—and then if somebody asks them, Why, what evil does he practice or teach? they do not know, and cannot tell; but in order that they may not appear to be at a loss, they repeat the ready-made charges which are used against all philosophers about teaching things up in the clouds and under the earth, and having no gods, and making the worse appear the better cause; for they do not like to confess that their pretense of knowledge has been detected—which is the truth: and as they are numerous and ambitious and energetic, and are drawn up in battle array and have persuasive tongues, they have filled your ears with their loud and inveterate slanders. And this is the reason why my three accusers, Meletus and Anytus and Lycon, have set upon me. . . .

Some one will say: And are you not ashamed, Socrates, of a course of life which is likely to bring you to an untimely end? To him I may fairly answer: There you are mistaken: a man who is good for anything ought not to calculate the chance of living or dying; he ought only to consider whether in doing anything he is doing right or wrong—acting the part of a good man or of a bad. . . . And therefore if you let me go now, . . . if you say to me, Socrates, this time we will not mind Anytus, and you shall be let off, but upon one condition, that you are not to enquire and speculate in this way any more, and that if you are caught doing so again you shall die; if this was the condition on which you let me go, I should reply: Men of Athens, I honor and love you; but I shall obey God rather than you, and while I have life and strength I shall never cease from the practice and teaching of philosophy, exhorting anyone whom I meet and saying to him after my manner: You, my friend—a citizen of the great and mighty and wise city of Athens—are you not ashamed of heaping up the greatest amount of money and honor and reputation, and caring so

> "Men of Athens, I honor and love you; but I shall obey God rather than you, and while I have life and strength I shall never cease from the practice and teaching of philosophy."
> —Socrates

little about wisdom and truth and the greatest improvements of the soul, which you never regard or heed at all? And if the person with whom I am arguing, says: Yes, but I do care; then I do not leave him or let him go at once; but I proceed to interrogate and examine and cross-examine him, and if I think that he has no virtue in him, but only says that he has, I reproach him with undervaluing the greater, and overvaluing the less. . . . This is my teaching, and if this is the doctrine which corrupts youth, I am a mischievous person. . . .

And now, Athenians, I am not going to argue for my own sake, as you may think, but for yours, that you may not sin against God by condemning me, who am his gift to you. For if you kill me you will not easily find a successor to me, who, if I may use such a ludicrous figure of speech, am a sort of gadfly, given to the state by God; and the state is a great and noble steed who is tardy in his motions owing to his very size, and requires to be stirred into life. I am that gadfly which God has attached to the state, and all day long and in all places am always fastening upon you, arousing and persuading and reproaching you. You will not easily find another like me, and therefore I would advise you to spare me. I dare say that you may feel out of temper (like a person who is suddenly awakened from sleep), and you think that you might easily strike me dead as Anytus advises, and then you would sleep on for the remainder of your lives, unless God in his care of you sent you another gadfly. . . .

And now, O men who have condemned me, I would give prophecy to you; for I am about to

die, and in the hour of death men are gifted with prophetic power. And I prophecy to you who are my murderers, that immediately after my departure punishment far heavier than you have inflicted on me will surely await you. Me you have killed because you wanted to escape the accuser, and not to give an account of your lives. But that will not be as you suppose: far otherwise. For I say that there will be more accusers of you than there are now; accusers whom hitherto I have restrained: and as they are younger they will be more inconsiderate with you, and you will be more offended at them. If you think that by killing me you can prevent someone from censuring your evil lives, you are mistaken; that is not a way of escape which is either possible or honorable; the easiest and noblest way is not to be disabling others,

but to be improving yourselves. This is the prophecy which I utter before my departure to the judges who have condemned me. . . .

Still I have a favor to ask of them. When my sons are grown up, I would ask you, O my friends, to punish them; and I would have you trouble them, as I have troubled you if they seem to care about riches, or anything, more than about virtue; or if they pretend to be something when they are really nothing—then reprove them, as I have reproved you, for not caring about that for which they ought to care, and thinking that they are something when they are really nothing. And if you do this, both I and my sons will have received justice at your hands.

The hour of departure has arrived, and we go on our ways—I to die, and you to live. Which is better God only knows.

Consider This:
- How is Socrates critical of the Athenian leaders in his *Apology*? What does he say in particular about freedom and virtue? Why is the condemnation of Socrates symbolic of the failure of Athenian civilization?

Fourth-Century Greece and the Hellenistic Age

The Philosophy of Plato

Plato was one of the greatest philosophers in Western Civilization. His influence has been so decisive that one scholar remarked that all subsequent thought is but a series of footnotes to Plato. He was a student of Socrates and shared his view that universal truths exist and can be discovered. Plato went further by developing a system called the "Theory of Ideas," which defies simple explanation but rather requires a kind of immersion in thought to understand its tenets. Plato's doctrine is founded on the belief that there are two worlds, one we can readily see and experience with our senses, and the other unseen and eternal. All objects in the sensory world are imperfect and transitory; the only true and perfect things, the eternal Ideas, exist in the abstract realm. Man's task in life is to struggle toward the ideal realm, the world of thought and spirit, by pursuing reason and logic. In this way, Plato hoped to address the concerns of his day. For Plato, democracy had failed, misdirecting society into constant turmoil, war, doubt, and depression. He saw a need to look to a higher ideal, a realm that was secure and offered answers and organization in a chaotic world. As Plato noted in his work The Republic, *"Until philosophers are kings or the kings and rulers of this world have the spirit of philosophy, until political power and wisdom are united . . . states will never have rest from their evils, nor . . . will the human race."*

The following passage from The Republic *explains Plato's Theory of Ideas. In the "Allegory of the Cave," he stresses the need to move away from the "shadows," which exist in the everyday realm of the senses, into the world of eternal truth and spiritual reality. Notice that Plato also believes that those who see the light, move toward it, and are thus freed from the captivity of the shadows, need to return in order to enlighten others; this is how civilization will progress.*

Allegory of the Cave
PLATO

Behold! human beings living in an underground den, which has a mouth open toward the light and reaching all along the den; here they have been from their childhood, and have their legs and necks chained so that they cannot move, and can only see before them, being prevented by the chains from turning round their heads. Above and behind them a fire is blazing at a distance, and between the fire and the prisoners there is a raised way; and you will see, if you look, a low wall built along the way, like the screen which marionette players have in front of them, over which they show the puppets. And do you see men passing along the wall carrying all sorts of vessels, and statues and figures of animals made of wood and stone and various materials, which appear over the wall? Some of them are talking, others silent.

You have shown me a strange image, and they are strange prisoners.

Like ourselves, I replied; and they see only their own shadows, or the shadows of one another, which the fire throws on the opposite wall of the cave?

True, he said; how could they see anything but the shadows if they were never allowed to move their heads?

And of the objects which are being carried in like manner they would only see the shadows. And if they were able to converse with one another, would they not suppose that they were naming what was actually before them?

Very true.

And suppose further that the prison had an echo which came from the other side, would they not be sure to notice when one of the passersby spoke that the voice which they heard came from the passing shadows? To them the truth would be literally nothing but the shadows of the images.

And now look again, and see what will naturally follow if the prisoners are released and exonerated of their error. At first, when any of them is liberated and compelled suddenly to stand up and turn his neck around and walk and look toward the light, he will suffer sharp pains; the glare will distress him, and he will be unable to see the realities of which in his former state he had seen the shadows; and then conceive someone saying to him, that what he saw before was an illusion, but that now, when he is approaching nearer to being and his eye is turned toward more real existence, he has a clearer vision—what will be his reply? And you may further imagine that his instructor is pointing to the objects as they pass and requiring him to name them—will he not be perplexed? Will he not think that the shadows which he formerly saw are truer than the objects which are now shown him?

And if he is compelled to look straight at the light, will he not have a pain in his eyes which will make him turn away to take refuge in the objects of vision which he can see, and which he will conceive to be in reality clearer than the things which are now being shown to him? And suppose once more, that he is reluctantly dragged up a steep and rugged ascent, and held fast until he is forced into the presence of the sun himself, is he not likely to be pained and irritated? When he approaches the light his eyes will be dazzled, and he will not be able to see anything at all of what are now called realities. He will require to grow accustomed to the sight of the upper world. And first he will see the shadows best, next the reflection of men and other objects in the water, and then the objects themselves; then he will gaze upon the light of the moon and the stars and the spangled heaven; and he will see the sky and the stars by night better than the sun or the light of the sun by day. Last of all he will be able to see the sun, and not mere reflections of him in the water, but he will see him in his own proper place, and not in another; and he will contemplate him as he is. He will then proceed to argue that this is he who gives the seasons and the years, and is the guardian of all that is in the visible world, and in a certain way the cause of all things which he and his fellows have accustomed to behold.

And when he remembered his old habitation, and the wisdom of the den and his fellow prisoners, do you not suppose that he would be happy about the change, and pity them? And if

"Allegory of the Cave" is from Plato, *The Republic*, 7.514–7.521, in *The Dialogues of Plato*, vol. II, trans. Benjamin Jowett (Boston: The Aldine Publishing Company, 1911), pp. 265–274. Translation modernized by the editor.

they were in the habit of conferring honors among themselves on those who were quickest to observe the passing shadows and to remark which of them went before, and which followed after, and which were together; and who were therefore best able to draw conclusions as to the future, do you think that he would care for such honors and glories or envy the possessors of them? Would he not say with Homer, "Better to be the poor servant of a poor master," and to endure anything, rather than think as they do and live after their manner?

> "In the world of knowledge the idea of good appears last of all, and is seen only with an effort. . . ."
> —Socrates

Imagine once more such a one coming suddenly out of the sun to be replaced in his old situation; would he not be certain to have his eyes full of darkness? And if there were a contest, and he had to compete in measuring the shadows with the prisoners who had never moved out of the den, while his sight was still weak, and before his eyes had become steady (and the time which he needed to acquire this new habit of sight might be very considerable), would he not be ridiculous? Men would say of him that up he went and down he came without his eyes; and that it was better not even to think of ascending; and if anyone tried to loose another and lead him up to the light, let them only catch the offender, and they would put him to death.

This entire allegory, you may now append, dear Glaucon, to the previous argument; the prison-house is the world of sight, the light of the fire is the sun, and you will not misunderstand me if you interpret the journey upwards to be the ascent of the soul into the intellectual world according to my poor belief, which, at your desire, I have expressed—whether rightly or wrongly God knows. But, whether true or false, my opinion is that in the world of knowledge the idea of good appears last of all, and is seen only with an effort: and, when seen, is also inferred to the universal author of all things beautiful and right, parent of light, and of the

lord of light in this visible world, and the immediate source of reason and truth in the intellectual; and that this is the power upon which he who would act rationally either in public or private life must have his eye fixed.

I agree, he said, as far as I am able to understand you.

Moreover, you must not wonder that those who attain to this beatific vision are unwilling to descend to human affairs; for their souls are ever hastening into the upper world where they desire to dwell; which desire of theirs is very natural, if our allegory may be trusted.

Yes, very natural. . . .

Then the business of us who are the founder of the State will be to compel the best minds to attain that knowledge which has been already declared by us to be the greatest of all—they must continue to ascend until they arrive at the good; but when they have ascended and seen enough we must not allow them to do as they do now.

What do you mean?

I mean that they remain in the upper world: but this must not be allowed; they must be made to descend again among the prisoners in the den, and partake of their labors and honors, whether they are worth having or not.

But is not this unjust? he said; ought we to give them an inferior life, when they might have a superior one?

You have forgotten, my friend, the intention of the legislator, who did not aim at making any one class in the State happy above the rest; the happiness was to be in the whole State, and he held the citizens together by persuasion and necessity, making them benefactors of the State, and therefore benefactors of one another; to this end he created them, not that they should please themselves, but they were to be his instruments in binding up the State.

True, he said, I had forgotten.

Observe, Glaucon, that there will be no injustice in compelling our philosophers to have a care and providence of others; we shall explain to them that in other States, men of their class are not obliged to share in the toils of politics: and this is reasonable, for they grow up at their own sweet will, and the government would rather not have them. Now the wild plant which owes culture to nobody, has nothing to pay for culture. But we have brought you into the world to be rulers of the hive, kings of yourselves and

of the other citizens, and have educated you far better and more perfectly than they have been educated, and you are better able to share in the double duty. Wherefore each of you, when his turn comes, must go down to the general underground abode, and get the habit of seeing in the dark; for all is habit; and by accustoming yourselves you will see ten thousand times better than the dwellers in the den, and you will know what the images are, and of what they are images, because you have seen the beautiful and just and good in their truth. And thus the order of our State, and of yours, will be a reality, and not a dream only, as the order of States too often is, for in most of them men are fighting with one another about shadows and are distracted in the struggle for power, which in their eyes is a great good. Whereas the truth is that the State in which the rulers are most reluctant to govern is best and most quietly governed, and the State in which they are most willing, the worst.

Quite true, he replied.

And will our pupils, when they hear this, refuse to share in turn the toils of State, when they are allowed to spend the greater part of their time with one another in the heaven of ideas? Impossible, he answered; for they are just men, and the commands which we impose upon them are just; there can be no doubt that every one of them will take office as a stern necessity, and not like our present ministers of State.

Yes, my friend, and there lies the point. You must contrive for your future rulers another and a better life than that of a ruler, and then you may have a well-ordered State; for only in the State which offers this, will they rule who are truly rich, not in silver and gold, but in virtue and wisdom, which are the true blessings of life. Whereas if they go to the administration of public affairs, poor and hungering after their own private advantage, thinking that hence they are to snatch the good of life, order there can never be; for they will be fighting about office, and the civil and domestic broils which thus arise will be the ruin of the rulers themselves and of the whole State.

Most true, he replied.

Consider This:

- In Plato's "Allegory of the Cave," how do you interpret the fire, shadows, and prisoners? How does Plato express his Theory of Ideas in this allegory?

The Thought of Aristotle

Aristotle (384–322 B.C.E.) was another of the great philosophers of this era who would greatly influence thinkers in the Middle Ages. A student of Plato and tutor to Alexander the Great, Aristotle believed that ideal forms and truths existed but were not found in some abstract world apart from everyday life. In fact, one could discover Truth by observing sensory objects and then logically (through the process of induction) discerning their universal characteristics. Thus Aristotle was very practical and believed that all theories must be abandoned if they could not be observed to be true. Aristotle wrote widely on politics and ethics and is very contemporary in application. Note how many of the following ideas can be applied to our own world.

On Education

ARISTOTLE

No one will doubt that a lawgiver should direct his attention above all to the education of youth, or that the neglect of education does harm to states. The citizen should be molded to suit the form of government under which he lives. For each government has a peculiar character, which originally formed and which continues to preserve it. The character of democracy

"On Education" is from Aristotle, *Politics*, 8.1–8.3, in *The Politics of Aristotle*, trans. Benjamin Jowett (Oxford: Oxford University Press, 1905), pp. 300–303.

creates democracy, and the character of oligarchy creates oligarchy. The better the character, always the better the government.

> "For each government has a peculiar character. . . . The better the character, always the better the government."
> —Aristotle

Now for the exercise of any faculty or art a previous training and practice are required; clearly they are required for the exercise of virtue. And since the entire state has one end, manifestly education should be one and the same for all, and should be public and not private. It should not be as at present, when everyone looks after his own children separately, and gives them separate instruction of the sort he thinks best. The training in things of common interest should be the same for all. Neither must we suppose that any one of the citizens belongs to himself, for they all belong to the state, and are each of them a part of the state, and the care of each part is inseparable from the care of the whole. In this particular the Spartans are to be praised, for they take the greatest pains about their children, and make education the business of the state.

That education should be regulated by law and should be an affair of state is not to be denied; but what should be the character of this public education, and how young persons should be educated, are questions yet to be considered. For men are by no means agreed about the things to be taught, whether we aim at virtue or the best life. Neither is it clear whether education should be more concerned with intellectual or with moral virtue. Existing practice is perplexing; no one knows on what principle we should proceed. Should the useful in life, or should virtue, or should higher knowledge, be the aim of our training? All three opinions have been entertained. Again, about method there is no agreement; for different persons, starting with different ideas about the nature of virtue, naturally disagree about the practice of it.

Undoubtedly children should be taught those useful things that are really necessary, but not all useful things. For occupations are divided into liberal and illiberal, and to young children should be imparted only such kinds of knowledge as will be useful to them without vulgarizing them. Any occupation, art, or science, which makes the body or soul or mind of the free man less fit for the practice or exercise of virtue, is vulgar. Therefore we call those arts vulgar which tend to deform the body, and likewise all paid employments; they absorb and degrade the mind. . . .

The customary branches of an education are four, namely, (1) reading and writing, (2) gymnastic exercises, (3) music, to which is sometimes added (4) drawing. Of these, reading, writing, and drawing are regarded as useful for the purposes of life in a variety of ways, and gymnastic exercises are thought to infuse courage. As to music a question may be raised. In our own day most men cultivate it for pleasure, but originally it was included in education because nature herself, as has been often said, requires that we should be able, not only to work well, but to use our leisure well. For, as I must repeat once again, the prime end of all action is leisure. Both are necessary, but leisure is better than labor.

Hence now the question must be asked in good earnest, what ought we to do when at leisure? Clearly we ought not to be always amusing ourselves, for then amusement would be the end of life. . . .

Apparently then there are branches of learning and education which we should study solely with a view to the employment of leisure, and these are to be valued for their own sake; whereas the kinds of knowledge which are useful in business are necessary, and exist for the sake of other things. Therefore our fathers admitted music into education, not on the ground of either its necessity or its utility; for it is not necessary, nor even useful in the same way that reading and writing are useful in wealth getting, in the management of a household, in the acquisition of knowledge, and in political life. Nor is it, like drawing, useful for a more correct judgment of the works of artists, nor again, like gymnastics, does it give health and strength, for neither of these is to be gained from music. There is, however, a use of music for intellectual

enjoyment in leisure, which seems indeed to have been the reason of its introduction into education. For music is one of the ways in which, it is thought, a freeman might pass his leisure. . . .

Evidently, then, there is a sort of education in which parents should train their sons, not because it is useful or necessary, but because it is liberal or noble.

Virtue and Moderation: The Doctrine of the Mean
ARISTOTLE

Aristotle's principle concern in his Ethics *is moral virtue, which might best be described as "good character." One obtains a good character by continually doing right acts until they become second nature. In defining "right action," Aristotle offers his Doctrine of the Mean, which serves as a guide toward achieving moral virtue and happiness. Right acts are those that lie between two extremes: courage, therefore, is the mean between the extremes of cowardice and rashness. Aristotle explains this in the following passage.*

It is not sufficient, however, merely to define virtue in general terms as a characteristic: we must also specify what kind of characteristic it is. It must, then, be remarked that every virtue or excellence (1) renders good the thing itself of which it is the excellence, and (2) causes it to perform its function well. For example, the excellence of the eye makes both the eye and its function good, for good sight is due to the excellence of the eye. Likewise, the excellence of a horse makes it both good as a horse and good at running, at carrying its rider, and at facing the enemy. Now, if this is true of all things, the virtue or excellence of man, too, will be characteristic which makes him a good man, and which causes him to perform his own function well. . . .

Of every continuous entity that is divisible into parts it is possible to take the larger, smaller, or equal either in relation to the entity itself, or in relation to us. The "equal" part is something median between excess and deficiency. By the median of an entity I understand a point equidistant from both extremes, and this point is one and the same for everybody. By the median relative to us I understand an amount neither too large nor too small, and this is neither one nor the same for everybody. To take an example . . . if ten pounds of food is much for a man to eat and two pounds little, it does not follow that the trainer will prescribe six pounds, for this may in turn be much or little for him to eat; it may be little for Mile [the wrestler] and much for someone who has just begun to take up athletics. The same applies to running and wrestling. Thus we see that an expert in any field avoids excess and deficiency, but seeks the median and chooses it—not the median of the object but the median relative to us.

If this, then, is the way in which every science perfects its work, by looking to the median and by bringing its work up to that point—and this is the reason why it is usually said of a successful piece of work that it is impossible to detract from it or to add to it, the implication being that excess and deficiency destroy success while the mean safeguards it (good craftsmen, we say, look toward this standard in the performance of their work)—and if virtue, like nature, is more precise and better than any art, we must conclude that virtue aims at the median. I am referring to moral virtue: for it is moral virtue that is concerned with emotions and actions, and it is in emotions and actions that excess, deficiency, and the median are found. Thus we can experience fear, confidence, desire, anger, pity, and generally any kind of pleasure and pain either too much or too little, and in either case not properly. But to experience all this at the right time, toward the right objects, toward the right people, for the right reason, and in the right manner—that is the median and the best course, the course that is a mark of virtue.

Similarly, excess, deficiency, and the median can also be found in actions. Now virtue is concerned with emotions and actions; and in emotions and actions excess and

"Virtue and Moderation: The Doctrine of the Mean" is from Aristotle, *Ethics*, 2.6. Reprinted with permission of Macmillan Publishing Company from Aristotle, *Nichomachean Ethics*, pp. 41–44, trans. Martin Oswald. Copyright © 1962 by Macmillan Publishing Company.

deficiency miss the mark, whereas the median is praised and constitutes success. . . .

We may thus conclude that virtue or excellence is a characteristic involving choice, and that it consists in observing the mean relative to us, a mean which is defined by a rational principle, such as a man of practical wisdom would use to determine it. It is the mean by reference to two vices: the one of excess and the other of deficiency. It is, moreover, a mean because some vices exceed and the others fall short of what is required in emotion and in action, whereas virtue finds and chooses the median.

Consider This:

- How does Aristotle's philosophy differ from that of Plato? Do you agree with his assessment of education? Define the "Doctrine of the Mean." Why is Aristotle called a "practical philosopher"?

The Cultural Intersection

CHINA: 350 B.C.E.

The Basis of Humane Government

MENCIUS

The most influential advocate of the ideas of the great Chinese philosopher, Confucius, was Mencius (372–289 B.C.E.?). In many ways, his career was similar to that of Confucius in that he became a professional teacher during a period of political disintegration in which his ideas of virtue and humanism went unheeded by the rulers of the day. Although Mencius' teaching derived from Confucius, he articulated a new stance on the topic of human nature. While Confucius implied that human nature is good, Mencius declared that humans were **originally** *good and that they have an* **innate** *knowledge of good and an innate ability to develop the mind and fulfill their destiny by doing good in the world.*

Mencius believed that political leaders should be guided by humanity and righteousness without a thought to utility, political advantage, or economic profit. In fact, he was the first to use the term "humane government." Since moral power was inherent in everyone's nature, each individual is complete in himself and equal to everyone else. Mencius argued that the ruler who neglects or oppresses his people is no true ruler and his subjects are absolved of their loyalty to him. This "right to revolution" was a novel and dangerous concept that caused Mencius' writings to be condemned by some rulers. But he remains the greatest advocate of political democracy in Chinese history.

Keep in Mind:
• How does Mencius define "virtue"?

Gao Zi said: "The nature of man may be likened to a swift current of water: you lead it eastward and it will flow to the east; you lead it westward and it will flow to the west. Human nature is neither disposed to good nor to evil, just as water is neither disposed to east nor west." Mencius replied: "It is true that water is neither disposed to east nor west, but is it neither disposed to flowing upward nor downward? The tendency of human nature to do good is like that of water to flow downward. There is no man who does not tend to do good; there is no water that does not flow downward. Now you may strike water and make it splash over your forehead, or you may even force it up the hills. But is this in the nature of water? It is of course due to the force of circumstances. Similarly, man may be brought to do evil, and that is because the same is done to his nature." . . .

The disciple Gongtu Zi said: "Gao Zi says that human nature is neither good nor bad. Some say that human nature can be turned to be good or bad. . . . Now, you say that human nature

"The Basis of Humane Government" is from William Theodore de Bary, ed., *Sources of Chinese Tradition* (New York: Columbia University Press, 1960), pp. 103–104; 107–108. Copyright © 1960 by Columbia University Press. Reprinted by permission.

is good. Are the others then all wrong? Mencius replied: When left to follow its natural feelings human nature will do good. This is why I say it is good. If it becomes evil, it is not the fault of man's original capability. The sense of mercy is found in all men; the sense of shame is found in all men; the sense of respect is found in all men; the sense of right and wrong is found in all men. The sense of mercy constitutes humanity; the sense of shame constitutes righteousness; the sense of respect constitutes decorum; the sense of right and wrong constitutes wisdom. Humanity, righteousness, decorum, and wisdom are not something instilled into us from without; they are inherent in our nature. Only we give them no thought. Therefore it is said: 'Seek and you will find them, neglect and you will lose them.' Some have these virtues to a much greater degree than others—twice, five times, and incalculably more—and that is because those others have not developed to the fullest extent their original capability. . . .

> "The people turn to a humane ruler as water flows downward or beasts take to wilderness."
>
> **—Mencius**

Mencius said: "When men are subdued by force, it is not that they submit from their hearts but only that their strength is unavailing. When men are won by virtue, then their hearts are gladdened and their submission is sincere. . . . States have been won by men without humanity, but the world, never."

Mencius said: "It was because Qin and Zhou [early Chinese dynasties] lost the people that they lost the empire, and it was because they lost the hearts of the people that they lost the people. Here is the way to win the empire: win the people and you win the empire. Here is the way to win the people: win their hearts and you win the people. Here is the way to win their hearts: give them and share with them what they like, and do not do to them what they do not like. The people turn to a humane ruler as water flows downward or beasts take to wilderness." . . .

[Mencius said to King Xuan]: "If your Majesty wishes to practice humane government, would it no be well to go back to the root of the matter? . . . Let attention be paid to teaching in schools and let the people be taught the principles of filial piety and brotherly respect, and white-headed old men will not be seen carrying loads on the road. When the aged wear silk and eat meat and the common people are free from hunger and cold, never has the lord of such a people failed to become king."

Compare and Contrast:

- Mencius and Aristotle lived during the same time in different cultures. Yet they were both concerned about the idea of virtue. How do their definitions of virtue differ? For Aristotle, what was the hallmark of virtue?

- Mencius argued that rulers lose their empires because they lose the hearts of their people. If a ruler can gain an empire without moral virtue, why is it impossible to maintain it without moral virtue? How would Aristotle's Doctrine of the Mean apply to a ruler who wanted to maintain power?

The Broader Perspective:

- Mencius believed that human beings were inherently good and that they could be gently taught to express their moral virtue in distinct acts of filial respect and piety. If this is true,

and a political leader demonstrates high moral character and expects the same from those around him in the general populace, will his rule be secure and progressive? Do despotic leaders fail to cultivate the good in their people and thus lose power?

- How do the most effective leaders in a democracy engage the citizenry in order to improve the state? Can you give examples of this? Or is political power inherently corrupt and simply an exercise in personal expediency? If so, does this mean that the general populace does not care about moral virtue?

Alexander the Great

One of the most fascinating and controversial figures of history was Alexander III of Macedon. After his father Philip's assassination in 336 B.C.E., Alexander was elected to the kingship and continued with his father's plans to invade and conquer Persia. His exploits became legendary and it is difficult to separate fact from fiction. The following selection recounts an early indication of Alexander's special abilities when he tamed a horse too wild for others to control.

"Carve Out A Kingdom Worthy of Yourself!"
PLUTARCH

Philonicus the Thessalian brought the horse Bucephalus to Philip, offering to sell him for thirteen talents; but when they went into the field to try him, they found him so very vicious and unmanageable, that he reared up when they endeavored to mount him, and would not so much as endure the voice of any of Philip's attendants. Upon which, as they were leading him away as wholly useless and intractable, Alexander, who stood by, said, "What an excellent horse do they lose, for want of skill and boldness to manage him!" Philip at first took no notice of what he said; but when he heard him repeat the same thing several times, and saw he was very frustrated to see the horse sent away, "Do you criticize," said Philip, "those who are older than yourself, as if you knew more, and were better able to manage him then they?" "I could manage this horse," replied Alexander, "better than others do." "And if you do not," said Philip, "what will you forfeit for your rashness?" "I will pay," answered Alexander, "the whole price of the horse." At this the whole company fell laughing; and as soon as the wager was settled among them, he immediately ran to the horse, and, taking hold of the bridle, turned him directly towards the sun, having, it seems, observed that he was disturbed at and afraid of the motion of his own shadow; then letting him go forward a little, still keeping the reins in his hand, and stroking him gently when he began to grow eager and fiery, . . .with one nimble leap, Alexander securely mounted him, and when he was seated, by little and little drew in the bridle, and curbed him without either striking or spurring him. Presently, when he found him free from all rebelliousness, and only impatient for the course, he let him go at full speed, inciting him now with a commanding voice, and urging him also with his heel. Philip and his friends looked on at first in silence and anxiety for the result, [but when he came] back rejoicing and triumphing for what he had performed, they all burst out into acclamations of applause; and his father, shedding tears, it is said, for joy, kissed him as he came down from his horse, and in his transport said, "O my son, carve out a kingdom equal to and worthy of yourself, for Macedonia is too small for you."

"Carve Out A Kingdom Worthy of Yourself" is from Plutarch, *Life of Alexander*, 5, in *Readings in Ancient History*, vol. 1, ed. William S. Davis (Boston: Allyn and Bacon, 1912), pp. 301–302.

The Leadership of Alexander

ARRIAN

In 334 B.C.E., Alexander set out to conquer the Persian empire and, until his death in 323, defeated every force thrown against him. Alexander's military abilities are beyond question, but it takes more than tactical knowledge to inspire and encourage a force to move thousands of miles away from their homeland in pursuit of the unknown. Finally, deep in India, Alexander's troops forced him to forget the "ends of the earth" and to return to Macedon. The journey home was difficult, and Alexander lost many men to the hardship of the desert. His leadership, as the following account reveals, was never in doubt.

At this point in my story I must not leave unrecorded one of the finest things Alexander ever did. . . . The army was crossing a desert of sand; the sun was already blazing down upon them, but they were struggling on under the necessity of reaching water, which was still far away. Alexander, like everyone else, was tormented by thirst, but he was none the less marching on foot at the head of his men. It was all he could do to keep going, but he did so, and the result (as always) was that the men were the better able to endure their misery when they saw that it was equally shared. As they toiled on, a party of light infantry which had gone off looking for water found some—just a wretched little trickle collected in a shallow gully. They scooped up with difficulty what they could and hurried back, with their priceless treasure, to Alexander; then, just before they reached him, they tipped the water into a helmet and gave it to him. Alexander, with a word of thanks for the gift, took the helmet, and, in full view of his troops, poured the water on the ground. So extraordinary was the effect of this action that the water wasted by Alexander was as good as a drink for every man in the army. I cannot praise this act too highly; it was a proof, if anything was, not only of his power of endurance, but also of his genius for leadership.

Consider This:

- After reading the sources on Alexander the Great, describe what kind of man he was. Be specific in your answer. Do you think his actions warrant the epithet "the Great"? Does "greatness" imply more than conquest? Is it more difficult to conquer than it is to consolidate and rule territory? To what extent can an individual change the course of history?

Hellenistic Philosophy

After the death of Alexander in 323 B.C.E., his empire fell away quickly and his generals fought over the remnants. This political vacuum precipitated a crisis of leadership and stability that affected much of the Greek West. The Hellenistic period from 323 to about 150 B.C.E. was thus characterized by philosophy concerned with surviving in an insecure world where political and social chaos was fast becoming a normal standard of life. Many people found consolation in the Stoic philosophy, which was fatalistic and advocated adherence to duty and responsibility (see Chapter 3: "The World of Rome"). One of the most popular schools of Hellenistic thought was founded by Epicurus (342–270 B.C.E.). The Epicureans denied that there was any interference of gods in human affairs or any life after death. All things were composed of atoms, which eventually returned to the "void." For an Epicurean, pleasure was the key to life. The following selections are maxims of Epicurus himself.

"The Leadership of Alexander" is from Arrian, *Anabasis*, 6.26, in *The Campaigns of Alexander*, trans. Aubrey de Sélincourt, revised by J. R. Hamilton (Baltimore, Md., and Harmondsworth, Middlesex: Penguin Books, 1958), pp. 338–339. Copyright © 1958, 1971 by Aubrey de Sélincourt. Reprinted by permission of Penguin Books, Ltd.

Epicureanism: Golden Maxims
EPICURUS

Pleasure is an original and natural good, but we do not choose every pleasure. Sometimes we avoid pleasures when a greater pain follows them; and many pains we consider preferable to pleasure when they lead eventually to a greater pleasure. Self-sufficiency is to be sought. Luxuries are hard to get, but natural things are easy and give us much pleasure.

When we say pleasure is the purpose of life, we do not mean the pleasures of the sensually self-indulgent, as some assert, but rather freedom from bodily pain and mental disturbance. The life of pleasure does not come from drinking or revels, or other sensual pleasures. It comes from sober thinking, the sensible investigation of what to choose and to avoid, and getting rid of ideas which agitate the soul. Common sense is our best guide. It tells us that we cannot live happily unless we live wisely, nobly, and justly without being happy. The virtues are inseparably linked with pleasure. For whom do you rate higher than the man who has correct beliefs about God, who has no fear of death, who has understood the purpose of Nature, who realizes that pain does not last long, and that Necessity, which some people consider the directing force of the world, is partly a matter of luck, and partly in our power?

• • •

Gods exist, but they are not as they are popularly thought to be. To destroy the gods as they are commonly thought to be is not impious; actually it is impious to have such distorted notions. The divine powers, blessed and incorruptible, neither are troubled themselves nor do they feel anger or gratitude toward men.

• • •

Accustom yourself to think that death means nothing to us. For what is good and bad is a matter of sensation, and death is an end of sensation. Grasping this principle makes human life pleasant, not by giving us any promise of immortality, but by freeing us from any desire for immortality. For there is nothing in life to be afraid of for a man who understands that he need not be afraid of its extinction. So death, usually regarded as the greatest of calamities, is actually nothing to us; for while we are, death is not, and when death is here, we are not. So death means nothing to either the living or the dead, for it has nothing to do with the living and the dead do not exist.

Consider This:

- Explain the nature of pleasure for an Epicurean philosopher. How would he define pleasure and what does it consist of? Do you consider Epicureanism to be a practical philosophy? Why or why not?

"Golden Maxims" is from Walter R. Agard, *The Greek Mind* (Princeton, N.J.: D. Van Nostrand Company, 1957), pp. 161–162. Copyright © 1957 by Walter R. Agard. Reprinted by permission of Elizabeth Agard.

The Principles of Skepticism

SEXTUS EMPIRICUS

Pyrrhro of Elis developed another important Hellenistic philosophy called skepticism. The Skeptics delighted in pointing out the inadequacies of the various competing philosophies of the day. They thought that nothing could really be known because reality was distorted by appearances. Since nothing could be known, they consoled themselves by insisting that nothing mattered. Life thus consisted of adaptation and acceptance of the world as it was.

The originating cause of Skepticism is, we say, the hope of attaining quietude. Men of talent, who were perturbed by the contradictions in things and in doubt as to which of the alternatives they ought to accept, were led on to inquire what is true in things and what false, hoping by the settlement of this question to attain quietude. The main basic principle of the Skeptic system is that of opposing to every proposition an equal proposition; for we believe that as a consequence of this we end by ceasing to dogmatize. . . .

That the senses differ from one another is obvious. Thus, to the eye paintings seem to have recesses and projections, but not so to the touch. Honey, too, seems to some pleasant to the tongue but unpleasant to the eyes; so that it is impossible to say whether it is absolutely pleasant or unpleasant. The same is true of sweet oil, for it pleases the sense of smell but displeases the taste. . . . Rain water, too, is beneficial to the eyes but roughens the windpipe and lungs; as also does olive oil, though it mollifies the epidermis. The cramp fish, also, when applied to the extremities produces cramp, but it can be applied to the rest of the body without hurt. Consequently we are unable to say what is the real nature of each of these things, although it is possible to say what each thing at the moment appears to be. . . .

Seeing, then, that there is a controversy . . . regarding "the true," since some assert that something true exists, others that nothing true exists, it is impossible to decide the controversy, because the man who says that something true exists will not be believed without proof, on account of the controversy; and if he wishes to offer proof, he will be disbelieved if he acknowledges that his proof is false, whereas if he declares that his proof is true he becomes involved in circular reasoning and will be required to show proof of the real truth of his proof, and another proof of that proof, and so on ad infinitum. But it is impossible to prove an infinite series; and so it is impossible also to get to know that something true exists. . . .

And since the criterion of truth has appeared to be unattainable, it is no longer possible to make positive assertions either about those things which . . . seem to be evident or about those which are non-evident; . . . if we are forced to suspend judgment about the evident, how shall we dare to make pronouncements about the non-evident?

Consider This:

- In what way can Skepticism be called a "defensive" philosophy? What are its basic tenets? For the Skeptic, what is true? What are the advantages to being a Skeptic? Are there any disadvantages?

"The Principles of Skepticism" is reprinted by permission of the publishers and the Loeb Classical Library from Sextus Empiricus, *Outlines of Pyrrhonism*, trans. R. G. Bury, vol. 1 (Cambridge, Mass.: Harvard University Press, 1933), pp. 9, 45, 205, 213. The Loeb Classical Library is a registered trademark of the President and Fellows of Harvard College.

The Artistic Vision

HELLENISTIC SCULPTURE
Heroic Death: "The Noble Savage"

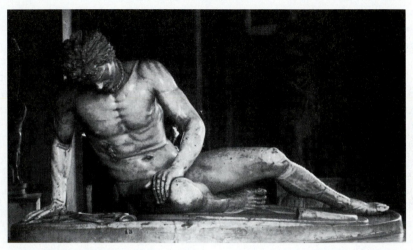

Figure 2–3 The Dying Gaul (SuperStock, Inc.).

Alexander the Great's dramatic march of conquest to the "ends of the earth" more closely integrated the Hellenic (Greek) world of the West with eastern cultures. The Hellenistic (or "Greek-like") period lasted from Alexander's death in 323 to about 150 B.C.E. and was characterized by increased trade and artistic exchange, but also by marked po-
litical chaos as successors to Alexander tried to carve out and maintain their own kingdoms in the shadow of the expanding Roman Republic.

One of the most impressive rulers of the time was Attalus I of Pergamum (reigned 241–197), whose kingdom on the coast of modern-day Turkey became legendary for its great wealth and patronage of the arts. Attalus commemorated his victories in the region by commissioning altars to Zeus and by donating works of art to other Greek centers, most notably Athens. His fame spread quickly and he was acclaimed "Soter" (Savior) for his victories over such invaders as the Gauls.

The Gauls were a Celtic people, who had inspired great fear as they swept down from Europe and into the region called Galatia (named after them) in central Turkey, just to the east of Pergamum. While other rulers had paid them off, Attalus decided to fight and defeated them so decisively that his kingdom was protected from further incursions for over a generation. Attalus commemorated his victory with a monument in Pergamum decorated with bronze statues of his vanquished enemies.

The sculptures in this section are marble reproductions that found their way throughout the Roman world. The Romans also fought the Gauls and had great respect for their values of courage and sacrifice. These "noble savages" were, indeed, worthy opponents.

The Dying Gaul is an excellent example of the pathos that often characterizes Hellenistic sculpture. The Gallic warrior has pulled himself from the battle and awaits death as blood pours from the wound in his side. With eyes fixed on his sword, he props himself up weakly with one arm, aware that he is alone and will soon lose his struggle with death. There is an

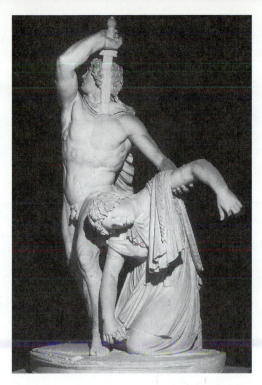

intimacy in this sculpture, an attraction in the realization of death and in the almost spiritual anguish of the defeated warrior.

We see this same expressive Hellenistic intensity in another Roman reproduction from Attalus' monument in The Gaul and His Wife. *The Gauls took their women and children with them on campaign and we see that this warrior, realizing defeat and resisting the inevitable slavery for those who are captured, has spared his wife the indignity by killing her. As he looks apprehensively over his shoulder at the advancing enemy, he plunges his sword into his own neck.*

Consider This:

- What Celtic values are reflected in these two sculptures? Why did Attalus of Pergamum and later the Romans commemorate such values by creating and reproducing these sculptures of heroic death? In essence, how did the defeated Gauls eventually win their battles with Attalus and the Romans?

Figure 2–4 The Gaul and His Wife (Picture Desk, Inc./Korbal Collection).

Compare and Contrast:

- The reflective detachment that we see in *The Dying Gaul* is one of the most intriguing aspects of Hellenistic sculpture. Compare this very human component with the majestic, but unemotional austerity of Egyptian or Greek classical sculpture. How does the very perfection of Greek statuary in the fifth century B.C.E. both celebrate and limit the dimensions of the human being?

3

The World of Rome

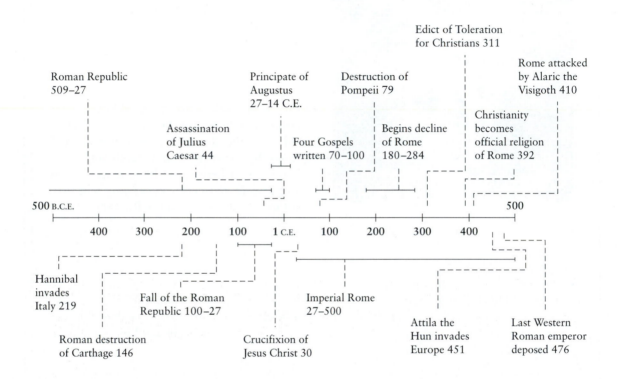

Edict of Toleration for Christians 311

Rome attacked by Alaric the Visigoth 410

Roman Republic 509–27

Principate of Augustus 27–14 C.E.

Destruction of Pompeii 79

Christianity becomes official religion of Rome 392

Assassination of Julius Caesar 44

Four Gospels written 70–100

Begins decline of Rome 180–284

500 B.C.E.

500

400 300 200 100 1 C.E. 100 200 300 400

Hannibal invades Italy 219

Fall of the Roman Republic 100–27

Imperial Rome 27–500

Attila the Hun invades Europe 451

Last Western Roman emperor deposed 476

Roman destruction of Carthage 146

Crucifixion of Jesus Christ 30

CHAPTER THEMES

- *The Institution and the Individual:* The system of government instituted by Augustus, called the "principate," functioned as a complex blend of power and authority. How well did his successors as emperors of Rome maintain his system of rule? Is freedom, most important, a thing of the mind? If the institutions of government are controlled, yet *appear* to be free, and if you *feel*, are you free?

- *Social and Spiritual Values:* To what extent does any society depend on a religious base? Does religion contribute to political and social stability or instability? How important is mythology to the character and success of a civilization?

- *The Power Structure:* How did the Romans control their empire? Were they efficient rulers who were respected by their subjects? Is imperialism that results in political and social stability necessarily a bad thing?

- *The Varieties of Truth:* Some historians have maintained that Augustus's rule was based less on his control of the military machine than on his patronage of poets in the realm. How was his image enhanced by various forms of propaganda? What role does image play in the maintenance of power?

- *Revolution and Transition:* How did Augustus fill the power vacuum left by the Roman civil war and maintain stability throughout the Roman world? Does history move in a cycle between chaos and stability? Why are some societies able to maintain stability longer than others? What are the sources of societal instability and chaos? Do these forces lead to repressive regimes that maintain domestic control at the expense of personal freedom?

- *The Big Picture:* Do all societies pass through a critical period of change that results in renewal or destruction? Must societies be challenged in order to survive and progress? Is this "challenge and response" theory of civilization applicable to one's personal life? Is a civilization, like a human being, a biological entity?

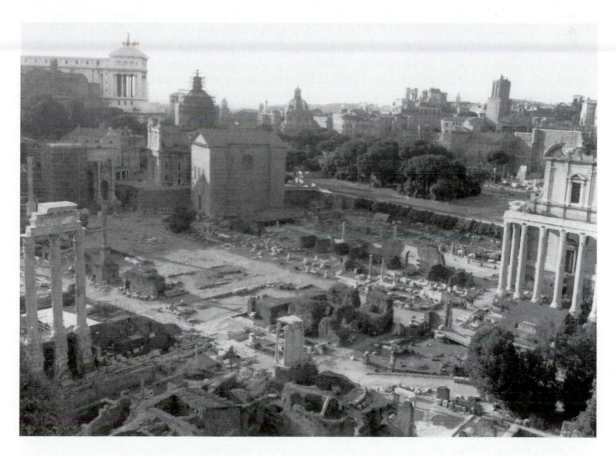

Figure 3–1 This contemporary view of the Roman Forum from the Palatine hill, which contained the palaces of the emperors, can now only hint at the majesty of the great capital of the Roman Empire and the busy "emporium of the world." William Hobbington: "As yourselves, your empires fall. And every kingdom hath a grave" (Perry M. Rogers).

The Roman Republic (509–27 B.C.E.)

Idealism is the noble toga that political gentlemen drape over their will to power.

—Aldous Huxley

Civilization is a stream with banks. The stream is sometimes filled with blood from people killing, stealing, shouting and doing things historians usually record, while on the banks, unnoticed, people build homes, make love, raise children, sing songs, [and] write poetry. . . . The history of civilization is the story of what happened on the banks.

—Will and Ariel Durant

Roman Virtues in the Early and Middle Republic

The rise and fall of the Roman Empire has been a topic of fascination and controversy for over 1,500 years. Even the Romans themselves were amazed at their history and understood that their accomplishments were unique and their legacy imposing. The Romans viewed their rise to dominance throughout the Mediterranean region and beyond as the fulfillment of their destiny. From their origins in 753 B.C.E. as one of many small tribes occupying the seven hills surrounding a marshy center, the Roman people solved each problem, conquered each tribe, established each alliance, and met each test they faced. This success was no accident of history in their minds, but rather the realization of their moral superiority and dominant will that created the most powerful war machine in antiquity and enabled their administration to hold effective sway over a formidable empire for hundreds of years.

It was this story of challenge and response that the emperor Augustus (reigned 27 B.C.E. to 14 C.E.) wanted to recount for posterity when he commissioned the historian, Titus Livy, to write the history of Rome from the foundation of the city. This work of over 142 Books occupied Livy for forty years until his death in 17 C.E. Augustus, who had emerged victorious in the civil war against Mark Antony after the death of Julius Caesar in 44 B.C.E., was in the midst of "refounding" Rome and "restoring the Republic" that had been so brutally torn asunder by the greed and lust for power of its generals. Augustus needed to refashion Roman morality and reestablish Roman gravity and dignity. Livy's job was to recount the fabled stories from Rome's glorious past, to focus the virtues of courage, honor, discipline, and sacrifice that had generated fear and respect among Rome's enemies and loyalty and stability from her citizens.

The following stories as compiled by Livy thus emphasize the foundation of Roman greatness and the expectations for Augustus's new glory. The first recounts the struggle about 670 B.C.E. between the Alban tribe and the Romans for local control. The hero, Horatius, defined the concept of Roman discipline and valor. In the second excerpt, the Roman matron, Lucretia, provided the model of sacrifice after Sextus Tarquinius, the son of the Roman king, raped her. Lucretia demonstrated that her honor was more important than her life. Her sacrifice furnished the spark that toppled the Roman kingship and paved the way for the establishment of the Republic in 509 B.C.E.. It is interesting to note that this effort was headed by Marcus Junius Brutus, the ancestor of the more famous tyrannicide, who sought to free Rome from the clutches of the dictator, Julius Caesar.

The Oath of the Horatii:
"One of the Great Stories of Ancient Times"
LIVY

In each army, there were three bothers—triplets—all equally young and active, belonging to the families of the Horatii and Curiatii. That these were their names has never been in

> **"The stakes were high; upon the luck or valor of three men hung empire or slavery."**
> **—Livy**

doubt, and the story is one of the great stories of ancient times. . . . To these young men the two rival commanders made their proposal, that they should fight, three against three, as the champions of their countries, the victorious to have dominion over the vanquished: the proposal was accepted; the time and place for the contest were arranged and a solemn agreement entered into by the Romans and Albans to the effect that whichever of the two peoples should prove victorious through the prowess of its champions should be undisputed master of the other. . . .

The six champions now made ready for battle. As they stepped forward into the lists between the two armies, their hearts were high, and ringing in their ears were the voices of friends, bidding them remember that their parents, their country, and their country's gods, their fellow-soldiers and all they loved at home, would be watching their prowess and that all eyes were on their swords. The rival armies were still in position; fear there was none, but every man present was tense with anxiety. The stakes were high; upon the luck or valor of three men hung empire or slavery. In an agony of suspense, the onlookers prepared for the spectacle. The trumpet blared. The brothers drew their swords, and with all the pride of embattled armies, advanced to the combat. Careless of death and danger, each thought only of

his country's fate, of the grim choice between lordship and ignominy, which they themselves, and they only, were about to decide. They met. At the flash of steel and the clang of shield on shield a thrill ran through the massed spectators, breathless and speechless while as yet neither side had the advantage. Soon the combatants were locked in a deadly grapple; bodies writhed and twisted, the leaping blades parried and thrust, and blood began to flow. Alba's three champions were wounded; a Roman fell, then another, stretched across his body and both at the point of death. A cheer burst from the Alban army, as the two Romans went down, while from their adversaries all hope was gone; life seemed to drain from them, as they contemplated the dreadful predicament of their one survivor, surrounded by the three Curiatii.

The young man, though alone, was unhurt. No match for his three opponents together, he was yet confident of his ability to face them singly, and, with this purpose in mind, he took

> **"Soon the combatants were locked in a deadly grapple; bodies writhed and twisted, the leaping blades parried and thrust, and blood began to flow."**
> **—Livy**

to his heels, sure that they would be after him with such speed as their wounds allowed. Not far from the scene of the first fight he looked back. His three enemies were coming, strung out one behind the other, the foremost almost upon him. He turned and attacked him furiously. A cry rose from the Alban army: "Your brother! Save him!" But it was too late. Horatius had already killed his man and, flushed with triumph,

was looking for his next victim. The Romans' cheer for their young soldier was like the roar of the crowd at the race when luck turns defeat into victory. Horatius pressed on to make an end. He killed his second man before the last, near though he was, could come to his aid.

Now it was one against one; but the two antagonists were far from equally matched in all else that makes for victory. Horatius was unhurt, and elated by his double success; his opponent, exhausted by running and loss of blood, could hardly drag himself along; his brothers had been killed before his eyes; he was a beaten man facing a victorious enemy. What followed cannot be called a fight. "I have killed two already," the Roman cried, "to avenge my brothers' ghosts. I offer the last to settle our quarrel, that Rome may be mistress of Alba." With these proud words, he plunged his sword with a downward stroke into the throat of his enemy, now too weak to sustain his shield, and then stripped him where he lay.

The cheering ranks of the Roman army, whose joy was the keener by the narrow escape from disaster, welcomed back their champion. The two sides then buried their dead, a common task, but performed with very different feelings by victors and vanquished. Alba was subject now to her Roman mistress.

Consider This:

- What were the virtues demonstrated by the Horatii in this struggle to the death? Note the pressure placed on the shoulders of the last Roman brother as success or failure became a personal responsibility. What message was being given to each Roman soldier?

The Rape of Lucretia
LIVY

With all courtesy Lucretia rose to bid her husband [Collatinus] and the princes welcome, and Collatinus, pleased with his success, invited his friends to sup with him. It was at that fatal supper that Lucretia's beauty, and proven chastity, kindled in Sextus Tarquinius the flame of lust, and determined him to debauch her.

Nothing further occurred that night. The little jaunt was over, and the young men rode back to camp.

A few days later Sextus, without Collatinus's knowledge, returned with one companion, where he was hospitably welcomed in Lucretia's house, and, after supper, escorted, like the honored visitor he was thought to be, to the guest-chamber. Here he waited till the house was asleep, and then, when all was quiet, he drew his sword and made his way to Lucretia's room determined to rape her. She was asleep. Laying his left hand on her breast, "Lucretia," he whispered, "not a sound! I am Sextus Tarquinius. I am armed—if you utter a word, I will kill you."

Lucretia opened her eyes in terror; death was imminent, no help at hand. Sextus urged his love, begged her to submit, pleaded, threatened, used every weapon that might conquer a woman's heart. But all in vain; not even the fear of death could bend her will. "If death will not move you," Sextus cried, "dishonor shall. I will kill you first, then cut the throat of a slave and lay his naked body by your side. Will they not believe that you have been caught in adultery with a servant—and paid the price?" Even the most resolute chastity could not have stood against this dreadful threat.

Lucretia yielded. Sextus enjoyed her, and rode away, proud of his success.

The unhappy girl wrote to her father in Rome and to her husband in Ardea, urging them both to come at once with a trusted friend— and quickly, for a frightful thing had happened. . . . They found Lucretia sitting in her room, in deep distress. Tears rose to her eyes as they entered, and to her husband's question, "Is it well

"The Rape of Lucretia" is from Livy, *The History of Rome from its Foundation*, trans. Aubrey de Sélincourt, *The Early History of Rome* (Baltimore, Md., and Harmondsworth, Middlesex: Penguin Books, 1960), 1.57–1.59, pp. 98–99. Copyright © 1960 by the Estate of Aubrey de Sélincourt. Reprinted by permission of Penguin Books, Ltd.

with you?" she answered, "No. What can be well with a woman who has lost her honor? In your bed, Collatinus, is the impress of another man. My body only has been violated. My heart is innocent, and death will be my witness. Give me your solemn promise that the adulterer shall by punished—he is Sextus Tarquinius. He it is who last night came as my enemy disguised as my guest, and took his pleasure of me. That pleasure will be my death—and his too if you are men."

The promise was given. One after another they tried to comfort her. They told her she was helpless, and therefore innocent; that he alone was guilty. It was the mind, they said, that sinned, not the body: without intention, there could never be guilt.

"What is due to *him*," Lucretia said, "is for you to decide. As for me, I am innocent of fault, but I will take my punishment. Never shall Lucretia provide a precedent for unchaste women to escape what they deserve." With these words, she drew a knife from under her robe, drove it into her heart, and fell forward, dead.

Her father and husband were overwhelmed with grief. While they stood weeping helplessly,

> ## "As for me, I am innocent of fault, but I will take my punishment."
> ### —Lucretia

Brutus drew the bloody knife from Lucretia's body, and holding it before him cried: "By this girl's blood—none more chaste till a tyrant wronged her—and by the gods, I swear that with sword and fire, and whatever else can lend strength to my arms, I will pursue Lucius Tarquinius the Proud, his wicked wife, and all his children, and never again will I let them or any other man be King in Rome."

Consider This:

- In this story, how did Livy define purity and guilt? What message was the Augustan regime giving to women about moral expectations in Roman society? What made Lucretia a good Roman?

- Note the pressure placed on Lucretia's father and husband to avenge her death "if you are men." In this instance, virtue and action were closely linked. It was not enough merely to agree with ideals—one had to live them, or die in their defense.

"Hannibal Is at the Gates!"

LIVY

In 264 B.C.E., the Carthaginians, who had established a commercial hegemony of sorts over the western Mediterranean, believed that the ascendant Rome threatened their control of the region. A series of Carthaginian (Punic) wars began that not only challenged the authority of Rome but also threatened her very existence.

When the great Carthaginian general, Hannibal, was but nine years old, his illustrious father, Hamilcar Barca, took him to an altar and made him swear that he would hate the Romans and make them his enemies. Hamilcar was expressing his anger at having been "sold out" by the Carthaginian government when they surrendered to Rome prematurely in concluding the First Punic War in 241 B.C.E. But Hannibal took the oath seriously and at age 24 assumed control of Carthaginian forces with a bold plan of attack. He violated terms of the peace with Rome in 219 B.C.E. and began the Second Punic War by unexpectedly heading over the Alps and descending upon northern Italy.

"Hannibal Is at the Gates" is from Livy, *The History of Rome from its Foundation*, trans. Aubrey de Sélincourt, *The War With Hannibal* (Baltimore, Md., and Harmondsworth, Middlesex: Penguin Books, 1965), 22.51–53, pp. 151-153. Copyright © 1965 by the Estate of Aubrey de Sélincourt. Reprinted by permission of Penguin Books, Ltd.

Hannibal was unbeatable as Roman forces fell time and again to his complex tactics and staggering ingenuity. The Romans and their allies lost tens of thousands of men in his onslaught and were only successful in deflecting Hannibal's entrance into Rome. But such tactics of hit and run could never result in victory and were considered cowardly and "un-Roman." In 216 B.C.E., the Roman commanders again offered battle. The armies met at Cannae where the Carthaginians destroyed over 70,000 Romans, who charged into a clever enveloping trap set by Hannibal. Rome's allies now began to desert and the cry went up: "Hannibal is at the gates!"

The historian Livy now recounts the fear and desperation just after the battle as all seemed lost. It was at this critical juncture that a young savior arose in the figure of Lucius Cornelius Scipio. Only 18 years old in this scene, he embodied the ancient Roman virtues of courage and discipline that allowed him eventually to defeat Hannibal by taking the war to his homeland in North Africa. Scipio afterwards assumed the title "Africanus" and his valor was recounted time and again as Romans looked back to this moment of destiny and decried the absence of such virtues after 100 B.C.E. as the Republic was destroyed by competing generals amid civil war.

At dawn next morning, the Carthaginians applied themselves to collecting the spoils and viewing the carnage, which even to an enemy's eyes was a shocking spectacle. All over the field, Roman soldiers lay dead in their thousands, horse and foot mingled, as the shifting phases of the battle, or the attempt to escape, had brought them together. Here and there wounded men, covered with blood, who had been roused to consciousness by the morning cold, were dispatched by a quick blow as they struggled to rise from amongst the corpses; others were found still alive with the sinews in their thighs and behind their knees sliced through, baring their throats and necks and begging who would to spill what little blood they had left. Some had their heads buried in the ground, having apparently dug themselves holes and by smothering their faces with earth had choked themselves to death. Most strange of all was a Numidian soldier, still living, and lying, with nose and ears horribly lacerated, underneath the body of a Roman who, when his useless hands had no longer been able to grasp his sword, had died in the act of tearing his enemy, in bestial fury, with his teeth. . . .

Meanwhile, all the remaining Romans who had strength or heart for the undertaking—in all about 4,000, together with 200 cavalrymen—escaped to Canusium, some marching in column, others . . . making their way individually over the countryside. . . .

With these fugitives were four military tribunes [who were] discussing with a few friends what measures to adopt, when Philus, the son of an ex-consul, broke in upon them with startling news: to cherish hope was useless, for all

> **"I swear with all the passion of my heart that I shall never desert our country, or permit any other citizen of Rome to leave her in the lurch."**
> **—Scipio Africanus**

was lost—the future had nothing to offer but misery and despair. A number of men of patrician blood, led by Lucius Caecilius Metellus, were turning their eyes to the sea and planning to abandon Italy and find refuge with some foreign prince. This news, dreadful enough in itself and coming as a new sort of horror on top of all their previous calamities, struck them into a kind of numbed stupor of incredulity. Those who had been listening to the tribunes' discussion proposed to call a general conference, but young Scipio—the man who was destined to command the Roman armies in this war—said that this was no matter for debate: the crisis had come, and what was needed was not words, but bold action. "Come with me," he cried, "instantly, sword in hand, if you wish to save our country. The enemy's camp is nowhere more truly than in the place where such thoughts can rise!" With a few followers, he went straight to where Metellus was staying. Assembled in the house were the men with whom Philus had spoken, still discussing their plans. Scipio burst in, and holding his bared sword over their heads, "I swear," he cried,

"with all the passion of my heart that I shall never desert our country, or permit any other citizen of Rome to leave her in the lurch. If I wilfully break my oath, may Jupiter, Greatest and Best, bring me to a shameful death, with my house, my family and all I possess! Swear the same oath, Caecilius; and, all the rest of you, swear it too. If anyone refuse, against him this sword is drawn." They could not have been more scared had they been looking in the face of their conqueror Hannibal. Every man of them took the oath, and gave himself into Scipio's custody.

Consider This:

- Hannibal's brilliant victories inspired a crisis in morale as Rome faced its most difficult and desperate struggle to survive. Note the resolve of the young Scipio in the face of fear and doubt. His realization that the enemy's camp was harbored in the vision of retreat captured the moment.

- Compare Scipio's demand of an oath of loyalty in this scene with that taken in "The Oath of the Horatii." Why were oaths so important at these critical junctures? What values are inherent in an oath?

- What role did shame play in the reaction to Scipio's stand and what does this say about the Romans?

The Fall of the Roman Republic (100–27 B.C.E.)

Although Rome seemed preeminent in the Mediterranean area by the middle of the second century B.C.E., other domestic problems were fast arising to threaten the state from within. The Romans had destroyed the Carthaginian menace largely by depending on an army composed of free farmers who had exchanged their hoes for swords. After the victory over Hannibal, many returned to find that his 15-year presence in Italy had destroyed their land. Rather than rebuild, which was expensive and a gamble in any event, many decided to sell their property to members of the senatorial aristocracy. The nobility thus increased their land holdings and created plantations called latifundia, *which were farmed by the cheap slave labor abundant after the Punic wars. Since one had to own property to be in the army, many of the displaced veterans went to the city of Rome, hoping to find employment. A gulf widened between rich and poor that threatened the unity of the state.*

By the opening of the first century B.C.E., Roman armies were no longer recruited from the free land-holding farmers but, rather, from those displaced veterans and unemployed who had migrated to Rome. A successful general named Marius offered them employment in the army without the requirement of property ownership. Marius thus created a professional army of soldiers who were promised land, booty, and glory; in return, they gave loyalty to their general. Competition for commands against important foreign enemies became intense and sometimes resulted in civil war. The following selection recounts the vengeance of the general Sulla against Marius's troops in 82 B.C.E. Blood-letting was becoming epidemic in its proportions.

The Wrath of Sulla

APPIAN

Sulla himself called the Roman people together in an assembly and made them a speech, vaunting his own exploits and making other menacing statements in order to inspire terror. He finished by saying that he would bring about a change which would be beneficial to the people

"The Wrath of Sulla" is reprinted by permission of the publishers and the Loeb Classical Library from Appian, *The Civil Wars*, 1.11.95–12.103, trans. Horace White (Cambridge, Mass.: Harvard University Press, 1913), pp. 175, 177, 183, 185.

if they would obey him, but of his enemies he would spare none, but would visit them with the utmost severity. He would take vengeance by strong measures on . . . everybody . . . who had committed any hostile act . . . [against] him. . . . After saying this, he forthwith proscribed about forty senators and 1,600 equites. He seems to have been the first to make such a formal list of those whom he condemned to death, to offer prizes to assassins and rewards to informers, and to threaten with punishment those who concealed the proscribed. Shortly afterward he added the names of other senators to the proscription. Some of these, taken unawares, were killed where they were caught, in their homes, in the streets, or in the temples. Others were hurled through mid-air and thrown at Sulla's feet.

Others were dragged through the city and trampled on, none of the spectators daring to utter a word of remonstrance against these horrors. Banishment was inflicted upon some, and confiscation upon others. Spies were searching everywhere for those who had fled from the city, and those whom they caught they killed. . . .

Thus Sulla became king, or tyrant, a de facto—not elected but holding power by force and violence. . . . There had been autocratic rule before—that of the dictators—but it was limited to short periods; under Sulla it first became unlimited, and so an absolute tyranny. But this much was added for propriety's sake, that they chose him dictator for the enactment of such laws as he himself might deem best and for the settlement of the commonwealth. . . .

"The Die Is Cast": Caesar Crosses the Rubicon
SUETONIUS

As violence and intimidation became acceptable tools of change, the state balanced on the brink of chaos. Under the direction of men such as Marcus Crassus, Pompey the Great, and Julius Caesar, the army became a tool for the achievement of glory and the defense of one's dignity. The Republic degenerated into civil war and dictatorship. With it died the ideals and character that had established equality among Roman citizens and had defeated the likes of Hannibal.

The most famous Roman of them all, Julius Caesar, had a difficult time achieving the kind of military glory or wealth needed to compete with Pompey and Crassus. When he finally got a major command in Gaul (58 B.C.E.), he conquered and consolidated the area, gaining wealth and the loyalty of his troops. After first cooperating with Pompey and Crassus, Caesar realized he would have to fight a senatorial aristocracy that distrusted him and championed Pompey. The first selection recounts Caesar's famous decision to cross the Rubicon River, thus beginning the civil war of 49–45 B.C.E. Cicero, the greatest orator of his age and a supporter of Pompey and the senate, also gives his perspective in letters written in the midst of this crisis.

When the news came to Ravenna, where Caesar was staying that [his compromise plan] had been utterly rejected, . . . he immediately sent forward some troops, yet secretly, to prevent any suspicion of his plan. . . . Coming up with his troops on the banks of the Rubicon, which was the frontier of his province, he halted for a while, and revolving in his mind the importance

of the step he meditated, he turned to those about him, saying: "Still we can retreat! But once we pass this little bridge,—nothing is left but to fight it out with arms!" . . . Caesar cried out, "Let us go when the omens of the Gods and the crimes of our enemies summon us! THE DIE IS NOW CAST!" Accordingly he marched his army over the river.

" 'The Die is Cast': Caesar Crosses the Rubicon" is from Suetonius, *Life of Caesar*, 31–33, in *Readings in Ancient History*, vol. 2, ed. William S. Davis (Boston: Allyn and Bacon, 1913), pp. 149–150.

"We Must Trust to the Mercy of the Storm"
CICERO

Menturnea, January 22, 49 B.C.E.

It is civil war, though it has not sprung from division among our citizens but from the daring of one abandoned citizen. He is strong in military forces, he attracts adherents by hopes and promises, he covets the whole universe. Rome is delivered to him stripped of defenders, stocked with supplies: one may fear anything from one who regards her temples and her homes not as his native land but as his loot. What he will do, and how he will do it, in the absence of senate and magistrates, I do not know. He will be unable even to pretend constitutional methods. But where can our party raise its head, or when? . . . We depend entirely upon two legions that were kept here by a trick and are practically disloyal. For so far the draft has found unwilling recruits, disinclined to fight. But the time of compromise is past. The future is obscure. We, or our leaders, have brought things to such a pass that, having put to sea without a rudder, we must trust to the mercy of the storm.

Formiae, February 8 or 9, 49 B.C.E.

I see there is not a foot of ground in Italy which is not in Caesar's power. I have no news of Pompey, and I imagine he will be captured unless he has taken to the sea. . . . What can I do? In what land or on what sea can I follow a man when I don't know where he is? Shall I then surrender to Caesar? Suppose I could surrender with safety, as many advise, could I do so with honor? By no means. . . . The problem is insoluble.

Formiae, March 1, 49 B.C.E.

I depend entirely on news from Brundisium. If Caesar has caught up with our friend Pompey, there is some slight hope of peace: but if Pompey has crossed the sea, we must look for war and massacre. Do you see the kind of man into whose hands the state has fallen? What foresight, what energy, what readiness! Upon my word, if he refrain from murder and rapine he will be the darling of those who dreaded him most. The people of the country towns and the farmers talk to me a great deal. They care for nothing at all but their lands, their little homesteads, and their tiny fortunes. And see how public opinion has changed: they fear the man they once trusted [Pompey] and adore the man they once dreaded [Caesar]. It pains me to think of the mistakes and wrongs of ours that are responsible for this reaction.

> "Do you see the kind of man into whose hands the state has fallen? What foresight, what energy, what readiness!"
> —Cicero

The Assassination of Julius Caesar (44 B.C.E.)
PLUTARCH

Caesar managed to defeat Pompey in a major battle at Pharsalus in 48 B.C.E. Pompey fled to Egypt, where he was murdered on orders of the young pharaoh who thereby hoped to ingratiate himself with Caesar. When Caesar arrived in Egypt, he mourned Pompey as a noble

" 'We Must Trust to the Mercy of the Storm' " is reprinted by permission of the publishers and the Loeb Classical Library from Cicero, *Letter to Atticus*, 7.13, 7.22, 8.13, trans. E. O. Winstead (Cambridge, Mass.: Harvard University Press, 1913), pp. 61, 63, 89, 161, 163.

"The Assassination of Julius Caesar" is from Plutarch, *Life of Caesar*, 66, trans. John and William Langhorne (New York: Harper and Brothers, 1872).

warrior and former son-in-law. Caesar was able, in the next years, to defeat the rest of Pompey's supporters, and he arrived in Rome amid acclamations of joy from the people. But a faction of about 60 senators saw in Caesar's reforms and imperial manner the makings of a king. They planned his murder and assassinated him on March 15, 44 B.C.E.

Antony, Caesar's faithful friend and a man of great physical strength, was detained outside the building by Brutus Albinus, who deliberately engaged him in a long conversation. When Caesar entered, the senate rose in his honor. Some of Brutus's accomplices stood behind his chair while others went to meet him, pretending to support the petition of Tullius Cimber for the recall of his brother from exile. They kept up their entreaties until he came to his chair. When he was seated he rejected their request, but they continued more and more urgently until he began to grow angry. Cimber then grasped his toga with both hands and

> ## "Whichever way Caesar turned, he met with blows and saw nothing but cold steel gleaming in his face."
> ### —Plutarch

pulled it off his neck, which was the signal for the attack. Casca struck the first blow, stabbing Caesar in the neck with his dagger. But the wound was not mortal or even dangerous, probably because at the beginning of so bold an action he was very nervous. Caesar therefore

was able to turn around and grasp the dagger and hold on to it. At the same time they both cried out, Caesar in Latin, "Casca, you villain! What does this mean!" and Casca in Greek to his brother, "Brother, help!"

After such a beginning, those who were unaware of the conspiracy were so astonished and horrified that they could neither run away or assist Caesar, nor could they even utter a word. But all the conspirators now drew their daggers and hemmed Caesar in on every side. Whichever way he turned, he met with blows and saw nothing but cold steel gleaming in his face. Like some wild beast attacked by hunters, he found every hand lifted against him, for they had agreed that all must share in this sacrifice and flesh themselves with his blood. For this reason Brutus also gave him a stab in the groin. Some say that Caesar resisted all the others, shifting his body to escape the blows and calling for help, but when he saw Brutus's drawn dagger he covered his head with his toga and sank to the ground. Either by chance or because he was pushed by his murderers, he fell against the pedestal of Pompey's statue and drenched it with his blood. So Pompey himself seemed to preside over this act of vengeance, treading his enemy under his feet and enjoying his agonies. Those agonies were great, for they say he received twenty-three wounds. And many of the conspirators wounded each other as they aimed their blows at him.

Consider This:

- Why was Julius Caesar assassinated? Did his actions appear to you to be tyrannical? After his assassination, his murderers made no plans, thinking that the Republic, once freed of the dictator, would be restored automatically. Why is this considered a naive idea?

- The great dramatist William Shakespeare used Plutarch as the primary source for his tragedy, *Julius Caesar*. Read Shakespeare's account of the aftermath of Caesar's assassination in the famous speech by Mark Antony on pages 308–312. Should the conspirators also have killed Mark Antony? Why or why not?

Against the Grain

CLEOPATRA: QUEEN OF THE NILE

"The Attraction Was Something Bewitching"

PLUTARCH

Whether Caesar intended to establish a monarchy or not will remain a subject of controversy among historians. But his death unleashed the forces of violence and chaos as the state once again endured civil wars, first against Caesar's assassins, then between Caesar's trusted commander Mark Antony and his nephew and heir Gaius Octavian.

One of the most fascinating personalities of this period was Cleopatra, Queen of Egypt. She had bewitched Caesar when he arrived in Egypt on the trail of Pompey, and he brought her back to Rome. Mark Antony saw her there and, after Caesar's assassination, became romantically involved with her. As the first excerpt indicates, her beauty and ability were renowned; Antony fell under her spell. She fought with him at Actium in 31 B.C.E. against the forces of Octavian and, after their defeat, both committed suicide in Egypt. Years later, the poet Horace, writing in support of Octavian, gave an assessment of her, as recounted in the second excerpt.

Keep in Mind:

- In the following selections, what specific words do Plutarch and Horace use to describe Cleopatra?

On her arrival, Antony sent to invite her to supper. She thought it fitter he should come to her; so, willing to show his good humor and courtesy, he complied, and went. He found the preparations to receive him magnificent beyond expression. . . .

For her actual beauty, it is said, was not in itself so remarkable that none could be compared with her, or that no one could see her without being struck by it, but the contact of her presence, if you lived with her, was irresistible; the attraction of her person, joining with the charm of her conversation, and the character that attended all she said or did, was something bewitching. It was a pleasure merely to hear the sound of her voice, with which, like an instrument of many strings, she could pass from one language to another; so that there were few of the barbarian nations that she answered by an interpreter; to most of them she spoke herself.

"The Attraction Was Something Bewitching" is from Plutarch, *Life of Antony*, 15–19, in *Readings in Ancient History*, vol. 2, ed. William S. Davis (Boston: Allyn and Bacon, 1913), pp. 163–164.

"She Was No Weak-Kneed Woman"

HORACE

Now for a drinking spree, now for a loose-footed
light fantastic, now is the time to pay
our debt to the gods, my friends,
and spread a spectacular banquet.
Before today, to bring the Caecuban from
family storerooms was wrong, while the crazy
queen was still scheming with her
sickly eunuchs, her pack of perverts,
to send the Capitol crashing and bury
the empire: wild were her dreams of doing
whatever she wished, the best
luck was her liquor. She sobered up
when her ships caught fire, scarcely one unscathed,
and delusions of mind nursed on Egypt's wine
were cured by Caesar [Octavian] with the facts
of fear, his navy close as she fled
from Italy, like a hawk going after
a gentle dove, or a swift hunter tracking
a hare over snow-covered fields
in Thessaly: chains awaited this
damnable monster. But a heroine's death
was her goal: she showed no female shivers
at the sight of a sword, and her
fast-sailing fleet sought no secret harbors.
Her courage was great: she looked on her fallen
palace, a smile still on her face, and boldly
played with venomous serpents,
her flesh drinking their bitter poison,
so highly she dared, her mind set on her death.
Not for her the enemy ship, the crownless
voyage, her role in the grand
parade: she was no weak-kneed woman.

Consider This:

- Plutarch described Cleopatra as "irresistible" and "bewitching." What was the attraction? Why was she so impressive? Do you detect any Roman biases against women in these accounts? Why was Cleopatra so different?

- Horace, writing for Cleopatra's victorious rival, Octavian, described her as a "damnable monster," both dangerous and scheming, but also "crazy" and courageous. In what ways did Cleopatra embody Roman virtues? How important was it for Horace to present Cleopatra as a "suitable" enemy of Rome—a foe worthy of respect and yet fated to be vanquished by the righteous power of Octavian?

" 'She Was No Weak-Kneed Woman' " is from Horace, *Odes*, 1.37, in *The Odes and Epodes of Horace*, trans. Joseph P. Clancy (Chicago: University of Chicago Press, 1960), pp. 70–71. Copyright © 1960 by the University of Chicago. Reprinted by permission of the University of Chicago Press.

Late Republican Thought and Literature

As the Republic of Rome fell apart in the mid-first century B.C.E. *amid contending generals and civil wars, proscriptions and assassinations, the social and literary landscape reflected this turmoil. The family, once the cornerstone of Roman virtues, was shaken as the rules that bound society and defined the parameters of morality unraveled during violent confrontations that often pitted brother against brother.*

In this world of political conflict and moral relativism, many of Rome's greatest literary artists flourished. Unconstrained by an oppressive state, they were free to create and apply philosophies and literary devices that had originated in Greece during the second century B.C.E. *One of the most interesting and beautiful creations of the period belongs to the poet, Titus Lucretius Carus, entitled* On the Nature of Things *or* The Way Things Are. *Born soon after 100* B.C.E., *he was probably dead by the time his poem appeared in 55* B.C.E., *just before the civil war between Pompey and Caesar. Lucretius was a devotee of Epicurean philosophy, which maintained that all knowledge derived from the senses and that the world was exactly as it appeared to be. All things were composed of atoms that were merely redistributed throughout the world upon death or destruction. Lucretius provided a literary exposition of these ideas that linked natural philosophy, physics, meteorology, geology, sociology, and cosmology. On the Nature of Things was an appeal in a disillusioned age to take comfort in the regularity and beauty of nature.*

On the Nature of The Universe

LUCRETIUS

MOTHER OF AENEAS and his race, delight of men and gods, life-giving Venus, it is your doing that under the wheeling constellations of the sky all nature teems with life, both the sea that buoys up our ships and the earth that yields our food. Through you all living creatures are conceived and come forth to look upon the sunlight. Before you the winds flee, and at your coming the clouds forsake the sky. For you the inventive earth flings up sweet flowers. For you the ocean levels laugh, the sky is calmed and glows with diffused radiance.

When first the day puts on the aspect of spring, when in all its force the fertilizing breath of the West Wind is unleashed, then, great goddess, the birds of air give the first intimation of your entry; for yours is the power that has pierced them to the heart. Next the cattle run wild, frisk through the lush pastures and swim the swift-flowing streams. Spell-bound by your charm, they follow your lead with fierce desire. So throughout seas and uplands, rushing torrents, lush meadows and the leafy shelters of the birds, into the breasts of one and all you instil alluring

love, so that with passionate longing they reproduce their several breeds.

Since you alone are the guiding power of the universe and without you nothing emerges into the shining sunlit world to grow in joy and

> "This it is that leads me to stay awake through the quiet of the night, studying how by choice of words and the poet's art I can display a clear light by which to gaze into the heart of hidden things."
>
> —Lucretius

loveliness, yours is the partnership I seek in striving to compose these lines *On the Nature of the Universe*. . . . This it is that leads me to stay awake through the quiet of the night, studying how by choice of words and the poet's art I can display a clear light by which to gaze into the heart of hidden things.

This dread and darkness of the mind cannot be dispelled by the sunbeams, the shining shafts of day, but only by an understanding of the outward form and inner workings of nature. In tackling this theme, our starting-point will be this principle: *Nothing can ever be created by divine power out of nothing*. The reason why all mortals are so gripped by fear is that they see all sorts of things happening on the earth and in the sky with no discernible cause, and these they attribute to the will of a god. Accordingly, when we have seen that nothing can be created out of nothing, we shall then have a clearer picture of the path ahead, the problem of how things are created and occasioned without the aid of the gods.

First then, if things were made out of nothing, any species could spring from any source and nothing would require seed. Men could arise from the sea and scaly fish from the earth, and birds could be hatched out of the sky. . . . The same fruits would not grow constantly on the same trees, but they would keep changing: any tree might bear any fruit. . . . Actually, since each species is formed out of specific seeds, it is born and emerges into the sunlit world only from a place where there exists the right material, the right kind of atoms. This is why everything cannot be born of everything, but a specific power of generation inheres in specific objects.

Again, why do we see roses appear in spring, grain in summer's heat, grapes under the spell of autumn? Surely, because it is only after specific seeds have drifted together at their own proper time that every created thing stands revealed, when the season is favorable and the life-giving earth can safely deliver delicate growths into the sunlit world. If they were made out of nothing, they would spring up suddenly after varying lapses of time and at abnormal seasons. . . . Similarly, in order that things might grow, there would be no need of any lapse of time for the accumulation of seed. Tiny tots would turn suddenly into grown men, and trees would shoot up spontaneously out of the earth. But it is obvious that none of these things happens, since everything grows gradually, as is natural, from a specific seed and retains its specific character. It is a fair inference that each is increased and nourished by its own raw material. . . .

The second great principle is this: *Nature resolves everything into its component atoms and never reduces anything to nothing*. If anything were perishable in all its parts, anything might perish all of a sudden and vanish from sight. There would be no need of any force to separate its parts and loosen their links. In actual fact, since everything is composed of indestructible atoms, nature obviously does not allow anything to perish till it has encountered a force that shatters it with a blow or creeps into chinks and unknits it.

If the things that are banished from the scene by age are annihilated through the exhaustion of their material, from what source does Venus bring back the several races of animals into the light of life? And, when they are brought back, where does the inventive earth find for each the special food required for its sustenance and growth? From what fount is the sea replenished by its native springs and the streams that flow into it from afar? Whence does the ether draw nutriment for the stars? For everything consisting of a mortal body must have been exhausted by the long day of time, the illimitable past. If throughout this bygone eternity, there have persisted bodies from which the universe has been perpetually renewed, they must certainly be possessed of immortality. Therefore, things cannot be reduced to nothing.

Consider This:

- What are the two primary principles that Lucretius uses to explain the workings of nature? Are they valid today as scientific axioms?

- Is this a scientific or a literary work? How does Lucretius' poem do justice to both areas? Does his poem reflect or reject the political world in which it was written?

"Let Us Live and Love": The Poetry of Catullus

The poet Catullus (ca. 84–57 B.C.E.) lived his short life amid the turmoil and conflict of the decaying Roman Republic. He was born in Verona, the second son of a wealthy army contractor. He received an excellent education and moved in a circle of young intellectuals, poets, lawyers, and politicians. Within this fashionable set, Catullus was the acknowledged trend-setter, the most desired lover, all-night drinker, and devoted friend. His poetry reflects all the risk, energy, and pathos that seemed to be the daily fare of a group living on the edge of good taste and political survival.

Into this tight circle fluttered Clodia, who as the wife of a rather heavy-handed Roman governor, was connected to the elite senatorial families. Catullus referred to her as "Lesbia" in imitation of the Greek poet, Sappho. Clodia was nearly five years older than Catullus, but intrigued him with her flirtations and defiant independence. The great lover met his match and Catullus's life became a whirlwind of capricious "maybes." He died young and left a legacy of beautiful poetry reflective of the lack of restraint and moral ambiguity of the late Republic.

> "The sun that sets may rise again, but when our light has sunk into the earth, it is gone forever."
>
> —Catullus

5

COME, Lesbia, let us live and love,
nor give a damn what sour old men say.
The sun that sets may rise again
but when our light has sunk into the earth,
it is gone forever.
 Give me a thousand kisses,
then a hundred, another thousand,
another hundred
 and in one breath
still kiss another thousand,
another hundred.
 O then with lips and bodies joined
many deep thousands;
 confuse
their number,
 so that poor fools and cuckolds (envious
even now) shall never

learn our wealth and curse us
with their
evil eyes.

6

FLAVIUS, if your girl friend
were not a little bastard,
you'd be telling your Catullus
all about her charms forever.

Now I know the story:
she's some feverish little bitch
that's warm and sweet and dirty
and you can't get up the nerve
to tell me that you love her.
Not a word! Look at your bed
still trembling with your labors
(tell me that you sleep alone)
sheets soiled with love and flowers,
and why, why?
 Look at your poor loins
all bruised and empty.
No matter who she is or why,
I'll immortalize you
and your dear young lady
in a blushing blissful song
that echoes against heaven.

8

POOR damned Catullus, here's no time for nonsense,
open your eyes, O idiot, innocent boy, look at what has
 happened:
once there were sunlit days when you followed after
where ever a girl would go, she loved with greater
love than any woman knew.
Then you took your pleasure
and the girl was not unwilling. Those were the bright days,
 gone;
now she's no longer yielding; you must be, poor idiot,
more like a man! not running after
her your mind all tears; stand firm, insensitive.
Say with a smile, voice steady, "Good-bye, my girl,"
 Catullus
strong and manly no longer follows you, nor comes when
 you are calling
him at night and you shall need him.
You whore! Where's your man to cling to, who will praise
 your beauty,
where's the man that you love and who will call you his,
and when you fall to kissing, whose lips will you devour?
But always, your Catullus will be as firm as rock is.

85

I HATE and love.
 And if you ask me why,
I have no answer, but I discern,
can feel, my senses rooted in eternal torture.

72

THERE was a time, O Lesbia, when you said Catullus was
 the only man on earth who could understand you,
who could twine his arms round you, even Jove himself less
 welcome.
And when I thought of you, my dear, you were not the mere
 flesh and
the means by which a lover finds momentary rapture.
My love was half paternal, as a father greets his son or
smiles at his daughter's husband.
Although I know you well (too well), my love now turns
 to fire
and you are small and shallow.
Is this a miracle? Your wounds in love's own battle
have made me your companion, perhaps, a greater lover,
 but O, my dear, I'll never be
the modest boy who saw you as a lady, delicate and sweet,
a paragon of virtue.

Dido and Aeneas in the Underworld

VIRGIL

Virgil (70–19 B.C.E.) has been regarded as perhaps the greatest of Roman poets. Born in northern Italy to a rural family, he delighted in nature and in the solid values generated by farming the land. By chance, he met Octavian, who would emerge victorious in Rome's civil wars to become the future emperor Augustus. This was, indeed, a fortuitous linking, because Augustus, in his reorganization of the state, needed a poet to honor and revitalize conservative Roman virtues that had degenerated during the conflicts that destroyed the Roman Republic.

At the height of his fame, Virgil decided to write an epic poem to conjoin a number of confusing myths about the origins of Rome. A glorious nation needed a glorious foundation. The epic would follow the fortunes of Aeneas, Prince of Troy, as he emerged from the burning city with his father on his shoulders, compelled as he was by the gods to found the city of Rome. On the way, Aeneas stopped in North Africa, where he fell in love with the Carthaginian Queen Dido. She gave herself completely to him, but Aeneas, true to his duty and the destiny of Rome, left her abruptly to complete his mission. In her despair, Dido committed suicide, the flames of her funeral bier visible as Aeneas sailed away to found Rome.

The following excerpt finds Aeneas passing through the underworld with the aid of a Sibyl or female seer. The link to Homer's Odyssey is unmistakable as Aeneas, like Odysseus, encountered many of his dead friends and enemies, and even his father. But most tragic was his meeting with Dido. The message was clear: The glory of Rome required supreme sacrifice and loss; but duty and loyalty to the state was the most revered of all Roman values.

Wandering among them in that great wood was Phoenician Dido with her wound still fresh. When the Trojan hero [Aeneas] stopped beside her, recognizing her dim form in the darkness, like a man who sees or thinks he has seen the new moon rising through the clouds at the beginning of the month, in that instant he wept and spoke sweet words of love to her: "So the news they brought me was true, unhappy Dido? They told me you were dead and had ended your life with the sword. Alas! Alas! Was I the cause of your dying? I swear by the stars, by the gods above, by whatever there is to swear by in the depths of the earth, it was against my will, O Queen, that I left your shore. It was the stern authority of the commands of the gods that drove me on, as it drives me now through the shades of this dark night in this foul and moldering place. I could not have believed that my leaving would cause you such sorrow. Do not move away. Do not leave my sight. Who are you running from? Fate has decreed that I shall not speak to you again." With these words Aeneas, shedding tears, tried to comfort that burning spirit, but grim-faced she kept her eyes upon the ground and did not look up at him. Her features moved no more when he began to speak than if she had been a block of flint or Parian marble quarried on Mount Marpessus. Then at last she rushed away, hating him, into the shadows of the wood where Sychaeus, who had been her husband, answered her grief with grief and her love with love. Aeneas was no less stricken by the injustice of her fate and long did he gaze after her, pitying her as she went.

Consider This:

- In this excerpt, Aeneas recognized that he was the cause of Dido's death. How did he rationalize and defend his actions? Aeneas, in fact, was stricken by "the injustice of her fate." How do you interpret this? Was Aeneas a pawn of the gods? What was the point that Virgil was trying to make?

Imperial Rome (27 B.C.E.–500 C.E.)

No one with absolute power can be trusted to give it up even in part.

—Justice Louis D. Brandeis

But you, Roman, must remember that you have to guide nations by your authority, for this is to be your skill, to graft tradition onto peace, to show mercy to the conquered, and to wage war until the haughty are brought low.

—Virgil, *The Aeneid*

As yourselves, your empires fall. And every kingdom hath a grave.

—William Hobbington

The Age of Augustus

By 27 B.C.E., Antony was dead and Octavian, by virtue of his military support, controlled the entire Roman Empire. At this point, he went to the senate and proclaimed that he had restored the Republic. At the request of the senators, he decided to assume the advisory position of princeps *or "first citizen" and the honorary title of "Augustus." The Republic was to function as it had in the past, with voting in the assemblies, election of magistrates, and*

traditional freedom. But as long as Augustus controlled the army, his "advice" could not be safely ignored. His system of government, called the principate, lasted in the same basic form until 180 C.E. Augustus maintained a political equilibrium by stressing his authority, not his blatant military power. He respected the dignity of the senators and their need to feel as if they actually controlled the government; in return, they generally supported his political solutions to the chaos of the Roman Republic. And although some senators grumbled and decried this facade of freedom, nevertheless the system worked for over 200 years. Those succeeding emperors who played the game well, respected the dignity of the senate, and maintained control of the army usually survived and prospered. Those who did not, like the emperors Caligula and Domitian, were assassinated. In the following source, note especially the cynicism of the historian Tacitus, who saw through the facade of republicanism and decried the loss of liberty.

The Transition from Republic to Principate
TACITUS

Augustus won over the soldiers with gifts, the populace with cheap [grain], and all men with the sweets of repose, and so grew greater by degrees, while he concentrated in himself the functions of the Senate, the magistrates, and the laws. He was wholly unopposed, for the boldest spirits had fallen in battle, or in the proscription, while the remaining nobles, the readier they were to be slaves, were raised the higher by wealth and promotion, so that, aggrandised by revolution, they preferred the safety of the present to the dangerous past. Nor did the provinces dislike that condition of affairs, for they distrusted the government of the Senate and the people, because of the rivalries between the leading men and the rapacity of the officials. . . . At home all was tranquil, and there were magistrates with the same titles; there was a younger generation, sprung up since the victory of Actium, and even many of the older men had been born during the civil wars. How few were left who had seen the Republic.

Thus the State had been revolutionized, and there was not a vestige left of the old sound morality. Stripped of equality, all looked up to the commands of a sovereign without the least apprehension for the present, while Augustus in the vigour of life, could maintain his own position, that of his house, and the general tranquility.

Consider This:

- What options for ruling the state did Octavian have after he defeated Antony? What was his political solution to the collapse of the Roman Republic? What are Tacitus's specific criticisms of the Augustan system?

- The Augustan system of government has often been regarded as a "sham," a deception that made the people feel they had control of their government when in fact they did not. Is freedom most importantly a thing of the mind? If the institutions of government are controlled yet *appear* to be free, and if you *feel* that you are free, are you free? How important is it to be truly free? Can you comment on this question using contemporary examples from the world around you?

"The Transition from Republic to Principate" is from Tacitus, *Annals*, 1.2–4, trans. Alfred Church and William Brodribb (New York: Macmillan and Co., 1891).

The Peace of Augustus

HORACE

Propaganda is an important component of the success of any new government or regime. It has been asserted that if people are told things often enough, they will believe them. One of the great accomplishments of the Augustan principate was the establishment and maintenance of a period of peace and stability that lasted for over 200 years. It was during the Pax Romana, or the Roman Peace, as it was called, that Roman roads, aqueducts, and baths were built, the provinces of the empire flourished, the Roman legal system developed, and Christianity grew. Augustus cultivated his poets well; in turn, they celebrated the new order. He is remembered particularly through their efforts, as the following selections indicate.

Phoebus, as I was about to celebrate
battles and cities conquered, twanged on the lyre,
warning me not to hoist a small sail
on the Tuscan sea. Your era, Caesar [Augustus],
has brought plentiful harvests back to the fields,
and restored to our shrine of Jove the banners
torn from the high and mighty poles
of the Parthians, and closed Janus's temple,
for no war was on, and imposed restrictions
on the freedom that wandered beyond proper
boundaries, and expelled wrongdoing,
and recalled the ancestral way of life
by which the Latin name of the power of
Italy grew, and the fame of the empire
and its majesty stretched from the sun's
western bed to the place of his rising.
While the state is in Caesar's [Augustus's] charge, no civil
madness, no disturbance shall drive away peace,
nor shall hatred, that forges its swords
and transforms poor towns into enemies.
Nor shall those who drink the Danube's deep waters
break the Julian laws, nor shall the Getae,
the Seres, the faithless Parthians,
nor those born near the river Tanais.
All of us, on working days and holy days,
among the gifts of laughter-loving Bacchus,
accompanied by wives and children,
will first, as is proper, pray to the gods,
then, in the way of our fathers, to the sound
of Lydian flutes we will hymn our heroes
and their noble achievements and Troy,
Anchises, and kind Venus's descendants.

"To Spare the Conquered and Crush the Proud"

VIRGIL

Now then, I shall describe the future glory that is to attend the Trojan people, the descendants from the Italian people that await you, illustrious souls destined to succeed to our name, and I shall unfold to you your fate. . . . Romulus, son of Mars . . . do you see how a double plume stands on his helmet, and how his father marks him out even now by his distinctive badge as one of the gods? Yes, my son, it is under his auspices that glorious Rome will extend her empire to the ends of the earth and her heroism to the sky, and will encircle together her seven hills with a wall, fortunate in her brood of heroes. . . . Now turn your eyes here, behold this

> "This, this is he, the man you have heard promised to you so often, Augustus Caesar, son of a god, who will once again establish the Golden Age."
> —Virgil

stock, your Romans. Here is Caesar and the whole progeny of Iulus, destined to come under the great vault of the sky. This, this is he, the man you have heard promised to you so often, Augustus Caesar, son of a god, who will once again establish the Golden Age. . . .

Those souls, now, which you see equally agleam in armor, harmonious now and as long as they are confined in darkness, alas! How great a war will they wage against each other if they reach the light of day, what battles, what carnage will ensue, the father-in-law descending from the ramparts of the Alps . . . the son-in-law arrayed against him with the forces of the east! [This is an allusion to the civil war between Pompey and Julius Caesar.] Do not, do not, my children, cherish such wars of your country; and do you first, you who derive your descent from the gods, do you forbear, cast the weapons from your hands, my descendant. . . .

Others, doubtless, will mould lifelike bronze with greater delicacy, will win from marble the look of life, will plead cases better, chart the motions of the sky with the rod and foretell the risings of the stars. You, O Roman, remember to rule the nations with might. This will be your genius—to impose the way of peace, to spare the conquered and crush the proud.

Consider This:

- What role does propaganda have in the success of a new government? In what ways are the previous two selections good examples of propaganda?

- Horace and Virgil have been considered by many classical historians to be outstanding poets, examples of the best Rome had to offer. But some critics have noted that this is great propaganda masquerading as great literature. What do you think? Must great literature speak to the ages and be free of the taint of propaganda?

"All Roads Lead to Rome"

Since the Augustan system of government brought political security to the state, the Roman Empire flourished in peace, a universal peace known as the Pax Romana. *It was during this time that the city of Rome served as the emporium of the world. All roads indeed ended sooner*

"'To Spare the Conquered and Crush the Proud'" is from Virgil, *The Aeneid*, 6.756–853, in *Roman Civilization, Sourcebook II: The Empire*, ed. N. Lewis and M. Reinhold, pp. 23–24. Copyright © 1955 by Columbia University Press. Reprinted by permission of Columbia University Press.

or later in the center of the magnificent city, whose population swelled to a million inhabitants. To hail from the provinces of the empire and to see Rome for the first time must have been a numbing experience. The theaters, baths, sewers, aqueducts, and monuments provided services and entertainment on a magnificent scale. And the spectacle was even more impressive in the Coliseum, where gladiators fought, or in the Circus Maximus, where over 250,000 people could thrill to the chariot races. The following excerpts pay homage to the magnificence of Rome and reveal the advantages and disadvantages of city life.

The Glory of the City
STRABO

[The Romans] paved the roads, cut through hills, and filled up valleys, so that the merchandise may be conveyed by carriage from the ports. The sewers, arched over with hewn stones, are large enough in parts for actual hay wagons to pass through, while so plentiful is the supply of water from the aqueducts, that rivers may be said to flow through the city and the sewers, and almost every house is furnished with water pipes and copious fountains.

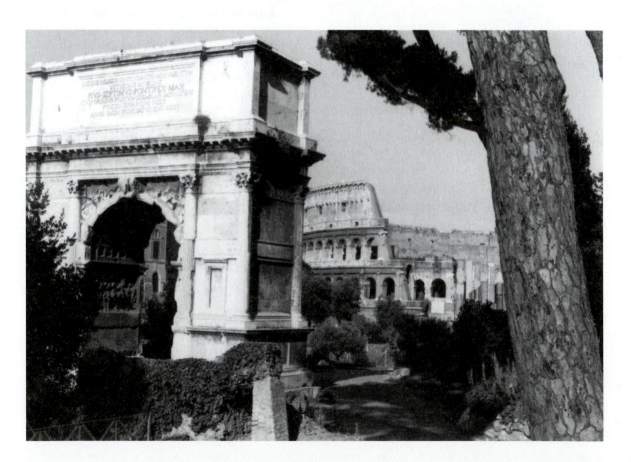

Figure 3–2 A view of the Arch of Titus and the magnificent Roman Coliseum beyond. Each successive building "caused you speedily to forget that which you have seen before. Such then is Rome!"—Strabo (Perry M. Rogers).

"The Glory of the City" is from Strabo, *Geography*, 5.3.8, in *Readings in Ancient History*, vol. 2, ed. William S. Davis (Boston: Allyn and Bacon, 1913), pp. 179–181.

We may remark that the ancients [of Republican times] bestowed little attention upon the beautifying of Rome. But their successors, and especially those of our own day, have at the same time embellished the city with numerous and splendid objects. Pompey, the Divine Caesar [i.e., Julius Caesar], and Augustus, with his children, friends, wife, and sister have surpassed all others in their zeal and munificence in these decorations. The greater number of these may be seen in the Campus Martius which to the beauties of nature adds those of art. The size of the plain is remarkable, allowing chariot races and the equestrian sports without hindrance, and multitudes [here] exercise themselves with ball games, in the Circus, and on the wrestling grounds. . . . The summit of the hills beyond the Tiber, extending from its banks with panoramic effect, present a spectacle which the eye abandons with regret.

Near to this plain is another surrounded with columns, sacred groves, three theaters, an amphitheater, and superb temples, each close to the other, and so splendid that it would seem idle to describe the rest of the city after it. For this cause the Romans esteeming it the most sacred place, have erected funeral monuments there to the illustrious persons of either sex. The most remarkable of these is that called the "Mausoleum" [the tomb of Augustus] which consists of a mound of earth raised upon a high foundation of white marble, situated near the river, and covered on the top with evergreen shrubs. Upon the summit is a bronze statue of Augustus Caesar, and beneath the mound are the funeral urns of himself, his relatives, and his friends. Behind is a large grove containing charming promenades. . . . If then you proceed to visit the ancient Forum, which is equally filled with basilicas, porticoes, and temples, you will there behold the Capitol, the Palatine, and the noble works that adorn them, and the piazza of Livia [Augustus's Empress],—each successive work causing you speedily to forget that which you have seen before. Such then is Rome!

The Architectural Foundation

THE AQUEDUCT: PONT DU GARD

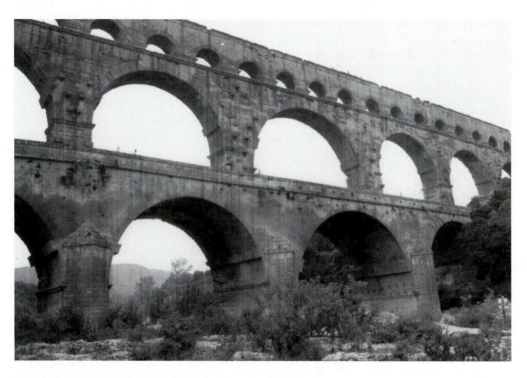

Figure 3–3 Pont du Gard (Perry M. Rogers).

The magnificence of Rome and its reputation as "emporium to the world" shone through its impressive architecture. The imposing majesty of the Coliseum and the Circus Maximus, the Pantheon, law courts, and triumphal arches—all testified to the consolidation of Roman power. This massive architecture was designed to dazzle, even as the buildings provided practical services for the people of Rome.

But Roman architecture was, most important, based on a Roman engineering genius. Roads, some of which are still used today, linked the empire from the misty forests of Germany in the north to Pontus on the Black Sea and to Alexandria at the mouth of the Nile in Egypt. Just as trade and the defense of Rome relied on this network of roads, so too did the health of the urban population depend on the infrastructure of sewer systems that eliminated waste and reduced disease.

But the most impressive demonstration of Roman engineering genius, the perfect union of form and function, can be found in the magnificent system of aqueducts that

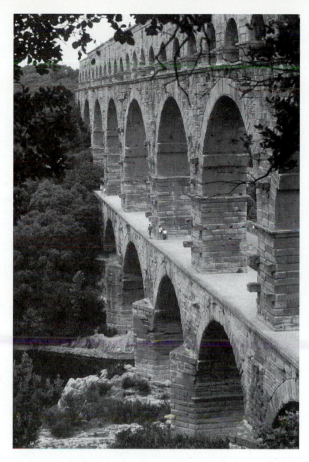

transported water for hundreds of miles throughout the Roman empire. The most famous of these, and perhaps the most majestic of all Roman ruins, was the Pont du Gard in southern France. It was constructed beginning about 20 B.C.E. by Marcus Agrippa, a general and close friend of the emperor Augustus, to transport water down a carefully calculated grade to the city of Nimes across the river Gard from a natural spring almost fifty kilometers to the north. Rome itself was supplied by several aqueducts that brought water directly into the emperor's apartments on the Palatine Hill and to the imposing Baths of Caracalla.

Figure 3–4 Pont du Gard Detail (Perry M. Rogers).

Keep in Mind:

- What was the function of a Roman aqueduct? What are the most evident architectural components of the Pont du Gard?

- Why might the Pont du Gard be considered a perfect union of form and function in Roman architecture? In what ways was it both a necessary part of the infrastructure serving the needs of the public and an artistic expression of Roman stability and power?

The Magnificence of the Baths

LUCIAN

The following description by the satirist and rhetorician Lucian about 150 C.E. helps us appreciate what an integral part the baths played in the social life of Rome and its provinces—all made possible by great aqueducts like the Pont du Gard.

"The Magnificence of the Baths" is reprinted by permission of the publishers and the Loeb Classical Library from Lucian, *Hippias*, trans. A. M. Harmon, vol. 1 (Cambridge, Mass.: Harvard University Press, 1913), pp. 39, 41, 43.

On entering [the baths], one is received into a public hall of good size, with ample accommodation for servants and attendants. On the left are the lounging rooms, also of just the right sort for a bath, attractive, brightly lighted retreats. Then, besides them, a hall, larger than need be for the purposes of a bath, but necessary for the reception of richer persons. Next, . . . locker rooms to undress in, on each side, with a very high and brilliantly lighted hall between them, in which are three swimming pools of cold water; it is finished in Laconian marble, and has two statues of white marble in the ancient style. . . .

On leaving this hall, you come into another which is slightly warmed instead of meeting you at once with fierce heat; it is oblong, and has an apse on each side. Next to it, on the right, is a very bright hall, nicely fitted up for massage, which has on each side an entrance decorated with Phrygian marble, and receives those who come in from the exercising floor. Then near this is another hall, the most beautiful in the world, in which one can stand or sit with comfort, linger without danger, and stroll about with profit. It also is resplendent with Phrygian marble clear to the roof. Next comes the hot corridor, faced with Numidian marble. The hall beyond it is very beautiful, full of abundant light and aglow with color like that of purple hangings. It contains three hot tubs.

When you have bathed, you need not go back through the same rooms, but can go directly to the cold room through a slightly warmed chamber. Everywhere there is copious illumination and full indoor daylight. . . . Why should I go on to tell you of the exercising floor and of the cloak rooms? . . . Moreover, it is beautified with all other marks of thoughtfulness—with two toilets, many exits, and two devices for telling time, a water clock that makes a bellowing sound and a sundial.

Consider This:

- In what ways did the public bath serve both the hygienic and social needs of the Romans? How important was the aqueduct to the continuity and progress of Roman civilization?

The Dark Side of Rome
JUVENAL

I cannot bear, Romans, a Greek Rome; and yet, how small a portion of our dregs is from Greece! Long since, Syrian Orontes [a river] has flowed into the Tiber, and has brought with it its language and manners. . . . The coming of the Greek has brought us a Jack-of-all-trades—grammarian, rhetorician, geometrician, painter, wrestling manager, prophet, rope-walker, physician, magician; he knows everything. Bid the hungry Greekling go to heaven, he will go. . . . The poor among the Romans ought to have migrated in a body long ago. Not easily do those emerge from obscurity whose noble qualities are cramped by domestic poverty. But at Rome the attempt is still harder for them; a great price must be paid for a wretched lodging,

> "In Rome, everything costs money . . ."
>
> —Juvenal

a great price for slaves's keep, a great price for a modest little dinner. A man is ashamed to dine off earthenware. . . . Here splendour of dress is carried beyond people's means; here something more than is enough is occasionally borrowed from another man's strongbox. This vice is common to all of us; here all of us live in a state of pretentious poverty. In a word, in Rome everything costs money. . . .

"The Dark Side of Rome" is from Juvenal, *Satires*, 3, trans. J. D. Lewis (London: Trubner, 1873).

Many a sick man dies here from want of sleep, the sickness itself having been produced by undigested food clinging to the fevered stomach. For what rented lodgings allow of sleep? It takes great wealth to sleep in the city. Hence the origin of the disease. The passage of carriages in the narrow winding streets, and the abuse of the drivers of the blocked teams would rob even [the heaviest sleepers] of sleep.

If a social duty calls him, the rich man will be carried through the yielding crowd and will speed over their heads on his huge Liburnian litter bearers; he will read on his way, or write, or even sleep inside, for a litter with closed windows induces sleep. Yet he will arrive before us. We in our hurry are impeded by the wave in front, while the multitude which follows us presses on our back in dense array; one strikes me with his elbow, another with a hard pole, one knocks a beam against my head, another a wine jar. My legs are sticky with mud; before long I am trodden on all sides by large feet, and the hobnails of a soldier stick into my toe. . . .

Observe now the different and varied dangers of the night. What a height it is to the lofty roofs, from which a tile brains you, and how often cracked and broken utensils fall from windows—with what a weight they mark and damage the pavement when they strike it! You may well be accounted remiss and improvident about sudden accidents if you go out to supper without making a will. There are just so many fatal chances as there are wakeful windows open at night when you are passing by. Hope, then, and carry this pitiable prayer about with you, that they may be content merely to empty broad wash basins over you.

"Bread and Circuses"

FRONTO

The emperors were very careful not to neglect the basic needs of the inhabitants of Rome.

> ## "The people demanded entertainment, and Rome responded . . ."
> ### —Fronto

Since an idle population was prone to boredom and rioting, the emperors promoted building programs that not only increased the glory of the city but also employed the masses. A sizable number of citizens were on the grain dole, a welfare program, that offered free grain for those who could not afford to buy it. It was therefore essential that grain ships arrived from Egypt on a regular basis, for a hungry populace was also prone to disturbance. Finally, the people demanded entertainment, and Rome responded with gladiatorial games in the Coliseum and chariot races in the Circus Maximus. The Circus was especially popular and could hold 250,000 people at one time—a quarter of the population of Rome! "Bread and Circuses" were the essential ingredients of harmony in the great city.

It was the height of political wisdom for the emperor not to neglect even actors and the other performers of the stage, the circus, and the arena, since he knew that the Roman people is held fast by two things above all, the grain supply and the shows, that the success of the government depends on amusements as much as on serious things. Neglect of serious matters entails the greater detriment, of amusements the greater unpopularity. The money largesses are less eagerly desired than the shows; the largesses appease only the grain-doled plebs singly and individually, while the shows keep the whole population happy.

" 'Bread and Circuses' " is from Fronto, *Elements of History*, 17, in *Roman Civilization, Sourcebook II: The Empire*, ed. N. Lewis and M. Reinhold (New York: Columbia University Press, 1955), pp. 229–230. Copyright © 1955 by Columbia University Press. Reprinted by permission of Columbia University Press.

"The Give and Take of Death": Gladiatorial Combat
SENECA

By chance I attended a mid-day exhibition, expecting some fun, wit, and relaxation—an exhibition at which men's eyes have respite from the slaughter of their fellow-men. But it was quite the reverse. The previous combats were the essence of compassion; but now all the trifling is put aside and it is pure murder. The men have no defensive armour. They are exposed to blows at all points, and no one ever strikes in vain. . . . In the morning they throw men to the lions and the bears; at noon, they throw them to the spectators. The spectators demand that the slayer shall face the man who is to slay him in his turn; and they always reserve the latest conqueror for another butchering. The outcome of every fight is death, and the means are fire and sword. This sort of thing goes on while the arena is empty. You may retort: "But he was a highway robber; he killed a man!" And what of it? Granted that, as a murderer, he deserved this punishment, what crime have you committed, poor fellow, that you should deserve to sit and see this show? In the morning they cried "Kill him! Lash him! Burn him! Why does he meet the sword in so cowardly a way? Why does he strike so feebly? Why doesn't he die game? Whip him to meet his wounds! Let them receive blow for blow, with chests bare and exposed to the stroke!" And when the games stop for the intermission, they announce: "A little throat-cutting in the meantime, so that there may still be something going on!"

Consider This:

- Discuss some of the benefits and drawbacks of life in imperial Rome. Do you consider the Romans barbaric because they often enjoyed such sports as chariot racing or gladiatorial combat? Can you think of any modern parallels to such activity in our own society?

Social Mobility: "Once a Mere Worm, Now a King"
PETRONIUS

Rome was a slave-holding society; it had obtained thousands of slaves during the Republic as spoils of conquest. Despite the decrease in war captives during the Pax Romana, there was still a thriving slave trade. The philosopher and politician Seneca commented, "On one occasion, a proposal was made by the senate to distinguish slaves from freemen by their dress; it then became apparent how great would be the impending danger if our slaves began to count our number." Slaves generally led a life of toil without many benefits; a slave in the mines might last a couple of years. Still, domestic service was often pleasant, and educated slaves from Greece became trusted tutors or accountants. Although the Romans feared slave rebellions, they passed legislation designed to regulate the treatment of slaves. In fact, Romans generally respected their slaves and often granted manumission. When a slave became a freedman, he gained in social stature and, with knowledge of a trade, could even make a fortune (as did Trimalchio in the selection below) or control the strings of political power; the emperors were often supported (or dominated in the case of the emperor Claudius) by their freedmen.

"'The Give and Take of Death'" is reprinted by permission of the publishers and the Loeb Classical Library from Seneca, *Moral Epistles*, 7.3–5, trans. Richard Gummere, vol. 1 (Cambridge, Mass.: Harvard University Press, 1917), pp. 31, 33.

"Social Mobility" is from Petronius, *Satyricon*, 65.8–67.6, in *Petronii Cena Trimanchionis*, trans. W. D. Lowe (Cambridge, England: Cambridge University Press, 1905).

Come, my friends, make yourselves at home. I too was once just like you, but by my ability I've reached my present position. What makes man is the heart, the rest is all trash. "I buy well, and I sell well;" others have different ideas. I am ready to burst with good luck. . . . My good management brought me to my present good fortune. I was only as big as the candlestick here when I came from Asia, in fact I used to measure myself by it every day and I smeared my lips with the lamp oil to get a hairy face quicker. Still for fourteen years I was my

> **"What makes man is the heart, the rest is all trash."**
> **—Trimalchio**

master's favorite. And where's the disgrace in doing what one's master tells one? All the same I managed to get into my mistress's good graces, too (you know what I mean: I hold my tongue, as I am not one to boast).

But by heaven's help I became master in the house, and then I took in my fool of a lord. To be brief, he made me co-heir with the emperor to his property, and I got a senator's fortune. But no one is ever satisfied, and I wanted to go into business. To cut it short, I built five ships, I loaded them with a cargo of wine—it was worth its weight in gold at that time—and I sent it to Rome. You would have thought I had ordered my bad luck: every ship was wrecked; it's a fact, no story. . . . Do you think I failed? No, I swear the loss only whetted my appetite as if nothing had happened. I built more ships, larger, better, and luckier ones, and everybody called me a courageous man—you know, a great ship shows great strength. I loaded them with wine again, bacon fat, beans, perfume, and slaves. . . . On one voyage I cleared around 10,000,000 sesterces. I immediately bought back all the estates that had belonged to my patron. I built a mansion, I bought up young slaves to sell, and beasts of burden: everything I touched grew like a honeycomb.

Once I was worth more than my whole native town put together, I quit the game: I retired from business and started lending money, financing freedmen. . . . I'll have done well enough in my lifetime. Meantime, with Mercury watching over me, I built this residence. As you know, it was a cottage; now it's fit for a god. It's got four dining rooms, twenty bedrooms, two marble colonnades, and the upstairs apartments, my own bedroom where I sleep, . . . an excellent porter's lodge, and enough guest rooms for all my guests. . . . And there are lots of other things, which I'll show you presently. Believe me, have a penny, you're worth a penny; have something, you'll be treated like something. And so your friend, once a mere worm, is now a king.

Consider This:

- Why do you think that Romans held slaves? Did they treat their slaves well? What does Trimalchio's status as a freedman say about mobility in Roman society?

The Stoic Philosophy

The Romans were never known for their contributions to abstract thought and did not produce a unique philosophy. Still, they borrowed well and adapted ideas that complemented their values. For the Roman, duty and organization were particularly important; consequently, the Stoic philosophy, which had originated in Greece in the third century B.C.E., was especially popular among the aristocracy. According to Stoic tenets, a divine plan ordered the universe, so whatever lot or occupation fell to one in life should be accepted and coped with appropriately. Restraint and moderation characterized the ideal Stoic, and he advocated tolerance as an essential component of the "brotherhood of man." To a Stoic who felt that his honor was somehow compromised, suicide was an acceptable and dutiful way of preserving his dignity. The following selections come from the writings of three Stoics of diverse backgrounds. Epictetus was the slave of a rich freedman; Seneca was tutor to the emperor Nero and finally committed suicide at his command in 66 C.E.; Marcus Aurelius became emperor in 161 C.E., an occupation he did not seek, but dutifully executed.

"How Will I Die"?
EPICTETUS

I must die: if instantly, I will die instantly; if in a short time, I will dine first; and when the hour comes, then I will die. How? As becomes one who restores what is not his own.

Do not you know that both sickness and death must overtake us? At what employment? The husbandman at his plough; the sailor on his voyage. At what employment would you

> "I would be found engaged in nothing but in the regulation of my own Will; how to render it undisturbed, unrestrained, uncompelled, free."
> —Epictetus

be taken? For my own part, I would be found engaged in nothing but in the regulation of my own Will; how to render it undisturbed, unrestrained, uncompelled, free. I would be found studying this, that I may be able to say to God, "Have I transgressed Thy commands? Have I perverted the powers, the senses, the instincts, which Thou hast given me? Have I ever accused Thee, or censured Thy dispensations? I have been sick, because it was Thy pleasure, like others; but I willingly. I have been poor, it being Thy will; but with joy. I have not been in power, because it was not Thy will; and power I have never desired. Hast Thou ever seen me saddened because of this? Have I not always approached Thee with a cheerful countenance; prepared to execute Thy commands and the indications of Thy will? Is it Thy pleasure that I should depart from this assembly? I depart. I give Thee all thanks that Thou hast thought me worthy to have a share in it with Thee; to behold Thy works, and to join with Thee in comprehending Thy administration." Let death overtake me while I am thinking, while I am writing, while I am reading such things as these.

"What Is the Principal Thing in Life?"
SENECA

What is the principal thing in human life? . . . To raise the soul above the threats and promises of fortune; to consider nothing as worth hoping for. For what does fortune possess worth setting your heart upon? . . . What is the principal thing? To be able to endure adversity with a joyful heart; to bear whatever occurs just as if it were the very thing you desired to have happen to you. For you would have felt it your duty to desire it, had you known that all things happen by divine decree. Tears, complaints, lamentations are rebellion [against divine order]. . . .

What is the principal thing? To have life on the very lips, ready to issue when summoned. This makes a man free, not by right of Roman citizenship but by right of nature. He is, moreover, the true freeman who has escaped from bondage to self; that slavery is constant and unavoidable—it presses us day and night alike, without pause, without respite. To be a slave to self is the most grievous kind of slavery; yet its fetters may easily be struck off, if you will cease to make large demands upon yourself, if you will cease to seek a personal reward for your services, and if you will set before your eyes your nature and your age, even though it be the bloom of youth; if you will say to yourself, "Why do I rave, and pant, and sweat? Why do I ply the earth? Why do I haunt the Forum? Man needs but little, and that not for long."

"How Will I Die?" is from T. W. Higginson, ed., *The Works of Epictetus* (Boston: Little, Brown, 1886).

"What Is the Principal Thing in Life?" is from Seneca, *Natural Questions*, 3. Preface, 10–17, trans. J. Clarke (London, 1910).

Meditations

MARCUS AURELIUS

1. He who acts unjustly acts impiously. For since the universal nature has made rational animals for the sake of one another to help one another according to their deserts, but in no way to injure one another, he who transgresses her will, is clearly guilty of impiety towards the highest divinity. And he too who lies is guilty of impiety to the same divinity; for there is a universal nature of things that are; and things that are have a relation to all things that come into existence.

2. It would be a man's happiest lot to depart from mankind without having had any taste of lying and hypocrisy and luxury and pride. However, to breathe out one's life when a man has had enough of these things is the next best voyage, as the saying goes. . . .

> **"Do not despise death, but be well content with it."**
> **—Marcus Aurelius**

3. Do not despise death, but be well content with it, since this too is one of those things which nature wills. For such as it is to be young and to grow old, and to increase and to reach maturity, and to have teeth and beard and grey hairs, and to beget, and to be pregnant and to bring forth, and all the other natural operations which the seasons of thy life bring, such also is dissolution. This, then, is consistent with the character of a reflecting man, to be neither careless nor impatient nor contemptuous with respect to death, but to wait for it as one of the operations of nature. . . .

4. Wipe out imagination: check desire: extinguish appetite: keep the ruling faculty in its own power.

Consider This:

- Pick out specific passages from the selections on Stoicism that reflect the tenets of that philosophy as described in the section introduction. Why can this be considered a philosophy compatible with Roman values?

"Meditations" is from Marcus Aurelius, *Meditations*, trans. George Long (London: The Chesterfield Library, 1862), pp. 241–242, 253.

The Artistic Vision

THE GOOD LIFE . . . AND DEATH IN POMPEII

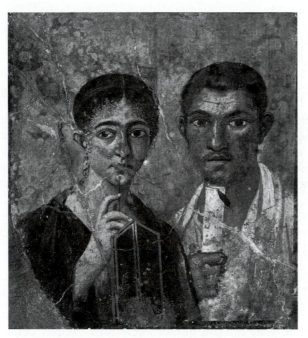

Figure 3–5 *Paquius Proculus and His Wife* (Art Resource, N.Y.).

Living the "good life" (if not always morally, then financially) was very important to the Roman aristocracy. But the despotic rule of the emperor Nero from 54 to 68 terrorized the Roman nobility throughout Italy. They had much to fear from the emperor's rapacious nature that threatened their wealth and authority. But the middle class enjoyed a period of growing prosperity as they garnered wealth and prestige from the trade and the service industry that developed in coastal cities like Pompeii on the Bay of Naples.

This fresco of a man and woman by an anonymous master in the mid-first century was found in the house of Paquius Proculus, a prosperous baker whose shop was next door. There is a security evident in the portrait as the couple appear relaxed and confident, confirmed in their status as working pillars of the community. The man holds a cylinder scroll pensively to his chin and his wife delicately handles a stylus, perhaps used to keep accounts on the wax tablet. Her feminine grace is reflected in her elegant neck, earrings, and the curls that frame her forehead. The couples' eyes are large and wide set, intelligent, refined, as if they are actually viewing us, searching our character, and gauging our worth. This intimate portraiture, influenced as it was by Etruscan art and Hellenistic painting styles, was characteristic of many of the frescoes from that period.

The Destruction of Pompeii (79 C.E.)

PLINY THE YOUNGER

But the "good life" in Pompeii was fragile, indeed. One of the most famous incidents in an-tiquity was the eruption of the volcano Vesuvius on August 24, 79 C.E. The accompanying earthquakes destroyed several villages, including the cities of Herculaneum and Pompeii. Both have yielded magnificent ruins that were well preserved because they were buried under rich volcanic ash. In Pompeii, once a thriving port city of about 25,000 people, we can glimpse life as it was just before the tragedy occurred. The graffiti that adorned the walls of the city give testimony to a vibrant political life and a "service-oriented" community that catered to traders and sailors. A rare eyewitness account of the destruction of the city, given by Pliny the Younger, follows.

Meanwhile on Mount Vesuvius broad sheets of fire and leaping flames blazed at several points, their bright glare emphasized by the darkness of night. . . . The buildings were now shaking with violent shocks, and seemed to be swaying to and fro as if they were torn from their foundations. . . . There was the danger of falling pumice-stones, even though these were light and porous. . . . As a protection against falling objects they put pillows on their heads tied down with cloths.

Elsewhere there was daylight by this time, but they were still in darkness, blacker and denser than any night that ever was, which they relieved by lighting torches and various kinds of lamps. . . .

My mother hurried into my room and found me already getting up to wake her if she were still asleep. We sat down in the forecourt of the house, between the buildings and the sea close by. . . . The buildings round us were already tottering, and the open space we were in was too small for us not to be in real and imminent danger if the house collapsed. This fi-nally decided us to leave the town. We were followed by a panic-stricken mob of people wanting to act on someone else's decision in preference to their own (an element in fear which is like prudence), who hurried us on our way by pressing hard behind in a dense crowd. Once beyond the buildings we stopped, and there we had some extraordinary expe-riences which thoroughly alarmed us. The carriages we had ordered to be brought out began to run in different directions though the ground was quite level, and would not remain sta-tionary even when wedged with stones. We also saw the sea sucked away and apparently forced back by the earthquake: at any rate it receded from the shore so that quantities of sea creatures were left stranded on dry sand. On the landward side a fearful black cloud was rent by forked and quivering bursts of flame, and parted to reveal great tongues of fire, like flashes of lightening magnified in size. . . .

> "We shall be knocked down and trampled underfoot in the dark by the crowd behind!"
>
> —Pliny the Younger

Soon afterwards the cloud sank down to earth and covered the sea; it had already blotted out Capri and hidden the promon-tory of Misenum from sight. Then my mother implored, entreated, and com-manded me to escape, whereas she was old and slow and could die in peace so long as she had not been the cause of my death too. I told her I refused to save myself without her, and grasping her hand forced her to quicken her pace. She gave in reluctantly, blaming

"The Destruction of Pompeii" is reprinted by permission of the publishers and the Loeb Classical Library from Pliny the Younger, *Letters*, 6.16, 6.20, trans. Betty Radice, vol. 1 (Cambridge, Mass.: Harvard University Press, 1969), pp. 431, 443, 445, 447. The Loeb Classical Library ® is a registered trademark of the President and Fellows of Harvard College.

herself for delaying me. Ashes were already falling, not as yet very thickly. I looked round: a dense black cloud was coming up behind us, spreading over the earth like a flood. "Let us leave the road while we can still see," I said, "or we shall be knocked down and trampled underfoot in the dark by the crowd behind." We had scarcely sat down to rest when darkness fell, not the dark of a moonless or cloudy night, but as if the lamp had been put out in a closed room. You could hear the shrieks of women, the wailing of infants, and the shouting of men; some were calling their parents, others their children or their wives, trying to recognize them by their voices. People bewailed their own fate or that of their relatives, and there were some who prayed for death in their terror of dying. Many besought the aid of the gods, but still more imagined there were no gods left and that the universe was plunged into eternal darkness for evermore. . . . A gleam of light returned, but we took this to be a warning of the approaching flames rather than daylight. However, the flames remained some distance off; then darkness came on once more and ashes began to fall again, this time in heavy showers. We rose from time to time and shook them off, otherwise we should have been buried and crushed beneath their weight. . . .

At last the darkness thinned and dispersed into smoke or cloud; then there was genuine daylight, and the sun actually shone out, but yellowish as it is during an eclipse. We were terrified to see everything changed, buried deep in ashes like snowdrifts.

Compare and Contrast:

- Compare the relaxed, confident portrait of the man and his wife with the violent cataclysm that perhaps took their lives. Why was this portrait, which gives us such insight into the society of Pompeii, so well preserved?

Caesar and Christ

Christianity, above all, has given a clear-cut answer to the demands of the human soul.

—Alexis Carrel

The blood of martyrs is the seed of the Church.

—Tertullian

The tyrant dies and his rule ends, the martyr dies and his rule begins.

—Søren Kierkegaard

So urgent . . . is the necessity of believing, that the fall of any system of mythology will probably be succeeded by the introduction of some other mode of superstition.

—Edward Gibbon

An important stabilizing force on Roman society was religion. The Romans had traditionally considered religion an important part of the prosperity of the state. They had established an intricate system of worship that employed nature gods, pagan deities syncretized from the Greeks, and a priesthood that saw to it the state enjoyed a close relationship with the gods by divining the future through the reading of animal entrails and the interpretation of omens. The state religion during the first century C.E. also came to include the worship of the emperor. Sacrifices to his health, however, were primarily patriotic in nature and did not demand or even encourage the emotional involvement of the people. For such satisfaction, many turned to the consoling logic

of philosophy, the emotional excitement of oriental mystery cults, or to a new religion established in the early first century—Christianity.

The growth of Christianity from an obscure Jewish sect to the official religion of the Roman Empire during the first through fourth centuries is one of the most fascinating dramas in history. But success for Christianity did not come easily. In addition to facing competition from religious cults and philosophies, Christianity labored under misunderstandings fostered by anti-Christian propaganda. The Roman state was concerned not only with what was described as a morally dissolute religion, but perhaps most of all with the threat Christianity posed to the political stability of the state. Christians refused to worship the emperor (merely a token of political allegiance), and their talk of a "messiah" and a "kingdom" connoted political unrest and agitation. Rome tried to punish and even eradicate the religion in sporadic persecutions (Nero in 64, Decius in 250, Diocletian and Galerius from 303 to 311), but Roman policy was often confused and ambivalent. By 311, Christianity was tolerated and later endorsed by the Emperor Constantine. By the end of the fourth century, Christianity had become the official religion of the Roman Empire.

The Message of Jesus

The New Testament of the Bible records the life of Jesus in four Gospels (Matthew, Mark, Luke, and John), the Acts of the Apostles, 21 Epistles (didactic letters), and the Book of Revelation. The New Testament is the primary source for the teaching of Jesus, who was crucified by the Romans about 30 C.E. The following excerpts relate some of the more pacifistic Christian beliefs regarding love, sympathy, forgiveness, and the nature of the Kingdom of God.

The Baptism of Jesus

Jesus left Galilee and went to the Jordan River to be baptized by John. But John kept objecting and said, "I ought to be baptized by you. Why have you come to me?" Jesus answered, "For now this is how it should be, because we must do all that God wants us to do." Then John agreed.

So Jesus was baptized. And as soon as he came out of the water, the sky opened, and he saw the Spirit of God coming down on him like a dove. Then a voice from heaven said, "This is my own dear Son, and I am pleased with him." . . .

Then Jesus started preaching, "Turn back to God! The kingdom of heaven will soon be here."

The Sermon on the Mount

Jesus Teaches, Preaches, and Heals

Jesus went all over Galilee, teaching in the Jewish meeting places and preaching the good news about God's kingdom. He also healed every kind of disease and sickness. News about him spread all over Syria, and people with every kind of sickness or disease were brought to him. Some of them had a lot of demons in them, others were thought to be crazy, and still others could not walk. But Jesus healed them all. Large crowds followed Jesus from Galilee and the region around the ten cities known as Decapolis. They also came from Jerusalem, Judea, and from across the Jordan River.

"The Baptism of Jesus" is from Matthew 3:13–17; 4:17, from the *Good News New Testament, The New Testament in Today's English Version*, 6th ed. (1992). Copyright © American Bible Society 1966, 1971, 1976, 1992. Reprinted by permission. All subsequent references to the New Testament are reprinted from this translation.

"The Sermon on the Mount" is from Matthew 4:23–25; 5:1–25; 5:38–48, 6:5–15.

The Beatitudes

When Jesus saw the crowds, he went up on the side of a mountain and sat down. Jesus' disciples gathered around him, and he taught them: God blesses those people who depend only on him. They belong to the kingdom of heaven! God blesses those people who grieve. They will find comfort! God blesses those people who are humble. The earth will belong to them! God blesses those people who want to obey him more than to eat or drink. They will be given what they want! God blesses those people who are merciful. They will be treated with mercy! God blesses those people whose hearts are pure. They will see him! God blesses those people who make peace. They will be called his children! God blesses those people who are treated badly for doing right. They belong to the kingdom of heaven. God will bless you when people insult you, mistreat you, and tell all kinds of evil lies about you because of me.

Be happy and excited! You will have a great reward in heaven. People did these same things to the prophets who lived long ago.

Salt and Light

You are like salt for everyone on earth. But if salt no longer tastes like salt, how can it make food salty? All it is good for is to be thrown out and walked on. You are like light for the whole world. A city built on top of a hill cannot be hidden, and no one would light a lamp and put it under a clay pot. A lamp is placed on a lampstand, where it can give light to everyone in the house. Make your light shine, so that others will see the good that you do and will praise your Father in heaven.

The Law of Moses

Don't suppose that I came to do away with the Law and the Prophets. I did not come to do away with them, but to give them their full meaning. Heaven and earth may disappear. But I promise you that not even a period or comma will ever disappear from the Law. Everything written in it must happen. If you reject even the least important command in the Law and teach others to do the same, you will be the least important person in the kingdom of heaven. But if you obey and teach others its commands, you will have an important place in the kingdom. You must obey God's commands better than the Pharisees and the teachers of the Law obey them. If you don't, I promise you that you will never get into the kingdom of heaven.

Anger

You know that our ancestors were told, "Do not murder" and "A murderer must be brought to trial." But I promise you that if you are angry with someone, you will have to stand trial. If you call someone a fool, you will be taken to court. And if you say that someone is worthless, you will be in danger of the fires of hell. So if you are about to place your gift on the altar and remember that someone is angry with you, leave your gift there in front of the altar. Make peace with that person, then come back and offer your gift to God.

Revenge

You know that you have been taught, "An eye for an eye and a tooth for a tooth." But I tell you not to try to get even with a person who has done something to you. When someone slaps your right cheek, turn and let that person slap your other cheek. If someone sues you for your shirt, give up your coat as well. If a soldier forces you to carry his pack one mile, carry it two miles. When people ask you for something, give it to them. When they want to borrow money, lend it to them.

Love

You have heard people say, "Love your neighbors and hate your enemies." But I tell you to love your enemies and pray for anyone who mistreats you. Then you will be acting like your Father in heaven. He makes the sun rise on both good and bad people. And he sends rain for the ones who do right and for the ones who do wrong. If you love only those people who love you, will God reward you for that? Even tax collectors love their friends. If you greet only your friends, what's so great about that? Don't even unbelievers do that? But you must always act like your Father in heaven.

Prayer

When you pray, don't be like those show-offs who love to stand up and pray in the meeting places and on the street corners. They do this just to look good. I can assure you that they already have their reward. When you pray, go into a room alone and close the door. Pray to your Father in private. He knows what is done in private, and he will reward you. When you pray, don't talk on and on as people do who don't know God. They think God likes to hear long prayers. Don't be like them. Your Father knows what you need before you ask. You should pray like this:

> Our Father in heaven,
> help us to honor your name.
> Come and set up your kingdom,
> so that everyone on earth will obey you, as you are obeyed in heaven.
> Give us our food for today.
> Forgive us for doing wrong, as we forgive others.
> Keep us from being tempted and protect us from evil.

If you forgive others for the wrongs they do to you, your Father in heaven will forgive you. But if you don't forgive others, your Father will not forgive your sins.

The Good Samaritan

An expert in the Law of Moses stood up and asked Jesus a question to see what he would say. "Teacher," he asked, "what must I do to have eternal life?" Jesus answered, "What is written in the Scriptures? How do you understand them?" The man replied, "The Scriptures say, 'Love the Lord your God with all your heart, soul, strength, and mind.' They also say, 'Love your neighbors as much as you love yourself.'" Jesus said, "You have given the right answer. If you do this, you will have eternal life."

But the man wanted to show that he knew what he was talking about. So he asked Jesus, "Who are my neighbors?" Jesus replied: "As a man was going down from Jerusalem to Jericho, robbers attacked him and grabbed everything he had. They beat him up and ran off, leaving him half dead. A priest happened to be going down the same road. But when he saw the man, he walked by on the other side. Later a temple helper came to the same place. But when he saw the man who had been beaten up, he also went by on the other side. A man from Samaria then came traveling along that road. When he saw the man, he felt sorry for him and went over to him. He treated his wounds with olive oil and wine and bandaged them. Then he put him on his own donkey and took him to an inn, where he took care of him. The next morning he gave the innkeeper two silver coins and said, 'Please take care of the man. If you spend more than

"The Good Samaritan" is from Luke 10:25–37.

this on him, I will pay you when I return.'" Then Jesus asked, "Which one of these three people was a real neighbor to the man who was beaten up by robbers?" The teacher answered, "The one who showed pity." Jesus said, "Go and do the same!"

The Mission of Jesus

One of the more difficult regions of the empire for the Roman government to manage was the province of Judea. Encompassing the Jewish homeland, it was a continual hotbed of disagreement and dissatisfaction. The career of a Roman administrator might easily be placed in jeopardy if he failed to maintain peace. Although much of this dissent was in response to Roman occupation of the area, various Jewish sects also competed among themselves for influence in the region. Thus, the appearance of a young, popular leader who was proclaimed by some as "King of the Jews" and who himself claimed to be the long-awaited Messiah, gave pause to both the Jewish hierarchy and Roman authorities. The following selections from Matthew reveal Jesus' own conception of his mission.

Instructions to the Twelve Disciples

Jesus Chooses His Twelve Apostles

Jesus called together his twelve disciples. He gave them the power to force out evil spirits and to heal every kind of disease and sickness. The first of the twelve apostles was Simon, better known as Peter. His brother Andrew was an apostle, and so were James and John, the two sons of Zebedee. Philip, Bartholomew, Thomas, Matthew the tax collector, James the son of Alphaeus, and Thaddaeus were also apostles. The others were Simon, known as the Eager One, and Judas Iscariot, who later betrayed Jesus.

Instructions for the Twelve Apostles

Jesus sent out the twelve apostles with these instructions: "Stay away from the Gentiles and don't go to any Samaritan town. Go only to the people of Israel, because they are like a flock of lost sheep. As you go, announce that the kingdom of heaven will soon be here. Heal the sick, raise the dead to life, heal people who have leprosy, and force out demons. You received without paying, now give without being paid. Don't take along any gold, silver, or copper coins. And don't carry a traveling bag or an extra shirt or sandals or a walking stick. Workers deserve their food.

So when you go to a town or a village, find someone worthy enough to have you as their guest and stay with them until you leave. When you go to a home, give it your blessing of peace. If the home is deserving, let your blessing remain with them. But if the home isn't deserving, take back your blessing of peace. If someone won't welcome you or listen to your message, leave their home or town. And shake the dust from your feet at them. I promise you that the day of judgment will be easier for the towns of Sodom and Gomorrah than for that town.

Warning about Trouble

I am sending you like lambs into a pack of wolves. So be as wise as snakes and as innocent as doves. Watch out for people who will take you to court and have you beaten in their meeting places. Because of me, you will be dragged before rulers and kings to tell them and the Gentiles about your faith. But when someone arrests you, don't worry about what you will say or how you will say it. At that time you will be given the words to say. But you will not really be the one speaking. The Spirit from your Father will tell you what to say.

"Instructions to the Twelve Disciples" is from Matthew 10:1–42.

Brothers and sisters will betray one another and have each other put to death. Parents will betray their own children, and children will turn against their parents and have them killed. Everyone will hate you because of me. But if you remain faithful until the end, you will be saved. When people mistreat you in one town, hurry to another one. I promise you that before you have gone to all the towns of Israel, the Son of Man will come. . . .

Not Peace, but Trouble

"Don't think that I came to bring peace to the earth! I came to bring trouble, not peace. I came to turn sons against their fathers, daughters against their mothers, and daughters-in-law against their mothers-in-law. Your worst enemies will be in your own family. If you love your father or mother or even your sons and daughters more than me, you are not fit to be my disciples. And unless you are willing to take up your cross and come with me, you are not fit to be my disciples. If you try to save your life, you will lose it. But if you give it up for me, you will surely find it.

> "Don't think that I came to bring peace to the earth! I came to bring trouble, not peace."
>
> **—Jesus**

Rewards

"Anyone who welcomes you welcomes me. And anyone who welcomes me also welcomes the one who sent me. Anyone who welcomes a prophet, just because that person is a prophet, will be given the same reward as a prophet. Anyone who welcomes a good person, just because that person is good, will be given the same reward as a good person. And anyone who gives one of my most humble followers a cup of cool water, just because that person is my follower, will surely be rewarded.

Peter: The Rock

Who Is Jesus?

When Jesus and his disciples were near the town of Caesarea Philippi, he asked them, "What do people say about the Son of Man?" The disciples answered, "Some people say you are John the Baptist or maybe Elijah or Jeremiah or some other prophet." Then Jesus asked them, "But who do you say I am?" Simon Peter spoke up, "You are the Messiah, the Son of the living God." Jesus told him: "Simon, son of Jonah, you are blessed! You didn't discover this on your own. It was shown to you by my Father in heaven. So I will call you Peter, which means 'a rock.' On this rock I will build my church, and death itself will not have any power over it. I will give you the keys to the kingdom of heaven, and God in heaven will allow whatever you allow on earth. But he will not allow anything that you don't allow." Jesus told his disciples not to tell anyone that he was the Messiah.

Suffering, Persecution, and the Son of Man

From then on, Jesus began telling his disciples what would happen to him. He said, "I must go to Jerusalem. There the nation's leaders, the chief priests, and the teachers of the Law of Moses will make me suffer terribly. I will be killed, but three days later I will rise to life."

"Peter: The Rock" is from Matthew 16:13–18.
"Suffering, Persecution, and the Son of Man" is from Matthew 16:21–28, 24:3–14, 29.

Peter took Jesus aside and told him to stop talking like that. He said, "God would never let this happen to you, Lord!" Jesus turned to Peter and said, "Satan, get away from me! You're in my way because you think like everyone else and not like God."

Then Jesus said to his disciples: "If any of you want to be my followers, you must forget about yourself. You must take up your cross and follow me. If you want to save your life,

you will destroy it. But if you give up your life for me, you will find it. What will you gain, if you own the whole world but destroy yourself? What would you give to get back your soul? The Son of Man will soon come in the glory of his Father and with his angels to reward all people for what they have done. I promise you that some of those standing here will not die before they see the Son of Man coming with his kingdom.". . .

Warning about Trouble

Later, as Jesus was sitting on the Mount of Olives, his disciples came to him in private and asked, "When will this happen? What will be the sign of your coming and of the end of the world?"

Jesus answered: "Don't let anyone fool you. Many will come and claim to be me. They will say that they are the Messiah, and they will fool many people. You will soon hear about wars

and threats of wars, but don't be afraid. These things will have to happen first, but that isn't the end. Nations and kingdoms will go to war against each other. People will starve to death, and in some places there will be earthquakes. But this is just the beginning of troubles.

"You will be arrested, punished, and even killed. Because of me, you will be hated by people of all nations. Many will give up and will

Figure 3–6 The Coliseum in Rome, where hundreds of Christians were sporadically sacrificed to the lions as condemned reprobates during the imperial era in the first through fourth centuries C.E. "If the weather will not change, if there is an earthquake, a famine, a plague—straightway the cry is heard: 'Toss the Christians to the lions!' "—Tertullian (Perry M. Rogers).

betray and hate each other. Many false prophets will come and fool a lot of people. Evil will spread and cause many people to stop loving others. But if you keep on being faithful right to the end, you will be saved. When the good news about the kingdom has been preached all over the world and told to all nations, the end will come. . . ."

When the Son of Man Appears

Right after those days of suffering, "The sun will become dark, and the moon will no longer shine. The stars will fall, and the powers in the sky will be shaken." Then a sign will appear in the sky. And there will be the Son of Man. All nations on earth will weep when they see the Son of Man coming on the clouds of heaven with power and great glory. At the sound of a loud trumpet, he will send his angels to bring his chosen ones together from all over the earth.". . .

The Final Judgment

When the Son of Man comes in his glory with all of his angels, he will sit on his royal throne. The people of all nations will be brought before him, and he will separate them, as shepherds separate their sheep from their goats. He will place the sheep on his right and the goats on his left. Then the king will say to those on his right, "My father has blessed you! Come and receive the kingdom that was prepared for you before the world was created. When I was hungry, you gave me something to eat, and when I was thirsty, you gave me something to drink. When I was a stranger, you welcomed me, and when I was naked, you gave me clothes to wear. When I was sick, you took care of me, and when I was in jail, you visited me." Then the ones who pleased the Lord will ask, "When did we give you something to eat or drink? When did we welcome you as a stranger or give you clothes to wear or visit you while you were sick or in jail?" The king will answer, "Whenever you did it for any of my people, no matter how unimportant they seemed, you did it for me."

Then the king will say to those on his left, "Get away from me! You are under God's curse. Go into the everlasting fire prepared for the devil and his angels! I was hungry, but you did not give me anything to eat, and I was thirsty, but you did not give me anything to drink. I was a stranger, but you did not welcome me, and I

> **"Whenever you did it for any of my people, no matter how unimportant they seemed, you did it for me."**
>
> **—Jesus**

was naked, but you did not give me any clothes to wear. I was sick and in jail, but you did not take care of me." Then the people will ask, "Lord, when did we fail to help you when you were hungry or thirsty or a stranger or naked or sick or in jail?" The king will say to them, "Whenever you failed to help any of my people, no matter how unimportant they seemed, you failed to do it for me." Then Jesus said, "Those people will be punished forever. But the ones who pleased God will have eternal life."

Paul's Answer to the Intellectuals

Christ did not send me to baptize. He sent me to tell the good news without using big words that would make the cross of Christ lose its power.

"The Final Judgment" is from Matthew 25:31–46.

"Paul's Answer to the Intellectuals" is from 1 Corinthians 1:17–2:8; Galatians 3:23–29.

Christ Is God's Power and Wisdom

The message about the cross doesn't make any sense to lost people. But for those of us who are being saved, it is God's power at work. As God says in the Scriptures, "I will destroy the wisdom of all who claim to be wise. I will confuse those who think they know so much." What happened to those wise people? What happened to those experts in the Scriptures? What happened to the ones who think they have all the answers? Didn't God show that the wisdom of this world is foolish?

God was wise and decided not to let the people of this world use their wisdom to learn about him. Instead, God chose to save only those who believe the foolish message we preach. Jews ask for miracles, and Greeks want something that sounds wise. But we preach that Christ was nailed to a cross. Most Jews have problems with this, and most Gentiles think it is foolish. Our message is God's power and wisdom for the Jews and the Greeks that he has chosen. Even when God is foolish, he is wiser than everyone else, and even when God is weak, he is stronger than everyone else.

My dear friends, remember what you were when God chose you. The people of this world didn't think that many of you were wise. Only a few of you were in places of power, and not many of you came from important families. But God chose the foolish things of this world to put the wise to shame. He chose the weak things of this world to put the powerful to shame. What the world thinks is worthless, useless, and nothing at all is what God has used to destroy what the world considers important. God did all this to keep anyone from bragging to him. . . .

Telling about Christ and the Cross

Friends, when I came and told you the mystery that God had shared with us, I didn't use big words or try to sound wise. In fact, while I was with you, I made up my mind to speak only about Jesus Christ, who had been nailed to a cross. At first, I was weak and trembling with fear. When I talked with you or preached, I didn't try to prove anything by sounding wise. I simply let God's Spirit show his power. That way you would have faith because of God's power and not because of human wisdom.

We do use wisdom when speaking to people who are mature in their faith. But it isn't the wisdom of this world or of its rulers, who will soon disappear. We speak of God's hidden and mysterious wisdom that God decided to use for our glory long before the world began. The rulers of this world didn't know anything about this wisdom. If they had known about it, they would not have nailed the glorious Lord to a cross.

"All of You Are God's Children"

The Law [of the Jews] controlled us and kept us under its power until the time came when we would have faith. In fact, the Law was our teacher. It was supposed to teach us until we had faith and were acceptable to God. But once a person has learned to have faith, there is no more need to have the Law as a teacher.

All of you are God's children because of your faith in Christ Jesus. And when you were baptized, it was as though you had put on Christ in the same way you put on new clothes. Faith in Christ Jesus is what makes each of you equal with each other, whether you are a Jew or a Greek, a slave or a free person, a man or a woman. So if you belong to Christ, you are now part of Abraham's family, and you will be given what God has promised.

The Resurection of Christ

Christ Was Raised to Life

My friends, I want you to remember the message that I preached and that you believed and trusted. You will be saved by this message, if you hold firmly to it. But if you don't, your faith was all for nothing.

I told you the most important part of the message exactly as it was told to me. That part is: Christ died for our sins, as the Scriptures say. He was buried, and three days later he was raised to life, as the Scriptures say. Christ appeared to Peter, then to the twelve. After this, he appeared to more than five hundred other followers. Most of them are still alive, but some have died. He also appeared to James, and then to all of the apostles. Finally, he appeared to me, even though I am like someone who was born at the wrong time.

I am the least important of all the apostles. In fact, I caused so much trouble for God's church that I don't even deserve to be called an apostle. But God was kind! He made me what I am, and his wonderful kindness wasn't wasted. I worked much harder than any of the other apostles, although it was really God's kindness at work and not me. But it doesn't matter if I preached or if they preached. All of you believed the message just the same.

God's People Will Be Raised to Life

If we preach that Christ was raised from death, how can some of you say that the dead will not be raised to life? If they won't be raised to life, Christ himself wasn't raised to life. And if Christ wasn't raised to life, our message is worthless, and so is your faith. If the dead won't be raised to life, we have told lies about God by saying that he raised Christ to life, when he really did not.

So if the dead won't be raised to life, Christ wasn't raised to life. Unless Christ was raised to life, your faith is useless, and you are still living in your sins. And those people who died after putting their faith in him are completely lost. If our hope in Christ is good only for this life, we are worse off than anyone else.

But Christ has been raised to life! And he makes us certain that others will also be raised to life. Just as we will die because of Adam, we will be raised to life because of Christ. Adam brought death to all of us, and Christ will bring life to all of us. And why do we always risk our lives and face death every day? The pride that I have in you because of Christ Jesus our Lord is what makes me say this. What do you think I gained by fighting wild animals in Ephesus? If the dead are not raised to life, "Let's eat and drink. Tomorrow we die."

What Our Bodies Will Be Like

Some of you have asked, "How will the dead be raised to life? What kind of bodies will they have?" Don't be foolish. A seed must die before it can sprout from the ground. Wheat seeds and all other seeds look different from the sprouts that come up. This is because God gives everything the kind of body he wants it to have. People, animals, birds, and fish are each made of flesh, but none of them are alike. Everything in the heavens has a body, and so does everything on earth. But each one is very different from all the others.

That's how it will be when our bodies are raised to life. These bodies will die, but the bodies that are raised will live forever. These ugly and weak bodies will become beautiful and strong. As surely as there are physical bodies, there are spiritual bodies. And our physical bodies will be changed into spiritual bodies. The first man was named Adam, and the Scriptures tell us that he was a living person. But Jesus, who may be called the last Adam, is a life-giving spirit. We see that the one with a spiritual body did not come first. He came after the one who had a physical body. The first man was made from the dust of the earth, but the second man came from heaven. Everyone on earth has a body like the body of the

"The Resurrection of Christ" is from 1 Corinthians 15:1–22, 31–32, 35–39, 42–55.

one who was made from the dust of the earth. And everyone in heaven has a body like the body of the one who came from heaven. Just as we are like the one who was made out of earth, we will be like the one who came from heaven.

My friends, I want you to know that our bodies of flesh and blood will decay. This means that they cannot share in God's kingdom, which lasts forever. I will explain a mystery to you. Not every one of us will die, but we will all be changed. It will happen suddenly, quicker than the blink of an eye. At the sound of the last trumpet the dead will be raised. We will all be changed, so that we will never die again. Our dead and decaying bodies will be changed into bodies that won't die or decay. The bodies we now have are weak and can die. But they will be changed into bodies that are eternal. Then the Scriptures will come true:

"Death has lost the battle!
Where is its victory?
Where is its sting?"

On Love

What if I could speak all languages of humans and of angels? If I did not love others, I would be nothing more than a noisy gong or a clanging cymbal. What if I could prophesy and understand all secrets and all knowledge? And what if I had faith that moved mountains? I would be nothing, unless I loved others. What if I gave away all that I owned and let myself be burned alive? I would gain nothing, unless I loved others. Love is kind and patient, never jealous, boastful, proud, or rude. Love isn't selfish or quick tempered. It doesn't keep a record of wrongs that others do. Love rejoices in the truth, but not in evil. Love is always supportive, loyal, hopeful, and trusting. Love never fails! Everyone who prophesies will stop, and unknown languages will no longer be spoken. All that we know will be forgotten. We don't know everything, and our prophecies are not complete. But what is perfect will someday appear, and what isn't perfect will then disappear. When we were children, we thought and reasoned as children do. But when we grew up, we quit our childish ways. Now all we can see of God is like a cloudy picture in a mirror. Later we will see him face to face. We don't know everything, but then we will, just as God completely understands us. For now there are faith, hope, and love. But of these three, the greatest is love.

Consider This:
- What were Paul's contributions to the message of Jesus? How did the Pax Romana contribute to the success of missionaries like Paul who were spreading the word of Christ?

"On Love" is from 1 Corinthians 13:1–13.

The Reflection in the Mirror

THE DECLINE OF THE WEST

Decline and Christianity

EDWARD GIBBON

One of the most famous theories for the decline of the Roman Empire belongs to Edward Gibbon, the celebrated 18th-century historian. His work The Decline and Fall of the Roman Empire *(1776) has proved an authoritative analysis of the end. But his emphasis on the importance of Christianity as a source of Roman decline still inspires controversy.*

Keep in Mind:

- According to Edward Gibbon, why was Christianity an important factor in the decline of the Roman Empire?

As the happiness of a future life is the great object of religion, we may hear, without surprise or scandal, that the introduction, or at least the abuse, of Christianity had some influence on the decline and fall of the Roman empire. The clergy successfully preached the doctrines of patience and pusillanimity; the active virtues of society were discouraged; and the last remains of the military spirit were buried in the cloister; a large portion of public and private wealth was consecrated to the specious demands of charity and devotion; and the soldiers's pay was lavished on the useless multitudes of both sexes, who could only plead the merits of abstinence and chastity. Faith, zeal, curiosity, and the more earthly passions of malice and ambition kindled the flame of theological discord; the church, and even the state, were distracted by religious factions, whose conflicts were sometimes bloody, and always implacable; the attention of the emperors was diverted from camps to [church] synods; the Roman world was oppressed by a new species of tyranny; and the persecuted sects became the secret enemies of their country. Yet party-spirit, however pernicious or absurd, is a principle of union as well as of dissension. The bishops, from eighteen hundred pulpits, inculcated the duty of passive obedience to a lawful and orthodox sovereign; their communion of distant churches; and the benevolent temper of the gospel was strengthened, though confined by the spiritual alliance of the Catholics. The sacred indolence of the monks was devoutly embraced by a servile and effeminate age; but, if superstition had not afforded a decent retreat, the same vices would have tempted the unworthy Romans to desert, from baser motives, the standard of the republic. Religious precepts are easily obeyed, which indulge and sanctify the natural inclinations of their votaries; but the pure and genuine influence of Christianity may be traced in its beneficial though imperfect, effects on the Barbarian proselytes of the North. If the decline of the Roman empire was hastened by the conversion of [the Emperor] Constantine, his victorious religion broke the violence of the fall, and mollified the ferocious temper of the conquerors.

"Decline and Christianity" is from Edward Gibbon, *The History of the Decline and Fall of the Roman Empire*, vol. 4, ed. J. B. Bury (London, 1901), pp. 162–163.

Consider This:

- Do you find Gibbon's theory of Roman decline to be valid? Why or why not? Note his use of the phrases "passive obedience" and "sacred indolence." Did Christianity end the warrior spirit that had made Rome great and replace it with a Christian emphasis on "loving one's neighbor" and "turning the other cheek?"

The Broader Perspective:

- The process of decline has fascinated humanity for centuries. Are civilizations biological in nature? Are they born and do they grow, mature, age, and die, as do other living entities? Does each civilization progress and transfer its benefits to the developing successor civilization?

- Are there any warning signs for decline, and can a civilization reverse the process once it has been started? Does technology have anything to do with decline? As we advance technologically, does this speed up the process of decline? Compare Roman and American societies in this regard.

Figure 3–7 Ruins of the Temple of Castor and Pollux in Rome (Perry M. Rogers).

PART TWO

The Consolidation of Western Civilization (500–1400)

4

Icon, Scimitar, and Cross
Early Medieval Civilization (500–1100)

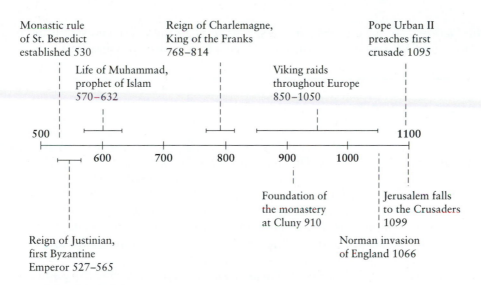

Understanding is the reward of faith. Therefore, do not seek to understand that you may believe, but believe that you may understand.

—St. Augustine

If the work of God could be comprehended by reason, it would no longer be wonderful.

—Pope Gregory I

There are two ways to slide through life: to believe everything or to doubt everything; both ways save us from thinking.

—Alfred Korzybski

CHAPTER THEMES

- *The Institution and the Individual:* What conditions contributed to the establishment of feudalism? How did feudalism benefit the individual and provide political and social solutions to the disruptions of the Early Middle Ages?

- *Social and Spiritual Values:* How did the establishment of the Christian church and the development of the papacy structure Christian beliefs, thus providing a spiritual foundation for the Middle Ages? How was devotion, whether Christian or Islamic, an encompassing theme for the period?

- *Revolution and Transition:* In what ways did medieval civilization represent a change from the civilizations of the ancient world? Can we speak of progress in the Middle Ages, or was the entire period a "Dark Age"?

- *The Big Picture:* To what extent can religion serve as a progressive and stabilizing force in society? How did Christianity give energy and direction to medieval civilization?

The Dawn of the European Middle Ages

Some historians have argued that one of the greatest disasters in history was the failure of Rome to maintain its civilization. The internal economic and social decay of the third and fourth centuries, and the weakened military and political structure of the empire, paved the way for the barbarization of the realm by an uncontrolled influx of Germanic invaders. Western Europe was subjected to an era of chaos and disaster, marked by brutish force and devoid of the moderation that maintains civilized existence; by the fifth century, darkness had descended on Europe. As the noted art historian Sir Kenneth Clark said, "In so far as we are the heirs of Greece and Rome, we got through by the skin of our teeth."

The period between the collapse of Roman civilization in the fifth century and the revival of classical learning in the Renaissance of the 15th century is called the Middle Ages or the medieval world. Renaissance scholars viewed their own era as one of light and progress, of renewed hope, where the emphasis centered no longer on God but on humanity. It was a secular era that condemned the chanting of prayers as mindless and viewed the collection of holy relics as absurd; it saw these practices as contradictory to the freedom of a new society focused on creativity. The Middle Ages were viewed with regret and scorn. Petrarch, a poet of the 14th century, lamented that "the Muse of History has been dead for a thousand years." When Rome fell, the Dark Ages settled over Western Europe and civilization retreated—and then remained static.

This view of the Middle Ages was accepted and remained popular until perhaps the 19th century, when a more detached and less advocative scholarship began to assess critically the contributions and limitations of the medieval world. Perhaps the Middle Ages seemed so foreign because it was generally an age of faith, in contrast to the secular and rational emphasis of the modern world. The Christian church had been born during the height of Roman civilization and developed by drawing from Roman organization, making accommodation and enduring occasional persecution. Christianity survived and triumphed eventually as the official religion of the Roman Empire because of the broad appeal of its doctrine, its committed membership, and its superior organization. While the facade of Roman civilization gradually crumbled, the spiritual substructure of Christianity kept the Latin language, architectural styles, and other Roman cultural benefits alive.

"By the Skin of Our Teeth": The Germanic Tribes

The Romans greatly respected the Germanic peoples who lived beyond the Rhine River. In his work, Germania, *the Roman historian Tacitus described them as "noble savages," who possessed a simple, but effective justice system based on relative equity, and a code of valor that reflected a warlike spirit. The Romans grew to admire their enemies even as Roman institutions broke down amid the onslaught of Germanic invasions during the third century. The transformation of Western Civilization in the Early Middle Ages owed much to the mingling of Roman and Germanic traditions.*

Beginning in the third century, Germanic tribes wandered throughout the western Roman Empire, contributing to its political disintegration and establishing new traditions upon the Roman foundation. In the first selection, Jerome, a Christian writer, describes the Germanic attacks in the western provinces. Amidst this chaos, people found solace in conversion to Christianity as noted in the experience of the North African saint, Augustine of Hippo.

News of the Attacks
JEROME

Innumerable and most ferocious people have overrun the whole of Gaul. The entire area bounded by the Alps, the Pyrenees, the ocean and the Rhine is occupied by the Quadi, Vandals, Carmatians, Alanni, Gepides, Saxons, Burgundians, Alammani—oh weep for the empire—and the hostile Pannonians. . . . Mainz, once a noble city, is captured and razed, and thousands have been massacred in the church. Worms has succumbed to a long siege. Rheims, the impregnable, Amiens, Artois, . . . Tours, Nimes and Strasburg are in the hands of the Germans. The provinces of Aquitaine, . . . of Lyons and Narbonne are completely occupied and devastated either by the sword from without or famine within. I cannot mention Toulouse without tears, for until now it has been spared, due to the merits of its saintly bishop Exuperus. The Spaniards tremble, expecting daily the invasion and recalling the horrors Spaniards suffer in continual anticipation.

Who would believe that Rome, victor over all the world, would fall, that she would be to her people both the womb and the tomb. Once all the East, Egypt and Africa acknowledged her sway and were counted among her men servants and her maid servants. Who would believe that holy Bethlehem would receive as beggars, nobles, both men and women, once abounding in riches? Where we cannot help we mourn and mingle with theirs our tears. . . . There is not an hour, not even a moment, when we are not occupied with crowds of refugees, when the peace of the monastery is not invaded by a horde of guests so that we shall either have to shut the gates or neglect the Scriptures for which the gates were opened. Consequently I have to snatch furtively the hours of the night, which now with winter approaching are growing longer, and try to dictate by candle light and thus . . . relieve a mind distraught. I am not boasting of our hospitality, as some may suspect, but simply explaining to you the delay.

"News of the Attacks" is from Jerome, *Epistles*, 123, 15 in E. F. Henderson, ed., *Select Historical Documents of the Middle Ages* (London: George Bell and sons, 1892), pp. 89–90.

Against the Grain

AUGUSTINE: FROM SINNER TO SAINT
The Confessions

SAINT AUGUSTINE

One of the most important voices of early Christianity was that of Saint Augustine. He was born in North Africa in 354 C.E. and lived, by his own admission, a rather dissolute life until his conversion to Christianity in 386 at age 32. He became a priest in 391 and Bishop of Hippo in 396. Three years later, Augustine wrote the Confessions, *an account of his life and conversion to Christianity. His greatest work,* The City of God, *was written as a consequence of the sack of Rome in 410 by Alaric the Visigoth. In it, Augustine answered pagan charges that this catastrophe was the result of the anger of the old gods against Christianity. In the following excerpt from the* Confessions, *Augustine reveals his personal struggle to trade the pleasures of the world for the glory of God. His towering intellect maintained a close connection with classical intellectual traditions and provided continuity for Western and Eastern Christianity during a difficult and chaotic time.*

Keep in Mind:

• Why did Augustine doubt his commitment to Christ? When he was "on the brink of resolution," what pushed him over the edge?

This was the nature of my sickness. I was in torment, reproaching myself more bitterly than ever as I twisted and turned in my chain. I hoped that my chain might be broken once and for all, because it was only a small thing that held me now. All the same it held me. And you, O Lord, never ceased to watch over my secret heart. In your stern mercy, you lashed me with the twin scourge of fear and shame in case I should give way once more and the worn and slender remnant of my chain should not be broken but gain new strength and bind me all the faster. In my heart I kept saying, "Let it be now, let it be now!", and merely by saying this I was on the point of making it, but I did not succeed. Yet I did not fall back into my old state. I stood on the brink of resolution, waiting to take fresh breath. I tried again and came a little nearer to my goal, and then a little nearer still, so that I could almost reach out and grasp it. But I did not reach it. I could not reach out to it or grasp it because I held back from the step by which I should die to death and become alive to life. My lower instincts, which had taken firm hold of me, were stronger than the higher, which were untried. And the closer I came to the moment which was to mark the great change in me, the more I shrank from its horror. But it did not drive me back or turn me from my purpose: it merely left me hanging in suspense. . . .

"The Confessions" is from Saint Augustine, *The Confessions*, trans. R. S. Pine-Coffin (New York and Harmondsworth, Middlesex: Penguin Books, 1961), Book 8.11-12, pp. 156; 158–159. Copyright © 1961 R. S. Pine-Coffin. Reprinted by permission of Penguin Books, Ltd.

I probed the hidden depths of my soul and wrung its pitiful secrets from it, and when I mustered them all before the eyes of my heart, a great storm broke within me, bringing with it a great deluge of tears. . . . Somehow, I flung myself down beneath a fig tree and gave way to the tears which now streamed from my eyes, the sacrifice that is acceptable to you. . . . For I felt that I was still the captive of my sins, and in my misery I kept crying, "How long shall I go on saying 'tomorrow, tomorrow?' Why not now? Why not make an end of my ugly sins at this moment?" . . .

So I hurried back to the place where I had put down the book containing Paul's Epistles. I seized it and opened it and in silence I read the first passage on which my eyes fell: *Not in reveling and drunkenness, not in lust and wantonness, not in quarrels and rivalries. Rather, arm yourselves with the Lord Jesus Christ; spend no more thought on nature and nature's appetites.* I had no wish to read more and no need to do so. For in an instant, as I came to the end of the sentence, it was as though the light of confidence flooded into my heart and all the darkness of doubt was dispelled.

Consider This:

- Why did Augustine have such difficulty in committing himself to God? What did this commitment mean?
- In Augustine's process of conversion to Christianity, Paul's *Epistles* were of great importance. What did Paul mean when he said "arm yourselves with the Lord Jesus Christ; spend no more thought on nature and nature's appetites"? Why did Augustine have to reject "nature's appetites"? Does this itself seem "unnatural"? Why must there be a higher standard of commitment and even sacrifice to do God's work?

Beowulf: The Germanic Hero

Out of the Germanic wanderings in the years following the collapse of the Roman Empire came a rich oral tradition that included most importantly the epic adventures of Beowulf, written in Old English in the eighth century. Epic poetry has been used throughout history to transmit cultural traditions from one generation to another, initially without the aid of writing. Oral narratives like the Sumerian epic of Gilgamesh or Homer's Iliad *and* Odyssey *tell of legends and the glorious deeds of national ancestors. Because many of these heroic stories were at some time written down, they allow historians to understand the values and motivation of past societies. In the following excerpt, the Anglo-Saxon king Beowulf (Lord of the Geats) fights to the death with the fire-breathing monster, Grendel, who guards a great treasure-trove.*

The king of the Geats roared a furious challenge. He shouted until his voice penetrated the cavern and his battle-cry thundered under the grey rock. The guardian of the treasure-hoard [Grendel] bristled with rage when it recognized the voice of a man. There was no time for appeasement. The monster's scorching breath spurted ahead of it, out of the rock, while earth reverberated. The hero, facing the barrow, swung his shield to meet the enemy; upon which the reptile was spurred to take the offensive. Already the king had drawn his sharp ancestral sword. But each of the adversaries was in awe of the other. The prince resolutely stood

> "The monster's scorching breath spurted ahead of it . . . while earth reverberated. The prince resolutely stood his ground in the shelter of his great shield."

his ground in the shelter of his great shield while the Worm gathered its coils together. Bent like a bow, the flaming monster hurtled towards

"Beowulf: The Germanic Hero" is from *Beowulf*, trans. David Wright (New York and Harmondsworth, Middlesex: Penguin Books, 1957), pp. 87–91, 101. Copyright © David Wright, 1957. Reprinted by permission of Penguin Books, Ltd.

him and rushed upon its fate. But the king's shield gave protection to life and limb for a shorter time than he had hoped. For the first time Beowulf had to fight without success, because fate refused to grant it to him. Raising his hand, the lord of the Geats struck the glittering monster with his sword, but the blade bounded off the scales and scarcely bit, just when the king had most need. The blow infuriated the guardian of the barrow. It spat a blast of glistering fire which leapt hither and thither. The king could boast of no advantage now that his naked blade had failed him in battle, as no good sword should do. It was no easy thing for Beowulf to make up his mind to quit this world and take up his lodging in some other whether he liked it or not. But this is the way in which everyone has to die.

Soon the antagonists joined battle once more. The Dragon had taken fresh heart and found its second wind, while the king, hedged round with fire, suffered agony. His comrades-in-arms, who were sons of princes, utterly failed to support him in strength like good fighting-men, but fled into a wood to save their lives. Yet one among them was pricked by conscience. To a right-thinking man, blood must always be thicker than water.

His name was Wiglaf son of Weohstan, a well-liked Swedish prince of the house of Aelfhere. Wiglaf could see that the king, in spite of his armor, was in distress from the flames. . . . In bitterness of heart Wiglaf reminded his comrades of their duty. "I can remember a time when we used to accept to whom we swore that if ever he fell into straits like these we would make some return for our fighting-gear—these swords and helmets. That is why he gave me valuable gifts, and you as well. He thought that we were brave spearmen and daring soldiers. . . . Let us go forward to our king's assistance. . . ." Then he dived into the perilous smoke, bearing arms to the king's help and crying . . . : "Brave prince, renowned for feats of arms, defend your life with all your might—I am coming to your help!"

At these words the Worm angrily emerged once more in swirls of sparkling flame, to take the field against its enemies, the human beings which it hated. Wiglaf's shield was burnt to the boss by a cataract of fire, while his corselet gave him no protection. The lad slipped quickly

behind his kinsman's shield as soon as the flames had burnt his own to cinders.

But the king was still mindful of his fame and struck so hard with his sword that, driven by the impetus, it struck square in the Dragon's head. Yet Beowulf's patterned sword, Naegling, failed him. It shattered to splinters. Never had it been his luck that a sword should be of use to him during a fight. His hand, they say, was so strong that the force of his blows overtaxed any weapon. Even when he carried one which was hardened in battle he was no better off.

The flame-spitting Dragon screwed up its courage for a third attack. When it saw its chance it set savagely upon the hero, catching him around the neck with lacerating fangs. A torrent of gore gushed out, and Beowulf was spattered with his own life-blood. . . .

Collecting his wits, the king pulled out a razor-sharp dagger which he wore at his corselet, and ripped open the belly of the Worm. Together the kinsmen killed their adversary. That

> **"The king pulled out a razor-sharp dagger . . . and ripped open the belly of the Worm. . . . It was Beowulf's crowning hour of triumph."**

is how a man should act in a right corner! It was Beowulf's crowning hour of triumph, his last feat of arms, and the end of his life's work.

For the wound which the Dragon had just inflicted upon him began to burn and swell. Beowulf soon discovered that mortal poison was working in his breast and had bitten deep into his entrails. . . . In spite of his pitiful wound, Beowulf began to speak. He knew well enough that his span of life and term of happiness on earth was over, his sum of days wholly spent, and death very close.

"I now would wish to hand over my armor to a son of mine, were it my luck to have had an heir of my body to come after me. I have reigned over this people for half a century, and there was not a king of any neighboring nation who dared to attack me with an army or to threaten me with war. The destiny allotted to me on earth I endured; what was mine I defended

well. I did not pick quarrels nor swear false oaths. Though wounded to death, I can rejoice in all these things; because when the life quits my body God cannot accuse me of the murder of my kin. . . ."

The people of the Geats prepared for Beowulf, as he had asked of them, a splendid pyre hung about with helmets, shields, and shining corselets. Then, mourning, the soldiers laid their loved and illustrious prince in the midst. Upon the hill the men-at-arms lit a gigantic funeral fire. . . . Then twelve chieftains, all sons of princes, rode round the barrow lamenting their loss, speaking of their king, reciting an elegy, and acclaiming the hero. They praised his manhood and extolled his heroic deeds. It is right that men should pay homage to their king with words, and cherish him in their hearts, when he has taken leave of the body. So the Geats who had shared his hall mourned the death of their lord, and said that of all kings he was the gentlest and most gracious of men, the kindest to his people and the most desirous of renown.

Consider This:

- In the Anglo-Saxon epic, *Beowulf*, what values are important to this society as represented by the hero Beowulf? Apart from his ability in combat, why was he considered a great king? Why did Beowulf have to die? How would you describe his burial?

The World of Charlemagne

Biographical writing constitutes a considerable part of medieval literature, but much of it cannot be relied on for accuracy. Medieval biographers who wrote about the lives of saints or kings often exaggerated their accomplishments for the sake of providing solid examples of moral living. A major exception to this practice was Einhard, a secretary and public works administrator at Charlemagne's court. Although his biography has some inaccuracies, nevertheless it is regarded as a trustworthy account of the life and deeds of Charlemagne, ruler of the Frankish empire from 768 to 814.

The Moderate and Progressive King
EINHARD

Charles was large and strong, and of lofty stature, though not excessively tall. The upper part of his head was round, his eyes very large and animated, nose a little long, hair auburn, and face laughing and merry. His appearance was always stately and dignified, whether he was standing or sitting, although his neck was thick and somewhat short and his abdomen rather prominent. The symmetry of the rest of his body concealed these defects. His gait was firm, his whole carriage manly, and his voice clear, but not so strong as his size led one to expect. His health was excellent, except during the four years preceding his death, when he was subject to frequent fevers; toward the end of his life he limped a little with one foot. Even in his later years he lived rather according to

> "Charlemagne's appearance was always stately and dignified . . . and his voice clear, but not so strong as his size led one to expect."
>
> —Einhard

his own inclinations than the advice of physicians; the latter indeed he very much disliked,

"The Moderate and Progressive King" is from Frederick Ogg, ed., *A Source Book of Medieval History* (New York: American Book Company, 1907), pp. 109–114.

because they wanted him to give up roasts, to which he was accustomed, and to eat boiled meat instead. In accordance with national custom, he took frequent exercise on horseback and in the chase, in which sports scarcely any people in the world can equal the Franks. He enjoyed the vapors from natural warm springs, and often indulged in swimming, in which he was so skillful that none could surpass him; and hence it was that he built his palace at Aix-la-Chapelle, and lived there constantly during his later years. . . .

Charles was temperate in eating, and especially so in drinking, for he abhorred drunkenness in anybody, much more in himself and those of his household; but he could not easily abstain from food, and often complained that fasts injured his health. He gave entertainments but rarely, only on great feast-days, and then to large numbers of people. His meals consisted ordinarily of four courses not counting the roast, which his huntsmen were accustomed to bring in on the spit; he was more fond of this than of any other dish. While at table, he listened to reading or music. The subjects of the readings were the stories and deeds of olden time. He was fond, too, of St. Augustine's books, and especially of the one entitled *The City of God*. He was so moderate in the use of wine and all sorts of drink that he rarely allowed himself more than three cups in the course of a meal. . . .

Charles had the gift of ready and fluent speech, and could express whatever he had to say with the utmost clearness. He was not satisfied with ability to use his native language merely, but gave attention to the study of foreign ones, and in particular was such a master of Latin that he could speak it as well as his native tongue; but he could understand Greek better than he could speak it. He was so eloquent, indeed, that he might have been taken for a teacher of oratory. He most zealously cherished the liberal arts, held those who taught them in great esteem, and conferred great honors upon them. He took lessons in grammar of the deacon Peter of Pisa, at that time an aged man. Another deacon, Albin of Britain, surnamed Alcuin, a man of Saxon birth, who was the greatest scholar of the day, was his teacher in other branches of learning. The king spent much time and labor with him studying rhetoric, dialectic, and especially astronomy. He learned to make calculations, and used to investigate with much curiosity and intelligence the motions of the heavenly bodies. He also tried to write, and used to keep tablets and blanks in bed under his pillow, that at leisure hours he might accustom his hand to form the letters; however,

> "Charlemagne learned to make calculations, and also tried to write; however as he began his efforts late in life, they met with little success."
> —Einhard

as he began his efforts late in life, and not at the proper time, they met with little success.

He cherished with the greatest fervor and devotion the principles of the Christian religion, which had been instilled into him from infancy. Hence it was that he built the beautiful basilica at Aix-la-Chapelle, which he adorned with gold and silver and lamps, and with rails and doors of solid brass. He had the columns and marbles for this structure brought from Rome and Ravenna, for he could not find such as were suitable elsewhere. He was a constant worshiper at this church as long as his health permitted, going morning and evening, even after nightfall, besides attending mass. He took care that all the services there conducted should be held in the best possible manner, very often warning the sextons not to let any improper or unclean thing be brought into the building, or remain in it. He provided it with a number of sacred vessels of gold and silver, and with such a quantity of clerical robes that not even the door-keepers, who filled the humblest office in the church, were obliged to wear their everyday clothes when in the performance of their duties. He took great pains to improve the church reading and singing, for he was well skilled in both, although he neither read in public nor sang, except in a low tone and with others.

He was very active in aiding the poor, and in that open generosity which the Greeks call alms; so much so, indeed, that he not only made a point of giving in his own country and his own kingdom, but when he discovered that

there were Christians living in poverty in Syria, Egypt, and Africa, at Jerusalem, Alexandria, and Carthage, he had compassion on their wants, and used to send money over the seas to them. The reason that he earnestly strove to make friends with the kings beyond seas was that he might get help and relief to the Christians living under their rule. He cared for the Church of St. Peter the Apostle at Rome above all other holy and sacred places, and heaped high its treasury with a vast wealth of gold, silver, and precious stones. He sent great and countless gifts to the popes; and throughout his whole reign the wish that he had nearest his heart was to reestablish the ancient authority of the city of Rome under his care and by his influence, and to defend and protect the Church of St. Peter, and to beautify and enrich it out of his own store above all other churches. Nevertheless, although he held it in such veneration, only four times did he repair to Rome to pay his vows and make his supplications during the whole forty-seven years that he reigned.

The *Missi Dominici* (802)

The greatness of a ruler has often been determined not just by how much territory he conquered, but by how well he maintained it. The administration of an empire as vast as Charlemagne's depended on efficient servants of the king. The selection below testifies to Charlemagne's organization and efficient rule. The Missi Dominici *were members of the church and nobility who traveled throughout the realm administering justice by acting as an appellate court; it was an attempt to inject the presence of the king directly into the law and affairs of the realm.*

Concerning the embassy sent out by the lord emperor. Therefore, the most serene and most Christian lord emperor Charles has chosen from his nobles the wisest and most prudent men, both archbishops and some of the other bishops also, and venerable abbots and pious laymen, and has sent them throughout his whole kingdom, and through them by all the following chapters has allowed men to live in accordance with the correct law. Moreover, where anything which is not right and just has been enacted in the law, he has ordered them to inquire into this most diligently and to inform him of it; he desires, God granting, to reform it. And let no one, through his cleverness or astuteness, dare to oppose or thwart the written law, as many would like to do, or the judicial sentence passed upon him, or to do injury to the churches of God or the poor or the widows or the wards or any Christian. But all shall live entirely in accordance with God's precept, justly and under a just rule, and each one shall be admonished to live in harmony with his fellows in his business or profession; the canonical clergy ought to observe in every respect a canonical life without seeking base gain, nuns ought to keep diligent watch over their lives, laymen and the secular clergy ought rightly to observe their laws without malicious fraud, and all ought to live in mutual charity and perfect peace.

Viking Onslaught: The Siege of Paris (806)

ABBO

One of the most haunting of medieval images is the prow of a Viking ship. As the ship glided down the rivers of Europe, people understood that death and destruction would follow in its wake. The word "Viking" means warrior; it is a general appellation for the Swedes, Danes, and Norwegians who left Scandinavia in the ninth century, looking for booty and adventure. The sleek, open ships of the Northmen, as the Vikings were also called, hugged the coasts of Europe

"The Missi Dominici" is from Dana Munro, ed., *Translations and Reprints from the Original Sources of European History*, vol. 6, pt. 5 (Philadelphia: University of Pennsylvania Press, 1899), p. 16.

"Viking Onslaught: The Siege of Paris" is from Frederick Ogg, ed., *A Source Book of Medieval History* (New York: American Book Company, 1907), pp. 168–171.

and Russia, sailed down the rivers, and survived passage of the open Atlantic to found settlements in North America. The navigational techniques of the Vikings and their establishment of trade routes to the Black Sea are reminders that they were important contributors to positive aspects of Western Civilization. But for the medieval family, their presence inspired fear and desperation. The following eyewitness description of the Viking siege of Paris in 806 by the monk Abbo underscores the destruction brought by the Northmen. Even the great Frankish emperor Charlemagne could not always protect his domains against the ravages of constant invasion.

The Northmen came to Paris with 700 sailing ships, not counting those of smaller size which were commonly called barques. At one stretch the Seine was lined with the vessels for more than two leagues, so that one might ask in astonishment in what cavern the river had been swallowed up, since it was not to be seen. The second day after the fleet of the Northmen arrived under the walls of the city, Siegfred, who was . . . in command of the expedition, came to the dwelling of the illustrious bishop. He bowed his head and said: "Gauzelin, have compassion on yourself and on your flock. We beseech you to listen to us, in order that you may escape death. Allow us only the freedom of the city. We will do no harm and we will see to it that whatever belongs either to you or to Odo shall be strictly respected." Count Odo, who later became king, was then the defender of the city. The bishop replied to Siegfred, "Paris has been entrusted to us by the Emperor Charles, who, after God, king and lord of the powerful, rules over almost all the world. He has put it in our care, not at all that the kingdom may be ruined by our misconduct, but that he may keep it and be assured of its peace. If, like us, you had been given the duty of defending these walls, and if you should have done that which you ask us to do, what treatment do you think you would deserve?" Siegfried replied: "I should deserve that my head be cut off and thrown to the dogs. Nevertheless, if you do not listen to my demand, on the morrow our war machines will destroy you with poisoned arrows. You will be the prey of famine and of pestilence and these evils will renew themselves perpetually every year." So saying, he departed and gathered together his comrades.

In the morning the Northmen, boarding their ships, approached the tower and attacked it. They shook it with their engines and stormed it with arrows. The city resounded with clamor, the people were aroused, the bridges trembled.

All came together to defend the tower. There Odo, his brother Robert, and the Count Ragenar distinguished themselves for bravery; likewise the courageous Abbot Ebolus, the nephew of the bishop. A keen arrow wounded the prelate, while at his side the warrior Frederick was struck by a sword. Frederick died, but the old man, thanks to God, survived. There perished many Franks; after receiving wounds they were deprived of life. At last the enemy withdrew, carrying off their dead. . . . At sunrise the Danes . . . once more . . . engaged the Christians in violent combat. On every side arrows sped and blood flowed. With the arrows mingled the stones hurled by slings and war-machines; the

> "At sunrise the Danes once more engaged the Christians in violent combat. On every side arrows sped and blood flowed."
>
> —Abbo

air was filled with them. The tower which had been rebuilt during the night groaned under the strokes of the darts, the city shook with the struggle, the people ran hither and thither, the bells jangled. The warriors rushed together to defend the tottering tower and to repel the fierce assault. . . . The redoubtable Odo who never experienced defeat continually revived the spirits of the worn-out defenders. He ran along the ramparts and hurled back the enemy. On those who were secreting themselves so as to undermine the tower he poured oil, wax, and pitch, which, being mixed and heated, burned the Danes and tore off their scalps. Some of them died; others threw themselves into the river to escape the awful substance. . . .

Now came the Emperor Charles, surrounded by soldiers of all nations, even as the sky is adorned with resplendent stars. A great throng, speaking many languages, accompanied him. He established his camp at the foot of the heights of Montmartre, near the tower.

He allowed the Northmen to have the country of Sens to plunder; and in the spring he gave them 700 pounds of silver on condition that by the month of March they leave France for their own kingdom. Then Charles returned, destined to an early death.

Consider This:

- How was Paris saved from the devastation of the Northmen? Would you call this a victory for the Franks? What does this accommodation say about the strength of the Franks and the security of Western Europe?

Feudal Obligations (1020)
BISHOP FULBERT OF CHARTRES

Feudalism was the political, military, and legal relationship between a lord and a vassal. It had existed rather informally since the later Roman Empire, but became more sophisticated and widespread during the ninth century as the Viking invasions demanded some form of defense. The lords provided the leadership, the vassals composed the army, and the people sought the protection of such regional strong-men. In return for this protection, the free peasant often gave up his land and labored on the fief of a noble for a specified amount of time. The peasant thus became a serf and was responsible for the production and upkeep of the lord's manor. The social, economic, and legal relationship between a serf and a member of the fighting nobility for whom he worked is called manorialism. *The following letter from the Bishop of Chartres to William, Duke of Aquitaine, further defines the nature of feudal obligation between a lord and vassal.*

To William most glorious duke of the Aquitanians, bishop Fulbert the favor of his prayers. Asked to write something concerning the form of fealty, I have noted briefly for you on the authority of the books the things which follow. He who swears fealty to his lord ought always to have these six things in memory: what is harmless, safe, honorable, useful, easy, practicable. Harmless, that is to say that he should not be injurious to his lord in his body; safe, that he should not be injurious to him in his secrets or in the defenses through which he is able to be secure; honorable, that he should not be injurious to him in his justice or in other matters that pertain to his honor; useful, that he should not be injurious to him in his possessions. . . .

However, that the faithful vassal should avoid these injuries is proper, but not for this does he deserve his holding; for it is not sufficient to abstain from evil, unless what is good is done also. It remains therefore, that in the same six things mentioned above he should faithfully counsel and aid his lord, if he wishes to be looked upon as worthy of his benefice and to be safe concerning the fealty which he has sworn.

The lord also ought to act toward his faithful vassal reciprocally in all these things. And if he does not do this he will be justly considered guilty of bad faith. . . .

I would have written to you at greater length, if I had not been occupied with many other things, including the rebuilding of our city and church which was lately entirely consumed in a great fire; from which loss though we could not for a while be diverted, yet by the hope of the comfort of God and of you we breathe again.

Consider This:

- Define feudalism. What conditions contributed to the rise of this system? What were some of the obligations of a vassal to his lord?

"Feudal Obligations" is from Edward P. Cheyney, ed., *Translations and Reprints from the Original Sources of European History*, vol. 4, pt. 3 (Philadelphia: University of Pennsylvania Press, 1897), pp. 23–24.

The Cultural Intersection

JAPAN: 1650

The Way of the Samurai

YAMAGA SOKŌ

The feudal relationship between a medieval knight or vassal and his lord provided stability for medieval society. But this contractual relationship and the code of honor it engendered was not restricted to European society. Japanese samurai warriors of the 17th century also linked themselves in service to local lords.

Yamaga Sokō (1622–1685) was a celebrated figure in Japanese history who was one of the "three great rōnin" of the Tokugawa period. As a rōnin he maintained no allegiance to a particular lord, as did most samurai warriors. But he was also concerned with the inactivity of the warrior class under Tokugawa rule in the 17th century and believed that they had a special status and role to perform. To Yamaga, the samurai represented the ideal of balance and commitment so important to enhancing the stature of Japan. A life of austerity, temperance, self-discipline, and readiness to meet death were bound into a creed known as bushidō, the "Way of the Warrior."

Keep in Mind:
• What are the obligations of a samurai warrior to his lord and to himself?

The master once said: The generation of all men and of all things in the universe is accomplished by means of the marvelous interaction of the two forces [yin and yang]. Man is the most highly endowed of all creatures, and all things culminate in man. Generation after generation, men have taken their livelihood from tilling the soil, or devised and manufactured tools, or produced profit from mutual trade, so that peoples' needs were satisfied. Thus the occupations of farmer, artisan, and merchant necessarily grew up as complementary to one another. However the samurai eats food without growing it, uses utensils without manufacturing them, and profits without buying or selling. What is the justification for this? . . . The samurai is one who does not cultivate, does not manufacture, and does not engage in trade, but it cannot be that he has no function at all as a samurai. He who satisfied his needs without performing any function at all would more properly be called an idler. Therefore, one must devote all one's mind to the detailed examination of one's calling. . . . One must first establish the basic principle of the samurai.

The business of the samurai consists in reflecting on his own station in life, in discharging loyal service to his master if he has one, in deepening his fidelity in associations with friends, and, with due consideration of his own position, in devoting himself to duty above all. However, in one's own life, one becomes unavoidably involved in obligations between father and child, older and younger brothers, and husband and wife. Though these are also

the fundamental moral obligations of everyone in the land, the farmers, artisans, and merchants have no leisure from their occupations, and so they cannot constantly act in accordance with them and fully exemplify the Way.

The samurai dispenses with the business of the farmer, artisan, and merchant and confines himself to practicing this Way; should there be someone in the three classes of common people who transgresses against these moral principles, the samurai summarily punishes him and thus upholds proper moral principles in the land. It would not do for the samurai to know the martial and civil virtues without manifesting them. Since this is the case, outwardly he stands in physical readiness for any call to service and inwardly he strives to fulfill the Way of the lord and subject, friend and friend, father and son, older and younger brothers, and husband and wife. Within his heart he keeps to the ways of peace, but without he keeps his weapons ready for use. The three classes of the common people make him their teacher and respect him. By following his teachings, they are enabled to understand what is fundamental and what is secondary.

> "Within the Samurai's heart he keeps to the ways of peace, but without he keeps his weapons ready for use."
> —Yamaga Sokō

Herein lies the Way of the samurai, the means by which he earns his clothing, food, and shelter; and by which his heart is put at ease, and he is enabled to pay back at length his obligation to his lord and the kindness of his parents. . . . This then is the samurai's calling. The man who takes or seeks the pay of a samurai and is covetous of salary without in the slightest degree comprehending his function must feel shame in his heart. Therefore I say that that which the samurai should take as his fundamental aim is to know his own function.

The terms "prince" and "minister" derive their significance from service to mankind. If I have no sense of duty to mankind I am an alien to the prince. If I come to serve him without any consideration for the welfare of mankind, then I am merely the prince's menial servant. If, on the other hand, I have the people's interest at heart, then I am the prince's mentor and colleague. Only then may I really be called a minister.

Compare and Contrast:

- Compare the duty and responsibilities of the samurai to the expectations of the feudal vassal in Europe. In general, both fought for an overlord. Is that where the similarity ended?

- According to Yamaga Sokō what was the "fundamental aim" of a samurai warrior? How far did loyalty to his master extend? Were there higher obligations?

- In what ways did the samurai serve as the regulator of society? How was European society regulated? Who was responsible for the continuity of life? The King? The Church? Or the feudal system?

The Broader Perspective:

- Yamaga Sokō noted that "within the heart of a samurai, he keeps to the ways of peace, but without he keeps his weapons ready to use." Is this sentence a contradiction? Does one only possess weapons if the heart is *not* peaceful? How would you compare Yamaga's idea to Theodore Roosevelt's famous dictum, "Walk softly and carry a big stick"? Is this solid advice or a betrayal of principle?

- Mahatma Gandhi argued that "human dignity is best preserved not by developing the capacity to deal destruction, but by refusing to retaliate." What do you think of this idea? Does it apply to the "Way of the Warrior"?

Education and the Scriptures
CHARLEMAGNE

Charlemagne's involvement in his empire went beyond its administrative regulation. He believed that learning was an essential aspect of life and established palace schools run by great scholars such as Alcuin of York. In these schools, members of the nobility were taught to read and write. In practical terms, this contributed to greater communication and a more efficient administration of the empire. In spiritual terms, the Bible and other Christian writings were now open to study and revision; accuracy was demanded by the emperor. The following selections are from letters written by Charlemagne to the clergy of his realm. They are clear statements of his educational policy.

Charles, by the grace of God, King of the Franks and Lombards and Patrician of the Romans, to Abbot Baugulf and to all the congregation, also to the faithful committed to you, we have directed a loving greeting by our ambassadors in the name of omnipotent God.

We, together with our faithful, have considered it to be useful that the bishoprics and monasteries entrusted by the favor of Christ to our control, . . . ought to be zealous in teaching those who by the gift of God are able to learn, . . . so that those who desire to please God by living rightly should not neglect to please him by speaking correctly. . . . For although correct conduct may be better than knowledge, nevertheless knowledge precedes conduct. Therefore, each one ought to study what he desires to accomplish, so that so much the more fully the mind may know what ought to be done, as the tongue hastens in the praises of omnipotent God without the hindrances of errors. . . . For when in the years just passed letters were often written to us from several monasteries in which it was stated that the brethren who dwelt there offered up in our behalf sacred and pious prayers, we have recognized in most of these letters both correct thoughts and uncouth expressions; because what pious devotion dictated faithfully to the mind, the tongue, uneducated on account of the neglect of study, was not able to express in the letter without error. . . . And we all know well that, although errors of speech are dangerous, far more dangerous are errors of the understanding. Therefore, we exhort you not only not to neglect the study of letters, but also with most humble mind, pleasing to God, to study earnestly in order that you may be able more easily and more correctly to penetrate the mysteries of the divine Scriptures. . . . And may this be done with a zeal as great as the earnestness

> "We exhort you . . . to study earnestly in order that you may be able . . . to penetrate the mysteries of the divine Scriptures."
> —Charlemagne

with which we command it. For we desire you to be, as it is fitting that soldiers of the church should be, devout in mind, learned in discourse, chaste in conduct and eloquent in speech, so that whosoever shall seek to see you out of reverence for God, or on account of your reputation for holy conduct, just as he is edified by your appearance, may also be instructed by your wisdom, which he has learned from your reading or singing, and may go away joyfully giving thanks to omnipotent God. Do not neglect, therefore, if you wish to have our favor, to send copies of this letter to all your fellow-bishops and to all the monasteries . . . farewell.

"Education and the Scriptures" is from Dana Munro, ed., *Translations and Reprints from the Original Sources of European History*, vol. 6, pt. 5 (Philadelphia: University of Pennsylvania Press, 1899), pp. 12–14.

Carolingian Scholarship (790)

CHARLEMAGNE

Charles, by the aid of God king of the Franks and Lombards and patricius of the Romans, to the clergy of his realm. . . . Now since we are very desirous that the condition of our churches should constantly improve, we are endeavoring by diligent study to restore the knowledge of letters which has been almost lost through the negligence of our ancestors, and by our example we are encouraging those who are able to do so to engage in the study of the liberal arts. In this undertaking we have already, with the aid of God, corrected all the books of the Old and New Testament, whose texts had been corrupted through the ignorance of copyists. . . . Finally, since we have found that many of the lessons to be read in the nightly service have been badly compiled and that the texts of these readings are full of mistakes, and the names of their authors omitted, and since we could not bear to listen to such gross errors in the sacred lessons, we have diligently studied how the character of these readings might be improved. Accordingly we have commanded Paul the Deacon, our beloved subject, to undertake this work; that is, to go through the writings of the fathers carefully, and to make selections of the most helpful things from them and put them together into a book, as one gathers occasional flowers from a broad meadow to make a bouquet. And he, wishing to obey us, has read through the treatises and sermons of the various catholic fathers and has picked out the best things. These selections he has copied clearly without mistakes and has arranged in two volumes, providing readings suitable for every feast day throughout the whole year. We have tested the texts of all these readings by our own knowledge, and now authorize these volumes and commend them to all of you to be read in the churches of Christ.

Consider This:

- The palace school of Alcuin was part of a larger educational movement that historians have termed the "Carolingian Renaissance." According to the sources, why did Charlemagne demand attention to reading and writing? Was the church at risk when more people could read the Bible and other Christian literature? Why?

"Carolingian Scholarship" is from Oliver Thatcher and Edgar McNeal, eds., *A Source Book of Medieval History* (New York: Charles Scribner's Sons, 1905), pp. 56–57.

The Artistic Vision

THE ILLUMINATION OF GOD:
THE BOOK OF KELLS

The Carolingian Renaissance that fostered literacy and learning in the late 8th century at Charlemagne's court by Alcuin of York was not the only example of progressive scholarship during the early Middle Ages. In fact, at about the same time on the distant island of Iona between Scotland and Ireland, devout monks began work on perhaps the most beautiful of all illuminated manuscripts, The Book of Kells. *Its name derived from the Abbey of Kells in the Irish Midlands where the book was kept, after Viking raids threatened Iona in the 9th century, until 1541. Since 1661, the manuscripts have been preserved in the library of Trinity College in Dublin.*

The Book of Kells *consists of the Latin text of the four Gospels written in ornate script and lavishly illustrated in as many as 10 colors. Scholars can identify four master painters and calligraphers whose particular skill and stylistic technique are distinguishable. The ornamentation of a particular letter displays the Word of God intimately and personally, an artistic commitment reflective of deep spirituality. This illuminated manuscript truly embraced the most intricate form of divine adoration. It remains one of the great examples of medieval devotion and artistic expression.*

Keep in Mind:

- Note the geometric combinations of circles and rectangles that anchor the illuminations on the manuscript. How do these illuminations express the adoration of God?

Consider This:

- This is perhaps the most famous illumination from *The Book of Kells*. The interposition of the Greek letters chi and rho that form the first two letters of "Christos" lead the eye in a swirl of motion as each curve establishes new opportunities for intricate combinations. Amid all the physical turmoil of Viking raids, how does this illuminated manuscript reflect the spiritual stability and dedication of the Christian community in Ireland and on the Scottish island of Iona?

- The medieval period was viewed by later Renaissance artists as static and uncreative. How do these illuminations challenge this interpretation of medieval art?

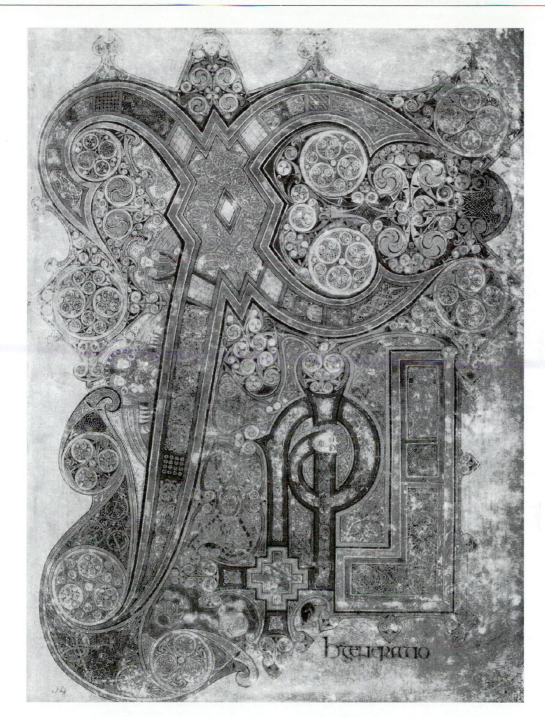

Figure 4–1 Chi/Rho Illumination from *The Book of Kells* (Art Resource, N.Y.).

Byzantine Spiritual Foundations

As the Western Roman Empire succumbed to Germanic invaders in the fourth and fifth centuries C.E., power shifted from Rome which was at constant risk, to the city of Byzantium. The emperor Constantine the Great began the rebuilding of Byzantium in 324 and renamed the city Constantinople in 330. Its well-defended and critical location on the lucrative eastern trade routes at the entrance to the Black Sea augured a dynamic future. Greek culture dominated the region, and this eastern successor to the glory of Rome became known as the Byzantine Empire. Between 324 and its demise in 1453, the Byzantine Empire provided an important link between the Eastern and Western cultures of the former Roman Empire.

The religious history of the Byzantine Empire is particularly interesting, owing to the relatively unrestricted and speculative intellectual heritage of the Greek East. A free flow of ideas had always been a feature of Greek philosophy, and the Christian churches in the eastern Mediterranean had been absorbed in this tradition. The patriarchs of Constantinople, Alexandria, Antioch, and Jerusalem were especially influential and competitive. Many doctrinal differences arose between the pope in Rome and these eastern patriarchs over such issues as the nature of the Trinity and the worship of religious icons (representation of saints and other religious artifacts), not to mention whether papal authority held primacy for Byzantine Christians. Eventually these matters led to a split in the Christian church in 1054, with the establishment of Eastern Orthodox Christianity and Roman Catholic Christianity. The churches still remain split, although Pope John Paul II has renewed the call for unity.

Byzantine emperors had a long tradition of involvement with religious affairs. In fact, the term "Caesaro-papism" describes this melding of political power and religious authority in the person of the emperor. The first selection discusses the concern over the appearance of a dangerous heresy in the late third century, which threatened the unity of the early Christian church. Arius was an Egyptian priest who argued that Jesus was the Son of God and since sons always existed after fathers, then Jesus could not be both the Son of God and God at the same time. Jesus was a created being and therefore not eternal, nor made of the same substance (homoousion) as the Father. Arius believed that Jesus was made of similar substance (homoiousion), but was primarily human. Constantine himself called the Council of Nicaea in 325 to settle the dispute and therein was formed the Nicene Creed, which settled the matter and provided a precedent for secular influence within the Eastern churches.

Heresy: The Threat of Arianism

EUSEBIUS

In this manner the emperor [Constantine], like a powerful herald of God, [wrote] to all the provinces, at the same time warning his subjects against superstitious error, and encouraging them in the pursuit of true godliness. But in the midst of his joyful anticipations of the success of this measure, he received tidings of a most serious disturbance which had invaded the peace of the Church. This intelligence he heard with deep concern, and at once endeavored to devise a remedy for the evil. The origin of this disturbance may be thus described.

The people of God were in a truly flourishing state, and abounding in the practice of good works. No terror from without assailed them, but a bright and most profound peace, through the favor of God, encompassed his Church on every side. Meantime, however, the spirit of envy was watching to destroy our blessings, which at first crept in unperceived, but soon

"Heresy: The Threat of Arianism" is from Eusebius, *The Life of the Blessed Emperor Constantine*, in *A Select Library of Nicene and Post-Nicene Fathers of the Christian Church*, vol. I, trans. Ernest C. Richardson (New York: The Christian Literature Company, 1890), pp. 515–516.

reveled in the midst of the assemblies of the saints. At length it reached the bishops themselves, and arrayed them in angry hostility against each other, on pretense of a jealous regard for the doctrines of Divine truth. Hence it was that a mighty fire was kindled as it were from a little spark, and which, originating in the first instance in the Alexandrian church, overspread the whole of Egypt and Libya, . . . and eventually extended its ravages to the other provinces and cities of the empire; so that not only the prelates of the churches might be seen encountering each other in the strife of words, but the people themselves were completely divided, some adhering to one faction and others to another. So notorious did the scandal of these proceedings become, that the sacred matters of inspired teaching were exposed to the most shameful ridicule in the very theaters of the unbelievers. . . .

The Nicene Creed (325)
EUSEBIUS

[In accordance with the Emperor Constantine's instructions,] the bishops drew up this formula of faith:

'We believe in one God, the Father Almighty, Maker of all things visible and invisible: and in one Lord Jesus Christ, the Son of God, the only-begotten of the Father, that is of the substance of the Father; God of God, Light of light, true God of true God; begotten not made, consubstantial with the Father; by whom all things were made both which are in heaven and on earth; who for the sake of us men, and on account of our salvation, descended, became incarnate, was made man, suffered and rose again on the third day; he ascended into the heavens and will come to judge the living and the dead. We believe also in the Holy Spirit. But those who say "There was a time when he was not," or "He did not exist before he was begotten," or "He was made of nothing," or assert that "He is of other substance or essence than the Father," or that the Son of God is created, or mutable, or susceptible of change, the Catholic and apostolic Church of God rejects. . . .

'Consequently [Christ] is no creature like those which were made by him, but is of a substance far excelling any creature; which substance the Divine Oracles teach was begotten of the Father by such a mode of generation as cannot be explained nor even conceived by any creature. Thus also the declaration that "the Son is consubstantial [homoousios] with the Father" having been discussed, it was agreed that this must not be understood in a corporeal sense, or in any way analogous to mortal creatures; inasmuch as it is neither by

> "The Son of God has no resemblance to created things . . . and he is of no other substance but of the Father."

division of substance, nor by any change of the Father's substance and power, since the underived nature of the Father is inconsistent with all these things. That he is consubstantial with the Father then simply implies, that the Son of God has no resemblance to created things, but is in every respect like the Father only who begat him; and that he is of no other substance or essence but of the Father. . . . Accordingly, since no divinely inspired Scripture contains the expression, "of things which do not exist" and "there was a time when he was not," and such other phrases as are therein subjoined, it seemed unwarrantable to utter and teach them.'

"The Nicene Creed" is from Eusebius, *The Life of the Blessed Emperor Constantine*, in *A Select Library of Nicene and Post-Nicene Fathers of the Christian Church*, vol. I, trans. Ernest C. Richardson (New York: The Christian Literature Company, 1890), pp. 515–518.

Iconoclasm and Orthodoxy:
The Second Council of Nicaea (787)

Another primary religious dispute within Eastern Christianity was the tradition of worshiping images of Christ, the Virgin, and the saints. Although this was acceptable practice in Western churches, in 726 the Byzantine emperor Leo IV abolished the cult of images by imperial edict. This was called "iconoclasm," and it is a primary example of Caesaro-papism. In 787, however, the empress Irene, who served as regent to her young son, reestablished the veneration of images at the Second Council of Nicaea, as the following source indicates. This policy remained under dispute for centuries.

We, therefore, following the royal pathway and the divinely inspired authority of our holy Fathers and the traditions of the Catholic Church for, as we all know, the Holy Spirit dwells in her, define with all certitude and accuracy, that

> **"He who shows reverence to the image shows reverence to the subject represented in it."**

just as the figure of the precious and life-giving cross, so also the venerable and holy images, as well in painting and mosaic, as of other fit materials, should be set forth in the holy churches of God. . . . For by so much the more frequently as they are seen in artistic representation, by so much the more readily are men lifted up to the memory of their prototypes, and to a longing after them; and to these should be given due salutation and honorable reverence, not indeed that true worship which pertains alone to the divine nature; but to these, as to the figure of the precious and life-giving cross, and to the book of the Gospels and to other holy objects, incense and lights may be offered according to ancient pious custom. For the honor which is paid to the image passes on to that which the image represents, and he who shows reverence to the image shows reverence to the subject represented in it.

Those, therefore, who dare to think or teach otherwise, or as wicked heretics dare to spurn the traditions of the Church and to invent some novelty, or else to reject some of those things which the Church hath received, to wit, the book of the Gospels, or the image of the cross, or the pictorial icons, or the holy relics of a martyr, or to devise anything subversive of the lawful traditions of the Catholic Church, or to turn to common uses the sacred vessels and the venerable monasteries, if they be bishops or clerics we command that they be deposed [and] be cut off from communion.

Consider This:

- Why was the Arian heresy such a threat to the religious unity of Christianity? How did the Nicene Creed solve the controversy? How would you interpret the statement that Jesus was "begotten not made"? What was the emperor Constantine's role in the Council of Nicaea, and how does this reflect the principles of Caesaro-papism?

"Iconoclasm and Orthodoxy" is from Joseph G. Ayer, Jr., ed., *A Source Book for Ancient Church History* (New York: Charles Scribner's Sons, 1913), pp. 696–697.

The Architectural Foundation

HAGIA SOPHIA

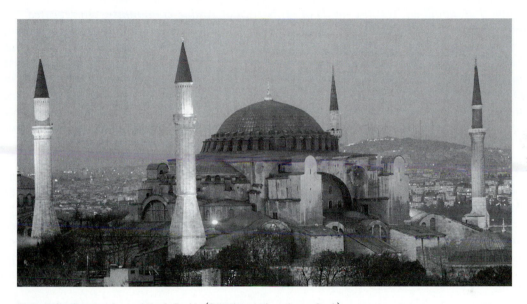

Figure 4–2 Exterior photo of Hagia Sophia (Getty Images Inc.—Image Bank).

Byzantine art has a stylized, religious emphasis that is distinguished by its naturalism, attention to intricate detail, and ornamented finery. The greatest monument of Byzantine architecture is Hagia Sophia or the Church of the Divine Wisdom in modern Istanbul. Built in a mere five years from 532 to 537, the emperor Justinian intended it as the keystone of a vast architectural campaign.

The interior of Hagia Sophia rejects any hint of homogeneity. There are columns of granite from Egypt, porphyry from Turkey, and green marble from Greece. The sunlight plays against beautiful mosaics and creates a mystical aura. Even more engaging are the minarets and other Islamic additions made after Constantinople fell to the Ottoman Turks in 1453. Hagia Sophia then became known as "The Blue Mosque" and today celebrates its eclectic artistic heritage.

Consider This:

- The architectural historian Marvin Trachtenberg noted that Hagia Sophia realized the "ideal Byzantine model" of architecture. How would you define Byzantine artistic style and how does Hagia Sophia reflect it?

Islamic Civilization

The rise of Islamic civilization is a story of faith and confrontation amid societies in political and cultural transition. The basic ideas of the Islamic worldview derived from a single prophetic revelation of the prophet Muhammad in the Qur'an: "There is but one God and his prophet is Muhammad." It is a simple revelation that has formed the basis of one of the world's most influential religions.

Muhammad (ca. 570–632) was an orphan who had worked on a caravan before marrying a wealthy widow. He was a man of great spiritual depth who had become troubled about the idolatry, worldliness, and lack of social conscience that plagued his society. Muhammad's discontent with this moral status quo and his searching nature positioned him to found a new religion that would address the needs of his particular Arabic community. On repeated occasions, he felt himself called by God (Allah) to "rise and warn" his fellow Arabs about their moral vacuousness. God's word had been delivered through other prophets prior to Muhammad, including Abraham, Moses, and Jesus. But the final revelation of God's work, the recitation (qur'an), was given to Muhammad by the messenger angel Gabriel. The message was clear: The Prophet Muhammad was to warn Arabs of God's displeasure with idolatrous worship and injustices to the weak and sick, the poor, widows, orphans, and women. God spoke of a judgment day when believers would enjoy the pleasures of paradise and nonbelievers would be cast into eternal hellfire, to be damned forever. God forgives the penitent and rewards those who respect his law and offer proper gratitude. Through submission (islam) to God's will, one becomes submissive (muslim) in worship and morality. A fervent monotheism is essential to the acceptance of the religion of Islam. Only humans have been given the choice either to obey or to reject the one true God.

At first Muhammad's revelations and strict demands invited opposition and even persecution in the city of Mecca, but his reputation as a moral leader increased and he was accepted in the city of Medina. This emigration (hegira) from Mecca to Medina in 622 became the starting point for year one of the Islamic calendar, signifying the creation of the Islamic community (umma).

Devotion to Islam is based on five basic principles or "pillars": (1) the acceptance of one God, Allah, and Muhammad as his prophet; (2) recitation of prayers five times a day toward Mecca after ritual purification before worship; (3) daytime fasting and abstinence from sexual relations from sunrise to sunset for one month a year; (4) payment of a tithe to support poor and unfortunate Muslims; and (5) a pilgrimage to Mecca at least once in a lifetime (hajj), if one is able. The moral codes of Islam help define the religion: allegiance to the Islamic community, abstention from alcohol and pork, and modesty in personal affairs.

After Muhammad's death in 632, the Islamic community struggled to maintain its unity since Muhammad had not named a successor. The success of Islam in organizing itself and in promoting the religion not only throughout Arab lands but beyond to Europe and the East is one of the great dramas of history. The influence of Islam on our contemporary world is formidable indeed, and it is important to understand the spiritual foundations of this impressive religion.

The following excerpts are primarily from the Qur'an and provide insight into some of the most important aspects of Islam.

The Religious Tenets of the Qur'an

The Heritage of Islam

In the Name of Allah, the Compassionate, the Merciful.

This Book is not to be doubted. It is a guide for the righteous, who have faith in the unseen and are steadfast in prayer; who bestow in charity a part of what We have given them; who trust what has been revealed to you and to others before you, and firmly believe in the life to come. These are rightly guided by their Lord; these shall surely triumph.

As for the unbelievers, it is the same whether or not you forewarn them; they will not have faith. God has set a seal upon their hearts and ears; their sight is dimmed and grievous punishment awaits them. . . .

To Moses We gave the Scriptures and after him We sent other apostles. We gave Jesus the son of Mary veritable signs and strengthened him with the Holy Spirit. Will you then scorn each apostle whose message does not suit your fancies, charging some with imposture and slaying others? They say: 'Our hearts are sealed.' But God has cursed them for their unbelief. They have but little faith.

And now that a Book confirming their own has come to them from God, they deny it, although they know it to be the truth and have long prayed for help against the unbelievers. God's curse be upon the infidels! Evil is that for which they have bartered away their soul. To deny God's own revelation, grudging the He should reveal His bounty to whom He chooses from among His servants! They have incurred God's most inexorable wrath. An ignominious punishment awaits the unbelievers. . . .

Many among the People of the Book [Jews and Christians] wish, through envy, to lead you back to unbelief, now that you have embraced the Faith and the truth has been made plain to them. Forgive them and bear with them until God makes known His will. God has power over all things.

Attend to your prayers and render the alms levy. Whatever good you do shall be rewarded by God. God is watching all your actions.

They declare: 'None shall enter Paradise but Jews and Christians.' Such are their wishful fancies. Say: 'Let us have your proof, if what you say be true.' Indeed, those that surrender themselves to God and do good works shall be rewarded by their Lord: they shall have nothing to fear or to regret.

The Jews say the Christians are misguided, and the Christians say it is the Jews who are misguided. Yet they both read the Scriptures. And the ignorant say the same of both. God will judge their disputes on the Day of Resurrection. . . .

They say: 'Accept the Jewish or the Christian faith and you shall be rightly guided.'

Say: 'By no means! We believe in the faith of Abraham, the upright one. He was no idolater.'

Say: 'We believe in God and that which is revealed to us; in what was revealed to Abraham, Ishmael, Isaac, Jacob, and the tribes; to Moses and Jesus and the other prophets by their Lord. We make no distinction among any of them, and to God we have surrendered ourselves.'

If they accept your faith, they shall be rightly guided; if they reject it, they shall surely be in schism. Against them God is your all-sufficient defender. He bears all and knows all. . . .

Believers, eat of the wholesome things with which We have provided you and give thanks to God, if it is Him you worship.

He has forbidden you carrion, blood, and the flesh of swine; also any flesh that is consecrated other than in the name of God. But whoever is compelled through necessity, intending neither to sin nor to transgress, shall incur no guilt. God is forgiving and merciful. . . .

Righteousness does not consist in whether you face towards the East or the West. The

"The Heritage of Islam" is from *The Koran*, trans. N. J. Dawood (New York and Harmondsworth, Middlesex: Penguin Books, 1956; Fifth Revised Edition, 1990), pp. 11, 18, 20–21, 23, 26–27, 29, 420. Copyright © 1956, 1959, 1966, 1968, 1974, 1990 by N. J. Dawood. Fifth Revised Edition Reprinted by permission of Penguin Books, Ltd.

righteous man is he who believes in God and the Last Day, in the angels and the Book and the prophets; who, though he loves it dearly, gives away his wealth to kinsfolk, to orphans, to the destitute, to the traveler in need and to beggars, and for the redemption of captives; who attends to his prayers and renders the alms levy; who is true to his promises and steadfast in trial and adversity and in times of war. Such are the true believers; such are the God-fearing. . . .

Fight for the sake of God those that fight against you, but do not attack them first. God does not love the aggressors.

Slay them wherever you find them. Drive them out of the places from which they drove

> "Fight for the sake of God those that fight against you, but do not attack them first. God does not love the aggressors."
>
> —The *Qur'an*

you. Idolatry is more grievous than bloodshed. But do not fight them within the precincts of the holy Mosque unless they attack you there; if they attack you put them to the sword. Thus shall the unbelievers be rewarded: but if they mend their ways, know that God is forgiving and merciful.

Fight against them until idolatry is no more and God's religion reigns supreme. But if they desist, fight none except the evil-doers. . . .

Give generously for the cause of God and do not with your own hands cast yourselves into destruction. Be charitable; God loves the charitable.

Make pilgrimage and visit the Sacred House [in Mecca] for His sake. If you cannot, send such offerings as you can afford and do not shave your heads until the offerings have reached their destination. But if any of you is ill or suffers from an ailment of the head, he must pay a ransom either by fasting or by almsgiving or by offering a sacrifice. . . .

When the sky is rent asunder; when the stars scatter and the oceans roll together; when the graves are hurled about; each soul shall know what it has done and what it has failed to do.

O man! What evil has enticed you from your gracious Lord who created you, gave you an upright form, and proportioned you? In whatever shape He willed He could have molded you. Yet you deny the Last Judgement. Surely there are guardians watching over you, noble recorders who know of all your actions.

The righteous will surely dwell in bliss. But the wicked shall burn in Hell upon the Judgement-day: nor shall they ever escape from it.

Would that you knew what the Day of Judgement is! Oh, would that you knew what the Day of Judgement is! It is the day when every soul will stand alone and God will reign supreme.

The *Qur'an* on Women

In the Name of Allah, the Compassionate, the Merciful.

Men, have fear of your Lord, who created you from a single soul. From that soul He created its mate, and through them He bestrewed the earth with countless men and women.

Fear God, in whose name you plead with one another, and honor the mothers who bore you. God is ever watching you.

Give orphans the property which belongs to them. Do not exchange their valuables for worthless things or cheat them of their possessions; for this would surely be a great sin. If you fear that you cannot treat orphan [girls] with fairness, then you may marry other women who seem good to you: two, three, or four of them. But if you fear that you cannot maintain equality among them, marry one only or any

"The *Qur'an* on Women" is from *The Koran*, trans. N. J. Dawood (New York and Harmondsworth, Middlesex: Penguin Books, 1956; Fifth Revised Edition, 1990), pp. 60–62, 64, 74. Copyright © 1956, 1959, 1966, 1968, 1974, 1990 by N. J. Dawood. Reprinted by permission of Penguin Books, Ltd.

> ## "Fear God . . . and honor the mothers who bore you. God is ever watching you."
> ### —The *Qur'an*

slave-girls you may own. This will make it easier for you to avoid injustice.

Give women their dowry as a free gift; but if they choose to make over to you a part of it, you may regard it as lawfully yours. . . .

God has thus enjoined you concerning your children: A male shall inherit twice as much as a female. If there be more than two girls, they shall have two-thirds of the inheritance; but if there be one only, she shall inherit the half. Parents shall inherit a sixth each, if the deceased have a child; but if he leaves no child and his parents be his heirs, his mother shall have a third. If he has brothers, his mother shall have a sixth after payment of any legacy he may have bequeathed or any debt he may have owed.

You may wonder whether your parents or your children are more beneficial to you. But this is the law of God; God is all-knowing and wise. . . .

If any of your women commit fornication, call in four witnesses from among yourselves against them; if they testify to their guilt confine them to their houses till death overtakes them or till God finds another way for them. . . .

Men have authority over women because God has made the one superior to the other, and because they spend their wealth to maintain them. Good women are obedient. They guard their unseen parts because God has guarded them. As for those from whom you fear disobedience, admonish them and send them to beds apart and beat them. Then if they obey you, take no further action against them. God is high, supreme. . . .

If a woman fears ill-treatment or desertion on the part of her husband, it shall be no offence for them to seek a mutual agreement, for agreement is best. . . . Try as you may, you cannot treat all your wives impartially. Do not set yourself altogether against any of them, leaving her, as it were in suspense. If you do what is right and guard yourselves against evil, you will find God forgiving and merciful. If they separate, God will compensate both out of His own abundance: God is munificent and wise.

The Love of Allah
AL-GHAZZALI

The love of God is the highest of all topics, and is the final aim to which we have been tending hitherto. We have spoken of spiritual dangers as they hinder the love of God in a man's heart, and we have spoken of various good qualities as being the necessary preliminaries to it. Human perfection resides in this, that the love of God should conquer a man's heart and possess it wholly, and even if it does not possess it wholly it should predominate in the heart over the love of all other things. Nevertheless, rightly to understand the love of God is so difficult a matter that one sect of theologians have altogether denied that man can love a Being who is not of his own species, and they have defined the love of God as consisting merely in obedience. Those who hold such views do not know what real religion is.

All Muslims are agreed that the love of God is a duty. God says concerning the believers, "He loves them and they love Him," and the Prophet [Muhammad] said, "Till a man loves God and His Prophet more than anything else he has not the right faith. . . ."

When we apply this principle to the love of God we shall find that He alone is really worthy of our love, and that, if any one loves Him not, it is because he does not know Him. Whatever we love in any one we love because it is a reflection of Him. It is for this reason that we love Muhammad, because he is the Prophet and the Beloved of God, and the love of learned and

"The Love of Allah" is from Al-Ghazzali, *The Alchemy of Happiness*, trans. Claud Field, *The Wisdom of the East Series* (London: John Murray Publishers, Ltd., 1910), pp. 51–54.

pious men is really the love of God. We shall see this more clearly if we consider what are the causes which excite love.

The first cause is this, that man loves himself and the perfection of his own nature. This leads him directly to the love of God, for man's very existence and man's attributes are nothing else but the gift of God, but for whose grace and kindness man would never have emerged from behind the curtain of non-existence into the visible world. Man's preservation and eventual attainment to perfection are also entirely dependent upon the grace of God. It would indeed be a wonder, if one should take refuge from the heat of the sun under the shadow of a tree and not be grateful to the tree, without which there would be no shadow at all. Precisely in the same way, were it not for God, man would have no existence nor attributes at all; wherefore, then, should he not love God, unless he be ignorant of Him? Doubtless fools cannot love Him, for the love of Him springs directly from the knowledge of Him, and whence should a fool have knowledge?

Consider This:

- What are the basic tenets of Islam as noted in the selections from the *Qur'an* and from Al-Ghazzali on "The Love of Allah"? Was Muhammad, like Jesus, considered to be divine in nature?

- How do you interpret the phrase "Fight for the sake of God those that fight against you, but do not attack them first. God does not love the aggressors"? The next statement reads: "Slay them wherever you find them. Drive them out of places from which they drove you." Do you find these ideas to be contradictory? Why or why not?

- How are women viewed by the *Qur'an*? Do women have legal rights? Do they assume equal status with men?

The Islamic Worldview

Within two centuries after the death of Muhammad in 632 C.E., the Muslim faith had spread to Spain and the Atlantic coast in the west, and to the borders of India and China in the east. This astonishing record of conversion was made possible by a centralized commitment to the faith of Islam even in the face of internal political turmoil, the strength and organization of a powerful Islamic military force, and very importantly, an Islamic interest in trade and exploration. After about 900, as the centralized caliphate administration gave way to the more flexible control of regional rulers, Islam spread to Afghanistan, India, and southeast Asia. Muslim maritime traders paved the way for this expansion of political control in the 15th and 16th centuries. Commercial interest was also responsible for Islamic expansion into sub-Saharan Africa from 850 to 1500. Caravans from Egypt, Libya, and Morocco in north Africa introduced the Islamic faith to the kingdoms of Ghana (ca. 700–1100) and Mali (1100–1400). The legendary trading center of Timbuktu on the Niger River near the Sahara became a major cultural center for Arabic and Muslim studies. By 1500, Islamic trade centers dotted the east coast of Africa.

The following selection is from one of the most celebrated story collections in the world. Under threat of death, Shahrazad, wife of the king of India and China, forestalled her execution by mesmerizing her husband with a new tale of love, deception, adventure, and conquest each night until in admiration, he lifted her sentence of death. Finally compiled in the 14th century, A Thousand and One Arabian Nights *reflects the rich folk traditions throughout the Islamic world. One of the most influential story cycles told of the adventures of Sinbad the Sailor. His seven voyages into the Indian Ocean reveal much about the Islamic spirit of adventure and attitude toward trade and risk.*

"We Begin Our Voyage": The Adventures of Sinbad

I dissipated the greatest part of my paternal inheritance in the excesses of my youth; but at length, seeing my folly, I became convinced that riches were not of much use when applied to such purposes as I had employed them in. . . . In short, I determined to employ to some profit the small sum I had remaining, and no sooner was this resolution formed than I put it into execution. I went to Basra [at the northern tip of the Persian Gulf], where I embarked with several merchants in a vessel which had been equipped at our united expense.

We set sail and steered toward the East Indies by the Persian Gulf. . . . One day, when in full sail, we were unexpectedly becalmed before a small island appearing just above the water, and which, from its green color, resembled a beautiful meadow. The captain ordered the sails to be lowered, and gave permission to those who wished it to go ashore, of which number I formed one. But during the time that we were regaling ourselves with eating and drinking, by way of relaxation from the fatigues we had endured at sea, the island suddenly trembled, and we felt a severe shock.

They who were in the ship perceived the earthquake in the island, and immediately called to us to re-embark as soon as possible, or we should all perish, for what we supposed to be an island was no more than the back of a whale! The most active of the party jumped into the boat, while others threw themselves into the water to swim to the ship: as for me, I was still on the island, or, more properly speaking, on the whale, when it plunged into the sea, and I had only time to seize hold of a piece of wood which had been brought to make a fire with. Meantime the captain, willing to avail himself of a fair breeze which had sprung up, set sail with those who had reached his vessel, and left me to the mercy of the waves. I remained in this situation the whole of that day and the following night; and on the return of morning I had neither strength nor hope left, when a breaker happily dashed me on an island. The shore was high and steep, and I should have found great difficulty in landing,

had not some roots of trees, which fortune seemed to have furnished for my preservation, assisted me. I threw myself on the ground, where I continued, more than half dead, till the sun rose.

Although I was extremely enfeebled by the fatigues I had undergone, I tried to creep about in search of some herb or fruit that might satisfy my hunger. I found some, and had also the good luck to meet with a stream of excellent water, which contributed not a little to my recovery. Having in a great measure regained my strength, I began to explore the island, and entered a beautiful plain. . . . I heard a voice of a man, who shortly after appeared, and coming to me, asked me who I was. I related by adventure to him; after which he took me by the hand and led me into a cave, where there were some other persons, who were not less astonished to see me than I was to find them there.

I ate some food which they offered me; and having asked them what they did in a place which appeared so barren, they replied that they were grooms to King Mihrage, who was the sovereign of that isle, and that they came every year about that time with some mares belonging to the king, for the purpose of having a breed between them and a sea-horse which came on shore at that spot. . . .

The following day they returned to the capital of the island with the mares, where I accompanied them. On our arrival, King Mihrage, to whom I was presented, asked me who I was, and by what chance I had reached his dominions; and when I had satisfied his curiosity, he expressed pity at my misfortune. At the same time, he gave orders that I should be taken care of and have everything I might want. These orders were executed in a manner that proved the king's generosity, as well as the exactness of his officers.

As I was a merchant, I associated with persons of my own profession. I sought, in particular, foreigners, as much to hear some intelligence of Baghdad, as with the hope of meeting with some one whom I could return with; for the capital of King Mihrage is situated on the sea-coast,

"We Begin Our Voyage" is from *The Arabian Nights' Entertainments*, trans. by Edward William Lane (London: George Routledge, 1890), pp. 113–114, 116.

and has a beautiful port, where vessels from all parts of the world daily arrive. I also sought the society of the Indian sages, and found great pleasure in their conversation; this, however, did not prevent me from attending at court very regularly, nor from conversing with the governors of provinces, and some less powerful kings, tributaries of Mihrage, who were about his person. They asked me a thousand questions about my country; and I, on my part, was not less inquisitive about the laws and customs of their different states, or whatever appeared to merit my curiosity. . . .

As I was standing one day near the port, I saw a ship come toward the land; when they had cast anchor, they began to unload its goods, and the merchants, to whom they belonged, took them away to their warehouses. Happening to cast my eyes of some of the packages, I saw my name written, and, having attentively examined them, I concluded them to be those which I had embarked in the ship in which I left Basra. I also recollected the captain; but as I was persuaded that he thought me dead, I went up to him . . . : "Captain, I am that Sinbad, whom you supposed dead, but who is still alive, and these parcels are my property and merchandise.". . .

He was rather staggered at my discourse, but was soon convinced that I was not an impostor; for some people arriving from his ship knew and began to congratulate me on my fortunate escape. . . . I selected the most precious and valuable thing in by bales, as presents for King Mihrage. . . . After that, I took my leave of him, and re-embarked in the same vessel, having first exchanged what merchandise remained with that of the country, which consisted of aloes and sandal-wood, camphor, nutmegs, cloves, pepper, and ginger. We touched at several islands, and at last landed at Basra, from whence I came here, having realized [as profit] about a hundred thousand [gold coins]. I returned to

> "I had resolved after my first voyage, to pass the rest of my days in tranquility at Baghdad. . . . But I soon grew weary of an idle life."
>
> —Sinbad

my family, and was received by them with the joy which a true and sincere friendship inspires. I purchased slaves of each sex, and bought a magnificent house and grounds. I thus established myself, determined to forget the disagreeable things I had endured, and to enjoy the pleasures of life. . . .

I had resolved after my first voyage, to pass the rest of my days in tranquility at Baghdad. . . . But I soon grew weary of an idle life; the desire of seeing foreign countries, and carrying on some negotiations by sea returned: I bought some merchandise, which I thought likely to [sell], and set off a second time with some merchants, upon whose probity I could rely. We embarked in a good vessel, and having recommended ourselves to the care of the Almighty, we began our voyage . . .

Consider This:

- What does the adventure of Sinbad the Sailor tell us about Arab exploration and trade? Why did Sinbad venture to the East Indies? Why was trade so important in promoting the expansion of Islam?

"O King, If You Believed in Allah": Islamic Conversion
AL-BAKRI

The Muslim geographer, Abu Ubaydallah al-Bakri (d. 1094), was a resident of Córdoba, Spain, and is most famous for his description of that region. In his Book of Routes and Realms *(1068), al- Bakri drew heavily on the oral information that Islamic merchants provided him about the peoples of West Africa. In this excerpt, he speaks of the conversion of a West African king to the tenets of Islam.*

On the opposite bank of the Nil [Niger River] is another great kingdom, stretching a distance of more than eight days' marching, the king of which has the title of Daw. The inhabitants of this region use arrows when fighting. Beyond this country lies another called Malal [Mali], the king of which is known as *al-musulmani* ["The Muslim"]. He is thus called because his country became afflicted with drought one year following another; the inhabitants prayed for rain, sacrificing cattle till they had exterminated almost all of them, but the drought and the misery only increased. The king had as his guest a Muslim who used to read the Qur'an and was acquainted with the Sunna [traditions of Sunni Muslims]. To this man the king complained of the calamities that assailed him and his people. The man said: "O King, if you believed in Allah (who is exalted) and testified that He is One, and testified as to the prophetic mission of Muhammad (God bless him and give him peace) and if you accepted all the religious laws of Islam, I would pray for your deliverance from your plight and that God's mercy would envelop all the people of your country and that

your enemies and adversaries might envy you on that account." Thus he continued to press the king until the latter accepted Islam and became a sincere Muslim. The man made the king recite from the Qur'an some easy passages and taught him religious obligations and practices which no one may be excused from knowing. Then the Muslim made him wait till the eve of the following Friday, when he ordered him to purify himself by a complete ablution, and clothed him in a cotton garment which he had. The two of them came out towards a mound of earth, and there the Muslim stood praying while the king, standing at his right side, imitated him. Thus they prayed for a part of the night, the Muslim reciting invocations and the king saying "Amen." The dawn had just started to break when God caused abundant rain to descend upon them. So the king ordered the idols to be broken and expelled the sorcerers from his country. He and his descendants after him as well as his nobles were sincerely attached to Islam, while the common people of his kingdom remained polytheists. Since then their rulers have been given the title of *al-musulmani*.

Consider This:

- According to the account of Al-Bakri, why did the West African King of Malal decide to convert to Islam? Even if the king's subjects remained polytheists, why was his conversion important to the success of Islamic conversion?

"O King, If You Believed in Allah" is from J. F. P. Hopkins, trans., and N. Levtzion and J. F. P. Hopkins, eds., *Corpus of Early Arabic Sources for West African History* (Cambridge: Cambridge University Press, 1981), p. 83. Copyright © University of Ghana, International Academic Union, Cambridge University Press, 1981. Reprinted with permission of Cambridge University Press.

5

The Sword of Faith
The Medieval Synthesis of Western Civilization (1100–1450)

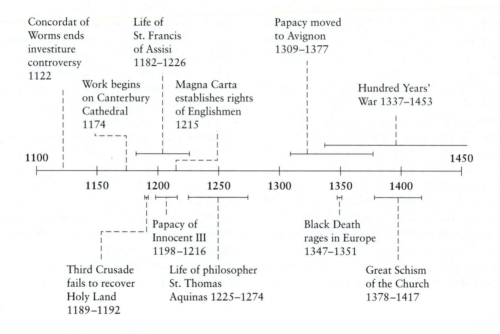

Concordat of Worms ends investiture controversy 1122

Life of St. Francis of Assisi 1182–1226

Papacy moved to Avignon 1309–1377

Work begins on Canterbury Cathedral 1174

Magna Carta establishes rights of Englishmen 1215

Hundred Years' War 1337–1453

1100

1450

1150 1200 1250 1300 1350 1400

Third Crusade fails to recover Holy Land 1189–1192

Papacy of Innocent III 1198–1216

Life of philosopher St. Thomas Aquinas 1225–1274

Black Death rages in Europe 1347–1351

Great Schism of the Church 1378–1417

To believe in God is impossible—not to believe in Him is absurd.

—Voltaire

To raise society to a higher level is the chief business of the Church.
To overcome evil with good is the genius of Christianity.

—A. P. Gouthrey

Man is great only when he is kneeling.

—Pope Pius XII

The tyrant dies and his rule ends, the martyr dies and his rule begins.

—Søren Kierkegaard

I am one who accompanies this living man; we go downward from level to level, and I mean to show him Hell.

—Dante Alighieri

CHAPTER THEMES

- *Social and Spiritual Values:* Why did the secular and spiritual worlds come into conflict during the Middle Ages? In this confrontation between church and state, which authority was dominant, and which legacy more enduring? Why is the Gothic cathedral often considered the quintessential expression of medieval values?

- *The Power Structure:* Some historians have considered the Crusades to be examples of a great "religious enterprise." To what extent were the Crusades about religion and to what extent about the lust for conquest?

- *Women in History and the Humanities:* What were the social and political positions of women during the medieval era? Was the Middle Ages a period of relative freedom for women, and to what extent was this based on the popular worship of the Virgin Mary? Were women really placed on pedestals, and did the medieval concept of chivalry enhance their positions? How did the Islamic view of women differ?

- *The Big Picture:* Why do people need religion? How can it be manipulated by the state in order to control a population? Are popes in essence the same as kings?

Power and Faith in the High Middle Ages

The Great Cathedrals

The Early Middle Ages from about 500 to 1100 was a period fraught with political turmoil and social dislocation. But by 1100, the Viking invasions of Europe had dwindled in intensity and frequency and the Islamic and Byzantine empires had become consolidated. The years from about 1100 to 1300, called the High Middle Ages, represent the acme of medieval civilization. Much of the history of this period involves attempts to achieve unity by restraining forces that contributed to chaos. In this respect, the conflicts between representatives of church and state, as well as the Viking invasions and the Black Death, were primary threats to the unity of medieval civilization. They were countered by movements that organized and directed energy such as the Crusades or the cult of the Virgin Mary (to whom so many cathedrals were dedicated), or by the security of the feudal relationship. In many ways, the Middle Ages was an era of progress that flowed from a spiritual base.

Another way to define this spiritual base and to explore its parameters is through the theme of devotion. The devotion of a vassal to his lord proved to be the cornerstone of political organization and the abstract devotion of a knight to chivalric ideals provided purpose and direction in life. But devotion to God was the foundation of the medieval world. The ascetic principles and

dutiful prayers of monks had great purpose in maintaining a proper relationship with the Creator. The overwhelming authority of the church as the repository of eternal life played a dominant role in the structure and function of society.

The cathedral was perhaps the quintessential expression of faith and devotion in the medieval world. It served as the seat of a bishop or archbishop and provided a spiritual focal point that helped to unify society. Within its walls, the Christian "flock" learned what was

Figure 5–1 The approach to Chartres cathedral (Perry M. Rogers).

expected from them in a society dependent on obedience and structure. The chants and stained glass windows directed people toward right action and salvation through simple messages. This popular devotion to God can best be seen in the construction of these magnificent cathedrals. Hundreds of people, often in small villages, labored for generations to contribute to the glory of God in some tangible way. They were baptized, married, and mourned within the cathedral's cavernous expanses. Pilgrims journeyed long distances simply to pray and offer gifts to an enshrined saint. The following selection by a local Abbot provides a sense of the devotion and importance of the cathedral to medieval life.

Faith and the Construction of the Cathedrals (1145)
ABBOT HAIMON OF SAINT-PIERRE-SUR-DIVES

Who has ever seen!—Who has ever heard tell, in times past, that powerful princes of the world, that men brought up in honor and in wealth, that nobles, men and women, have bent their proud and haughty necks to the harness of carts, and that, like beasts of burden, they have dragged to the abode of Christ these wagons, loaded with wines, grains, oil, stone, wood, and all that is necessary for the wants of life, or for the construction of the church? But while they draw these burdens, there is one thing admirable to observe; they march in such silence that not a murmur is heard. . . . When they halt on the road, nothing is heard but the confession of sins, and pure and suppliant prayer to God to obtain pardon. At the voice of the priests, who exhort their hearts to peace, they forget all hatred, discord is thrown far aside, debts are remitted, the unity of hearts is established. . . . There one sees the priests who preside over each wagon exhort every one to penitence, to confession of faults, to the resolution of better life! There one sees old people, young people, little children, calling on the Lord with a suppliant voice, and uttering to Him, from the depth of the heart, sobs and signs with words of glory and praise! After the people, warned by the sound of trumpets and the sight of banners, have resumed their road, the march is made with such ease that no obstacle can retard it. . . .

"Faith and the Construction of the Cathedrals" is from Henry Adams, *Mont Saint-Michel and Chartres* (Boston, 1904).

The Gothic Style of Chartres Cathedral

The word "Gothic" was adopted by the humanists of the Italian Renaissance as a synonym for "barbaric." The Goths were a particularly aggressive Germanic tribe that had sacked Rome in 410 and had contributed to the destruction of the empire. And yet, there is nothing barbaric about this architectural style. Indeed, the Romanesque architecture of the Early Middle Ages emphasized a closer, more earthbound massing of pillars and arches. This gave way about 1100 to a bold, new style that, in the words of the scholar Henry Adams, "gave the effect of flinging its passion against the sky." The spires of the Gothic cathedral soared like hands touched in prayer, as they pointed to Heaven. Interior columns, displacing more and more weight to accommodate the new heights, were supported by exterior stone bridges that later were replaced by flying buttresses, channeling the thrust of the weight down as it lifted the eye up, past the roofs and spires, to the heights of human aspiration.

The walls of the Gothic cathedral eventually ceased to have a structural function so the masonry was reduced to a bare minimum. The stolid walls of the Romanesque cathedral were replaced by windows through which light bathed the interior. When you enter a Gothic cathedral, there is a breathtaking sensation. One 14th-century visitor commented: "On entering, one feels as if ravished to Heaven, and ushered into one of the most beautiful chambers of paradise." The great cathedrals of Chartres, Notre Dame, Rheims, Salisbury, and Canterbury remain as the author Victor Hugo described them— "vast symphonies in stone."

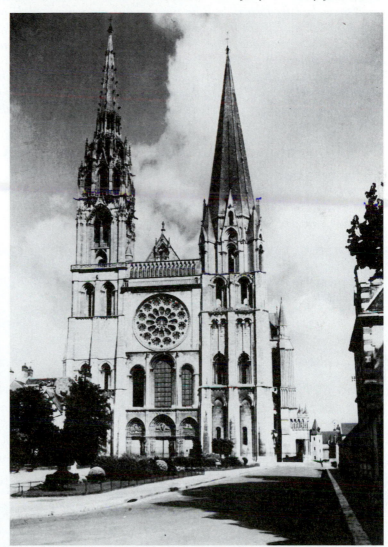

Figure 5–2 The west facade of Chartres cathedral (Perry M. Rogers).

In no other Gothic church of comparable size is the architecture, sculpture, and glass so harmoniously integrated as at Chartres cathedral. This is primarily because of the comparatively short period of construction between 1194 and 1220. The west front of Chartres in particular contains many features typical of Gothic architecture including the great rose window centered between the two towers. But the façade of Chartres is rare in having a pair of spires atop the towers. Spires had been planned for the cathedrals at Rouen and Amiens, but never

completed. Chartres is also rather unique also in that its spires present two different architectural styles. After a fire destroyed the original north spire, the architect in the early 16th century replaced it with a richly decorated, elegant spire reflective of late Gothic style.

The Sculpture of the Gothic Cathedral

The sculpture of the Gothic cathedral was a "visual encyclopedia" depicting a complex iconography of medieval philosophy and theology, as well as the variety of social occupation and class structure. We find knights and ladies of the aristocracy juxtaposed with praying monks, craftsmen and tradespeople. The tympanums atop the portals or entrances to the cathedral provided sculptors with the opportunity to encase scenes from the Bible in the permanence of stone. The famous tympanums over the three "Royal Portals" on the west façade of Chartres depict the majesty of the Holy Family. The right tympanum recounts the life of the Virgin Mary to whom the cathedral is dedicated, while the left concentrates on the last days of Christ and his ascension to Heaven. The central tympanum presents the figure of Christ in Majesty surrounded by the four symbolic beasts of the Evangelists and the 24 elders of the Apocalypse.

An Inventory of Saintly Relics in Canterbury Cathedral (1346)

The medieval cathedral often served as a repository for relics of Christian martyrs to be viewed by pilgrims who made their devotional journeys. The following inventory at Canterbury cathedral testifies to its importance as a pilgrimage destination. The contributions of devout pilgrims were a lucrative source of income for the church.

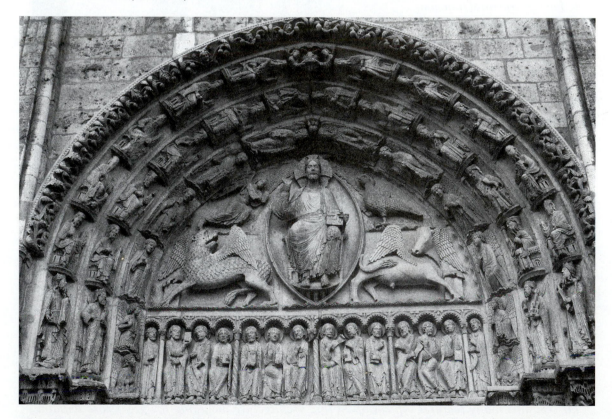

Figure 5–3 The central tympanum on the west façade of Chartres cathedral depicting Christ in Majesty (Perry M. Rogers).

"An Inventory of Saintly Relics in Canterbury Cathedral" is from A. G. Little, ed., *Liber Exemplorum* (Aberdeen, 1908), p. 52.

A piece of the Lord's sign of the Cross, of His lance, and His column. Of the manna which rained from Heaven. Of the stone whereon Christ's blood was spilt. Item, another little cross of slivered wood, containing pieces of the Lord's sepulcher and of St. Margaret's veil. Of the Lord's cradle in a certain copper reliquary.

Given by the Lord Dean [Bocheux]. In certain crystal vessel, portions of the stone tablets whereon God wrote the law for Moses with his finger. Item, in the same vessel, of the stone whereupon St. James crossed the sea. . . .

Of St. Mary. Of the hairs of St. Mary; item, of her robe; item, a shallow ivory box without any ornament save only a knob of copper, which box contains some of the flower which the Blessed Virgin held before her Son, and of the window through which the Angel Gabriel entered when he saluted her. . . .

Of the Martyrs. Of the tunic of St. Thomas of Canterbury, Archbishop and Martyr; of his hair shirt, of his dust, of his hairs. . . . Again of his hairs, of the blanket that covered him, of his woolen shirt. . . . Item, of the blood of the same St. Thomas of Canterbury. Item, the staff of the aforesaid St. Thomas the Martyr, Archbishop of Canterbury.

The Artistic Vision

THE ART OF STAINED GLASS

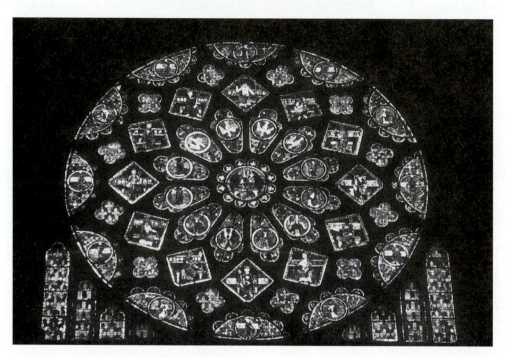

Figure 5–4 The stained glass of Chartres: rose window (Perry M. Rogers).

Pilgrims viewed the spires of magnificent cathedrals looming in the distance as they made their way to pray at altars dedicated to the Virgin Mary or to offer gifts at the shrines of martyred saints. But cathedrals were not impersonal monoliths or mere depositories of Christian relics, for within their walls was contained the abstract presence of God. The imposing verticality of the central nave that inspired awe in the faithful was tempered by the warmth of light that filtered into the cathedral through immense and intricate panels of stained glass.

There is a mystery to stained glass. It captures the light and transforms it into a living expression of doctrine. These decorated windows express the transcendental concepts of devotion and salvation, of power and permanence through a kaleidoscope of color.

Because most of the devout could not read and did not have access to the Bible, they relied on clergy to interpret the Gospels and sustain their faith. In many ways, stained glass served as a medium of communicating the life of Christ in a wondrous way. As one medieval monk put it, stained glass showed "simple people unfamiliar with the Scriptures what they should believe." But in another sense, the faithful experienced a window more than read it. Here was the artistic expression of a local community of glaziers who conceived of an infinite variety of shapes and combinations arranged to fashion the Mystery of the Christian faith.

The glass of Chartres cathedral remains among the most magnificent examples of this local artistic interaction. Chartres's 176 panels of stained glass reflect the diversity of the community from local craft guilds that dedicated windows in honor of bakers or masons, to wealthier donations of the nobility, and even the royal contributions of the great rose windows.

The artists who produced the glass for the Gothic cathedrals often prided themselves on their rose windows, the centerpieces of Gothic interior design, located most often in the west façade and in the north or south transepts. The structure of the windows generally consisted of concentric circles that corresponded to precise geometric formulas. But there were symbolic meanings attached to the windows as well. The circular shape alluded both to the sun, the symbol of Christ, and to the rose, that of the Virgin Mary. The light that colored the interior of the cathedral possessed a "divine luminosity," identified by theologians like Saint Thomas Aquinas with harmony and proportion, beauty and salvation.

The glass of Chartres serves both structural and decorative purposes as an integral part of the architectural plan. The iconographical themes of piety and devotion to the Virgin Mary emanate from the glass panels above the High Altar where the Queen of Heaven sits enthroned, surrounded by neighboring panels of saints and prophets, craftsmen and tradespeople. The religious devotion of the age finds its most integrated and magnificent expression in the stained glass of Chartres cathedral. In many ways, stained glass, like the complex designs of illuminated manuscripts, linked earthly devotion with heavenly vision, worldly concern with eternal justice.

A Martyrdom in Glass:
The Murder of Saint Thomas Becket

EDWARD GRIM

The conflict between spiritual and secular authority was one of the fundamental themes of medieval civilization. Both king and pope claimed supremacy over the other and based their positions on the evidence of scripture and logic. A king might well argue that the very survival of the church depended on his military strength; as defender of the faith, his will should prevail. By contrast, the pope's position as successor to Saint Peter and representative of God on earth commanded the respect of all. For he was entrusted with the "Keys of Heaven," and there could be no exception to the ultimate authority of God.

This confrontation was played out most intensely during the reign of the English king Henry II (1154–1189). On the death of Theobald, Archbishop of Canterbury in 1161, Henry was faced with the dilemma of appointing a new Primate of England. Hopeful of gaining an upper hand on the pope, he decided to appoint his friend and chancellor, Thomas Becket. By having "his man" installed as leader of the English church, Henry hoped to impose his royal will on religious affairs.

Becket was immediately invested as a priest and then ordained a bishop the next day. Later that afternoon on June 2, 1162, Thomas Becket became Archbishop of Canterbury, serving Henry both as chancellor and Primate of England.

But Becket could not reconcile his divided loyalty between God and king. He shifted his allegiance, born apparently of a new and sincere spiritual devotion, to the church. And in the ensuing confrontation with Henry concerning the issue of secular control over religious tribunals, Becket stood in opposition to the encroachment of the state over spiritual jurisdiction.

Frustrated with Becket's commitment to the "honor of God," Henry was purported to have raged to his knights: "What sluggards, what cowards have I brought up in my court, who care nothing for their allegiance to their lord. Who will rid me of this meddlesome priest?"

"A Martyrdom in Glass" is from Edward Grim, *Vita S. Thomae, Cantuariensis Archepiscopi et Martyris*, ed. by James Robertson, *Materials for the Life of Thomas Becket* (London: Rolls Series, 1875–1885), Vol. 2.

In the late afternoon of December 29, 1170, five knights arrived at Canterbury cathedral and found Becket at the altar. They drew their swords and split him in two. The following account of the murder comes from Becket's biographer, Edward Grim, a monk who was present at the execution and was himself wounded in the attack. Henry hunted down the guilty knights and did penance at Becket's tomb. In 1173, Pope Alexander III hailed Becket as a Christian martyr and elevated him to sainthood. Becket's shrine at Canterbury became one of the most celebrated pilgrimage sites in western Europe and the destination of Geoffrey Chaucer's pilgrims in The Canterbury Tales.

Keep in Mind:

- Although this is an eyewitness account, Edward Grim was certainly influenced by Becket's sainthood. Thus we get a favorable perspective, although the fundamentals of the account are likely true.

When the holy archbishop entered the cathedral, the monks who were glorifying God abandoned vespers, which they had begun to celebrate, and ran to their father whom they had heard was dead but they saw alive and unharmed. They hastened to close the doors of the church in order to bar the enemies from slaughtering the bishop, but [Becket] turned toward them and ordered that the doors be opened. "It is not proper," he said, "that a house of prayer, a church of Christ, be made a fortress since although it is not shut up, it serves as a fortification for his people; we will triumph over the enemy through suffering rather than by fighting—and we come to suffer, not to resist." Without delay the sacrilegious men entered the house of peace and reconciliation with swords drawn; indeed, the sight alone as well as the rattle of arms inflicted not a small amount of horror on those who watched. And those knights who approached the confused and disordered people who had been observing vespers...exclaimed in a rage: "Where is Thomas Becket, traitor to the king and kingdom?" No one responded and instantly they cried out more loudly, "Where is the archbishop?" Unshaken, Becket replied to this voice as it is written: "The

> **"Where is Thomas Becket, traitor to the king and kingdom?"**

righteous will be like a bold lion and free from fear." He descended from the steps to which he had been taken by the monks who were fearful of the knights and said in an adequately audible voice, "Here I am, not a traitor of the king but a priest; why do you seek me?" . . .

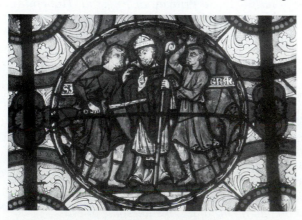

Figure 5–5 Canterbury Cathedral: Martyrdom of Thomas Becket (Perry M. Rogers).

With rapid motion they laid sacrilegious hands on him, [attempting to drag] him roughly outside of the walls of the church so that there they would slay him or carry him from there as a prisoner, as they later confessed. But when it was not possible to easily move him from the column, he bravely pushed one of the knights who was pursuing and drawing near to him; he called him a panderer saying, "Don't touch me, Rainaldus, you who owe me faith and obedience, you who foolishly follow your accomplices." On account of the rebuff, the knight was suddenly set on fire with a terrible rage and,

wielding a sword against the [Archbishop] said, "I don't owe faith or obedience to you that is in opposition to the fealty I owe my lord king." The invincible martyr, seeing that the hour which could bring the end to his miserable mortal life was at hand and already promised by God to be the next to receive the crown of immortality, with his neck bent as if he were in prayer and with his joined hands elevated above, commended himself and the cause of the Church to God, Saint Mary, and the blessed martyr Saint Denis.

He had barely finished speaking when the impious knight, fearing that Thomas would be saved by the people and escape alive, suddenly set upon him and shaved off the summit of his crown. . . . Then, with another blow received on the head, Becket remained firm. But with the third, the stricken martyr bent his knees and elbows, offering himself as a living sacrifice, saying in a low voice, "For the name of Jesus and the protection of the church, I am ready to embrace death." The third knight inflicted a grave wound on the fallen one; with this blow he shattered the sword on the stone, and Becket's crown, which was large, separated from his head so that the blood turned white from the brain yet not less did the brain turn red from the blood. . . . The fourth knight drove away those who were gathering so that the others could finish the murder more freely and boldly. The fifth . . . placed his foot on the neck of the holy priest and precious martyr and (it is horrible to say) scattered the brains with the blood across the floor, exclaiming to the rest, "We can leave this place, knights—he will not get up again."

> "We can leave this place, knights—he will not get up again."

Consider This:

- After Thomas Becket's elevation to sainthood, his shrine at Canterbury became a popular pilgrimage destination and a lucrative source of income for the church. Analyze the stained glass in this segment depicting Becket's martyrdom. How do these images cultivate not just the story of Becket's sacrifice, but also the concept of spiritual primacy over

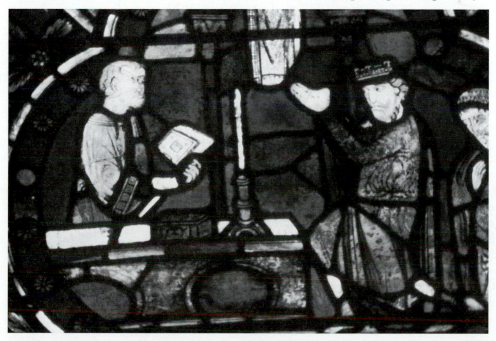

Figure 5–6 A praying monk at Chartres Cathedral (Perry M. Rogers).

the secular power of the state? In this case, how did the stained glass serve both a spiritual and political cause?

- What are the messages presented by the stained glass in Gothic cathedrals? What does it tell us of the life and values of the age?

The Broader Perspective:
- If stained glass was a wondrous art form that expressed the devotion of medieval communities, to what extent was it also a kind of propaganda for the indoctrination of "simple minds" in support of the spiritual and political authority of the church?

The Spiritual Center: Medieval Monasticism

Monasticism arose in Egypt and western Asia and was practiced by monks who were true hermits. Their life was one of ascetic denial and personal devotion to God. As the movement spread to the West in the middle of the fourth century and became more popular, the monks began to live together in houses. Although they preserved as much of their personal isolation as possible, it became necessary to formulate rules of conduct. These rules, however, were not severe or even binding in most cases; monks did not even have to take a vow to remain in the monastery. The reforms of Saint Benedict about 530 were designed to remedy this problem and other abuses that permeated the monastic life. Benedict moved away from the hermetic emphasis of the East in favor of a common experience among the brothers in the order. His strict rule was popularized by Pope Gregory I (himself a Benedictine) and became the basis for all reforms in monasticism for several centuries. The following excerpts provide a glimpse into this structured life of contemplation and isolation from the world.

The Rule of Saint Benedict

Ch. 1. The kinds of monks: There are four kinds of monks. The first kind is that of the cenobites, those who live in a monastery according to a rule, and under the government of an abbot. The second is that of the anchorites, or hermits, who have learned how to conduct the war against the devil by their long service in the monastery and their association with many brothers, and so, being well trained, have separated themselves from the troop, in order to wage single combat, being able with the aid of God to carry on the fight alone against the sins of the flesh. The third kind (and a most abominable kind it is) is that of the sarabites, who have not been tested and proved by obedience to the rule and by the teaching of experience, as gold is tried in the furnace, and so are soft and pliable like a base metal; who in assuming the tonsure are false to God, because they still serve the world in their lives. They do not congregate in the master's fold, but dwell apart without a shepherd, by twos and threes, or even alone. Their law is their own desires, since they call that holy which they like, and that unlawful which they do not like. The fourth kind is composed of those who are called *gyrovagi* (wanderers), who spend their whole lives wandering about through different regions and living three or four days at a time in the cells of different monks. They are always wandering about and never remain long in one place, and they are governed by their own appetites and desires. They are in every way worse than the sarabites. But it is better to pass over in silence than to mention their manner of life. Let us, therefore, leaving these aside, proceed, with the aid of God, to the consideration of the cenobites, the highest type of monks.

"The Rule of Saint Benedict" is from Oliver Thatcher and Edgar McNeal, eds., *A Source Book of Medieval History* (New York: Charles Scribner's Sons, 1905), pp. 434–438, 445–447, 457, 459, 461–462, 467–468, 471–474.

Ch. 6. Silence: . . . It is the business of the master to speak and instruct, and that of the disciples to hearken and be silent. And if the disciple must ask anything of his superior, let him ask it reverently and humbly, lest he seem to speak more than is becoming. Filthy and foolish talking and jesting we condemn utterly, and forbid the disciple ever to open his mouth to utter such words.

Ch. 7. Humility: . . . The sixth step of humility is this, that the monk should be contented with any lowly or hard condition in which he may be placed, and should always look upon himself as an unworthy laborer, not fitted to do what is entrusted to him. . . . The seventh step of humility is this, that he should not only say, but should really believe in his heart that he is the lowest and most worthless of all men. . . . The eighth step of humility is this, that the monk should follow in everything the common rule of the monastery and the examples of his superiors. . . .

> "The monk should always be meditating upon his sins and thinking of the dread day of judgment."
> —Rule of St. Benedict

The twelfth step of humility is this, that the monk should always be humble and lowly, not only in his heart, but in his bearing as well. Wherever he may be, in divine service, in the oratory, in the garden, on the road, in the fields, whether sitting, walking, or standing, he should always keep his head bowed and his eyes upon the ground. He should always be meditating upon his sins and thinking of the dread day of judgment, saying to himself as did that publican of whom the gospel speaks: "Lord, I am not worthy, I a sinner, so much as to lift mine eyes up to heaven" [Luke 18:13]; and again with the prophet: "I am bowed down and humbled everywhere" [Ps. 119:107]. . . .

Ch. 22. How the monks should sleep: The monks shall sleep separately in individual beds, and the abbot shall assign them their beds according to their conduct. If possible all the monks shall sleep in the same dormitory, but if their number is too large to admit of this, they are to be divided into tens or twenties and placed under the control of some of the older monks. A candle shall be kept burning in the dormitory all night until daybreak. The monks shall go to bed clothed and girt with girdles and cords, but shall not have their knives at their sides, lest in their dreams they injure one of the sleepers. They should be always in readiness, rising immediately upon the signal and hastening to the service, but appearing there gravely and modestly. The beds of the younger brothers should not be placed together, but should be scattered among those of the older monks. When the brothers arise they should gently exhort one another to hasten to the service, so that the sleepy ones may have no excuse for coming late. . . .

Figure 5–7 Canterbury Cathedral: Henry II doing penance at Becket's tomb (Perry M. Rogers).

Ch. 33. *Monks should not have personal property:* The sin of owning private property should be entirely eradicated from the monastery. No one shall presume to give or receive anything except by the order of the abbot; no one shall possess anything of his own, books, paper, pens, or anything else; for monks are not to own even their own bodies and wills to be used at their own desire, but are to look to the father [abbot] of the monastery for everything. So they shall have nothing that has not been given or allowed to them by the abbot; all things are to be had in common according to the command of the Scriptures, and no one shall consider anything as his own property. If anyone has been found guilty of this most grievous sin, he shall be admonished for the first and second offence, and then if he does not mend his ways he shall be punished.

Ch. 38. *The weekly reader:* There should always be reading during the common meal, but it shall not be left to chance, so that anyone may take up the book and read. On Sunday one of the brothers shall be appointed to read during the following week. . . . At the common meal, the strictest silence shall be kept, that no whispering or speaking may be heard except the voice of the reader. The brethren shall mutually wait upon one another by passing the articles of food and drink, so that no one shall have to ask for anything; but if this is necessary, it shall be done by a sign rather than by words, if possible. In order to avoid too much talking no one shall interrupt the reader with a question about the reading or in any other way, unless perchance the prior may wish to say something in the way of explanation. . . .

Ch. 39. *The amount of food:* Two cooked dishes, served either at the sixth or the ninth hour, should be sufficient for the daily sustenance. We allow two because of differences in taste, so that those who do not eat one may satisfy their hunger with the other, but two shall suffice for all the brothers, unless it is possible to obtain fruit or fresh vegetables, which may be served as a third. . . . In the case of those who engage in heavy labor, the abbot may at his discretion increase the allowance of food, but he should not allow the monks to indulge their appetites by eating or drinking too much. For no vice is more inconsistent with the Christian character. . . .

Ch. 48. *The daily labor of the monks:* Idleness is the great enemy of the soul, therefore the monks should always be occupied, either in manual labor or in holy reading.

 . . . When the ninth hour sounds they shall cease from labor and be ready for the service at the second bell. After dinner they shall spend the time in reading the lessons and the psalms. During Lent the time from daybreak to the third hour shall be devoted to reading, and then they shall work at their appointed tasks until the tenth hour. At the beginning of Lent each of the monks shall be given a book from the library of the monastery which he shall read entirely through. One or two of the older monks shall be appointed to go about through the monastery during the hours set apart for reading, to see that none of the monks are idling away the time, instead of reading, and so not only wasting their own time but perhaps disturbing others as well. . . . Sunday is to be spent by all the brothers in holy reading, except by such as have regular duties assigned to them for that day. And if any brother is negligent or lazy, refusing or being unable profitably to read or meditate at the time assigned for that, let him be made to work, so that he shall at any rate not be idle. . . .

> "Idleness is the great enemy of the soul, therefore the monks should always be occupied, either in manual labor or in holy reading."
> —Rule of St. Benedict

Ch. 58. *The way in which new members are to be received:* Entrance into the monastery should not be made too easy. . . . So when anyone applies at the monastery, asking to be accepted as a monk, he should first be proved by every test. He shall be made to wait outside four or five days, continually knocking at the door and begging to be admitted; and then he shall be taken in as a

guest and allowed to stay in the guest chamber a few days. If he satisfies these preliminary tests, he shall then be made to serve a novitiate of at least one year, during which he shall be placed under the charge of one of the older and wiser brothers, who shall examine him and prove, by every possible means, his sincerity, his zeal, his obedience, and his ability to endure shame. And he shall be told in the plainest manner all the hardships and difficulties of the life which he has chosen. If he promises never to leave the monastery the rule shall be read to him after the first two months of his novitiate, and again at the end of six more months, and finally, four months later, at the end of his year. Each time he shall be told that this is the guide which he must follow as a monk, the reader saying to him at the end of the reading: "This is the law under which you have expressed a desire to live; if you are able to obey it, enter; if not, depart in peace." Thus he shall have been given every chance for mature deliberation and every opportunity to refuse the yoke of service. But if he still persists in asserting his eagerness to enter and his willingness to obey the rule and the commands of his superior, he shall then be received into the congregation, with the understanding that from that day forth he shall never be permitted to draw back from the service or to leave the monastery . . .

The Vow of a Monk

I hereby renounce my parents, my brothers and relatives, my friends, my possessions and my property, and the vain and empty glory and pleasure of this world. I also renounce my own will, for the will of God. I accept all the hardships of the monastic life, and take the vows of purity, chastity, and poverty, in the hope of heaven; and I promise to remain a monk in this monastery all the days of my life.

Consider This:

- What is monasticism and what medieval values does it represent? Why was the monastic movement so popular? Which of the rules of Saint Benedict impresses you most and why? Compared to other lifestyles in the Middle Ages, was it hard being a monk?

A Description of the Abbey of Clairvaux
WILLIAM OF ST. THIERRY

The most important individual in the monastic reform movement of the 12th century was Saint Bernard of Clairvaux (1091–1153). He was a particularly effective speaker and was influential in reinvigorating Europe with a sense of purpose and commitment. At the request of the pope, Bernard preached in support of the Second Crusade. But it was as a monastic reformer that Saint Bernard is best known. His foundation of the monastery at Clairvaux in 1115, which is described in the following excerpt from his contemporary biographer, William of St. Thierry, gave respect and energy to the growing Cistercian order.

At the first glance as you entered Clairvaux by descending the hill you could see that it was a temple of God; and the still, silent valley bespoke, in the modest simplicity of its buildings, the unfeigned humility of Christ's poor. Moreover, in the valley full of men, where no one was permitted to be idle, where one and all were occupied with their allotted tasks, a silence deep as that of night prevailed. The sounds of labor, or the chants of the brethren in

"The Vow of a Monk" is from Oliver Thatcher and Edgar McNeal, eds., *A Source Book of Medieval History* (New York: Charles Scribner's Sons, 1905), p. 486.

"A Description of the Abbey of Clairvaux" is from Frederic Ogg, ed., *A Source Book of Medieval History* (New York: American Book Company, 1907), pp. 258–260.

the choral service, were the only exceptions. The orderliness of this silence, and the report that went forth concerning it, struck such a reverence even into secular persons that they dreaded breaking it . . . even by proper remarks. The solitude, also, of the place—between dense forests in a narrow gorge of neighboring hills—in a certain sense recalled the cave of our father St. Benedict [the compiler of the rules to which the monastery adhered], so that while they strove to imitate his life, they also had some similarity to him in their habitation and loneliness. . . .

Although the monastery is situated in a valley, it has its foundations on the holy hills, whose gates the Lord loveth more than all of the dwellings of Jacob. Glorious things are spoken of it, because the glorious and wonderful God therein worketh great marvels. There the insane recover their reason, and although their outward man is worn away, inwardly they are born again. There the proud are humbled, the rich are made poor, and the poor have the Gospel preached to them, and the darkness of sinners is changed into light. A large multitude of blessed poor from the ends of the earth have there assembled, yet have they one heart and one mind; justly, therefore, do all who dwell there rejoice with no empty joy. They have the certain hope of perennial joy, of their ascension heavenward already commenced. . . .

For my part, the more attentively I watch them day by day, the more do I believe that they are perfect followers of Christ in all things. When they pray and speak to God in spirit and in truth, by their friendly and quiet speech to Him, as well as by their humbleness of demeanor, they are plainly seen to be God's companions and friends. When, on the other hand, they openly praise God with psalms, how pure and fervent are their minds, is shown by their posture of body in holy fear and reverence, while by their careful pronunciation and modulation of the psalms, is shown how sweet to their lips are the words of God—sweeter than honey to their mouths. As I watch them, therefore, singing without fatigue from before midnight to the dawn of day, with only a brief interval, they appear a little less than the angels, but much more than men. . . .

As regards their manual labor, so patiently and placidly, with such quiet countenances, in such sweet and holy order, do they perform all things, that although they exercise themselves at many works, they never seem moved or burdened in anything, whatever the labor may be. . . . Many of them, I hear, are bishops and earls, and many illustrious through their birth or knowledge; but now, by God's grace, all distinction of persons being dead among them, the greater any one thought himself in the world, the more in this flock does he regard himself as less than the least. I see them in the garden with hoes, in the meadows with forks or rakes, in the fields with scythes, in the forest with axes. To judge from their outward appearance, their tools, their bad and disordered clothes, they appear a race of fools, without speech or sense. But a true thought in my mind tells me that their life in Christ is hidden in the heavens.

Visions of Ecstasy

HILDEGARD OF BINGEN

Hildegard of Bingen (1098–1179) has emerged through recent scholarship as one of the most creative and accomplished voices from the Middle Ages. A religious visionary and head of a convent near Bingen, Germany, Hildegard also wrote hymns and chants in honor of saints and the Virgin Mary. Her noble family dedicated her at birth to the Church and she received a rudimentary religious education near a Benedictine monastery. Throughout her life, starting at age three, Hildegard had visions of luminous objects that grew more detailed and complex as she aged. When Hildegard was 42 years old, she had a vision in which "the heavens were opened and a blinding light of exceptional brilliance flowed through my entire brain." This gave her an instant understanding of the meaning of the religious texts and she was commanded to write

"Visions of Ecstacy" is from Hildegard of Bingen, *Scivias*, trans. Columba Hart and Jane Bishop (Mahwah, N.J.: Paulist Press, 1990), pp. 150–151. Copyright © 1990 by Abbey of Regina Laudis: Benedictine Congregation Regina Laudis of the Strict Observance, Inc. Reprinted by permission of Paulist Press.

down her visionary observations. Physicians who have analyzed the descriptions of her visual hallucinations have regarded them as symptomatic of classic migraines.

With the blessing of Pope Eugenius, Hildegard finished her first visionary work entitled Scivias ("Know the Ways of the Lord"). In the following excerpt, Hildegard discusses the omnipotence and indivisibility of God. She believed that human beings were the most glorious expression of God's work and the vehicle through which the dimensions of God's macrocosm might be understood. Hildegard's story is an inspirational account of a vibrant intellect that transcended the cultural and gender barriers of the medieval world.

And I heard the voice saying to me from the living fire: "O you who are wretched earth and, as a woman, untaught in all learning of earthly teachers and unable to read literature with philosophical understanding, you are nonetheless touched by My light, which kindles in you an inner fire like a burning sun; cry out and relate and write these My mysteries that you see and hear in mystical visions. So do not be timid, but say those things you understand in the Spirit as I speak them through you. . . . Therefore, O uncertain mind, who are taught inwardly by mystical inspiration, though because of Eve's transgression you are trodden on by the masculine sex, speak of that fiery work this sure vision has shown you."

> **"And I heard the voice saying to me: 'Do not be timid, but say those things you understand in the Spirit as I speak them through you."**
> **—Hildegard of Bingen**

The Living God, then, Who created all things through His Word, by the Word's Incarnation brought back the miserable human who had sunk himself in darkness to certain salvation. What does this mean?

On God's Omnipotence This *blazing fire* that you see symbolizes the Omnipotent and Living God, Who in His most glorious serenity was never darkened by an evil; *incomprehensible*, because He cannot be divided by any division; *inextinguishable*, because He is that Fullness that no limit ever touched; *wholly living*, for there is nothing that is hidden from Him or that He does not know; and *wholly Life*, for everything that lives takes its life from Him, as Job shows, inspired by Me, when he says: "Who is ignorant that the hand of the Lord has made all these things? In His hand is the soul of every living thing and the spirit of all human flesh" [Job 12:9–10]. What does this mean? No creature is so dull of nature as not to know what changes in the things that make it fruitful cause it to attain its full growth. The sky holds light, light air, and air the birds; the earth nourishes plants, plants fruit and fruit animals; which all testify that they were put there by a strong hand, the supreme power of the Ruler of All, Who in His strength has provided so for them all that nothing is lacking to them for their use. And in the omnipotence of the same Maker is the motion of all living things that seek the earth for earthly things like the animals which are not inspired by God with reason, as well as the awakening of those who dwell in human flesh and have reason, discernment and wisdom. How?

The Discernment of the Soul The soul goes about in earthly affairs, laboring through many changes as fleshly behavior demands. But the spirit raises itself in two ways: sighing, groaning and desiring God; and choosing among options in various matters as if by some rule, for the soul has discernment in reason. Hence Man contains in himself the likeness of heaven and earth. In what way? He has a circle, which contains his clarity, breath and reason, as the sky has its lights, air and birds; and he has a receptacle containing humidity, germination, and birth, as the earth contains fertility, fruition and animals. What is this? O human, you are wholly in every creature, and you forget your Creator; you are subject to Him as was ordained, and you go against His commands?

Consider This:

- What evidence does Hildegard offer as examples of God's omnipotence? What does Hildegard mean when she says "O human, you are wholly in every creature"?

- In this passage, how does Hildegard represent herself? What limitations did she impose on herself simply by virtue of her sex as a woman? How were women generally perceived at this time?

"The Canticle of Brother Sun" (1225)
SAINT FRANCIS OF ASSISI

One of the most remarkable figures in the world of the medieval church was Saint Francis. Born in 1181 to a wealthy merchant in the little town of Assisi, Saint Francis eventually rejected his prescribed role as heir to the family business, gave his belongings to the poor, and became a barefoot preacher. He quickly gained adherents by advocating a simple rule of poverty and complete service to God. His order received the approval of Pope Innocent III in 1209. He died in 1226 and was canonized in 1228. He was buried in the impressive basilica San Francesco in Assisi, an ironic turn, since Saint Francis had always preached the virtues of poverty and simplicity.

The Franciscans were not a monastic order, but rather considered their business to be within the world. They were called friars, or brothers, and combined the asceticism and simplicity of a regular order of monks with the popular contact that was the preserve of the secular order of priests. With a foot in both worlds of the church and a dedication to poverty and simplicity, the Franciscans were a kind of hybrid, both reviled and admired by competing forces within the church.

Saint Francis's great love of nature and the purity of his devotion to God are distilled in perhaps the most articulate and sensitive of his poems, "The Canticle of Brother Sun." He began it in 1225, during his last illness amid intense physical suffering, and added the final verses about Sister Death shortly before his own demise. The "Canticle," for all the depth of feeling it evokes about nature and the creatures he cared so much about, is an earnest prayer and hymn of praise to God.

> Most high, all-powerful, all good, Lord!
> All praise is yours, all glory, all honor
> And all blessing.
> To you, alone, Most High, do they belong.
> No mortal lips are worthy
> To pronounce your name.
> All praise be yours, my Lord, through all that you have made,
> And first my lord Brother Sun,
> Who brings the day; and light you give to us through him.
> How beautiful is he, how radiant in all his splendor!
> Of you, Most High, he bears the likeness.
> All praise be yours, my Lord, through Sister Moon and Stars;
> In the heavens you have made them, bright
> And precious and fair.
> All praise be yours, my Lord, through Brothers Wind and Air,
> And fair and stormy, all the weather's moods,

"The Canticle of Brother Sun" is from Marion A. Habig, ed., *St. Francis of Assisi, Writings and Early Biographies*, 4th revised ed. (Chicago: Franciscan Herald Press, 1983), pp. 130–131. Copyright © 1983. Reprinted by permission of Franciscan Herald Press.

By which you cherish all that you have made.
All praise be yours, my Lord, through Sister Water,
So useful, lowly, precious and pure.
All praise be yours, my Lord, through Brother Fire,
Through whom you brighten up the night.
How beautiful is he, how gay! Full of power and strength.
All praise be yours, my Lord, through Sister Earth, our mother,
Who feeds us in her sovereignty and produces
Various fruits with colored flowers and herbs.
All praise be yours, my Lord, through those who grant pardon
For love of you; through those who endure
Sickness and trial.
Happy those who endure in peace,
By you, Most High, they will be crowned.
All praise be yours, my Lord, through Sister Death,

From whom no mortal can
 escape.
Woe to those who die in
 mortal sin!
Happy those She finds
 doing your will!
The second death can do
 no harm to them.
Praise and bless my Lord,
 and give him thanks,
And serve him with great humility.

> "All praise be yours, my Lord, through Sister Death, from whom no mortal can escape."
> —St. Francis of Assisi

Figure 5–8 This sculpture of an angel at Rheims cathedral actually interacts with visitors (Perry M. Rogers).

Theme: Revolution and Transition

Against the Grain

GIOTTO AT THE CREATIVE EDGE

Figure 5–9 Giotto, *The Kiss of Judas* (Art Resource, N.Y.).

Giotto di Bondone (1267–1337) was born to a small landed farmer in a tiny village near Florence. He became apprenticed as a young boy to the workshop of Cimabue, a well-known Florentine painter, who recognized his extraordinary artistic abilities. An architect, sculptor and painter, Giotto encountered a world that was grounded in devotion to the spiritual and artistic dictates of the medieval church. In this world, the creativity of the artist was often subordinated to the exposition of doctrine and the manifestation of God's glory. Artistic representations of the Passion of Christ were filled with reverence; the pictorial embodiment of the Word of God required a certain conformity of conception and presentation. In the Greek East, icons or "snapshot" depictions of the Holy Family and Saints became important conduits for meditation and faith in a simple, yet specific framework.

But for Giotto, this framework became too confining. Like his friend Dante, Giotto was a transitional figure between the static conformity of medieval restraint and the human world of emotions and expressive devotion. Giotto's work broke free from the iconographic stylings of Byzantine art and introduced a naturalism in his background landscapes and in his depictions of human beings. Although he still dealt with traditional religious subjects, nevertheless we admire the human presence—the subtleties of anguish and faith that are expressed through the eyes, the parting of the lips, the glance that connotes fear or sorrow.

Nowhere is this more evident than in Giotto's "Lamentation over the Dead Christ" (1304–1306). This is a scene of sorrow and hope as Mary, the mother of God, holds Christ's lifeless head gently in her enveloping arms. There is a calm serenity in her intense gaze, an expression perhaps of inner certainty that the Passion of Christ was running its course, and that

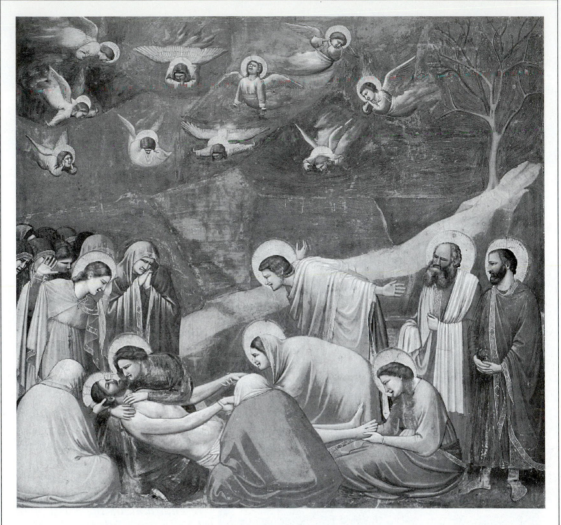

Figure 5–10 Giotto, *Lamentation over the Dead Christ* (SuperStock, Inc.).

salvation for humankind was at hand. Thus, the sense of despair and sorrow that is so per-sonally registered on the faces of the mourners as they direct their eyes to the head of Christ, is tempered with the sense of hope expressed in Mary's maternal adoration. The mourners on the left side of the painting are balanced with the startled intensity of the center as Saint John thrusts his arms back in wonder. The action flows to Mary Magdalen, who is carefully in-specting the wounds on Christ's feet, and ends in the calm detachment of Joseph of Arimath-ea and Nicodemus. The angels in the sky each reveal their sorrow in anguished contortions. The landscape of a barren rocky outcrop cuts diagonally across the scene from a leafless tree and directs the eye to Christ. These elements combine to impart a sense of sorrow and de-spair, all reconciled by the pathos of Mary's serene inspiration. The complexity of Giotto's conception and technique contrasts with other religious scenes of the time that are character-ized by a remoteness and sense of awe.

Giotto was recognized by his own contemporaries as the first genius of the Italian Re-naissance. The biographer, Giorgio Vasari, an artist himself, discusses Giotto's influence in the following selection.

Giotto di Bondone:
"The Student of Nature Herself"

GIORGIO VASARI

Keep in Mind:
- According to Vasari, what was Giotto's role in the transition to a more natural style of art?

The debt owed by painters to Nature, which serves them continually as an example, that from her they may select the best and finest parts for reproduction and imitation, is due also, in my opinion, to the Florentine painter Giotto; because when the methods and outlines of good painting had been buried for so many years under the ruins caused by war, he alone, although born in the midst of unskillful artists, through God's gift in him, revived what had fallen into such an evil plight and raised it to a condition which one might call good. Certainly it was nothing short of a miracle, in so gross and unskillful an age, that Giotto should have worked to such purpose that design, of which the men of the time had little or no conception, was revived to a vigorous life by his means. . . .

Giotto proceeded to Assisi, a city of Umbria, where he was summoned by Fra Giovanni di Muro della Marca, at that time general of the friars of St. Francis. In the upper church of this town he painted a series of thirty-two scenes in fresco of the life of St. Francis, under the course which runs round the church, below the windows, sixteen on each side, with such perfection that he acquired the highest reputation thereby. In truth the work exhibits great variety, not only in the gestures and postures of the different figures, but in the composition of each subject. . . .

One of the most beautiful of these represents a thirsty man, whose desire for water is represented in the most lively manner as he kneels on the ground to drink from a spring, with such wonderful reality that one might imagine him to be a real person. . . . Let it suffice to say that by these works, Giotto acquired the highest reputation for the excellence of his figures, for his arrangement, sense of proportion, truth to Nature, and his innate facility that he had greatly increased by study, while he never failed to express his meaning clearly. Giotto indeed was not so much the student of any human master as of Nature herself. . . .

When San Francesco was at length finished, Giotto returned to Florence, where he painted with extraordinary care a picture of St. Francis in the fearful desert of Vernia, to be sent to Pisa. Besides a landscape full of trees and rocks, a new thing in those days, the attitude of the saint, who is receiving the stigmata, on his knees, with great eagerness, exhibits an ardent desire to receive them and an infinite love towards Jesus Christ, who is in the air surrounded by angels granting them to him, the varied emotions being all represented in the most telling manner imaginable. . . . The work may now be seen in San Francesco at Pisa, on a pillar beside the high altar, where it is held in high veneration in memory of so great a man.

Compare and Contrast:
- Giotto painted a series of frescoes depicting the life of Christ. Compare the intensity of Judas's focus as he betrays Christ in *The Kiss of Judas* with the gaze of Mary as she holds Jesus in *Lamentation over the Dead Christ*. How does this focal point in both paintings almost freeze the action taking place around it? What makes Giotto an artist "on the creative edge"?

"Giotto di Bondone: 'The Student of Nature Herself'" is from Giorgio Vasari, *The Lives of the Painters, Sculptors, and Architects* (New York: E. P. Dutton & Co., Inc., 1900), Vol. 1, pp. 65–66, 68–70.

The Crusades

"It Is the Will of God!": Launching the Crusades (1095)
ROBERT THE MONK

The first expedition to free the Holy Land from the control of the Infidel Muslim was launched in 1095 at the Council of Clermont. Pope Urban II presided and in a rousing speech excited the crowd with this impassioned plea for action. Although we are not sure about the accuracy of the text (we have five contemporary versions), the following account by Robert the Monk is credible and clearly illustrates Urban's justification for the First Crusade as well as his popular appeal.

In 1095 a great council was held in Auvergne, in the city of Clermont. Pope Urban II, accompanied by cardinals and bishops, presided over it. It was made famous by the presence of many bishops and princes from France and Germany. After the council had attended to ecclesiastical matters, the pope went out into a public square,

> **"The Muslims compel some to stretch out their necks and then they try to see whether they can cut off their heads with one stroke of the sword."**
>
> **—Pope Urban II**

because no house was able to hold the people, and addressed them in a very persuasive speech, as follows: "O race of the Franks, O people who live beyond the mountains [the Alps], O people loved and chosen of God, as is clear from your many deeds, distinguished over all other nations by the situation of your land, your catholic faith, and your regard for the holy church, we have a special message and exhortation for you. For we wish you to know what a grave matter has brought us to your country. The sad news has come from Jerusalem and Constantinople that the people of Persia, an accursed and foreign race, enemies of God, a generation that set not their heart aright, and whose spirit was not steadfast with God [Ps. 78:8], have invaded the lands of those Christians and devastated them with the sword, rapine, and fire. Some of the Christians they have carried away as slaves, others they have put to death. The churches they have either destroyed or turned into mosques. They desecrate and overthrow the altars. They circumcise the Christians and pour the blood from the circumcision on the altars or in the baptismal fonts. Some they kill in a horrible way by cutting open the abdomen, taking out a part of the entrails and tying them to a stake; they then beat them and compel them to walk until all their entrails are drawn out and they fall to the ground. Some they use as targets for their arrows. They compel some to stretch out their necks and then they try to see whether they can cut off their heads with one stroke of the sword. It is better to say nothing of their horrible treatment of the women. They have taken from the Greek empire a tract of land so large that it takes more than two months to walk through it. Whose duty is it to avenge this and recover that land, if not yours? For to you more than to other nations the Lord has given the military spirit, courage, agile bodies, and the bravery to strike down those who resist you. Let your minds be stirred to bravery by the deeds of your forefathers, and by the efficiency and greatness of [Charlemagne], and of Ludwig his son, and of the other kings who have destroyed Turkish kingdoms, and established Christianity in their lands. You should be moved especially by the holy grave of our Lord and Savior which is now held by unclean peoples, and by the holy places which are treated with dishonor and irreverently befouled with their uncleanness.

"It Is the Will of God!" is from Oliver Thatcher and Edgar McNeal, eds., *A Source Book of Medieval History* (New York: Charles Scribner's Sons, 1905), pp. 518–520.

"O bravest of knights, descendants of unconquered ancestors, do not be weaker than they, but remember their courage. If you are kept back by your love for your children, relatives and wives, remember what the Lord says in the Gospel: 'He that loveth father or mother more than me is not worthy of me' [Matt. 10:37]; 'and everyone that hath forsaken houses, or brothers, or sisters, or father, or mother, or wife, or children, or lands for my name's sake, shall receive a hundredfold and shall inherit everlasting life' [Matt. 19:29]. Let no possessions keep you back, no solicitude for your property. Your land is shut in on all sides by the sea and mountains, and is too thickly populated. There is not much wealth here, and the soil scarcely yields enough to support you. On this account you kill and devour each other, and carry on war and mutually destroy each other. Let your hatred and quarrels cease, your civil wars come to an end, and all your dissensions stop. Set out on the road to the holy sepulcher, take the land from that wicked people, and make it your own. . . . This land our Savior made illustrious by his birth, beautiful with his life, and sacred with his suffering; he redeemed it with his death and glorified it with his tomb. This royal city is now held captive by her enemies, and made pagan by those who know not God. She asks and longs to be liberated and does not cease to beg you to come to her aid. She asks aid especially from you because, as I have said, God has given more of the military spirit to you than to other nations. Set out on this journey and you will obtain the remission of your sins and be sure of the incorrigible glory of the kingdom of heaven."

When Pope Urban had said this and much more of the same sort, all who were present were moved to cry out with one accord,

> **"Set out on the road to the holy sepulcher, take the land from that wicked people, and make it your own."**
> **—Pope Urban II**

"It is the will of God, it is the will of God!" When the pope heard this he raised his eyes to heaven and gave thanks to God, and, commanding silence with a gesture of his hand, he said: "My dear brethren, today there is fulfilled in you that which the Lord says in the Gospel, 'Where two or three are gathered in my name, there am I in the midst' [Matt. 18:20]. For unless the Lord God had been in your minds you would not all have said the same thing. For although you spoke with many voices, nevertheless it was one and the same thing that made you speak. So I say unto you, God, who put those words into your hearts, has caused you to utter them. Therefore let these words be your battle cry, because God caused you to speak them. Whenever you meet the enemy in battle, you shall all cry out, 'It is the will of God! It is the will of God!' "

Consider This:

- In the Clermont speech of Pope Urban II, what specific reasons are given for the necessity of a Crusade to the Holy Land? How does he justify a military expedition in which bloodshed could be expected?

The Fall of Jerusalem (1099)

The Crusaders who set out at the behest of Pope Urban II in 1096 were quite successful in defeating Muslim armies, capturing territory along the pilgrimage route into Syria, and maintaining it with defensive castles established at Edessa and Antioch. Their ultimate goal, however, was Jerusalem, a city sacred to Christian, Jew, and Muslim alike. Its bloody fall to the Christian forces in 1099 is described in the following account known as the Gesta Francorum.

"The Fall of Jerusalem" is from Rosalind Hill, ed., *Gesta Francorum* (London: Oxford University Press, 1962), pp. 89–92. Reprinted by permission of Oxford University Press.

During this siege, we suffered so badly from thirst that we sewed up the skins of oxen and buffaloes, and we used to carry water in them for the distance of nearly six miles. We drank the water from these vessels, although it stank, and what with foul water and barley bread we suffered great distress and affliction every day, for the Saracens used to lie in wait for our men by every spring and pool, where they killed them and cut them to pieces; moreover they used to carry off the beasts into their caves and secret places in the rocks.

Our leaders then decided to attack the city with engines, so that we might enter it and worship at our Savior's Sepulcher. They made two wooden siege-towers and various other mechanical devices. Duke Godfrey filled his siege-tower with machines, and so did Count Raymond, but they had to get the timber from far afield. When the Saracens saw our men making these machines, they built up the city wall and its towers by night, so they were exceedingly strong. When, however, our leaders saw which was the weakest spot in the city's defenses, they had a machine and a siege-tower transported round to the eastern side one Saturday night. They set up these engines at dawn, and spent Sunday, Monday and Tuesday in preparing the siege-tower and fitting it out, while the count of St. Gilles was getting his engine ready on the southern side. All this time we were suffering so badly from the shortage of water that for one penny a man could not buy sufficient to quench his thirst.

On Wednesday and Thursday we launched a fierce attack upon the city, both by day and by night, from all sides, but before we attacked, our bishops and priests preached to us, and told us to go in procession round Jerusalem to the Glory of God, and to pray and give alms and fast, as faithful men should do. On Friday at dawn we attacked the city from all sides but could achieve nothing, so that we were all astounded and very much afraid, yet, when that hour came when our Lord Jesus Christ deigned to suffer for us upon the cross, our Knights were fighting bravely on the siege-tower, led by Duke Godfrey and Count Eustace his brother. At that moment one of our knights, called Lethold, succeeded in getting on to the wall. As soon as he reached it, all the defenders fled along the walls and through the city, and our men went after them, killing them and cutting them down as far as Solomon's Temple, where there was such a massacre that our men were wading up to their ankles in enemy blood.

Count Raymond was bringing up his army and a siege-tower from the south to the neighborhood of the wall, but . . . when he heard that the Franks were in the city he said to his men, Why are you so slow? Look! All the other Franks are in the city already! Then the amir who held David's Tower surrendered to the count, and opened for him the gate where the pilgrims used to pay their taxes, so our men entered the city, chasing the Saracens and killing them up to Solomon's Temple, where they took refuge and fought hard against our men for the whole day, so that all the temple was streaming with their blood. At last, when the pagans were defeated, our men took many prisoners, both men and women, in the temple. They killed whom they chose, and whom they chose they saved alive. On the roof of the Temple of Solomon were crowded great numbers of pagans of both sexes. . . .

After this our men rushed round the whole city, seizing gold and silver, horses and mules, and houses full of all sorts of goods, and they all came rejoicing and weeping from excess of gladness to worship at the Sepulcher of our Savior Jesus, and there they fulfilled their vows to him. Next morning they went cautiously up on to the Temple roof and attacked the Saracens, both men and women, cutting off their heads with drawn swords. Some of the Saracens threw themselves down headlong from the temple. . . . Our leaders then took counsel and ordered that every man should give alms and pray that God would choose for himself whomsoever he wished, to rule over the other and to govern the city. They also commanded that all the Saracen corpses should be thrown outside the city because of the fearful stench,

> ## "There was such a massacre that our men were wading up to their ankles in enemy blood."
> ## —*Gesta Francorum*

for almost the whole city was full of their dead bodies. So the surviving Saracens dragged the dead ones out in front of the gates, and piled them up in mounds as big as houses. No-one has ever seen or heard of such a slaughter of pagans, for they were burned on pyres like pyramids, and no-one save God alone knows how many there were. . . .

The Protection of Allah
USAMAH IBN-MUNQIDH

It has been said that history is often written through the eyes of the conquerors. And although one cannot speak of a "winner" or "loser" in the Crusades because of the complexities of the issues, it is true that there were distinct Christian and Islamic perspectives. Usamah Ibn-Munqidh, an Arab who lived through most of the 12th century, was a keen observer of the Crusaders. The following accounts give a particularly interesting view of the Christians, their customs, and Muslim confidence in the protection of Allah.

I saw a proof of the goodness of Allah and of his splendid protection when the Franks (the curse of Allah upon them!) encamped against us with knights and foot-soldiers. We were separated from one another by the Orontes River, whose waters were so swollen that the Franks could not reach us and we were prevented from reaching them. They pitched their tents on the mountain, while some took up their position in the gardens in their neighborhood, set their horses free in the meadows and went to sleep. Some young foot-soldiers from Schaizar took off their clothes, took their swords, swam towards these sleepers and killed several of them. Then a number of our enemies rushed at our companions, who took to the water and returned, while the Frankish army rushed down the mountain on horseback like a flood. Near them there was a mosque, the mosque of Abou'l-Madjd ibn Soumayya, in which there was a man named Hasan az-Zahid (the ascetic), who lived on a flat roof and used to retire to the mosque to pray. He was dressed in black woollen clothes. We saw him, but we had no means of reaching him. The Franks came, got down at the gate of the mosque and went towards him, while we said, "Power and might belong to Allah alone! The Franks will kill him." But he, by Allah, neither stopped praying nor moved from his position. The Franks stopped, turned away, remounted their horses and rode off, while he remained motionless in the same place, continuing to pray. We did not doubt that Allah (glory be to him!) had blinded the Franks with regard to him and had hidden him from their sight. Glory to the Almighty, the Merciful!

Consider This:

- Who was Usamah Ibn-Munqidh and what was his general impression of the western Crusaders? What theme seems to dominate his accounts of his contact with Europeans?

"The Protection of Allah" is from G. R. Potter, trans., *The Autobiography of Ousama (1095–1188)* (London: George Routledge and Sons, 1929), pp. 123–124.

The Architectural Foundation

MOORISH STYLE: LA ALHAMBRA

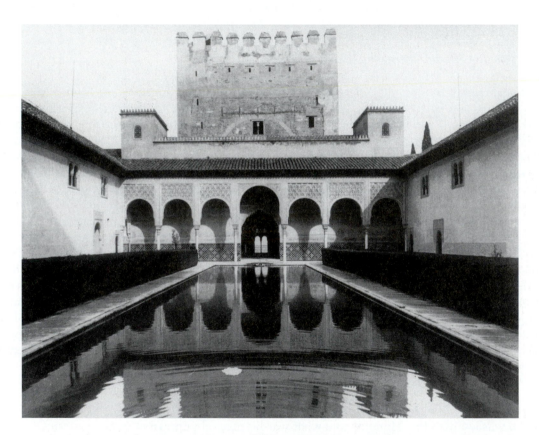

Figure 5–11 La Alhambra (reflecting pool with columns) (Spanish National Tourist Office).

The Crusades remain such an interesting phenomenon primarily because they represent the clash of two civilizations, European and Islamic, over the control of land sacred to each. And although consolidation of the Holy Land proved elusive, nevertheless the Crusades resulted in closer economic ties and even a grudging appreciation of the complex spiritual, political, and cultural depth of these two civilizations in conflict.

This cultural sophistication can be assessed in the monumental architecture of the period. For Europeans, their spiritual values were embodied in the soaring Gothic cathedral. But Muslim artistic styles were reflected in the many palaces and mosques that dotted Spain and North Africa.

> *Perhaps chief among them was the beautiful palace on a hill overlooking Granada, Spain, called La Alhambra. This was a citadel fortified with strong walls that enclosed a palace with court complex, a bath, and mosque. It was begun in the 13th century by Ibn al-Ahmal, founder of the Nasrid dynasty and was continued by his successors into the fourteenth century.*
>
> *La Alhambra is a wonderful celebration of Moorish style articulated by arches with narrow columns and the intricate relief patterns that grace interior and exterior walls. Most impressive and romantic is the juxtaposition of these honeycombed columns and arches with courtyard gardens and fountains offering a refreshing contrast of color and sound. Here was a glimpse into the physical nature of Paradise, so ordained by the Qur'an.*
>
> ## Compare and Contrast:
> - Compare the architecture of La Alhambra with that of the Gothic cathedrals. What do each say about the artistic values of Islamic and European civilizations?
>
> - During the Crusades, the combatants described each other as "infidels" (unfaithful) and decried the barbarism inherent in the enemies' vicious nature. Do you see this barbarism reflected in the respective artistic examples of their civilizations? How could such sophisticated societies commit atrocities as were described in the preceding sources on the Crusades? Why did they fight?

Mind and Society in the Middle Ages

The World of Thought

The Existence of God
SAINT THOMAS AQUINAS

The 12th century was truly remarkable for its intellectual focus and development of thought. The new commitment to learning was reflected in a system of argument and study called Scholasticism. Scholars edited and commented on ancient writers, methodically arguing for the acceptance or rejection of such philosophers as Aristotle and Plato. No longer was it enough simply to accept the existence of God without a rational argument of proof. Saint Thomas Aquinas (1225–1274) is generally regarded as the most insightful and important philosopher of the Middle Ages. The following excerpts from his Summa Theologica *demonstrate the structure of Scholastic argument and relate his conclusions on the existence of God. Saint Bernard's passage on the love of God reflects the argument of faith.*

Third Article: Whether God exists?

Objection 1: It seems that God does not exist; because if one of two contraries be infinite, the other would be altogether destroyed. But the name God means that He is infinite goodness. If, therefore, God existed, there would be no evil discoverable; but there is evil in the world. Therefore God does not exist.

"The Existence of God" is from *Summa Theologica*, in *Basic Writings of Saint Thomas Aquinas*, Vol. 1, trans. A. C. Pegis (New York: Random House, 1945), pp. 21–24. Copyright © 1945 by Anton Pegis. Reprinted by permission of the Estate of Anton Pegis.

Objection 2: Further, it is superfluous to suppose that what can be accounted for by a few principles has been produced by many. But it seems that everything we see in the world can be accounted for by other principles, supposing God did not exist. For all natural things can be reduced to one principle, which is human reason, or will. Therefore there is no need to suppose God's existence.

I Answer That: The existence of God can be proved in five ways: The first and more manifest way is the argument from motion. It is certain, and evident to our senses, that in the world some things are in motion. . . . [Now], whatever is moved must be moved by another. If that by which it is moved be itself moved, then this also must needs be moved by another, and that by another again. But this cannot go on to infinity, because then there would be no first mover, and, consequently, no other mover, seeing that subsequent movers move only inasmuch as they are moved by the first mover; as the staff moves only because it is moved by the hand. Therefore it is necessary to arrive at a first mover, moved by no other; and this everyone understands to be God.

> "Therefore it is necessary to arrive at a first mover, moved by no other; and this everyone understands to be God."
> —Saint Thomas Aquinas

The second way is from the nature of efficient cause. In the world of sensible things we find there is an order of efficient causes. There is no case known (neither is it, indeed, possible) in which a thing is found to be the efficient cause of itself; for so it would be prior to itself, which is impossible. Now in efficient causes it is not possible to go on to infinity, because in all efficient causes following in order, the first is the cause of the intermediate cause and the intermediate is the cause of the ultimate cause, whether the intermediate cause be several, or one only. Now to take away the cause is to take away the effect. Therefore, if there be no first cause among efficient causes, there will be no ultimate, nor any intermediate, cause. . . . Therefore it is necessary to admit a first efficient cause, to which everyone gives the name of God.

The third way is taken from possibility and necessity, and runs thus. We find in nature things that are possible to be and not to be, since they are found to be born, and to die, and consequently they are possible to be and not to be. But it is impossible for these always to exist, for that which is possible not to be at some time is not. Therefore, if everything is possible not to be, then at one time there could have been nothing in existence. Now, if this were true, even now there would be nothing in existence, because that which does not exist only begins to exist by something already existing. Therefore, if at one time nothing was in existence, it would have been impossible for anything to have begun to exist; and thus even now nothing would be in existence—which is clearly false. Therefore, not all beings are merely possible, but there must exist something the existence of which is necessary. But every necessary thing either has its necessity caused by another, or not. Now, it is impossible to go on to infinity in necessary things which have their necessity caused by another, as has been already proved in regard to efficient causes. Therefore, we must admit the existence of some being having of itself its own necessity, and not receiving it from another, but rather causing in others their necessity. This all men speak of as God.

The fourth way is taken from the gradation to be found in things. Among beings there are some more and some less good, true, noble, and the like. But "more" and "less" are predicated on different things, according as they resemble in their different ways something which is the maximum, as a thing is said to be hotter according as it more nearly resembles that which is hottest. There is then something which is truest, something best, something noblest, and, consequently, something which is most being; for those things that are greatest in truth are greatest in being. . . . Therefore, there must also be something which is to all beings the cause of their being, goodness, and every other perfection. And this we call God.

The fifth way is taken from the governance of the world. We see that things which lack knowledge, such as natural bodies, act for an end, and this is evident from their acting always, or nearly always, in the same way, so as to obtain the best result. Hence it is plain that they achieve their end, not fortuitously, but designedly. Now whatever lacks knowledge cannot move towards an end, unless it be directed by some being endowed with knowledge and intelligence; as the arrow is directed by the archer. Therefore some intelligent being exists by whom all natural things are directed to their end; and this being we call God.

Reply to Objection One: As Augustine says: "Since God is the highest good, He would not allow any evil to exist in His works, unless His omnipotence and goodness were such as to bring good even out of evil." This is part of the infinite goodness of God; that He should allow evil to exist, and out of it produce good.

Reply to Objection Two: Since nature works for a determinate end under the direction of a higher agent, whatever is done by nature must be traced back to God, as to its first cause. . . . For all things that are changeable and capable of defect must be traced back to an immovable and self-necessary first principle, as was shown in the body of this Article.

The Love of God
SAINT BERNARD OF CLAIRVAUX

You would hear from me, then, why and how God is to be loved? I answer: The cause of loving God is God; the manner is to love without measure. Is this enough? Yes, perhaps, for the wise. But I am debtor to the unwise as well; where enough is said for the wise, we must comply with the others also. Therefore I will not refuse to repeat it, more fully rather than more deeply, for the sake of the slower in apprehension. I may say that God is to be loved for His own sake for a double reason: because nothing can be loved more justly, nothing more fruitfully. . . . Assuredly I find no other worthy cause of loving Him, save Himself. . . .

Consider This:
- What is Saint Thomas Aquinas's essential argument for the existence of God? Does it sound logical to you? Is it persuasive, or can you find defects in the proof? Is Saint Bernard's argument more satisfying?

The Dialectical Method: *Sic et Non*
PETER ABELARD

One of the greatest minds of the Middle Ages belonged to Peter Abelard. He was a renowned scholar and teacher whose method of inquiring into spiritual issues often created formidable enemies (among them, Saint Bernard of Clairvaux). Abelard's method of applying critical thought to the interpretation of sacred texts is best revealed in his famous work Sic et Non

"The Love of God" is from E. G. Gardner, trans., *On the Love of God* (London: J. M. Dent and Sons, 1916), p. 27. Reprinted by permission of the publisher.

"The Dialectical Method: *Sic et Non*" is from Roland Bainton, ed., *The Medieval Church* (Princeton, N.J.: D. Van Nostrand, 1962), pp. 129–130. Copyright © 1962. Reprinted by permission of Wadsworth Publishing Company.

(Yes and No). Abelard would pose a problem and then cite arguments, supported by the most revered church fathers, that the statement was true. He then produced another series of logical and well-supported arguments that proved it false. Abelard did not want to reconcile the conflicting views, but by this dialectical process he hoped to "sharpen the minds" of his students. The pathway to Truth had to be critically examined. The following excerpts demonstrate his method and are good examples of Scholastic argument.

Inasmuch as among the multitudinous words of the saints there are some which . . . not only [differ] but actually [contradict one another], we are not to judge lightly of these saints who themselves will judge the world. . . . If there are divine mysteries which we cannot understand in the spirit in which they were written, better to reserve judgment than to define rashly. We are not to rely on apocryphal writings and we must be sure that we have the correct text on the canonical. For example, Matthew and John say that Jesus was crucified at the sixth hour, but Mark at the third. This is an error of transcription in Mark. We are to observe because he carelessly incorporated the work of someone else, as Augustine confessed he had done with reference to Origen. We must bear in mind the diversity of situation in which particular sayings were uttered. In case of controversy between the saints, which cannot be resolved by reason, we should hold to that opinion which has the most ancient and

> ## "By doubting we come to inquire, and by inquiry we arrive at the truth."
> ### —Peter Abelard

powerful authority. And if sometimes the fathers were in error we should attribute this not to duplicity but ignorance, and if sometimes they were absurd, we are to assume that the text is faulty, the interpreter in error or simply that we do not understand.

Therefore it has seemed to us fitting to collect from the holy fathers apparently contradictory passages that tender readers may be incited to make inquiry after the truth. . . . By doubting we come to inquire, and by inquiry we arrive at the truth. . . . We are including nothing from the Apocrypha and nothing from the writings of Augustine which he later retracted.

Example XXXII. That God may do all things and that He may not.

Chrysostom said that God is called almighty because it is impossible to find anything that is impossible for Him. Nevertheless He cannot lie, or be deceived, He cannot be ignorant. He cannot have a beginning or an end.

He cannot forget the past, be involved in the present or be ignorant of the future. Finally, He cannot deny Himself. Augustine said there are some things God can do as to His power, but not as to His justice. Being himself justice He cannot commit injustice. He is omnipotent in the sense that He can do what He wants. But He cannot die, He cannot change and He cannot be deceived.

Example XI. That the divine persons differ from each other and that they do not.

Athanasius said there is one person of the Father, one of the Son and one of the Holy Spirit. The Father is not made, created or begotten. The son comes solely from the Father. He is not made or created but He is begotten. The spirit proceeds from the Father and the Son. He is not begotten or created but proceeding. But Pope Leo I said, "In the divine Trinity nothing is dissimilar, nothing unequal."

Consider This:

- Peter Abelard summed up his attitude in this way: "By doubting, we come to inquire, by inquiring, we come to the truth." Saint Anselm said, "I believe in order that I may understand." What is the essential difference between the two statements? Do you believe that Abelard was seeking to undermine faith in God? What is the "truth" he sought?

To the Depths of Hell:
"Abandon All Hope, You Who Enter Here"
DANTE ALIGHIERI

There are few poets who have made such an indelible mark on their age as did Dante Alighieri (1265–1321). A Florentine by birth, Dante was active in local politics and was exiled by his victorious opponents whose short-sighted action cost Florence the glory of providing a tomb for the great poet. Instead, Dante moved to Ravenna where he composed poetry celebrating his eternal love for Beatrice, his fictionalized persona of grace and idealized beauty. But Dante's vision went well beyond love poetry and extended to the complex allegory of his masterpiece, The Divine Comedy. Written in Italian, the influence of this work shifted the literary focus of Europe from France to Italy, which complemented this status until about 1600 with the brilliant dominance of its artists and craftsmen.

The Divine Comedy was written about 1314 in 100 Cantos that are divided into an introduction and three parts of 33 Cantos each: Hell (The Inferno), Purgatory, and Paradise. Dante's vision, like Saint Augustine centuries before, was based on a medieval division of the universe into the City of Man and the City of God. The City of God was the repository of all who loved God purely to the exclusion of self. Conversely, the City of Man was populated by all those whose self-interest bound them to sin, where all were competitors and enemies. Both cities were spiritual states and the earthly kingdom was a proving ground where saints and sinners mingled and interacted as pilgrims on the road to one of the two spiritual states. At the Last Judgment however, all the damned would be separated forever from the blessed. Dante's Inferno is thus a vision of the City of Man in the afterlife, where all reside who have sinned against God.

Sin, however, is relative. Though the inhabitants of Hell are all condemned, those who reside in the upper levels are less culpable than those in the deepest regions. So in the foregate of Hell reside those pagans who through their blameless ignorance never had the opportunity to accept Christ. The lower reaches were reserved for those who consciously defied God's laws and were guilty of fraud, betrayal, and violent crime in myriad variations.

The Inferno begins during Easter in 1300, as the poet Dante finds himself adrift, having "strayed from the True Path" into the "Dark Wood of Error." He is guided in his journey of self-discovery by the Roman poet Virgil, the symbol of Human Reason. Virgil has been sent to show Dante the torments of those who transgressed God's laws in hopes of restoring him to the right path. Virgil, however, can only take Dante to the depths of Hell and begin the ascent through Purgatory. Another guide, his Beatrice as the symbol of Divine Love, must lead him to Paradise.

In the following excerpt, we encounter Virgil and Dante at the Gates of Hell as they are about to cross the river Styx with Charon the boatman into the first circles, the realm of those Opportunists who remained neutral in life's decisions, drifting with the wind, never committing to God's will; they spend eternity harried by wasps and maggots, chasing whirling banners, illusions of a "blind life" so inconsequential that the world is "deaf to their memory."

CANTO III

THROUGH ME YOU ENTER INTO THE CITY OF WOES,
THROUGH ME YOU ENTER INTO ETERNAL PAIN,
THROUGH ME YOU ENTER THE POPULATION OF LOSS.

JUSTICE MOVED MY HIGH MAKER, IN POWER DIVINE,
 WISDOM SUPREME, LOVE PRIMAL, NO THINGS WERE
 BEFORE ME NOT ETERNAL; ETERNAL I REMAIN.

ABANDON ALL HOPE, YOU WHO ENTER HERE.
 These words I saw inscribed in some dark color
 Over a portal, "Master," I said, "make clear

Their meaning, which I find too hard to gather."
 Then he, as one who understands: "All fear
 Must be left here, and cowardice die. Together,

We have arrived where I have told you: here
 You will behold the wretched souls who've lost
 the good of intellect." Then, with good cheer

In his expression to encourage me, he placed
 His hand on mine: so, trusting to my guide,
 I followed him among things undisclosed.

The sighs, groans and laments at first were so loud,
 Resounding through starless air, I began to weep:
 Strange languages, horrible screams, words imbued

With rage or despair, cries as of troubled sleep
 Or of a tortured shrillness—they rose in a coil
 Of tumult along with noises like the slap

Of beating hands, all fused in a ceaseless flail
 That churns and frenzies that dark and timeless air
 Like sand in a whirlwind. And I, my head in a swirl

Of error, cried: "Master, what is this I hear?
 What people are these, whom pain has overcome"?
 He: "This is the sorrowful state of souls unsure,

Whose lives earned neither honor nor bad fame.
 And they are mingled with angels of that base sort
 Who, neither rebellious to God nor faithful to Him,

Chose neither side, but kept themselves apart—
 Now Heaven expels them, not to mar its splendor,
 And Hell rejects them, lest the wicked of heart

Take glory over them." And then I: "Master,
 What agony is it, that makes them keen their grief
 With so much force?" He: "I will make brief answer:

They have no hope of death, but a blind life
 So abject, they envy any other fate.
 To all memory of them, the world is deaf.

Mercy and justice disdain them. Let us not
 Speak of them: look and pass on." I looked again:
 A whirling banner sped at such a rate

I seemed it might never stop; behind it a train
 Of souls, so long that I would not have thought
 Death had undone so many. . . . So at once I understood

Beyond all doubt that this was the dreary guild
 Repellent both to God and His enemies—
 Hapless ones never alive, their bare skin galled

By wasps and flies, blood trickling down the face,
 Mingling with tears for
 harvest underfoot
 By writhing maggots.
 Then, when I turned
 my eyes

Farther along our course, I
 could make out
 People upon the shore
 of some great river.
 "Master," I said, "it
 seems by this dim light

> "Bare skin galled by wasps and flies, blood trickling down the face, mingling with tears for harvest underfoot by writhing maggots."
> —Dante Alighieri

That all of these are eager to cross over—
 Can you tell me by what law, and who they are?"
 He answered, "Those are things you will discover

When we have paused at Acheron's dismal shore."
 I walked on with my head down after that,
 Fearful I had displeased him, and spoke no more.

Then, at the river—an old man in a boat:
 White-haired, as he drew closer shouting at us,
 "Woe to you, wicked souls! Give up the thought

Of Heaven! I come to ferry you across
 Into eternal dark on the opposite side,
 Into fire and ice! And you there—leave this place,

You living soul, stand clear of these who are dead!"
 And then, when he saw that I did not obey:
 "By other ports, in a lighter boat," he said,

"You will be brought to shore by another way."
 My master spoke then, "Charon, do not rage:
 Thus is it willed where everything may be

Simply if it is willed. Therefore, oblige,
 And ask no more." That silenced the grizzled jaws
 Of the gray ferryman of the livid marsh,

Who had red wheels of flame about his eyes.
 But at his words the forlorn and naked souls
 Were changing color, cursing the human race,

God and their parents. Teeth chattering in their skulls,
 They called curses on the seed, the place, the hour
 Of their own begetting and their birth. With wails

And tears they gathered on the evil shore
 That waits for all who don't fear God. There demon
 Charon beckons them, with his eyes of fire;

Crowded in a herd, they obey if he should summon,
 And he strikes at any laggards with his oar.
 As leaves in quick succession sail down in autumn

Until the bough beholds its entire store
 Fallen to the earth, so Adam's evil seed
 Swoop from the bank when each is called, as sure

As a trained falcon, to cross to the other side
 Of the dark water; and before one throng can land
 On the far shore, on this side new souls crowd.

"My son," said the gentle master, "here are joined
 The souls of all who die in the wrath of God,
 From every country, all of them eager to find

Their way across the water—for the goad
 Of Divine Justice spurs them so, their fear
 Is transmuted to desire. Souls who are good

Never pass this way; therefore, if you hear
 Charon complaining at your presence, consider
 What that means." Then, the earth of that grim shore

Began to shake: so violently, I shudder
 And sweat recalling it now. A wind burst up
 From the tear-soaked ground to erupt red light and batter

My senses—and so I fell, as though seized by sleep.

CANTO VI

In this Canto, we meet Cerberus, the three-headed dog, who in classical mythology guarded the entrance to the Underworld. Dante, however, presents him as a demon who holds sway over the gluttons of the Third Circle of Hell.

I see new torments and tormented ones again
 Wherever I step or look. I am in the third
 Circle, a realm of cold and heavy rain—

A dark, accursed torrent eternally poured
 With changeless measure and nature. Enormous hail
 And tainted water mixed with snow are showered

Steadily through the shadowy air of Hell;
 The soil they drench gives off a putrid odor.
 Three-headed Cerberus, monstrous and cruel,

Barks doglike at the souls immersed here, louder
 For his triple throat. His eyes are red, his beard
 Grease-black, he has the belly of a meat-feeder

And talons on his hands: he claws the horde
 Of spirits, he flays and quarters them in the rain.
 The wretches, howling like dogs where they are mired

And pelted, squirm about again and again,
 Turning to make each side a shield for the other.
 Seeing us, Cerberus made his three mouths yawn

To show the fangs—his reptile body aquiver
 In all its members. My leader, reaching out
 To fill both fists with as much as he could gather.

Threw gobbets of earth down each voracious throat.
 Just as a barking dog grows suddenly still
 The moment he begins to gnaw his meat,

Struggling and straining to devour it all,
 So the foul faces of Cerberus became—
 Who thundered so loudly at the souls in Hell

They wished that they were deaf. We two had come
 Over the shades subdued by the heavy rain—
 Treading upon their emptiness, which seem
 Like real bodies. . . .

CANTO XXVIII

Virgil guides Dante into the depths of Hell, each successive Circle reserved for more egregious sins until they arrive at the Pit of Hell for those who have betrayed kin and country, guests and benefactors. In the next excerpt, we are in the Eighth Circle, close to the Pit, among those who have committed the sins of Fraud: seducers, flatterers, hypocrites, and thieves. This Canto pays particular attention to the schismatics, those who have divided countries, religions, and families through lies and false doctrines. It is here that Dante encounters Muhammad, the Prophet of Islam who, in Christian eyes, preached heresy. The disputed succession to the leadership of the Caliphate by Muhammad's nephew and son-in-law Ali caused a schism of Islam into Sunni and Shi'ite sects.

This Canto also provides a good example of Dante's concept of retribution—punishment in Hell fits the nature of the crime. So these schismatics who divided others are themselves cut to pieces. The most glaring example is that of Bertan de Born, lord of Hautefort in France, who inspired the rebellion of King Henry II's oldest son against his father. Bertram is condemned to wander the landscape of Hell eternally, carrying his severed head at his side.

Who could find words, even in free-running prose,
 For the blood and wounds I saw, in all their horror—
 Telling it over as often as you choose,

It's certain no human tongue could take the measure
 Of those enormities. Our speech and mind,
 Straining to comprehend them, flail, and falter. . . .

And some were showing wounds still hot and open,
Others the gashes where severed limbs had been:
It would be nothing to equal the mutilation

I saw in that Ninth Chasm. No barrel staved-in
And missing its end-piece ever gaped as wide
As the man I saw split open from his chin

Down to the farting-place, and from the splayed
Trunk the spilled entrails dangled between his thighs.
I saw his organs, and the sack that makes the bread

We swallow turn to shit. Seeing my eyes
Fastened upon him, he pulled open his chest
With both hands, saying, "Look how Muhammad claws

And mangles himself, torn open down the breast!
Look how I tear myself! And Ali goes
Weeping before me—like me, a schismatic, and cleft:

Split open from the chin along his face
Up to the forelock. All you see here, when alive,
Taught scandal and schism, so they are cleavered like this.

A devil waits with a sword back there to carve
Each of us open afresh each time we've gone
Our circuit round this road, where while we grieve

Our wounds close up before we pass him again—
But who are you that stand here, perhaps to delay
Torments pronounced on your own false words to men?"

"Neither has death yet reached him, nor does he stay
For punishment of guilt," my master replied,
"But for experience. And for that purpose I,

Who am dead, lead him through Hell as rightful guide,
From circle to circle. Of this, you can be as sure
As that I speak to you here at his side."

More than a hundred shades were gathered there
Who hearing my master's words had halted, and came
Along the trench toward me in order to stare,

Forgetting their torment in wonder for a time. . . .

Another there, whose face was cruelly broken,
The throat pierced through, the nose cut off at the brow.
One ear remaining, stopped and gazed at me, stricken

With recognition as well as wonder. "Ah, you,"
His bleeding throat spoke, "you here, yet not eternally
Doomed here by guilt—unless I'm deceived, I knew

Your face when I still walked above in Italy. . . .

I stayed to see more, one sight so incredible
 As I should fear to describe, except that conscience,
 Being pure in this, encourages me to tell:

I saw—and writing it now, my brain still envisions—
 A headless trunk that walked, in sad promenade
 Shuffling the dolorous track with its companions,

And the trunk was carrying the severed head,
 Gripping its hair like a
 lantern, letting it swing,
 And the head looked up
 at us: "Oh me!" it cried.

He was himself and his lamp
 as he strode along,
 Two in one, and one in
 two—and how it can be,
 Only He knows, who so
 ordains the thing.

> **"I saw . . . a headless trunk that walked in sad promenade . . . and the trunk was carrying the severed head, gripping its hair like a lantern . . ."**
>
> **—Dante Alighieri**

Reaching the bridge, the trunk held the head up high
 So we could hear his words, which were "Look well,
 You who come breathing to view the dead, and say

If there is punishment harder than mine in Hell.
 Carry the word, and know me: Bertran de Born,
 Who made the father and the son rebel

The one against the other, by the evil turn
 I did the young king, counseling him to ill.
 David and Absalom [David's son] had nothing worse to learn

From the wickedness contrived by Achitophel [David's counselor].
 Because I parted their union, I carry my brain
 Parted from this, its pitiful stem: Mark well

This retribution that you see is mine."

Consider This:

- Note the characterizations of Charon the boatman and Cerberus the three-headed dog. What are their respective responsibilities in Hell? How does Virgil appease each of them before he and Dante can pass?

- Discuss Dante's conception of retribution. Compare the Opportunists of Canto III with the Schismatics of Canto XXVIII. What were their respective crimes and penalties? How do the punishments fit the crimes?

- What was Dante's reason for writing *The Divine Comedy*? Why is his conception of Hell medieval in outlook? By presenting himself as a pilgrim who was guided through Hell by Virgil as the embodiment of Reason, what was Dante's message for the world of the living?

The Reflection in the Mirror

THE BLACK DEATH: "BEHOLD, A PALE HORSE"

Figure 5–12 Geoffrey Tory, *The Triumph of Death* (woodcut) (Art Resource, N.Y.).

Behold, a pale horse; and his name that sat on him was Death.

—Revelation 6:8

In October 1347, a Genoese fleet docked in Sicily at the port of Messina. The entire crew was either dead or dying, afflicted with a disease that clung, as the chronicler noted, "to their very bones." The ship had arrived from the Black Sea region and was filled with grain for ready distribution. Also aboard were the omnipresent rats, black rats, infested with fleas that, in turn, harbored the Yersinia pestis bacillus. Before the fleet could be quarantined, the rats had run down the ropes and into the city. Over the next four years, the scene would be repeated again and again. The Black Death had arrived.

The mere words "Black Death" have an ominous ring about them. They dredge up images of rotting corpses, broken families, and despair. The people of Europe were devastated by a disease they did not understand nor were prepared to suffer. It was an epidemic of such magnitude that one-third to one-half of the population of Europe was killed.

In a recent study by the Rand Corporation, the Black Death ranked as one of the three greatest catastrophes in the history of the world. It did much more than eliminate people; it altered the very fabric of medieval society and jeopardized the unity of Western Civilization. Familial ties were shattered as people refused to care for their relatives out of fear of contracting the disease themselves. Whole families were destroyed; we can truly speak of "lost generations." Survivors were often left in psychological and moral crisis. It was evident to all that Europe was in the throes of change by forces that could not be understood, moving toward a future that could not be guaranteed.

A Most Terrible Plague

GIOVANNI BOCCACCIO

Giovanni Boccaccio is best known as a humanist of the Italian Renaissance. The following excerpt is from his most famous work, The Decameron. *Written during the plague years between 1348 and 1353, it is a collection of stories told intimately between friends while they passed the time away from Florence in the solitude and safety of the country. It begins with a detailed description of the pestilence. Over two-thirds of the population of Florence died of the plague.*

Figure 5–13 Francesco Traini, *The Triumph of Death/Detail* (SuperStock, Inc.).

Keep in Mind:
- According to Boccaccio, what were the symptoms of the Black Death and how did people react to the crisis?

In the year then of our Lord 1348, there happened at Florence, the finest city in all Italy, a most terrible plague; which, whether owing to the influence of the planets, or that it was sent from God as a just punishment for our sins, had broken out some years before in the Levant, and after passing from place to place, and making incredible havoc all the way, had now reached the west. There, in spite of all the means that art and human foresight could suggest, such as keeping the city clear from filth, the exclusion of all suspected persons, and the publication of copious instructions for the preservation of health; and notwithstanding manifold supplications

"A Most Terrible Plague" is from Giovanni Boccaccio, *The Decameron,* in *Stories of Boccaccio,* trans. John Payne (London: Bibliophilist Library, 1903), pp. 1–6.

offered to God in processions and otherwise, it began to show itself in the spring of the aforesaid year, in a sad and wonderful manner. Unlike what had been seen in the east, where bleeding from the nose is the fatal prognostic, here there appeared certain tumors in the groin or under the armpits, some as big as a small apple, others as an egg; and afterwards purple spots in most parts of the body; in some cases large and but few in number, in others smaller and more numerous—both sorts the usual messengers of death. To the cure of this malady, neither medical knowledge nor the power of drugs was of any effect; whether because the disease was in its own nature mortal, or that the physicians (the number of whom, taking quacks and women pretenders into the account, was grown very great) could form no just idea of the cause, nor consequently devise a true method of cure; whichever was the reason, few escaped; but nearly all died the third day from the first appearance of the symptoms, some sooner, some later, without any fever or accessory symptoms. What gave the more virulence to this plague, was that, by being communicated from the sick to the healthy, it spread daily, like fire when it comes in contact with large masses of combustibles. Nor was it caught only by conversing with, or coming near the sick, but even by touching their clothes, or anything that they had before touched. . . . These facts, and others of the like sort, occasioned various fears and devices amongst those who survived, all tending to the same uncharitable and cruel end; which was, to avoid the sick, and every thing that had been near them, expecting by that means to save themselves. And some holding it best to live temperately, and to avoid excesses of all kinds, made parties, and shut themselves up from the rest of the world; eating and drinking moderately of the best, and diverting themselves with music, and such other entertainments as they might have within doors; never listening to anything from without, to make them uneasy. Others maintained free living to be a better preservative, and would baulk no passion or appetite they wished to gratify, drinking and reveling incessantly from tavern to tavern, or in private houses (which were frequently found deserted by the owners, and therefore common to every one), yet strenuously avoiding, with all this brutal indulgence, to come near the infected. And such, at that time, was the public distress, that the laws, human and divine, were no more regarded; for the officers, to put them in force, being either dead, sick, or in want of persons to assist them, every one did just as he pleased. A third sort of people chose a method between these two: not confining themselves to rules of diet like the former, and yet avoiding the intemperance of the latter; but eating and drinking what their appetites required, they walked everywhere with [fragrances and nose-coverings], for the whole atmosphere seemed to them tainted with the stench of dead bodies, arising partly from the distemper itself, and

> "What numbers of both sexes, in the prime and vigor of youth breakfasted in the morning with their living friends, and supped at night with their departed friends in the other world!"
> —Giovanni Boccaccio

partly from the fermenting of the medicines within them. Others with less humanity, but . . . with more security from danger, decided that the only remedy for the pestilence was to avoid it: persuaded, therefore, of this, and taking care for themselves only, men and women in great numbers left the city, their houses, relations, and effects, and fled into the country; as if the wrath of God had been restrained to visit those only within the walls of the city. . . .

I pass over the little regard that citizens and relations showed to each other; for their terror was such, that a brother even fled from his brother, a wife from her husband, and, what is more uncommon, a parent from his own child. Hence numbers that fell sick could have no help but what the charity of friends, who were very few, or the avarice of servants supplied; and even these were scarce and at extravagant wages, and so little used to the business that they were fit

only to reach what was called for, and observe when their employer died; and this desire of getting money often cost them their lives. . . .

It fared no better with the adjacent country, for . . . you might see the poor distressed laborers, with their families, without either the aid of physicians, or help of servants, languishing on the highways, in the fields, and in their own houses, and dying rather like cattle than human creatures. The consequence was that, growing dissolute in their manners like the citizens, and careless of everything, as supposing every day to be their last, their thoughts were not so much employed how to improve, as how to use their substance for their present support.

What can I say more, if I return to the city, unless that such was the cruelty of Heaven, and perhaps of men, that between March and July following, according to authentic reckonings, upwards of a hundred thousand souls perished in the city only; whereas, before that calamity, it was not supposed to have contained so many inhabitants. What magnificent dwellings, what noble palaces were then depopulated to the last inhabitant! What families became extinct! What riches and vast possessions were left, and no known heir to inherit them! What numbers of both sexes, in the prime and vigor of youth . . . breakfasted in the morning with their living friends, and supped at night with their departed friends in the other world!

Consider This:

- How were the patterns of social interaction and urban production altered by the Black Death? Which passage in Boccaccio's description makes the greatest impression on you and why?

- Religion is often considered a stabilizing force in society, helping to mollify fear of the unknown. How was faith a casualty of this disease? What is the role of disease in history? How potent is disease as a force for historical change?

- The "Dance of Death" and the fragility of life were important themes in medieval art during the plague years. A familiar expression of the time was *Media vita in morte sumus* ("In the midst of life, we are in death"). How do you interpret this expression and see it reflected in Francesco Traini's *Triumph of Death*?

- How is the psychological devastation of the plague expressed in Geoffrey Tory's woodcut depicting the "Triumph of Death"? Consider the children's nursery rhyme: "Ring around the rosie/Pocket full of posies/ Ashes, Ashes/We all fall down. . . . " How is this a formula for the Triumph of Death?

"I Thrive on Pain and Laugh with All My Tears"
FRANCESCO PETRARCH

Francesco Petrarch (1304–1374) was one of the great literary figures during the transition from the Late Middle Ages to the Renaissance. He lived in a medieval world of superstition and eroding faith, characterized by the corruption and division of the church and the trauma of the Black Death that raged through Europe from 1348 to 1351.

Born in Italy and linked especially to Florence and Rome, Petrarch traveled widely throughout Europe, uncovering and editing the texts of antiquity, thus beginning a revival of Classical learning that would provide the literary models and inspiration for scholars and artists of the Italian Renaissance. Like Dante, who was his older contemporary, Petrarch wrote his poetry in the Italian vernacular. His masterpiece, the Canzoniere (Song Book) *is a*

"I Thrive on Pain and Laugh with All My Tears" is from Francesco Petrarch, *The Canzoniere and Other Works*, trans. Mark Musa, Sonnets 61, 132, 134, 311. Copyright © 1985 Mark Musa. Reprinted by permission of Oxford University Press.

collection of 366 sonnets, reflections on life and death that were often dedicated to his idyllic love for Laura, the inspiration of his muse, the tormentor of his soul, the personification of beauty and truth. But Laura was married to another and never returned his affection. This "love from afar" is reminiscent of the medieval chivalric tradition of the troubadours, but these sonnets reflect a personal anguish and subtlety that is very modern in outlook. When Laura fell victim to the Black Death in 1348, Petrarch's poetry changed from the longing ideal to a reconciliation with death, the acceptance that nothing lasts forever.

61

Oh blessèd be the day, the month, the year,
the season and the time, the hour, the instant,
the gracious countryside, the place where I
was struck by those two lovely eyes that bound me;

and blessèd be the first sweet agony
I felt when I found myself bound to Love,
the bow and all the arrows that have pierced me,
the wounds that reach the bottom of my heart.

And blessèd be all of the poetry
I scattered, calling out my lady's name,
and all the sighs, and tears, and the desire;

blessèd be all the paper upon which
I earn her fame, and every thought of mine,
only of her, and shared with no one else.

132

If it's not love, then what is it I feel?
But if it's love, by God, what is this thing?
If good, why then the bitter mortal sting?
If bad, then why is every torment sweet?

If I burn willingly, why weep and grieve?
And if against my will, what good lamenting?
O living death, O pleasurable harm,
how can you rule me if I not consent?

And if I do consent, it's wrong to grieve.
Caught in contrasting winds in a frail boat
on the high seas I am without a helm,

so light of wisdom, so laden of error.
That I myself do not know what I want,
and shiver in midsummer, burn in winter.

134

I find no peace, and I am not at war,
I fear and hope, and burn and I am ice;

I fly above the heavens, and lie on earth,
and I grasp nothing and embrace the world.

One keeps me jailed who neither locks nor opens,
nor keeps me for her own nor frees the noose;
Love does not kill, nor does he loose my chains;
he wants me lifeless but won't loosen me.

I see with no eyes, shout without a tongue;
I yearn to perish, and I beg for help;
I hate myself and love somebody else.

I thrive on pain and laugh with all my tears;
I dislike death as much as I do life:
because of you, lady, I am this way.

311

That nightingale so tenderly lamenting
perhaps his children or his cherished mate,
in sweetness fills the sky and countryside
with many notes of grief skillfully played,

and all night long he stays with me it seems,
reminding me of my harsh destiny;
I have no one to blame except myself
for thinking that Death could not take a goddess.

How easy to deceive one who is sure!
Those tow lights, lovely, brighter than the sun,
whoever thought would turn the earth so dark?

And now I know what this fierce fate of mine
would have me learn as I live on in tears:
that nothing here can please and also last.

Compare and Contrast:

- How does Petrarch characterize his love for Laura? What kind of love is it? Physical or spiritual? Real or imagined?

- Identify examples of Petrarch's use of the oxymoron ("O living death") or the technique of description through antithesis ("I burn and I am ice"). Why is this approach so interesting and attractive?

- The Roman poet Catullus was also a tormented soul in his unrequited love for Clodia (pages 121–123). Dante yearned for his idealized Beatrice (pages 215–221). The Roman poet, Virgil, Dante's guide through Hell, told of Aeneas's tragic affair with Dido, Queen of Carthage, that ended in her rejection and suicide (pages 123–124). What is it about these poets? Must love be tragic or unattainable in order to be worthy of poetic expression? Why don't poets write about couples in fulfilled relationships?

Canterbury Tales: The Wife of Bath
GEOFFREY CHAUCER

We know little of the life of Geoffrey Chaucer (ca. 1340–1400), but his masterpiece, The Canterbury Tales *remains one of the best-loved and most important works of poetry in the English language. Written about 1385, it is the story of a group of travelers on the road from Southwark (near London) to Canterbury, there to pay homage at the shrine of the martyred Saint Thomas Becket. This is a rag-tag group of pilgrims, including such characters as a nun, a squire, a knight, a prioress, a miller, a monk, a doctor, and an Oxford cleric. To pass time on the journey, each spins a tale of love and deception, greed and desire, hoping to entertain and beguile their traveling companions. These stories are often comedic and sometimes philosophical, but always reflect a variety of perspective that constitutes one of our more explicit descriptions of medieval English society.*

Chaucer's wit and psychological insight combine in the tale of the Wife of Bath. She was a talented weaver with a roving eye and a garish taste in clothes. Her tale about a knight brought to judgment for the rape of a maiden is a compelling narrative of sexual politics with a few twists along the way that give perspective to the relationship between crime and justice, physical attraction and inner beauty. Chaucer's surprising moral is that grace and gentility are gifts from God alone and not derived from social position. After setting the scene in the Prologue, Chaucer presents his tale of the Wife of Bath.

The Prologue

When in April the sweet showers fall
And pierce the drought of march to the root, and all
The veins are bathed in liquor of such power
As brings about the engendering of the flower,
When also Zephyrus with his sweet breath
Exhales an air in every grove and heath
Upon the tender shoots, and the young sun
His half-course in the sign of the *Ram* has run,
And the small fowl are making melody
That sleep away the night with open eye
(So nature pricks them and their heart engages)
Then people long to go on pilgrimages
And palmers long to seek the stranger strands
of Far-off saints, hallowed in sundry lands,
And specially, from every shire's end
Of England, down to Canterbury they wend
To seek the holy blissful martyr, quick
To give his help to them when they were sick.
 It happened in that season that one day
In Southwark, at *The Tabard*, as I lay
Ready to go on pilgrimage and start
For Canterbury, most devout at heart,
At night there came into that hostelry
Some nine and twenty in a company

"Canterbury Tales" is from *The Canterbury Tales*, trans. Nevill Coghill, 4th rev. ed. (Baltimore, Md., and Harmondsworth, Middlesex: Penguin Books, 1977), Prologue, lines 1–34; The Wife of Bath, lines 27–96; 129–218; 228–270; 292–310; 323–336; 353–410. Copyright © 1958, 1960, 1975, 1977 by Nevill Coghill. Reprinted by permission of Penguin Books, Ltd..

Of sundry folk happening then to fall
In fellowship, and they were pilgrims all
That towards Canterbury meant to ride.
The rooms and stables of the inn were wide;
They made us easy, all was of the best.
And, briefly, when the sun had gone to rest,
I'd spoken to them all upon the trip
And was soon one with them in fellowship.
Pledged to rise early and to take the way
To Canterbury, as you heard me say. . . .

The Wife of Bath's Tale: "What Is the Thing That Women Most Desire?"

Now it so happened, I began to say,
Long, long ago in good King Arthur's day,
There was a knight who was a lusty liver.
One day as he came riding from the river
He saw a maiden walking all forlorn
Ahead of him, alone as she was born.
And of that maiden, spite of all she said,
By very force he took her maidenhead.

 This act of violence made such a stir,
So much petitioning of the king for her,
That he condemned the knight to lose his head
By course of law. He was as good as dead
(It seems that then the statutes took that view)
But that the queen, and other ladies too,
Implored the king to exercise his grace
So ceaselessly, he gave the queen the case
And granted her his life, and she could choose
Whether to show him mercy or refuse.

 The queen returned him thanks with all her might,
And then she sent a summons to the knight
At her convenience, and expressed her will:
"You stand, for such is the position still,
In no way certain of your life," said she,
"Yet you shall live if you can answer me:
What is the thing that women most desire?
Beware the axe and say as I require.

 "If you can't answer on the moment, though,
I will concede you this: you are to go
A twelvemonth and a day to seek and learn
Sufficient answer, then you shall return.
I shall take gages from you to extort
Surrender of your body to the court."

 Sad was the knight and sorrowfully sighed,
But there! All other choices were denied,
And in the end he chose to go away

And to return after a year and day
Armed with such answer as there might be sent
To him by God. He took his leave and went.

He knocked at every house, searched every place,
Yes, anywhere that offered hope of grace.
What could it be that women wanted most?
But all the same he never touched a coast,
Country or town in which there seemed to be
Any two people willing to agree.

Some said that women wanted wealth and treasure,
"Honor," said some, some "Jollity and pleasure,"
Some "Gorgeous clothes" and others "Fun in bed,"
"To be oft widowed and remarried," said
Others again, and some
 that what most
 mattered
Was that we should be
 cossetted and flattered.
That's very near the
 truth, it seems to me;
A man can win us best
 with flattery.
To dance attendance on
 us, make a fuss,
Ensnares us all, the best
 and worst of us.

> "He knocked at every house, searched every place,
> Yes, anywhere that offered hope of grace.
> What could it be that women wanted most?"
> —Geoffrey Chaucer

Some say the things we most desire are these:
Freedom to do exactly as we please,
With no one to reprove our faults and lies,
Rather to have one call us good and wise.
Truly there's not a woman in ten score
Who has a fault, and someone rubs the sore,
But she will kick if what he says is true,
You try it out and you will find so too.
However vicious we may be within
We like to be thought wise and void of sin.
Others assert we women find it sweet
When we are thought dependable, discreet
And secret, firm of purpose and controlled,
Never betraying things that we are told.
But that's not worth the handle of a rake;
Women conceal a thing? For Heaven's sake! . . .

This knight that I am telling you about
Perceived at last he never would find out
What it could be that women loved the best.
Faint was the soul within his sorrowful breast
As home he went, he dared no longer stay;
His year was up and now it was the day.

As he rode home in a dejected mood,
Suddenly, at the margin of a wood,
He saw a dance upon the leafy floor
Of four and twenty ladies, nay, and more.
Eagerly he approached, in hope to learn
Some words of wisdom ere he should return;
But lo! Before he came to where they were,
Dancers and dance all vanished into air!
There wasn't a living creature to be seen
Save on old woman crouched upon the green.
A fouler-looking creature I suppose
Could scarcely be imagined. She arose
And said, "Sir knight, there's no way on from here.
Tell me what you are looking for, my dear,
For peradventure that were best for you;
We old, old women know a thing or two."

"Dear mother," said the knight, "alack the day!
I am as good as dead if I can't say
What thing it is that women most desire;
If you could tell me I would pay your hire."
"Give me your hand," she said, "and swear to do
Whatever I shall next require of you
—If so to do should lie within your might—
And you shall know the answer before night."
"Upon my honor," he answered, "I agree."
"Then," said the crone, "I dare to guarantee
Your life is safe; I shall make good my claim.
Upon my life the queen will say the same.
Show me the very proudest of them all
In costly coverchief or jeweled caul
That dare say no to what I have to teach.
Let us go forward without further speech."
And then she crooned her gospel in his ear
And told him to be glad and not to fear.

> "My liege and lady, in general," said he, "a woman wants the self-same sovereignty over her husband as over her lover, and master him; he must not be above her."
> —Geoffrey Chaucer

They came to court. This knight in full array,
Stood forth and said, "O Queen, I've kept my day
And kept my word and have my answer ready."

There sat the noble matrons and the heady
Young girls, and widows too, that have the grace
Of wisdom, all assembled in that place,
And there the queen herself was throned to hear
And judge his answer. Then the knight drew near
And silence was commanded through the hall.

The queen then bade the knight to tell them all
What thing it was that women wanted most.
He stood not silent like a beast or post,
But gave his answer with the ringing word
Of a man's voice and the assembly heard:

"My liege and lady, in general," said he,
"A woman wants the self-same sovereignty
Over her husband as over her lover,
And master him; he must not be above her.
That is your greatest wish, whether you kill
Or spare me; please yourself. I wait you will."
In all the court not one that shook her head
Or contradicted what the knight had said;
Maid, wife and widow cried, "He's saved his life!"

And on the word up started the old wife,
The one the knight saw sitting on the green,
And cried, "Your mercy, sovereign lady queen!
Before the court disperses, do me right!
'Twas I who taught this answer to the knight,
For which he swore and pledged his honor to it,
That the first thing I asked of him he'd do it,
So far as it should lie within his might.
Before this court I ask you then, sir knight,
To keep your word and take me for your wife;
For well you know that I have saved your life.
If this be false, deny it on your sword!"

"Alas!" he said, "Old lady, by the Lord
I know indeed that such was my behest,
But for God's love think of a new request,
Take all my goods, but leave my body free."
"A curse on us," she said, "if I agree!
I may be foul, I may be poor and old,
Yet will not choose to be, for all the gold
That's bedded in the earth or lies above,
Less than your wife, nay, than your very love!"

"My love?" said he. "By Heaven, my damnation!
Alas that any of my race and station
Should ever make so foul a misalliance!"
Yet in the end his pleading and defiance
All went for nothing, he was forced to wed.
He takes his ancient wife and goes to bed. . . .

Great was the anguish churning in his head
When he and she were piloted to bed;
He wallowed back and forth in desperate style.
His ancient wife lay smiling all the while;
At last she said "Bless us! Is this, my dear,
How knights and wives get on together here?
Are these the laws of good King Arthur's house?
I am your own beloved and your wife,

And I am she, indeed, that saved your life;
And certainly I never did you wrong.
Then why, this first of nights, so sad a song?
You're carrying on as if you were half-witted!
Say, for God's love, what sin have I committed?
I'll put things right if you will tell me how."

 "Put right?" he cried. "That never can be now!
Nothing can ever be put right again!
You're old, and so abominably plain,
So poor to start with, so low-bred to follow;
It's little wonder if I twist and wallow!
God, that my heart would burst within my breast!"
"Is that," said she, "the cause of your unrest?"
"Yes, certainly," he said, "and can you wonder?"

 "I could set right what you suppose a blunder,
That's if I cared to in a day or two,
If I were shown more courtesy by you.
Just now," she said, "you spoke of gentle birth,
Such as descends from ancient wealth and worth.
If that's the claim you make for gentlemen
Such arrogance is hardly worth a hen.
Whoever loves to work for virtuous ends,
Public and private, and who most intends
To do what deeds of gentleness he can,
Take him to be the greatest gentleman.
Christ wills we take our gentleness from Him,
Not from a wealth of ancestry long dim,
Though they bequeath their whole establishment
By which we claim to be of high descent.
Our fathers cannot make us a bequest
Of all those virtues that became them best
And earned for them the name of gentleman,
But bade us follow them as best we can. . . .

 "But gentleness, as you will recognize,
Is not annexed in nature to possessions,
Men fail in living up to their professions;
But fire never ceases to be fire.
God knows you'll often find, if you inquire,
Some lording full of villainy and shame.
If you would be esteemed for the mere name
Of having been by birth a gentleman
And stemming from some virtuous, noble clan,
And do not live yourself by gentle deed
Or take your fathers' noble code and creed,
You are no gentleman, though duke or earl.
Vice and bad manners are what make a churl.

 "Gentility is only the renown
For bounty that your fathers handed down,
Quite foreign to your person, not your own;

Gentility must come from God alone.
That we are gentle comes to us by grace
And by no means is it bequeathed with place. . . .

　　　　"As for my poverty which you reprove,
Almighty God Himself in whom we move,
Believe and have our being, chose a life
Of poverty, and everyman or wife
Nay, every child can see our Heavenly King
Would never stoop to choose a shameful thing.
No shame in poverty if the heart is gay,
As Seneca and all the learned say.
He who accepts his poverty unhurt
I'd say is rich although he lacked a shirt.
But truly poor are they who whine and fret
And covet what they cannot hope to get.
And he that, having nothing, covets not,
Is rich, though you may think he is a sot. . . .

　　　　"Lastly you taxed me, sir, with being old.
Yet even if you never had been told
By ancient books, you gentlemen engage
Yourselves in honor to respect old age.
To call an old man 'father' shows good breeding,
And this could be supported from my reading.

　　　　"You say I'm old and fouler than a fen.
You need not fear to be a cuckold, then.
Filth and old age, I'm sure you will agree,
Are powerful wardens upon chastity.
Nevertheless, well knowing your delights,
I shall fulfil your worldly appetites.

　　　　"You have two choices; which one will you try?
To have me old and guly till I die,
But still a loyal, true and humble wife
That never will displease you all her life,
Or would you rather I were young and pretty
And chance your arm what happens in a city
Where friends will visit you because of me,
Yes, and in other places too, maybe.
Which would you have? The choice is all your own."

　　　　The knight though long, and with a piteous groan
At last he said, with all the care in life,
"My lady and my love, my dearest wife,
I leave the matter to your wise decision.
You make the choice yourself, for the provision
Of what may be agreeable and rich
In honor to us both, I don't care which;
Whatever pleases you suffices me."

"And have I won the mastery?" said she,
"Since I'm to choose and rule as I think fit?"
"Certainly, wife," he answered her, "that's it."
"Kiss me," she cried. "No quarrels! On my oath
And word of honor, you shall find me both,
that is, both fair and faithful as a wife;
May I go howling mad and take my life
Unless I prove to be as good and true
As ever wife was since the world was new!
And if tomorrow when the sun's above
I seem less fair than any lady-love,
than any queen or empress east or west,
Do with my life and death as you think best.
Cast up the curtain, husband. Look at me!"

And when indeed the knight had looked to see,
Lo, she was young and lovely, rich in charms.
In ecstasy he caught her in his arms,
His heart went bathing in a bath of blisses
And melted in a hundred thousand kisses,
And she responded in the fullest measure
With all that could delight or give him pleasure.

So they lived ever after to the end
In perfect bliss; and may Christ Jesus send
Us husbands meek and young and fresh in bed,
And grace to overbid them when we wed.
And—Jesu hear my prayer!—cut short the lives
Of those who won't be governed by their wives;
And all old, angry niggards of their pence,
God send them soon a very pestilence!

Consider This:

- What are some of the answers that the knight uncovered in trying to find the solution to the question, "What is the thing that women most desire?" What answer did he settle on and why? Do you think that this remains the proper answer?

- The concept of justice is at issue in this tale. Do you think that the judgment of the Queen was an effective punishment that fit the crime? Why wasn't justice swift and absolute? Why does it carry an instructive dimension in the case of the knight? What did he learn?

- What is the theme of this tale and how does that differ from the moral? What was Chaucer's purpose in writing *The Canterbury Tales*?

The Medieval Woman

Throughout most of the Middle Ages, women were portrayed in a negative light, completely subservient to men, as temptresses to the will of God, banished from the halls of government and the fields of battle, and confined to the bed and nursery. But the 12th century saw a renaissance of sorts in the position of women. The popularity of the Virgin Mary soared as cathedrals were dedicated in her name. Women such as Eleanor of Aquitaine, the empress Matilda, Blanche of

Castile, and Marie de France assumed an unprecedented influence in the affairs of state. This resurgence did not continue much beyond the century, but important precedents had been set.

The following selection is from the Summa Theologica *of Saint Thomas Aquinas. Although he subscribed to the rigid Aristotelian concept of woman as the "misbegotten male," and thus reflected the church's conservatism, he also was willing to concede a certain dignity (albeit minor) regarding woman's creation.*

Whether Woman Was Fittingly Made from the Rib of Man?
SAINT THOMAS AQUINAS

Objection 1: It would seem that woman should not have been formed from the rib of man. For the rib was much smaller than the woman's body. Now from a smaller thing a larger thing can be made only, either by addition . . . or by [thinning out], because, as Augustine says: A body cannot increase in bulk except by [thinning out]. But the woman's body is not [thinner] than man's, at least not in the proportion of a rib to Eve's body. Therefore Eve was not formed from a rib of Adam.

Objection 2: Further, in those things which were first created there was nothing superfluous. Therefore a rib of Adam belonged to the integrity of his body. So if a rib was removed, his body remained imperfect; which is unreasonable to suppose.

Objection 3: Further, a rib cannot be removed from man without pain. But there was no pain before sin. Therefore, it was not right for a rib to be taken from the man, that Eve might be made from it. On the contrary, it is written (Genesis, 2.22): God built the rib, which He took from Adam, into a woman.

I answer that: It was right for the woman to be made from a rib of man. First, to signify the social union of man and woman, for the woman should neither use authority over man, and so she was not made from his head; nor was it right for her to be subject to man's contempt as his slave, and so she was not made from his feet. [She was made from the rib of man by Divine Power], for the sacramental signification; for from the side of Christ sleeping on the Cross the Sacraments flowed—namely blood and water—on which the Church was established.

Consider This:
- According to this reading, how did Saint Thomas Aquinas view women? Is his logic regarding the creation of women impeccable? In what ways does he evince a conservative and rather typical medieval view of woman, and in what ways is he more liberal in his attitude?

The Tragedy of Abelard and Heloise

The great logician, teacher, and scholar Peter Abelard (Sic et Non) *became legendary for his tragic love affair with a student named Heloise. He had attained an enviable yet controversial reputation among scholars and churchmen. But his life changed drastically when he met Heloise and the two fell passionately in love. Abelard relates the saga in his autobiography,* A Story of Calamities.

"Whether Woman Was Fittingly Made from the Rib of Man?" is from *The Fathers of the English Dominican Province, The Summa Theologica of St. Thomas Aquinas* (London: Burns, Oates & Washbourne, 1920), Part 1, Question 92.

"The Tragedy of Abelard and Heloise" is from Betty Radice, trans., *The Letters of Abelard and Heloise* (Baltimore, Md., and Harmondsworth, Middlesex: Penguin Books, 1974), pp. 66–68, 75–76. Copyright © 1974 by Betty Radice. Reprinted by permission of Penguin Books, Ltd.

There was in Paris at the time a young girl named Heloise, the niece of Fulbert, one of the canons, and so much loved by him that he had done everything in his power to advance her education in letters. In looks she did not rank lowest, while in the extent of her learning she stood supreme. A gift for letters is so rare in women that it added greatly to her charm and had won her renown throughout the realm. I considered all the usual attractions for a lover and decided she was the one to bring to my bed, confident that I should have an easy success; for at that time I had youth and exceptional good looks as well as my great reputation to recommend me, and feared no rebuff from any woman I might choose to honor with my love. Knowing the girl's knowledge and love of letters I thought she would be all the more ready to consent, and that even when separated we could enjoy each other's presence by exchange of written messages in which we could speak more openly than in person, and so need never lack the pleasures of conversation.

All on fire with desire for this girl I sought an opportunity of getting to know her through private daily meetings and so more easily winning her over; and with this end in view I came to an arrangement with her uncle, with the help of some of his friends, whereby he should take me into his house, which was very near my school, for whatever sum he liked to ask. As a pretext I said that my household cares were hindering my studies and the expense was more than I could afford. Fulbert dearly loved money, and was moreover always ambitious to further his niece's education in letters, two weaknesses which made it easy for me to gain his consent and obtain my desire: he was all eagerness for my money and confident that his niece would profit from my teaching. This led him to make an urgent request which furthered my love and fell in with my wishes more than I had dared to hope; he gave me complete charge over the girl, so that I could devote all the leisure time left me by my school to teaching her by day and night, and if I found her idle I was to punish her severely. I was amazed by his simplicity—if he had entrusted a tender lamb to a ravening wolf it would not have surprised me more. . . .

Need I say more? We were united, first under one roof, then in heart; and so with our lessons as a pretext we abandoned ourselves entirely to love. Her studies allowed us to withdraw in private, as love desired, and then with our books open before us, more words of love than of our reading passed between us, and more kissing than teaching. My hands strayed oftener to her bosom than to the pages; love drew our eyes to look on each other more than reading kept them on our texts. . . . In short, our desires left no stage of love-making untried, and if love could devise something new, we welcomed it. We entered on each joy the more eagerly for our previous inexperience, and were the less easily stated.

Now the more I was taken up with these pleasures, the less time I could give to philosophy and the less attention I paid to my school. It was utterly boring for me to have to go to the school, and equally wearisome to remain there and to spend my days on study when my nights were sleepless with love-making. As my interest and concentration flagged, my lectures lacked all inspiration and were merely repetitive; I could do no more than repeat what had been said long ago, and when inspiration did come to me, it was for writing love-songs, not the secrets of philosophy. . . .

> "Need I say more? We were united, first under one roof, then in heart; and so with our lessons as a pretext, we abandoned ourselves entirely to love."
>
> —Peter Abelard

[After several months had passed, Heloise's uncle found out about her affair with Abelard. He separated the lovers, but they continued to meet and Heloise became pregnant. Abelard secretly married her and arranged that she remain in a convent for safety after the baby was born. Abelard continues the story:]

At this news her uncle and his friends and relatives imagined that I had tricked them, and had found an easy way of ridding myself of Heloise by making her a nun. Wild with indignation they plotted against me, and one night as I slept peacefully in an inner room in my lodgings, they bribed one of my servants to admit them and there took cruel vengeance on me of such appalling barbarity as to shock the whole world; they cut off the parts of my body whereby I had committed the wrong of which they complained. Then they fled, but the two who could be caught were blinded and mutilated as I had been, one of them being the servant who had been led by greed while in my service to betray his master.

Next morning the whole city gathered before my house, and the scene of horror and amazement, mingled with lamentations, cries and groans which exasperated and distressed me, is difficult, no, impossible, to describe. In particular, the clerks and, most of all, my pupils tormented me with their unbearable weeping and wailing until I suffered more from their sympathy than from the pain of my wound, and felt the misery of my mutilation less than my shame and humiliation. All sorts of thoughts filled my mind—how brightly my reputation had shone, and now how easily in an evil moment it had been dimmed or rather completely blotted out; how just a judgment of God had struck me in the parts of my body

> "How could I show my face in public, to be pointed at by every finger, derided by every tongue, a monstrous spectacle to all I met?"
>
> —Peter Abelard

with which I had sinned. . . . What road could I take now? How could I show my face in public, to be pointed at by every finger, derided by every tongue, a monstrous spectacle to all I met? . . .

I admit that it was shame and confusion in my remorse and misery rather than any devout wish for conversion which brought me to seek shelter in a monastery cloister. Heloise had already agreed to take the veil in obedience to my wishes and entered a convent. So we both put on the religious habit, I in the Abbey of St. Denis, and she in the Convent of Argenteuil which I spoke of before. There were many people, I remember, who in pity for her youth tried to dissuade her from submitting to the yoke of monastic rule as a penance too hard to bear, but all in vain; she broke out as best she could through her tears and sobs into Cornelia's famous lament:

> O noble husband,
> Too great for me to wed, was it my fate
> To bend that lofty head? What prompted me
> To marry you and bring about your fall?
> Now claim your due, and see me gladly pay. . . .

[Although they never saw one another again, Abelard and Heloise continued to correspond for years. Some letters discussed academic and spiritual subjects, while others reflected on their tragic love. Through it all, the letters reveal that the couple overcame self-pity and found acceptance of a changed, but everlasting, relationship.]

Consider This:

- Why was the love between Abelard and Heloise so tragic? It is interesting that both Abelard and Heloise retreated to monastic orders after their crisis. Why do you think they did this? What does this action say about the medieval church?

Chivalric Ideals: The Function of Knighthood
JOHN OF SALISBURY

The High Middle Ages saw the transition from a rather crude and barbaric nobility to one controlled by ideals of right action and proper conduct. Knights were expected to comport themselves with dignity and spiritual devotion, especially in the presence of ladies. Knighthood became a rigorous trial, and tales of the "quest" for the Holy Grail or the mystical unicorn became popular. The following account of John of Salisbury presents the ideal of knighthood.

The chivalric ideal of the High Middle Ages enhanced the position of women in medieval society. With the popularity of the Virgin Mary in the 12th and 13th centuries, women were viewed less as temptresses who encouraged sinful thoughts and acts and more as respected individuals, worthy of love and adoration. Knights fought for the honor of their Lady, whom they set on a pedestal and worshiped from afar.

But what is the office of the duly ordained soldiery? To defend the Church, to assail infidelity, to venerate the priesthood, to protect the poor from injuries, to pacify the province, to pour out their blood for their brothers (as the formula of their oath instructs them), and, if need be, to lay down their lives. The praises of God are in their throat, and two-edged swords are in their hands to execute punishment on the nations and rebuke upon the peoples, and to bind their kings in chains and their nobles in links of iron. But to what end? To the end that they may serve madness, vanity, avarice, or their own private self-will? By no means. Rather to the end that they may execute the judgment that is committed to them to execute; wherein each follows not his own will but the deliberate decision of God, the angels, and men, in accordance with equity and the public utility. . . . For soldiers that do these things are "saints," and are the more loyal to their prince in proportion as they more zealously keep the faith of God; and they advance the more successfully the honor of their own valor as they seek the more faithfully in all things the glory of their God.

Consider This:
- Explain the concept of chivalry. What were the most important functions of knighthood? Why was it important to provide an ideal for knights?

The Minds of Women: "Freer and Sharper"
CHRISTINE DE PIZAN

Christine de Pizan (1364–ca. 1430) was born of a Venetian father who served as an astrologer to the French court. Christine married a court secretary, but her identity as an Italian in a French world marginalized her social status, especially after the death of her husband in 1389. Well-educated and independent of mind, Christine wrote The Book of the City of Ladies *as a rebuttal against the misogynistic argument that women, because of the corruption initiated by Eve in the Garden of Eden, were temptresses and inherently inferior to men in ability and worth. Christine's answer to this attack assumed that women shared the goodness of God and*

"Chivalric Ideals: The Function of Knighthood" is from Frederick Ogg, ed., *A Source Book of Medieval History* (New York: American Book Company, 1907), p. 401.

"The Minds of Women" is from Christine de Pizan, *The Book of the City of Ladies*, 1.27, trans. Earl Jeffrey Richards (New York: Persea Books, 1982), pp. 38–39. Copyright © 1982 by Persea Books, Inc. Reprinted by permission of Persea Books, Inc.

that although weaker physically, they were certainly intellectually equal to men, if given the proper education and opportunities. This argument is decidedly contemporary as we still seek to find equity between men and women under law and in the marketplace.

The following excerpt is a conversation between Christine and "Lady Reason" concerning the ability and worth of the female mind. This was an extraordinary argument at the time that shifted the status of women from a dependence on chivalric notions of male protection to independent worth.

After hearing these things, I replied to the lady who spoke infallibly: "My lady, truly has God revealed great wonders in the strength of these women whom you describe. But please enlighten me again, whether it has ever pleased this God, who has bestowed so many favors on women, to honor the feminine sex with the privilege of the virtue of high understanding and great learning, and whether women ever have a clever enough mind for this. I wish very much to know this because men maintain that the mind of women can learn only a little."

She answered, "My daughter, since I told you before, you know quite well that the opposite of their opinion is true, and to show you this even more clearly, I will give you proof through examples. I tell you again—and don't doubt the contrary—if it were customary to send daughters to school like sons, and if they were then taught the natural sciences, they would learn as thoroughly and understand the subtleties of all the arts and sciences as well as sons. And by chance there happen to be such women, for, as I touched on before, just as women have more delicate bodies than men, weaker and less able to perform many tasks, so do they have minds that are freer and sharper whenever they apply themselves."

"My lady, what are you saying? With all due respect, could you dwell longer on this point, please. Certainly men would never admit this answer is true, unless it is explained more plainly, for they believe that one normally sees that men know more than women do."

She answered, "Do you know why women know less?"

"Not unless you tell me, my lady."

"Without the slightest doubt, it is because women are not involved in many different things, but stay at home, where it is enough for them to run the household, and there is nothing which so instructs a reasonable creature as the exercise and experience of many different things."

"My lady, since they have minds skilled in conceptualizing and learning, just like men, why don't women learn more?"

She replied, "Because, my daughter, the public does not require them to get involved in the affairs which men are commissioned to execute, just as I told you before. It is enough for women to perform the usual duties to

> "There is no doubt that Nature provided women with the qualities of body and mind found in the wisest and most learned men."
> —Christine de Pizan

which they are ordained. As for judging from experience, since one sees that women usually know less than men, that therefore their capacity for understanding is less, look at men who farm the flatlands or who live in the mountains. You will find that in many countries they seem completely savage because they are so simple-minded. All the same, there is no doubt that Nature provided them with the qualities of body and mind found in the wisest and most learned men. All of this stems from a failure to learn, though, just as I told you, among men and women, some possess better minds than others. . . ."

Consider This:

- Christine poses the question whether women have a "clever enough mind for higher understanding and great learning" as do men. What is the proof she offers in the affirmative? Is this a strong argument?

Compare and Contrast:

- In the selection entitled "Visions of Ecstasy" on page 198 written about 1140, the visionary Hildegard of Bingen recounted the voice of God: "O you who are wretched earth and, as a woman, untaught in all learning of earthly teachers and unable to read literature with philosophical understanding, you nonetheless are touched by My light." Thus, in spite of Hildegard's limitations as an ignorant woman, God still offered His light to her. God went on to note that "because of Eve's transgression you [Hildegard] are trodden on by the masculine sex." How would Christine de Pizan have responded to these ideas? Had the conception of woman as transgressor, as limited and restricted, changed by 1405 when Christine wrote *The Book of the City of Ladies?*

PART THREE

Transitions to the Modern World (1400–1650)

6

The Age of the Renaissance

Death of
Dante 1321

Hundred Years'
War 1337–1453

Columbus' first
voyage to the
New World 1492

Michelangelo's
David completed
1504

Luther posts
95 Theses
1517

Henry VIII's
Act of Supremacy
1534

Jesuit order
formed by
Ignatius
Loyola 1540

1300 1350 1400 1450 1500 1550

Papacy moved
to Avignon
1309–1377

Great Schism
of the Church
1378–1417

Medici rule
established in
Florence 1434

Movable type
printing press
1450

Rule of Lorenzo
d'Medici in
Florence
1478–1492

Florentine
Republic
1498–1512

Cortes defeats
Aztec forces in
Mexico 1519–1521

Calvin active
in Geneva
1536

Learning is the only thing the mind never exhausts, never fears and never regrets.

—Leonardo da Vinci

Apart from man, no being wonders at his own existence.

—Arthur Schopenhauer

Man is the measure of all things.

—Protagoras

Man—a creature made at the end of the week's work when God was tired.

—Mark Twain

CHAPTER THEMES

- *The Power Structure:* How did the Medici family control Florence? Was their influence based on their "power" or on their "authority"? How could this be compared to the rule of the Roman emperor Augustus?

- *Women in History and the Humanities:* The Renaissance was a period in which conventional social, religious, and political structures were being challenged. Did women benefit from this new climate?

- *The Institution and the Individual:* What were the fundamental tenets of humanism, and why were they considered radical, especially to the church? How did the demand for religious orthodoxy restrict personal artistic expression?

- *Revolution and Transition:* The Renaissance has been seen as a period of transition between the "static" Middle Ages and the "vibrant" modern world. Is this a reasonable interpretation? How was progress measured during the Renaissance, and what drawbacks were evident? What debt does our contemporary world owe to the Renaissance?

- *The Big Picture:* Why was the Renaissance period so creative? Is artistic and cultural creativity best served by political and religious stability, or does the progress of civilization depend on the energy that chaos promotes?

The Humanist Movement

The term renaissance *means "rebirth"; it was coined by scholars in the 15th and 16th centuries who felt a new inspiration. They viewed the medieval world as one of mindless chanting and uncreative introspection. According to Renaissance thinkers, the preceding centuries were "Middle Ages" between the brilliance of the ancient Greeks and Romans and the reflection of that light in the culture of 15th-century Italy. The Middle Ages, therefore, became synonymous with the "Dark Ages." For the scholars of the Renaissance, the hope of Western Civilization lay in a cultivation of the classical works of antiquity. The masters of thought and erudition were figures like Cicero, Aristotle, Plato, Virgil, and Thucydides. They became models and authorities for argument, insight, and eloquence. No longer was it enough to be able to read Cicero: one was now expected to imitate his Latin style. A cult of the classics developed as people admired the ancient monuments of Roman civilization and sought copies of the ancient texts. The Renaissance movement was primarily a scholarly pursuit of the ideals and values of classical civilization.*

Chief among those values was the emphasis on human beings; this led to the movement known as humanism. The Renaissance emphasized the most positive aspects of humanity. Rational thought and creative instinct were prized. Human beings possessed a dual nature: the brutal force of the animal and some of the divine qualities of God. Most important, they had the free will to pursue their own path. The course of life was determined not by God, but by personal ambition, talent, or deceit. The glory of humanity was portrayed in the poetry and astoundingly rich art of the period. The names of Leonardo, Raphael, and Michelangelo evoke mastery of technique and perfection of style. But perhaps the most transparent assessment of reality was made by Niccolò Machiavelli. For him, power and control were the watchwords of existence. This was man, stripped of his embellishment and conscious of the political realities of life. The Prince was Machiavelli's manual on practical survival in a chaotic age. Glory could also be attained by strong, competent rule.

Machiavelli made people aware of the realities of power politics, and in doing so he was fulfilling a need in society. For Italy was not a united kingdom, but rather a disjointed chaotic grouping of

city-states, led variously by despots, oligarchs, and republicans. It is a curious paradox that societal chaos seems to breed creativity; Michelangelo painted the Sistine Chapel while Rome was in peril of being taken by French armies. The relationship between chaos and creativity is a question worth pursuing for it precedes discussion of a wider issue: the progress of civilization. Why was the Renaissance such a creative period, artistically, technologically, and politically? Is creativity truly an ingredient of progress, or is the progress of civilization best served by solid administration and continuity, as we found during the height of the Roman Empire? This chapter will investigate some of the ideas and attitudes that influenced European Renaissance society and beyond.

A Humanist Education

LEONARDO BRUNI

An important exponent of the humanist movement in the 15th century was the great luminary of the Italian Renaissance, Leonardo Bruni, who is most famous as one of the "civic humanists." These were scholars who not only devoted themselves to the classics but also felt a responsibility to be involved in their respective cities and states. Bruni himself served as chancellor of Florence. In the following selection, he offers his ideas about the importance of education in a letter to an aspiring young scholar.

Your recent letter gave me the greatest pleasure. For it demonstrated both the excellence of your spirit and your vigorous and intelligent schooling, the product of study and diligence. Considering your age and the penetration of that letter, it is clear to me that your maturity appears admirable and plainly beyond your years. Nor do I doubt, unless you should be untrue to yourself, that you will become a most distinguished man. Therefore, I beg you, take care, add a little every day and gather things in: remember that these studies promise you enormous prizes in both the conduct of your life and for the fame and glory of your name. These two, believe me, are the way to those ample riches which have never yet been lacking to famous and accomplished men, if only the will was present. You have an excellent teacher whose diligence and energy you should imitate. Devote yourself to two kinds of study. In the first place, acquire a knowledge of letters, not the common run of it, but the more searching and profound kind in which I very much want you to shine. Secondly, acquaint yourself with what pertains to life and manners—those things that are called humane studies because they are perfect and adorn man. In this kind of study your knowledge should be wide, varied, and taken from every sort of experience, leaving out nothing that might seem to contribute to the conduct of your life, to honor, and to fame. I shall advise you to read authors who can help you not only by their matter but also by the splendor of their style and their skill in writing; that is to say, the works of Cicero and of any who may possibly approach his level. If you will listen to me, you will thoroughly explore the fundamental and systematic treatment of those matters in Aristotle; as for beauty of expression, a rounded style, and all the wealth of words and speech, skill in these things you, if I may so put it, borrow from Cicero. For I would wish an outstanding man to be both abundantly learned and capable of giving elegant expression to his learning. However, no one can hope to achieve this without reading a lot, learning a lot, and taking a lot away from everywhere. Thus one must not only learn from the scholars (which is the foundation of all study) but must also get instruction from poets, orators and historians, so that one's style may become eloquent, elegant, and never crude in substance. . . . If you do obtain that excellence which I expect of you, what riches will compare with the rewards of these studies?

Oration on the Dignity of Man (1486)
PICO DELLA MIRANDOLA

Perhaps the supreme statement of the Renaissance idolization of man is an extended essay by Pico della Mirandola, a linguist and philosopher who lived from 1463 to 1494. Note Pico's conception of man's relationship to God in this excerpt from the Oration on the Dignity of Man.

At last it seems to me I have come to understand why man is the most fortunate of creatures and consequently worthy of all admiration and what precisely is that rank which is his lot in the universal chain of Being—a rank to be envied not only by brutes but even by the stars and by minds beyond this world. It is a matter past faith and a wondrous one. Why should it not be? For it is on this very account that man is rightly called and judged a great miracle and wonderful creature indeed. . . . God the Father, the supreme Architect, had already built this

> **"To Man it is granted to have whatever he chooses, to be whatever he wills."**
> **—Pico della Mirandola**

cosmic home we behold, the most sacred temple of His godhead, by the laws of His mysterious wisdom. The region above the heavens He had adorned with Intelligences, the heavenly spheres. He had quickened with eternal souls, and the . . . filthy parts of the lower world He had filled with a multitude of animals of every kind. But, when the work was finished, the Craftsman kept wishing that there were someone to ponder the plan of so great a work, to love its beauty, and to wonder at its vastness. Therefore, when everything was done. . . . He finally took thought concerning the creation of man. But there was not among His archetypes that from which He could fashion a new offspring, nor was there in His treasure houses anything which He might bestow on His new son as an inheritance, nor was there in the seats of all the world a place where the latter might

sit to contemplate the universe. All was now complete; all things had been assigned to the highest, the middle, and the lowest orders. But in its final creation it was not the part of the Father's power to fail as though exhausted. It was not the part of His wisdom to waver in a needful matter through poverty of counsel. It was not the part of His kindly love that he who was to praise God's divine generosity in regard to others should be compelled to condemn it in regard to himself. At last the best of artisans ordained that the creature to whom He had been able to give nothing proper to himself should have joint possession of what ever had been peculiar to each of the different kinds of being. He therefore took man as a creature of indeterminate nature and, assigning him a place in the middle of the world, addressed him thus: "The nature of all other beings is limited and constrained within the bounds of laws prescribed by Us. Thou, constrained by no limits, in accordance with thine own free will, in whose hand We have placed thee, shalt ordain for thyself the limits of thy nature. We have set thee at the world's center that thou mayest from thence more easily observe whatever is in the world. We have made thee neither of heaven nor of earth, neither mortal nor immortal, so that with freedom of choice and with honor, as though the maker and molder of thyself, thou mayest fashion thyself in whatever shape thou shalt prefer. Thou shalt have the power to degenerate into the lower forms of life, which are brutish. Thou shalt have the power, out of thy soul's judgment, to be reborn into the higher forms, which are divine." O supreme generosity of God the Father, O highest and most marvelous felicity of man! To him it is granted to have whatever he chooses, to be whatever he wills.

The Soul of Man (1474)

MARSILIO FICINO

The ideas of the Greek philosopher Plato were revived during the Renaissance by Neoplatonists who applied his theory on transmigration of the soul to Christian concepts of resurrection. The leading exponent of this philosophy was Marsilio Ficino, who in the following excerpt defines the relationship between God and his human creation.

Man is really the vicar of God, since he inhabits and cultivates all elements and is present on earth without being absent from the ether. He uses not only the elements, but also all the animals which belong to the elements, the animals of the earth, of the water, and of the air, for food, convenience, and pleasure, and the higher celestial beings for knowledge and the miracles of magic. Not only does he make use of the animals, he also rules them. It is true, with the weapons received from nature some animals may at times attack man or escape his control. But with the weapons he has invented himself man avoids the attacks of wild animals, puts them to flight and tames them. Who has ever seen any human beings kept under the control of animals, in such a way as we see everywhere herds of both wild and domesticated animals obeying men throughout their lives? Man not only rules the animals by force, he also governs, keeps and teaches them. Universal providence belongs to God, who is the universal cause. Hence man who provides generally for all things, both living and lifeless, is a kind of god. Certainly he is the god of the animals, for he makes use of them all, and instructs many of them. It is also obvious that he is the god of the elements for he inhabits and cultivates all of them. Finally, he is the god of all materials for he handles, changes and shapes all of them. He who governs the body in so many and so important ways, and is the vicar of the immortal God, he is no doubt immortal. . . .

Individual animals are hardly capable of taking care of themselves or their young. Man alone abounds in such a perfection that he first rules himself, something that no animals do,

> **"Man is a great miracle, a living creature worthy of reverence and adoration, for he transforms himself into God as if he were God himself."**
> **—Marsilio Ficino**

and thereafter rules the family, administers the state, governs nations and rules the whole world. . . .

We have shown that our soul in all its acts is trying with all its power to attain the first gift of God, that is, the possession of all truth and all goodness. Does it also seek His second attribute? Does not the soul try to become everything just as God is everything? It does in a wonderful way; for the soul lives the life of a plant when it serves the body in feeding it; the life of an animal, when it flatters the senses; the life of a man, when it deliberates through reason on human affairs; the life of the heroes, when it investigates natural things; . . . the life of the angels, when it enquires into the divine mysteries; the life of God, when it does everything for God's sake. Every man's soul experiences all these things in itself in some way, although souls do it in different ways, and thus the human species strives to become all things by living the lives of all things. . . . Man is a great miracle, a living creature worthy of reverence and adoration, for he . . . transforms himself into God as if he were God himself.

"The Soul of Man" is from Josephine L. Burroughs, trans., "Marsilio Ficino's Platonic Theology," *Journal of the History of Ideas* 5 (1944), pp. 234–236. Copyright © by The Journal of the History of Ideas, Inc. Reprinted by permission of The Johns Hopkins University Press.

Consider This:

- How would you define "humanism"? Give examples of its most important tenets from the many sources offered in the section entitled "The Humanist Movement." According to Pico della Mirandola, what is man's relationship to God?

- The humanists were criticized by the church for their secular interest at the expense of devotion to God. Do you agree with this criticism? Were the humanists disrespectful of God and irreligious? Note especially Marsilio Ficino on this point. In his opinion, what is man's position with respect to God?

The Artistic Vision

THE HUMAN INSIGHT OF DONATELLO

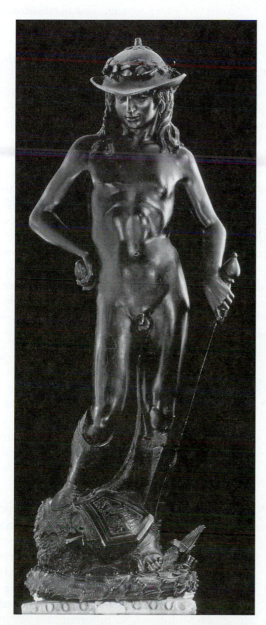

Figure 6–1 Donatello, *David* (SuperStock, Inc.).

Among the many great artists, architects, and sculptors of the Italian Renaissance, few have achieved the preeminence accorded to Donato di Niccolò di Betto Bardi, known to the world as Donatello (ca. 1386–1466). Possessed of a bold imagination and assertive independence, Donatello was known by his humanist friends to be a connoisseur of ancient art, even though he was not a cultural intellectual. His wide-ranging knowledge of classical subject matter and technique allowed him to transform ancient vision into a new and daring expression of human perfection and frailty. The two sculptures presented here, separated as they are by nearly 30 years, testify to Donatello's personal development in expressing the depth of the human spirit.

The full power of Donatello's humanist vision is revealed in his bronze David *(ca. 1430), the first large-scale, free-standing nude produced since antiquity. Commissioned by a private patron, this was not public art and would have shocked even refined Florentine sensibilities. The* David *captures that delicate, ambiguous moment in adolescence, an androgynous moment, when boys and girls can look alike, poised on the brink of sexual identity. There is a relaxed confidence in this statue, evinced in the gentle sway of the hips and the perfection of proportion. He is lost in a dreamy reverie, almost as if immersed in the contemplation of his own beauty. This is youth, a confident presence, as close as the 15th century comes to the celebration of beauty for its own sake.*

But the Donatello who produced the glorious David *about 1430 at age 44 was an old man nearly 30 years later in 1457 when he fashioned this wooden statue of Mary*

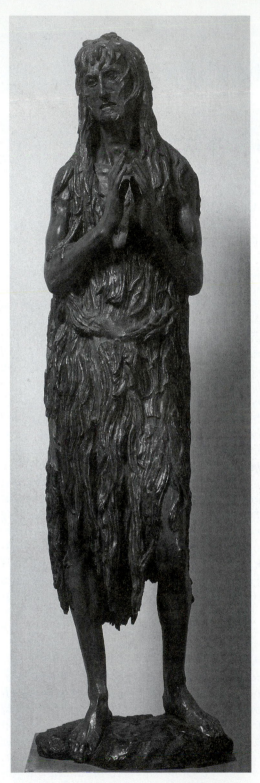

Figure 6–2 Donatello, *Saint Mary Magdalen* (SuperStock, Inc.).

Magdalen. Donatello, in fact, had passed through a crisis by 1456, a protracted illness that had prevented him from working for years. When he finally did produce, it was this humble statue that reflected his spiritual transformation and new insight into human desolation.

Carved in wood, this statue again must have shocked the Florentines, who had embraced a new generation of sculptors with their emphasis on the sensuous treatment of bronze and marble surfaces that Donatello had pioneered years earlier. The very subject matter inspires admiration—Mary Magdalen, the fallen woman whose open commitment to Jesus left her vulnerable to stinging reproach, but complete in spirit. After Jesus' death, she retreated into the wilderness and through ascetic denial, grew wild herself. We feel the oily locks of hair that clothe her body and enshrine her face, a face grotesque in its parted lips and single tooth. Here is the repentant sinner who in her youth possessed mere physical beauty; but now that her body has deteriorated, her inner beauty wells up through her eyes and shines with an astonishing clarity. Out of human desolation, she was transformed by spiritual penitence, and there was born a beauty of the spirit reflected in the delicacy of her hands as they touch in prayer. This statue of Mary Magdalen captures the redeeming value of hope—this woman whose sins were forgiven, as the Gospel says, "because she loved so much."

Compare and Contrast:

- How does Donatello's statue of David reflect Renaissance humanism? How does it differ in conception and presentation from Michelangelo's later statue of David? Would you regard them both as expressions of humanist ideals?

- Compare Donatello's *David* with his statue of Mary Magdalen produced nearly 30 years later in 1457. What values does the statue of Mary reflect? Are these values different from the humanist vision of the *David*? In what ways does Mary Magdalen redefine the nature of beauty? What does the creation of these two sculptures, so different and yet so alike, tell you about Donatello as an artist?

The Life of Florence

The Rule of Cosimo d'Medici

VESPASIANO

Florence was perhaps the city most representative of Renaissance activity and inspiration. This was the home of the statesman Leonardo Bruni, the sculptor Michelangelo, the political scientist Machiavelli, and the greatest literary figure of the age, Dante. But during this era, Florence truly belonged to one family—the Medici. They were led by Cosimo d'Medici, who developed the family's financial interests, and they eventually became the bankers of the papacy. Cosimo and his son Lorenzo (the Magnificent) wrote poetry, discussed philosophy, and heavily patronized the great artists of Florence. They were truly humanists in their own right. Although Florence was ostensibly a republic, it was in fact dominated by the Medici family. In their reign, they applied a valuable lesson of "controlled freedom" from the Roman emperor Augustus. In many ways Florence owed her greatness to their efforts. The portrait of Cosimo below is by the Renaissance biographer Vespasiano.

Cosimo di Giovanni dé Medici was of most honourable descent, a very prominent citizen and one of great weight in the republic. . . .

He had a knowledge of Latin which would scarcely have been looked for in one occupying the station of a leading citizen engrossed with affairs. He was grave in temperament, prone to associate with men of high station who disliked frivolity, and averse from all buffoons and actors and those who spent time unprofitably. He had a great liking for men of letters and sought their society. . . . His natural bent was to discuss matters of importance; and, although at this time the city was full of men of distinction, his worth was recognised on account of his praiseworthy qualities, and he began to find employment in affairs of every kind. By his twenty-fifth year he had gained great reputation in the city. . . . Cosimo and his party took every step to strengthen their own position. . . . Cosimo found that he must be careful to keep the support [of influential citizens] by temporising and making believe that [they would] enjoy power equal to his own. Meantime he kept concealed the source of his influence in the city as well as he could. . . .

I once heard Cosimo say that the great mistake of his life was that he did not begin to spend his wealth ten years earlier; because, knowing well the disposition of his fellow-citizens, he was sure that, in the lapse of fifty years, no memory would remain of his personality or of his house save the few fabrics he might have built. He went on, 'I know that after my death my children will be in worse case than those of any other Florentine who has died for many years past; moreover, I know I shall not wear the crown of laurel more than any other citizen.' He spoke like this because he knew the difficulty of ruling a state as he had ruled Florence, through the opposition of influential citizens who rated themselves his equals in former times. He acted privately with the greatest discretion in order to safeguard himself, and whenever he sought to attain an object he contrived to let it appear that the matter had been set in motion by some one other than himself and thus he escaped envy and unpopularity. His manner was admirable; he never spoke ill of anyone, and it angered him greatly to hear slander spoken by others. He was kind and patient to all who sought speech with him. He was more a man of deeds than of words—he always performed what he promised, and when this had been done he sent to let the petitioner know that his wishes had been granted. His replies were brief and sometimes obscure, so that they might be made to bear a double sense. . . .

So great was his knowledge of all things, that he could find some matter of discussion with men of all sorts, he would talk literature with a man of letters and theology with a theologian, being well versed therein through his natural liking, and for the reading of the Holy Scripture.

"The Rule of Cosimo d'Medici" is from Vespasiano da Bisticci, *Lives of Illustrious Men of the XV Century*, trans. W. George and E. Waters (London: Routledge and Kegan Paul, Ltd., 1926), pp. 213, 217, 222–224.

> "So great was Cosimo's knowledge of all things, that he could find some matter of discussion with men of all sorts . . ."
>
> —Vespasiano

With philosophy it was just the same. . . . He took kindly notice of all musicians, and delighted greatly in their art. He had dealings with painters and sculptors and had in his house works of diverse masters. He was especially inclined towards sculpture and showed great favour to all worthy craftsmen, being a good friend to Donatello and all sculptors and painters; and because in his time the sculptors found scanty employment, Cosimo, in order that Donatello's chisel might not be idle, commissioned him to make the pulpits of bronze in St. Lorenzo and the doors of the sacristy. He ordered the bank to pay every week enough money to Donatello for his work and for that of his four assistants. . . . He had a good knowledge of architecture, as may be seen from the buildings he left, none of which were built without consulting him; moreover, all those who were about to build would go to him for advice.

Precepts of Power:
"Everyone Sees What You Seem to Be, Few Perceive What You Are"
NICCOLÒ MACHIAVELLI

Over the centuries, the name of Machiavelli has become synonymous with evil. The adjective "Machiavellian" still evokes images of deceit and political backstabbing. Machiavelli's ideas were condemned by the church as immoral and inspired by Satan himself. In reality, Niccolò Machiavelli (1469–1527) was a loyal citizen of Florence who had been schooled in the classics and had chosen a career in public service. He disliked the rule of the Medici and was a great advocate of republicanism. In 1498, the restrictive theocracy of the Dominican friar, Giorlamo Savonarola, was replaced by a true republic, led by elected officials of the people. Machiavelli became ambassador to France, and this duty served as a laboratory for the science of politics where he could observe men and governments in action. The Florentine republic was successful until 1512, when a Spanish mercenary army defeated Machiavelli's personally trained Florentine militia. They reinstalled Medici rule, and Machiavelli was tortured on the rack and thrown into prison for a time. He retired to the country and wrote a little book entitled The Prince. *In it, Machiavelli gives the wisdom of his experience in politics. It is a manual of power: how to obtain it, maintain it, and lose it. In his analysis, Machiavelli is brutally realistic about the nature of human beings and the world of power politics: Learn the rules and you may survive and prosper. In the political chaos of Renaissance Italy, where alliances shifted frequently and distrust prevailed, such a guide proved useful and popular. Some of Machiavelli's most important ideas from* The Prince *are excerpted below.*

On Those Who Have Become Princes by Crime

It is to be noted that in taking a state its conqueror should weigh all the harmful things he must do and do them all at once so as not to have to repeat them every day, and in not repeating them to be able to make men feel secure and to win them over with the benefits he bestows upon them. Anyone who does otherwise, either out of timidity or because of poor advice, is always obliged to keep his knife in his hand; nor can he ever count upon his subjects, who, because of their fresh and continual injuries, cannot feel secure with him. Injuries, therefore,

"Precepts of Power" is from N. Machiavelli, *The Prince*, chapters 8, 17 and 18, from *The Portable Machiavelli*, edited and trans. Peter Bondanella and Mark Musa (New York: Viking Press, 1979), pp. 106–107, 131–136. Copyright © 1979 by Viking Penguin Inc. Reprinted by permission of Penguin Putnam, Inc.

should be inflicted all at the same time, for the less they are tasted, the less they offend; and benefits should be distributed a bit at a time in order that they may be savored fully. And a prince should, above all, live with his subjects in such a way that no unforseen event, either good or bad, may make him alter his course; for when emergencies arise in adverse conditions, you are not in time to resort to cruelty, and what good you do will help you little, since it will be judged a forced measure and you will earn from it no thanks whatsoever.

On Cruelty and Mercy

A prince must be cautious in believing and in acting, nor should he be afraid of his own shadow; and he should proceed in such a manner, tempered by prudence and humanity, so that too much trust may not render him imprudent nor too much distrust render him intolerable.

From this arises an argument: whether it is better to be loved than to be feared, or the contrary. I reply that one should like to be both one and the other; but since it is difficult to join them together, it is much safer to be feared than to be loved when one of the two must be lacking. For one can generally say that about men:

> "The Prince should avoid the property of others; for men forget more quickly the death of their father than the loss of their patrimony."
> —Niccolò Machiavelli

that they are ungrateful, fickle, simulators and deceivers, avoiders of danger, greedy for gain; and while you work for their good they are completely yours, offering you their blood, their property, their lives, and their sons, as I said earlier, when danger is far away; but when it comes nearer to you they turn away. And that prince who bases his power entirely on their words, finding himself stripped of other preparations, comes to ruin; for friendships that are acquired by a price and not by greatness and nobility of character are purchased but are not owned, and at the proper moment they cannot be spent. And men are less hesitant about harming someone who makes himself loved than one who makes himself feared because love is held together by a chain of obligation which, since men are a sorry lot, is broken on every occasion in which their own self-interest is concerned; but fear is held together by a dread of punishment which will never abandon you.

A prince must nevertheless make himself feared in such a manner that he will avoid hatred, even if he does not acquire love; since to be feared and not hated can very well be combined; and this will always be so when he keeps his hands off the property and the women of his citizens and his subjects. And if he must take someone's life, he should do so when there is proper justification and manifest cause; but, above all, he should avoid the property of others; for men forget more quickly the death of their father than the loss of their patrimony. Moreover, the reasons for seizing their property are never lacking; and he who begins to live by stealing always finds a reason for taking what belongs to others; on the contrary, reasons for taking a life are rarer and disappear sooner. . . . I conclude, therefore, returning to the problem of being feared and loved, that since men love at their own pleasure and fear at the pleasure of the prince, a wise prince should build his foundation upon that which belongs to him, and not upon that which belongs to others: he must strive only to avoid hatred, as has been said.

How a Prince Should Keep His Word

How praiseworthy it is for a prince to keep his word and to live by integrity and not by deceit everyone knows; nevertheless, one sees from the experience of our times that the princes who have accomplished great deeds are those who have cared little for keeping their promises and who have known how to manipulate the minds of men by shrewdness; and in the end they have surpassed those who laid their foundations upon honesty.

You must, therefore, know that there are two means of fighting: one according to the laws, the other with force; the first way is proper to man, the second to beasts; but because the first, in many cases, is not sufficient, it becomes necessary to have recourse to the second. Therefore, a prince must know how to use wisely the natures of the beast and the man. . . .

Since, then, a prince must know how to make good use of the nature of the beast, he should choose from among the beasts the fox and the lion; for the lion cannot defend itself from traps and the fox cannot protect itself from wolves. It is therefore necessary to be a fox in order to recognize the traps and a lion in order to frighten the wolves. Those who play only the part of the lion do not understand matters. A wise ruler, therefore, cannot and should not keep his word when such an observance of faith would be to his disadvantage and when the reasons which

> "Since men are a sorry lot and will not keep their promises to you, you likewise need not keep yours to them. A prince never lacks legitimate reasons to break his promises."
> —Niccolò Machiavelli

made him promise are removed. And if men were all good, this rule would not be good; but since men are a sorry lot and will not keep their promises to you, you likewise need not keep yours to them. A prince never lacks legitimate reasons to break his promises. Of this one could cite an endless number of modern examples to show how many pacts, how many promises have

been made null and void because of the infidelity of princes; and he who has known best how to use the fox has come to a better end. But it is necessary to know how to disguise this nature well and to be a great hypocrite and a liar: and men are so simpleminded and so controlled by their present necessities that one who deceives will always find another who will allow himself to be deceived. . . .

A prince, therefore, must be very careful never to let anything slip from his lips which is not full of the five qualities mentioned above: he should appear, upon seeing and hearing him, to be all mercy, all faithfulness, all integrity, all kindness, all religion. And there is nothing more necessary than to seem to possess this last quality. And men in general judge more by their eyes than their hands; for everyone can see but few can feel. Everyone sees what you seem to be, few perceive what you are, and those few do not dare to contradict the opinion of the many who have the majesty of the state to defend them; and in the actions of all men, and especially of princes, where there is no impartial arbiter, one must consider the final result. Let a prince therefore act to seize and to maintain the state; his methods will always be judged honorable and will be praised by all; for ordinary people are always deceived by

> "For ordinary people are always deceived by appearances and . . . in the world there is nothing but ordinary people."
> —Niccolò Machiavelli

appearances and by the outcome of a thing; and in the world there is nothing but ordinary people.

Consider This:

- Niccolò Machiavelli has been called "the disciple of the Devil." After reading the excerpts from *The Prince*, why do you think this view has prevailed? Is it better for a prince to be loved or feared? Why kill all enemies or potential enemies when you come into power through crime? Interpret the phrase "the ends justify the means."

- How does Machiavelli's view of human nature compare with that of other Renaissance humanists? Do you see Machiavelli as moral, immoral, or amoral? Why did he write *The Prince*?

The Cultural Intersection

CHINA: 1662

A Plan for the Prince

ZHANG TINGYU

The Chinese historian Zhang Tingyu (1610–1675) was the son of a high official during the Ming Dynasty. After his father died in prison at the hands of unscrupulous political toadies, he swore vengeance and brought them to justice at age eighteen. Upon the collapse of the Ming dynasty in 1644, Zhang led unsuccessful guerrilla operations against the new Manchu dynasty and then settled down at age 52 to write the history of the Ming. Perhaps his most impressive work, A Plan for the Prince, *analyzes political and economic weaknesses of 17th-century China.*

In many ways, Zhang's life parallels that of the Florentine political observer, Niccolò Machiavelli (1469–1527). They were both concerned with effective leadership in government, but argued from different perspectives.

Keep in Mind:
• Note Zhang Tingyu's Confucian emphasis on the importance of character in good government, both in the position of the Prince and in his ministers.

In ancient times, the people were considered hosts and the prince was the guest. All of his life the prince spent working for the sake of the people. Now the prince is host and the people are guests. Because of the prince, people can find peace and happiness nowhere. In order to achieve his ends, people must be harmed and killed and their families broken up—all for the aggrandizement of one man's fortune. Without feeling the least pity for mankind, the prince says: "I want only to establish this estate for the sake of my descendants." Yet when he has established it, the prince still wrings every drop of blood and marrow from the people and takes away their sons and daughters to serve his excessive pleasures. It seems entirely proper to him. It is, he says, the interest on his estate. Thus the greatest enemy of mankind is the prince and nothing but the prince.

If there had been no rulers, each man would have lived for himself and secured what was to his own benefit. Could it be that the institution of rulership was meant to work out like this? In ancient times men loved their prince, thought of him as a father, likened him to God; and truly this was no more than just. Now men hate their prince, think of him as a mortal foe, call him an "outcast" . . .

It is not easy to make plain the function of the prince, but any fool can see that a brief moment of excessive pleasure is not worth an eternity of sorrows.

The reason for ministership lies in the fact that the world is too big for one man to govern and that it is necessary to share the work with others. Therefore, when I come forth to serve, it is for the whole world and not for the prince; it is for all men and not for one family. . . .

But those who act as ministers today do not understand this concept. They say that a minister is created for the prince, that he rules only because the prince shares part of the world with him and delegates to him some leadership over the people. They look upon the world and its people as personal property in the prince's pouch. . . .

Whether there is peace or disorder in the world does not depend on the rise and fall of dynasties, but upon the happiness or distress of the people. . . .

The terms "prince" and "minister" derive their significance from service to mankind. If I have no sense of duty to mankind I am an alien to the prince. If I come to serve him without any consideration for the welfare of mankind, then I am merely the prince's menial servant. If, on the other hand, I have the people's interest at heart, then I am the prince's mentor and colleague. Only then may I really be called a minister.

Compare and Contrast:

- How did Zhang Tingyu's assessment of honorable character and the responsibilities of the Prince and his ministers contrast with Machiavelli's emphasis on gaining and maintaining power? Why is Zhang's argument so appealing?

- Do you think that Cosimo d'Medici's patronage of Florence would have been praised by Zhang? Is the patronage of artists or of a community generally an act of altruism? Was there a payoff for Cosimo? Was this good government for Florence or Machiavellian deceit?

Consider This:

- In 1796, a young Napoleon Bonaparte surveyed the political landscape three years before he came to power in France: "The nation must have a head, a head rendered illustrious by glory and not by theories of government, fine phrases, or the talk of idealists, of which the French understand not a whit. Let them have their toys and they will be satisfied. They will amuse themselves and allow themselves to be led, provided the goal is cleverly disguised." Were Machiavelli and Napoleon correct? Is politics a game to be played by "concealing intent" and "disguising goals" for the sole benefit of the Prince? Or must politicians adopt Zhang's attitude if the state is truly to serve the interests of the people?

The Broader Perspective:

- Must any ideal in the political world remain of secondary importance to the necessity of gaining and maintaining power? Apply this question to the issue of campaign finance reform in the United States.

- Has the nature of political power changed in our contemporary world or has technology simplified the "creation of belief" and thus made personal freedom even more difficult to maintain?

"As If Created by a Breath":
Ghiberti and the Competition for the Baptistry Doors
GIORGIO VASARI

Through the 16th century, Florence remained the artistic center of the Italian Renaissance. The workshops of its great masters like Andrea Verrocchio and Lorenzo Ghiberti served both as

"As If Created by a Breath" is from Giorgio Vasari, *The Lives of the Painters, Sculptors, and Architects* (New York: E. P. Dutton & Co., Inc., 1900), Vol. 1, pp. 241–243.

schools to promising apprentices and as manufacturing centers for the production of statuary and painting that embodied the humanist ideals of classical proportion and form. This art was not to be tucked away for private viewing, but rather displayed in the city as an expression of civic patriotism and pride. To walk through Florence around 1500 was to commune with an artistic spirit that linked creativity with civic virtue over many decades.

One of the greatest of early Renaissance sculptors was Lorenzo Ghiberti (1378–1455). Originally trained as a goldsmith, his sculpture achieved a technical perfection and lyrical balance that marked him among Florence's artistic elite. In 1403, he entered a contest to win the prestigious commission to create the bronze panels for the baptistry doors of Florence's cathedral, the Duomo. The competition for this commission was formidable and included the great architect Filippo Brunelleschi. As the Renaissance biographer Vasari describes in the following selection, the commissioners chose as a subject the story from Genesis of the sacrifice of Abraham's son, Isaac. Brunelleschi produced a powerful, excruciatingly intense scene where the angel of God prevented Abraham from sacrificing his son at the critical second by physically restraining his arm. Ghiberti's entry, by contrast, created the same tension, but also produced a less threatening interruption that emphasized Abraham's spiritual obedience to God. Ghiberti won the competition

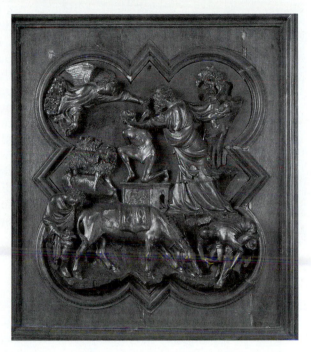

Figure 6–3 Filippo Burnelleschi, *The Sacrifice of Abraham* (Corbis Bettmann).

and from 1403 to 1424 produced 14 scenes in bronze panels of the life of Christ, the Apostles, and the church fathers. Ghiberti finished a second set of bronze doors for the bapistry that were called the "Gates of Paradise" by Michelangelo in admiration of the master.

It was arranged that all the masters considered to be the best in Italy should be invited to come to Florence to compete in making bronze panels [for the doors of San Giovanni]. . . . Many foreigners had already arrived and reported themselves to the consuls of the arts. From among them seven masters in all were selected: three Florentines, and the remainder Tuscans. A provision of money was set apart for them, and it was stipulated that within a year each of them should produce, as an example of his skill a sample bronze panel. It was determined that the scene represented should be the sacrifice of Isaac by Abraham, which was considered to be a good subject in which the masters could grapple with the difficulties of the art, because it comprises a landscape, figures both nude and draped, and animals, while the figures in the foreground might be made in full relief, those in the middle distance in half-relief, and those in the background in bas-relief. . . .

When the time arrived for it to be exhibited in the competition, his panel and those of the other masters were handed over to the art of the merchants to be adjudicated upon. When they came to be examined by the consuls and several other citizens many various opinions were expressed. Numbers of strangers had assembled in Florence, some painters, some sculptors, and some goldsmiths, who were invited by the consuls to come and judge the works in conjunction with others of the same professions who lived in Florence. . . .

Lorenzo's alone was perfect in every part, and it may still be seen in the audience chamber of the art of the merchants. The whole

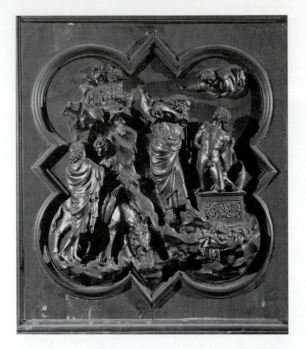

Figure 6–4 Lorenzo Ghiberti, *The Sacrifice of Abraham* (Art Resource, N.Y.).

scene was sell designed and the composition excellent, the figures being slender and graceful, the pose admirable and so beautifully finished that it did not look as if it had been cast and polished, but rather as if it had been created by a breath. The judges, when they perceived what diligence Lorenzo had devoted to his work, withdrew to one side and agreed that the work ought to be given to him, for it seemed to them that public and private interests would thus be best served, and as Lorenzo was a young man, not past twenty, he would be able to realize in the production of this work the great promise of his beautiful scene, which, according to their judgment, he had made more excellently than the others, adding that it would be shameful to dispute his right to preeminence than generous to admit. Accordingly, Lorenzo Ghiberti began on the door.

Compare and Contrast:

- Compare the two panels submitted by Brunelleschi and Ghiberti for the competition to cast the doors of the Baptistry in Florence. How were their conceptions of the sacrifice of Isaac different? Do you think Brunelleschi should have won the commission?

The Dome of Brunelleschi
GIORGIO VASARI

Filippo Brunelleschi (1377–1446) ranked supreme among Florence's architects. His was a robust personality—confident, innovative, and willing to risk all in creating new solutions to seemingly impossible challenges. His architectural emphasis on mathematics, proportion, and perspective drew glowing praise from his supporters and grudging admiration from his many critics. After losing the competition for the baptistry doors to Ghiberti in 1403, Brunelleschi in 1418 once again put himself on the line in another competition to construct the dome for Florence's cathedral, the Duomo. No architect seemed to be able to solve the many structural complexities of producing an enormous dome or cupola, over the altar that would not collapse of its own weight. In the following account, Vasari described how Brunelleschi won the competition. His cupola, which remains the most visible public assertion of Florentine brilliance, was praised by Michelangelo who used it as a model for his dome of Saint Peter's cathedral in Rome.

At length, in 1420, all these foreign masters and those of Tuscany were assembled at Florence with all the principal Florentine artists, and Filippo returned from Rome. They all met together . . . in the presence of the consuls and wardens and a chosen number of the ablest citizens, so that . . . the method of vaulting the open cupola. They sent for the architects one by one

"The Dome of Brunelleschi" is from Giorgio Vasari, *The Lives of the Painters, Sculptors, and Architects* (New York: E. P. Dutton & Co., Inc., 1900), Vol. 1, pp. 278–280.

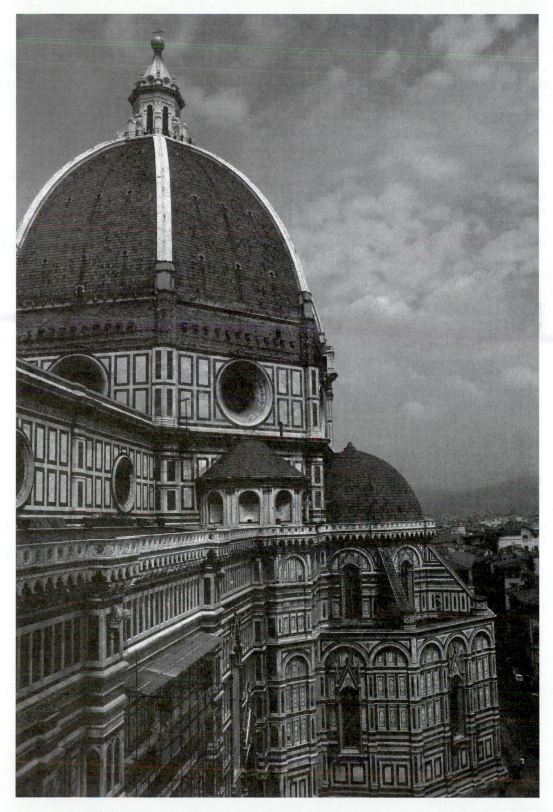

Figure 6—5 Filippo Brunelleschi, The Cupola of the Duomo (Perry M. Rogers)

and heard what they had to suggest. It was a remarkable thing to hear the curious and varied opinions upon the subject, for some said that they would build pillars from the ground level to bear arches to carry the beams which would support the weight; others thought it would be good to vault it with pumice stone, so that the weight might be lighter; and many agreed to make a pillar in the middle and construct it in the manner of a tent. . . . Filippo alone said that he could easily vault it without so many beams and pillars or earth, at less expense than would be involved by a quantity of arches, and without a framework. The consuls expected some flighty plan, and the wardens and all the citizens thought that Filippo had spoken like a madman, and they mocked him, telling him to speak of something else, as his plan was the device of a fool. . . .

But there were all routed by Filippo, and it is said that the dispute of the egg arose during these discussion. They wanted Filippo to declare his plan in detail, and to show his model as they had shown theirs, but he refused, and proposed to the masters assembled that whoever should make an egg stand upright on a flat marble surface should make the cupola, as this would be a test of their ability. He produced an egg and all the masters endeavored to make it stand, but no one succeeded. Then they passed it to Filippo, who lightly took it, broke the end with a blow on the marble and made it stand. All the artists cried out that they could have done as much themselves, but Filippo answered laughing that they would also know how to vault the cupola after they had seen his model and design. And so it was resolved that he should have the conduct of the work.

Consider This:

- Why did the Florentine's often demand competitions for an artistic commission? Can great art be judged as winner and loser? How did Brunelleschi win the competition for the cupola over the Duomo? How important is confidence and pure ego in achieving victory in such a competition? Was Bruelleschi's achievement equal to his boast?

Renaissance Arts and Manners

The Development of Art (1550)

GIORGIO VASARI

Giorgio Vasari was a talented painter, but he is best known for his biographies of Renaissance artists. In this selection, he sets his contemporary scene by comparing it artistically with past ages.

We find, then, that the art of sculpture was zealously cultivated by the Greeks, among whom many excellent sculptors appeared: Phidias, Praxiteles and Polycletus. . . . Painting was in like manner honoured, and those who practised it successfully were rewarded and among the ancient Greeks and Romans; this is proved by their according the rights of citizenship, and the most exalted dignities, to such as attained high distinction in these arts. . . .

I suggested above that the origin of these arts was Nature itself—the first image or model, the most beautiful fabric of the world—and the master, the divine light infused into us by special grace, and which has made us not only superior to all other animals, but has exalted us, if it be permitted so to speak, to the similitude of God Himself. . . .

But as fortune, when she has raised either persons or things to the summit of her wheel, very frequently casts them to the lowest point, whether in repentance or for her sport, so it chanced that, after these things, the barbarous nations of the world arose, in [different] places, in rebellion against the Romans. . . . There ensued, in no long time, not only the decline of that great empire, but the utter ruin of the whole and more especially of Rome herself, when all the best artists, sculptors, painters, and architects, were in like manner

"The Development of Art" is from Giorgio Vasari, *Lives of the Most Eminent Painters, Sculptors and Architects*, trans. J. Foster (London: H. G. Bohn, 1850), pp. 20–22.

totally ruined, being submerged and buried, together with the arts themselves, beneath the miserable slaughters and ruins of that much renowned city. . . .

> ## "But infinitely more ruinous than all other enemies to the arts above named, was the fervent zeal of the new Christian religion . . ."
> —Giorgio Vasari

But infinitely more ruinous than all other enemies to the arts above named, was the fervent zeal of the new Christian religion, which, after long and sanguinary combats, had finally overcome and annihilated the ancient creeds of the pagan world, by the frequency of miracles exhibited, and by the earnest sincerity of the means adopted; and ardently devoted, with all diligence, to the [elimination] of error, nay, to the removal of even the slightest temptation to heresy, it not only destroyed all the wondrous statues, paintings, sculptures, mosaics, and other ornaments of the false pagan deities, but at the same time extinguished the very memory, in casting down the honours, of numberless ex-

cellent ancients, to whom statues and other monuments had been erected, in public places, for their virtues, by the most virtuous times of antiquity. No, more than this, to build the churches of the Christian faith, this zeal not only destroyed the most renowned temples of the heathens, but, for the richer ornament of St. Peter's, and in addition to the many spoils previously bestowed on that building, the tomb of Adrian, now called the castle of St. Angelo, was deprived of its marble columns, to employ them for this church, many other buildings being in like manner despoiled, and which we now see wholly devastated. And although the Christian religion did not effect this from hatred to these works of art, but solely for the purpose of abasing and bringing into contempt the gods of the Gentiles, yet the result of this too ardent zeal did not fail to bring such total ruin over the noble arts, that their very form and existence was lost. . . .

The overwhelming flood of evils by which unhappy Italy had been submerged and devastated, had not only destroyed whatever could properly be called buildings, but, a still more deplorable consequence, had totally exterminated the artists themselves, when, by the will of God, in the year 1240, Giovanni Cimabue, of the noble family of that name, was born, in the city of Florence, to give the first light to the art of painting. . . .

Consider This:
- Why did Giorgio Vasari have such a low opinion of medieval art? What was wrong with it? Would you call him irreligious? Why or why not? Does his argument sound reasonable?

The Broader Perspective:
- Politically, the Renaissance in Italy was an insecure, chaotic period, with shifting alliances and numerous invasions. Amid all this disunity, an intense cultural creativity was reflected in the art and music of the period. Do you think that chaos is a prerequisite for creativity or at least a contributor to creative energy? Or are great art, literature, and music best fostered in an atmosphere of relative calm and security? Relate this question specifically to the Renaissance, but also give contemporary examples.

Against the Grain

I, Leonardo
The Notebooks of a Universal Man

LEONARDO DA VINCI

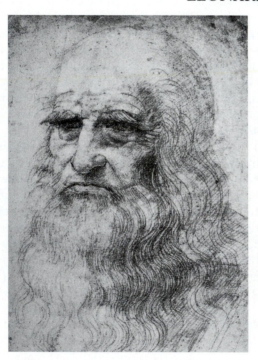

Figure 6–6 Leonardo Da Vinci, *Self-Portrait* (Corbis Bettmann).

The Renaissance produced several outstanding artists, scholars, and statesmen, but no one seemed to imprint this creative age as did Leonardo da Vinci (1452–1519). Leonardo was a painter of great talent. He was especially innovative in producing naturalistic backgrounds, in his perfection of the techniques of perspective and geometric arrangement of figures, and in the subtle treatment of light and shade. But Leonardo never really considered himself to be primarily a painter. His curiosity for the world around him was too great. He wanted to "learn the causes of things." Toward that end, he observed and made notes in a book for future reference and was constantly inventing machines that he believed would have military value; his sketches of helicopters, tanks, and submarines were far beyond the realities of his times. Leonardo's notebooks give fascinating insight into the workings of his fertile mind. Some of his comments on birds, flight, sketching, and painting are offered below.

Keep in Mind:
• Note Leonardo's methodical attention to detail on both scientific and artistic topics.

The Observation of Birds and Thoughts of Flight The thrushes and other small birds are able to make headway against the course of the wind, because they fly in spurts; that is they take a long course below the wind, by dropping in a slanting direction towards the ground, with their wings half closed, and they open the wings and catch the wind in them with their reverse movement, and so rise to a height; and then they drop again in the same way.

"The Notebooks of a Universal Man" is from Edward McCurdy, ed., *Leonardo Da Vinci Notebooks* (New York: Empire State Book Co., 1922), pp. 150–153, 188–189, 197–199.

Remember that your bird should have no other model than the bat, because its membranes serve as an armor or rather as a means of binding together the pieces of its armor, that is the framework of the wings.

And if you take as your pattern the wings of feathered birds, these are more powerful in structure of bone and sinew because they are penetrable, that is to say the feathers are separated from one another and the air passes through them. But the bat is aided by its membrane which binds the whole together and is not penetrated by the air. Dissect the bat, study it carefully, and on this model construct the machine. . . .

There is as much pressure exerted by a substance against the air as by the air against the substance. Observe how the beating of its wings against the air suffices to bear up the weight of the eagle in the highly rarefied air which borders on the fiery element! Observe also how the air moving over the sea, beaten back by the bellying sails, causes the heavily laden ship to glide onwards! So that by adducing and expounding the reasons of these things you may be able to realise that man when he has great wings attached to him, by exerting his strength against the resistance of the air and conquering it, is enabled to subdue it and to raise himself upon it.

The Importance of Sketching When you have thoroughly learnt perspective, and have fixed in your memory all the various parts and forms of things, you should often amuse yourself when you take a walk for recreation, in watching and taking note of the attitudes and actions of men as they talk and dispute, or laugh or come to blows one with another, both their actions and those of the bystanders who either intervene or stand looking on at these things; noting these down with rapid strokes in this way, in a little pocket-book, which you ought always to carry with you. And let this be tinted paper, so that it may not be rubbed out; but you should change the old for a new one, for these are not things to be rubbed out but preserved with the utmost diligence; for there is such an infinite number of forms and actions of things that the memory is incapable of preserving them, and therefore you should keep those [sketches] as your patterns and teachers.

The Way to Paint a Battle Show first the smoke of the artillery mingled in the air with the dust stirred up by the movement of the horses and of the combatants. . . . The smoke which is mingled with the dust-laden air will as it rises to a certain height have more and more the appearance of a dark cloud, at the summit of which the smoke will be more distinctly visible than the dust. The smoke will assume a bluish tinge, and the dust will keep its natural colour. From the side whence the light comes this mixture of air and smoke and dust will seem far brighter than on the opposite side.

As for the combatants, the more they are in the midst of this turmoil the less they will be visible, and the less will be the contrast between their lights and shadows. You should give a ruddy glow to the faces and the figures and the air around them, and to the gunners and those near to them, and this glow should grow fainter as it is further away from its cause. The figures which are between you and the light, if far away, will appear dark against a light background, and the nearer their limbs are to the ground the less will they be visible, for there the dust is greater and thicker. And if you make horses galloping away from the throng make little clouds of dust as far distant one from another as is the space between the strides made by the horse, and that cloud which is further away from the horse should be the least visible, for it should be high and spread out and thin, while that which is nearer should be more conspicuous and smaller and more compact.

Let the air be full of arrows going in various directions, some mounting upwards, other falling, others flying horizontally, and let the balls shot from the guns have a train of smoke following their course. Show the figures in the foreground covered with dust on their hair and eyebrows and such other level parts as afford the dust a space to lodge.

Make the conquerors running, with their hair and other things streaming in the wind, and with brows bent down; and they should be thrusting forward opposite limbs, that is, if a man advances the right foot the left arm should also come forward. If you represent any one fallen you should show the mark where he has been dragged through the dust, which has become changed to bloodstained mire, and round about in the half-liquid earth you should show the marks of the tramping of men and horses who have passed over it. Make a horse dragging the dead body of his master, and leaving behind him in the dust and mud the track of where the body was dragged along.

Make the beaten and conquered pallid, with brows raised and knit together, and let the skin above the brows be all full of lines of pain; at the sides of the nose show the furrows going in an arch from the nostrils and ending where the eye begins, and show the dilation of the nostrils which is the cause of these lines; and let the lips be arched displaying the upper row of teeth, and let the teeth be parted after the manner of such as cry in lamentation. Show some one using his hand as a shield for his terrified eyes, turning the palm of it towards the enemy, and having the other resting on the ground to support the weight of his body; let others be crying out with their mouths wide open, and fleeing away. Put all sorts of arms lying between the feet of the combatants, such as broken shields, lances, broken swords, and other things like these. Make the dead, some half buried in dust, others with the dust all mingled with the oozing blood and changing into crimson mud; and let the line of the blood be discerned by its colour, flowing in a sinuous stream from the corpse of the dust. Show others in the death agony grinding their teeth and rolling their eyes, with clenched fists grinding against their bodies, and with legs distorted . . . but see that there is no level spot of ground that is not trampled over with blood.

Consider This:

- Scientific discovery is often based on an inductive process where the observation of particular experiments in a laboratory leads to the formulation of a general scientific theory. In what ways do Leonardo's notebooks demonstrate this thought process?

- Leonardo's observations of birds and bats led him to conclude that when man "has great wings attached to him, by exerting his strength against the resistance of the air and conquering it, is enabled to subdue it and to raise himself upon it." In other words, human beings linked to a mechanical apparatus and powered by their own physical exertions could fly like birds. Where did Leonardo go wrong in his assumptions? Was this an error based on faulty observation, or was the error tied to Leonardo's confidence that humans could achieve their most fantastic technological dreams? Leonardo never solved the problem of human flight. Why? How necessary is failure in achieving success?

Linking the Humanities:

- Are you surprised that Leonardo used the same scientific process of observation in painting that he used in inventing? To what extent is a work of art, which may appear so natural and expressive of human emotion and reflection, a process of proportion and mathematical calculation?

Book of the Courtier (1518)
BALDASSARE CASTIGLIONE

With the growing emphasis on diplomacy and contact with ambassadors of other states during the Renaissance, rules of etiquette were established. The new age demanded that knights become gentlemen and that the relationship between the sexes be redefined. Baldassare Castiglione provided the instruction in his Book of the Courtier.

I wish, then, that this Courtier of ours should be nobly born and of gentle race; because it is far less unseemly for one of ignoble birth to fail in worthy deeds, than for one of noble birth, who, if he strays from the path of his predecessors, stains his family name, and not only fails to achieve but loses what has been achieved already; for noble birth is like a bright lamp that manifests and makes visible good and evil deeds, and kindles and stimulates to virtue both by fear of shame and by hope of praise. . . .

But to come to some details, I am of the opinion that the principal and true profession of the Courtier ought to be that of arms; which I would have him follow actively above all else, and be known among others as bold and strong, and loyal to whomsoever he serves. And he will win a reputation for these good qualities

> **"Let us be content . . . with perfect loyalty and unconquered courage, and that the courtier be always seen to possess them."**
> **—Baldassare Castiglione**

by exercising them at all times and in all places, since one may never fail in this without severest censure. And just as among women, their fair fame once sullied never recovers its first lustre, so the reputation of a gentleman who bears arms, if once it be in the least tarnished with cowardice or other disgrace, remains forever infamous before the world and full of ignominy. Therefore the more our Courtier excels in this art, the more he will be worthy of praise; and yet I do not deem essential in him that perfect knowledge of things and those other qualities that befit a commander; since this would be too wide a sea, let us be content, as we have said, with perfect loyalty and unconquered courage, and that he be always seen to possess them. . . .

Therefore let the man we are seeking, be very bold, stern, and always among the first, where the enemy are to be seen; and in every other place, gentle, modest, reserved, above all things avoiding ostentation and that impudent self-praise by which men ever excite hatred and disgust in all who bear them. . . .

Then coming to the bodily frame, I say it is enough if this be neither extremely short nor tall, for both of these conditions excite a certain contemptuous surprise, and men of either sort are gazed upon in much the same way that we gaze on monsters. Yet if we must offend in one of the two extremes, it is preferable to fall a little short of the just measure of height than to exceed it, for besides often being dull of intellect, men thus huge of body are also unfit for every exercise of agility, which thing I should much wish in the Courtier. And so I would have him well built and shapely of limb, and would have him show strength and lightness and suppleness, and know all bodily exercises that befit a man of war: I think the first should be to handle every sort of weapon well on foot and on horse, to understand the advantages of each, and especially to be familiar with those weapons that are ordinarily used among gentlemen; for besides the use of them in war, where such subtlety in contrivance is perhaps not needful, there frequently arise differences between one gentleman and another, which afterwards result in duels often fought with such weapons as happen at the moment to be within reach: thus knowledge of this kind is a very safe thing. . . .

It is fitting also to know how to swim, to leap, to run, to throw stones, for besides the use

"Book of the Courtier" is from Baldassare Castiglione, *Book of the Courtier*, trans. Leonard Opdycke (New York: Horace Liveright, 1903), pp. 22, 25–26, 28–31.

that may be made of this in war, a man often has occasion to show what he can do in such matters; whence good esteem is to be won, especially with the multitude, who must be taken into account withal. Another admirable exercise, and one very befitting a man at court, is the game of tennis, in which are well shown the disposition of the body, the quickness and

suppleness of every member, and all those qualities that are seen in nearly every other exercise. Nor less highly do I esteem vaulting on horse, which although it be fatiguing and difficult, makes a man very light and dexterous more than any other thing; and besides its utility, if this lightness is accompanied by grace, it is to my thinking a finer show than any of the others.

On the Nature and Purpose of Women and Men

BALDASSARE CASTIGLIONE

"Now you said that Nature's intention is always to produce the most perfect things, and therefore she would if possible always produce men, and that women are the result of some mistake or defect rather than of intention. But I can only say that I deny this completely. You cannot possible argue that Nature does not intend to produce the women without whom the human race cannot be preserved, which is something that Nature desires above everything else. For by means of the union of male and female, she produces children, who then return the benefits received in childhood by supporting their parents when they are old; then they renew them when they themselves have children. . . . In this way Nature, as if moving in a circle, fills out eternity and confers immortality on mortals. And since woman is as necessary to this process as man, I do not see how it can be that one is more the fruit of mere chance than the other. It is certainly true that Nature always intends to produce the most perfect things, and therefore always intends to produce the species man, though not male rather than female; and indeed, if Nature always produced males this would be imperfection: for just as there results from body and soul a composite nobler than its parts, namely man himself, so from the union of male and female there results a composite that preserves the human species, and without which its parts would perish. Thus male and female always go naturally together, and one cannot exist without the other. . . ."

Then signor Gaspare said: "I do not wish us to go into such subtleties because these ladies would not understand them; and

though I were to refute you with excellent arguments, they would still think that I was wrong, or pretend to at least; and they would

> "Woman does not receive her being from man, but rather perfects him just as she is perfected by him."
> —Baldassare Castiglione

at once give a verdict in their own favor. However, since we have made a beginning, I shall say only that, as you know, it is the opinion of very learned men that man is as the form and woman as the matter, and therefore just as form is more perfect than matter, and indeed it gives it its being, so man is far more perfect than woman. . . ."

The Magnifico Guiliano at once replied: "The poor creatures do not wish to become men in order to make themselves more perfect but to gain their freedom and shake off the tyranny that men have imposed on them by their one-sided authority. Besides, the analogy you give of matter and form is not always applicable; for woman is not perfected by man in the way that matter is perfected by form. . . . Woman does not receive her being from man but rather perfects him just as she is perfected by him, and thus both join together for the purpose of procreation which neither can ensure alone. Moreover, I shall attribute

"On the Nature and Purpose of Women and Men" is from Baldassare Castiglione, *Book of the Courtier*, trans. George Bull (Baltimore, Md., and Harmondsworth, Middlesex: Penguin Books, 1967), pp. 219–221. Copyright © 1967 by George Bull. Reprinted by permission of Penguin Books, Ltd.

woman's enduring love for the man with whom she has first been, and man's detestation for the first woman he possesses, . . . but to the resolution and constancy of women and the inconstancy of men. And for this, there are natural reasons: for because of its hot nature, the male sex possesses the qualities of lightness, movement and inconstancy, whereas from its coldness, the female sex derives its steadfast gravity and calm and is therefore more susceptible."

Consider This:

- What was a courtier, and what did Castiglione require of him? Why do you think Castiglione's book was so popular? What values of Renaissance society did it promote? According to Castiglione, what should be the relationship between women and men?

The Broader Perspective:

- In 1929, the British author Virginia Woolf commented in her book *A Room of One's Own* that "women have served all these centuries as looking-glasses possessing the magic and delicious power of reflecting the figure of man at twice its natural size." How would you compare this idea to Castiglione's view that "woman does not receive her being from man, but rather perfects him just as she is perfected by him." Do you agree that the relationship between men and women is symbiotic or have women been held in lesser esteem throughout the centuries because they have been expected to enhance the image of men? How modern is Castiglione in his thinking?

7

The Reformation Era

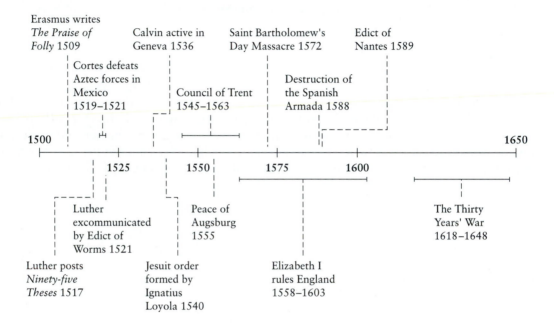

Erasmus writes *The Praise of Folly* 1509

Cortes defeats Aztec forces in Mexico 1519–1521

Calvin active in Geneva 1536

Council of Trent 1545–1563

Saint Bartholomew's Day Massacre 1572

Destruction of the Spanish Armada 1588

Edict of Nantes 1589

1500 — 1525 — 1550 — 1575 — 1600 — 1650

Luther excommunicated by Edict of Worms 1521

Luther posts *Ninety-five Theses* 1517

Peace of Augsburg 1555

Jesuit order formed by Ignatius Loyola 1540

Elizabeth I rules England 1558–1603

The Thirty Years' War 1618–1648

What a piece of work is man, how noble in reason, how infinite in faculty; in form and moving, how express and admirable, in action how like an angel, in apprehension how like a god: a beauty of the world, the paragon of animals!

—William Shakespeare, *Hamlet*

I am more afraid of my own heart than of the pope and all his cardinals. I have within me the great pope—Self.

—Martin Luther

Whatever your heart clings to and confides in, that is really your God.

—Martin Luther

All religions must be tolerated for every man must get to heaven his own way.

—Frederick the Great

CHAPTER THEMES

- *Social and Spiritual Values:* Why did the Reformation occur? What led Martin Luther to challenge the belief system of the church? To what extent can faith and personal commitment to a religion change the course of history? Is faith a more powerful force than any army?

- *Revolution and Transition:* Was the Protestant Reformation a spiritual revolution, which consequently altered the political and economic institutions of Europe? Or was it a spiritually based reform movement that sought limited change in religious matters? Was Luther a revolutionary who was just as influential as Robespierre, Napoleon, or Lenin?

- *The Power Structure:* How had the papacy insulated itself from doctrinal issues and administrative corruption that weakened the church? Were the Catholic Reformation and Inquisition defensive reactions to Protestant demands or a part of the renewal process of Catholic institutions?

- *The Varieties of Truth:* How did art and architecture reflect the changing perspectives and dynamics of the Reformation when traditions were challenged and salvation itself open to dispute? What variations of faith emerged from the art of Albrecht Dürer in Germany and El Greco in Spain?

- *The Big Picture:* Was the Protestant Reformation ultimately the best thing that could have happened to the Christian church in the West? Do you expect another splinter movement in the contemporary Catholic church, and if so, over what issues and with what ramifications?

Northern Humanism and the State of the Papacy

During the Middle Ages, the church was the focal point of society. One's life was inextricably bound to the dictates of religion from the baptism that followed birth to the last rites that accompanied death. But by the 16th century, the omnipotence of the church, both in a spiritual sense and in the political realm, had been called into question. The papacy was occupied with finding new sources of income that would help it fend off political challenges to its territory and increase its influence in the secular realm. The Renaissance papacy became infamous in its corruption and succumbed to the sensual delights of the world, as well as to the more traditional abuses of simony (the selling of church offices) and pluralism (allowing an individual to hold more than one position). Pope Julius II (1503–1513) was a glaring example of the age as, bedecked in armor, he personally led his armies into battle. These actions resulted in a plentitude of criticism from within the church and especially from northern humanists.

Humanism, the state of mind that formed the cornerstone of the Italian Renaissance, spread to the north in the late 15th and 16th centuries and became popular in Germany and the Netherlands, and in the courts of France and England. The emphasis on the wonder, versatility, and individuality of humankind was evident in the art and literature of the period. Humanism also fostered scholarship that, in the north especially, tended to criticize the abuses within the church.

Perhaps the most controversial practice of the church was the sale of indulgences. An indulgence was a piece of paper, signed by the pope, that remitted punishment in Purgatory because of sin. It was based on the theory that all humans are by nature sinful and after death will have to undergo a purgation of sin before being allowed to enter the Kingdom of Heaven. The pope, however, controlled an infinite "treasury of grace" that could be dispensed to mortals,

thus removing the taint of sin and freeing the soul from Purgatory. The first selection is a response from the German humanist Jacob Wimpheling to a letter written by Enea Silvio Piccolomini (a cardinal and later Pope Pius II) that recounts grievances against the church in 1515, just two years before the Reformation began in earnest. The second piece is a satire written by the most famous of all northern humanists, Desiderius Erasmus. In it he criticizes abuses within the church and thereby expresses the hope of promoting a greater spirituality in religion.

The Pope's Special Mission (1515)
JACOB WIMPHELING

The Council of Basel [1431–1449] pointed out that our sacred church fathers had written their canons for the purpose of assuring the Church of good government, and that honor, discipline, faith, piety, love, and peace reigned in the Church as long as these regulations were observed. Later however, vanity and greed began to prevail; the laws of the fathers were neglected, and the Church sank into immorality and depravity, debasement, degradation and abuse of office. This is principally due to papal reservations of prelacies and other ecclesiastical benefices, also to the prolific award of expectancies to future benefices, and to innumerable concessions and other burdens placed upon churches to clergy. To wit:

Church incomes and benefices are given to unworthy men and Italians.

High offices and lucrative posts are awarded to persons of unproven merit and character.

Few holders of benefices reside in their churches, for as they hold several posts simultaneously they cannot reside in all of them at once. Most do not even recognize the faces of their parishioners. They neglect the care of souls and seek only temporal rewards.

The divine service is curtailed.

Hospitality is diminished.

Church laws lose their force.

Ecclesiastical buildings fall into ruin.

The conduct of clerics is an open scandal.

Able, learned, and virtuous priests who might raise the moral and professional level of the clergy abandon their studies because they see no prospect of advancement.

The ranks of the clergy are riven by rivalry and animosity; hatred, envy, and even the wish for the death of others are aroused.

Striving after pluralities of benefices is encouraged.

Poor clerics are maltreated, impoverished, and forced from their posts.

Crooked lawsuits are employed to gather benefices.

Some benefices are procured through simony.

Other benefices remain vacant.

Able young men are left to lead idle and vagrant lives.

Prelates are deprived of jurisdiction and authority.

The hierarchical order of the Church is destroyed.

In this manner, a vast number of violations of divine and human law is committed and condoned. . . . "It is the pope's special mission," writes Enea, "to protect Christ's sheep. He should accomplish this task in such a way as to lead all men to the path of salvation. He must see that the pure Gospel is preached to all, that false doctrines, blasphemies, and unchristian teachings are eradicated, and that all enemies of the faith are driven from the lands of Christendom. He must heal schisms and end wars, abolish robbery, murder, arson, adultery, drunkenness and gluttony, spite, hatred and strife. He must promote peace and order, so that concord might reign among men, and honor and praise be given to God."

So Enea. My question is: Does a court of ephebes and muleteers and flatterers help the

"The Pope's Special Mission" is from Gerald Strauss, *Manifestations of Discontent in Germany on the Eve of the Reformation* (Bloomington: Indiana University Press, 1971), pp. 43–45. Copyright © 1971. Reprinted by permission of Indiana University Press.

pope prevent schism and abolish blasphemy, wars, robbery, and the other crimes mentioned

> **"Does a court of ephebes and muleteers and flatterers help the pope prevent schism and abolish blasphemy, wars, robbery, and other crimes?"**
> **—Jacob Wimpheling**

by Enea? Would he not be better served by men learned in canon law and Scripture, by men who know how to preach and can help the faithful ease their conscience in the confessional? The Council of Basel was surely inspired when it decreed that a third of all benefices should go to men versed in the Bible. . . . If I am not mistaken, the conciliar fathers wished to see the true Gospel of Christ preached everywhere. They wished honor and glory given to God. Ourselves want nothing else. We would rejoice if many men were to praise God, if every priest in his sufficiently endowed benefice were to serve God and celebrate the Eucharist, if popes and emperors, if the whole Church were to draw rich benefit from this holy work, the most efficacious office of them all.

The Praise of Folly (1509)
DESIDERIUS ERASMUS

The next to be placed among the regiment of fools are such as make a trade of telling or inquiring after incredible stories of miracles and prodigies. Never doubting that a lie will choke them, they will muster up a thousand several strange relations of spirits, ghosts, apparitions, raising of the devil, and such like bugbears of superstition; which the farther they are from being probably true, the more greedily they are swallowed, and the more devoutly believed. And these absurdities do not only bring an empty pleasure and cheap divertisement, but they are a good trade and procure a comfortable income to such priests and friars as by this craft get their gain.

To these again are nearly related such others as attribute strange virtues to the shrines and images of saints and martyrs, and so would make their credulous proselytes believe that if they pay their devotion to St. Christopher in the morning, they shall be guarded and secured the day following from all dangers and misfortunes. If soldiers, when they first take arms, shall come and mumble over such a set prayer before the picture of St. Barbara, they shall return safe from all engagements. Or if any pray to Erasmus on such particular holidays, with the ceremony of wax candles and other fopperies, he shall in a short time be rewarded with a plentiful increase of wealth and riches. The Christians have now their gigantic St. George, as well as the pagans had their Hercules; they paint the saint on horseback, and drawing the horse in splendid trapping very gloriously accoutred, they scarce refrain in a literal sense from worshipping the very beast.

What shall I say of such as cry up and maintain the cheat of pardons and indulgences? That by these compute the time of each soul's residence in purgatory, and assign them a longer or shorter continuance, according as they purchase more or fewer of these paltry pardons and saleable exemptions? Or what can be said bad enough of others, who pretend that by the force of such magical charms, or by the fumbling over their beads in the rehearsal of such, and such petitions; which some religious imposters invented, either for diversion, or, what is more likely, for advantage; they shall procure riches, honor, pleasure, health, long life, a lusty old age, nay, after death a sitting at the right hand of our Saviour in His kingdom.

By this easy way of purchasing pardons, any notorious highwayman, any plundering soldier, or any bribe-taking judge shall disburse some part of their unjust gains, and so think all their

"The Praise of Folly" is from Desiderius Erasmus, *The Praise of Folly* (London: Hamilton Adams and Company, 1887), pp. 90–96, 143–149, 164–169.

grossest impieties sufficiently atoned for. So many perjuries, lusts, drunkenness, quarrels, bloodsheds, cheats, treacheries, shall all be, as it were, struck a bargain for, and such a contract made, as if they had paid off all arrears and might now begin upon a new score.

From the same principles of folly proceeds the custom of each country's challenging their particular guardian-saint. Nay, each saint has his distinct office alloted to him and is accordingly addressed to upon the delivery in childbirth, a third to help persons to lost goods, another to protect seamen in a long voyage, a fifth to guard the farmer's cows and sheep, and so on. For to rehearse all instances would be extremely tedious.

And now for some reflections upon popes, cardinals and bishops, who in pomp and splendour have almost equalled if not [outdone] secular princes. Now if any one consider that their

> "And now for some reflections upon popes, cardinals and bishops, who in pomp and splendour have almost equalled if not outdone secular princes."
>
> —Erasmus

upper crotchet of white linen is to signify their unspotted purity and innocence; that their forked mitres, with both divisions tied together by the same knot, are to denote the joint knowledge of the Old and New Testament. That their always wearing gloves represents their keeping their hands clean and undefiled from lucre and covetousness; that the pastoral staff implies the care of a flock committed to their charge; that the cross carried before them expresses their victory over all carnal affection. He that considers this, and much more of the

like nature, must needs conclude they are entrusted with a very weighty and difficult office. But alas, they think it sufficient if they can but feed themselves, and as to their flock, either commend them to the care of Christ Himself, or commit them to the guidance of some inferior vicars and curates. [They do] not so much as remember what their name of bishop imports, to wit, labor, pains and diligence, but by base simoniacal contracts, they are in a profane sense . . . overseers of their own gain and income.

The popes of Rome . . . pretend themselves Christ's vicars; if they would but imitate His exemplary life . . . an unintermitted course of preaching [and] attendance with poverty, nakedness, hunger and a contempt of this world; if they did but consider the import of the word pope, which signifies a father; or if they did but practice their surname of most holy, what order or degrees of men would be in a worse condition? There would be then no such vigorous making of parties and buying of votes in the conclave upon the vacancy of that see.

And those who, by bribery or other indirect courses, should get themselves elected would never secure their sitting firm in the chair by pistol, poison, force and violence. How much of their pleasure would be abated if they were but endowed with one dram of wisdom? Wisdom, did I say? Nay, with one grain of salt which our Saviour bid them not lose the savor of. All their riches, all their honor, their jurisdictions, their Peter's patrimony, their offices, their dispensations, their licenses, their indulgences, their long train and attendants, see in how short a compass I have abbreviated all their marketing of religion; in a word, all their perquisites would be forfeited and lost; and in their [place] would succeed watchings, fastings, tears, prayers, sermons, hard studies, repenting sighs and a thousand such like severe penalties. . . . The very Head of the Church, the spiritual prince, would then be brought from all his splendour to the poor equipage of a scrip and staff.

Consider This:

- Discuss the abuses within the church during the 15th and 16th centuries. What specifically are the criticisms of Jacob Wimpheling and Desiderius Erasmus?

- What were the values of the northern humanists? Can they be accurately referred to as "Christian humanists?" Were these northern critics irreligious or simply opposed to papal corruption? Was there any difference in the eyes of the church?

Against the Grain

NORTHERN LIGHT: THE GENIUS OF ALBRECHT DÜRER

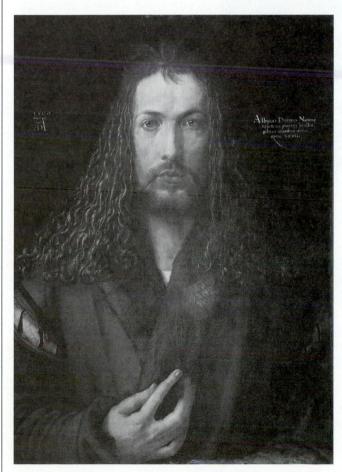

Figure 7–1 Albrecht Dürer, *Self Portrait* (1500) (Art Resource, N.Y.).

The Northern Renaissance was based primarily in the Netherlands and Germany, producing several outstanding artists including Hieronymus Bosch, Jan van Eck, Lucas Cranach the Elder, and Roger van der Weyden. But certainly the most remarkable of a strong talent pool was Albrecht Dürer (1471–1528). Living in Nuremburg, halfway between the Netherlands and Italy, he provided the essential link between the humanistic style of the Italian Renaissance and the more focused and detailed conservatism of the north. Dürer was a conduit, a great innovator who provided a model for his northern brethren through which they could combine their interest in naturalistic detail with the more theoretical Italian emphasis on idealized figures, mythological and ancient subjects.

Dürer found inspiration in the major European artistic centers of the time. After his apprenticeship in the workshop of Michael Wolgemut, where he learned the craft of woodcut illustration, he embarked on a journey to Switzerland in 1490 and then to Italy in 1494, where he focused on watercolors, oils, and engraving. Returning home to Nuremburg in 1495, he spent the next 10 years producing a number of diverse works that established his technical mastery of the woodcut and engraving media.

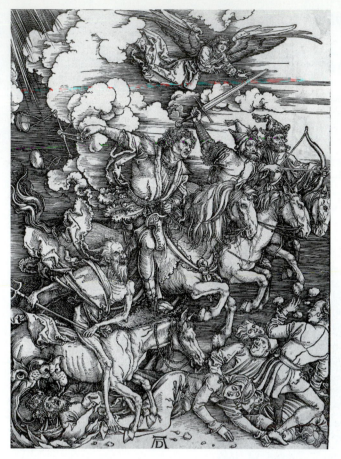

Figure 7–2 Albrecht Dürer, *The Four Horsemen of the Apocalypse* (1498) (Museum of Fine Arts, Boston).

This expertise and devotion to detail can be seen in one of Dürer's first great works, a series of woodcuts in 1498 illustrating the Revelation of Saint John. *The signs and portents of the Second Coming of Christ with its consequent destruction of the world proved to be a popular subject in northern Europe. Many believed that these prophecies would come true in their lifetime as continuing plagues and corruption weakened faith in the legitimacy of the Church as the repository of God's grace. Dürer's artistic visions of apocalyptic events and the accompanying terrors of doomsday had never been portrayed with such intensity and power. Here the* Four Horsemen of the Apocalypse *representing Death, Famine, War, and Pestilence, ride rampant over the earth, trampling men and women, while Death's bony horse leaps over a bishop falling into the gaping jaws of the Dragon of Hell.*

In Dürer's famous depiction of the celestial struggle between the Angels of God, led by Saint Michael, and the forces of evil gathered around the Devil, there is a sense of urgency based on Revelation 12:7–12: "And now war broke out in heaven, when Michael with his angels attacked the dragon. The dragon fought back with his angels, but they were defeated and driven out of heaven. The great dragon, the primeval serpent, known as the devil or Satan, who had led all the world astray, was hurled down with him. Then I heard a voice shout from heaven, "Salvation and power and empire for ever have been won by our God, and all authority for his son Christ, now that the accuser, who accused our brothers day and night before our God, has been brought down. They have triumphed over him by the blood of the Lamb and by the Word to which they bore witness, because even in the face of death they did not cling to life. So let the heavens rejoice and all who live there; but for you, earth and sea, disaster is coming—because the devil has gone down to you in a rage, knowing that he has little time left."

In Dürer's conception, there are no traditional poses showing Saint Michael's inevitable conquest. Michael is in deadly earnest as he thrusts his spear with both hands into the throat of the dragon. This was a hard-fought victory that inspired the faithful in their daily contest with sin.

To get a good sense of the dynamic virtuosity of Albrecht Dürer, juxtapose the intensity and movement of Saint Michael's struggle against the great dragon with the spiritual presence embodied in this Study of Praying Hands (1508). Once again, detailed shadings articulate the gentle curve of the fingers, bones and veins of the hands. But there is balance in this drawing, an emphasis on proportion and human perfection that reflects an Italian humanist vision.

This relationship between God and man, between omnipotence and penitence in the medieval mind, and the assimilation of divine and human perfection in the Renaissance, is perhaps best viewed in Dürer's Self-Portrait

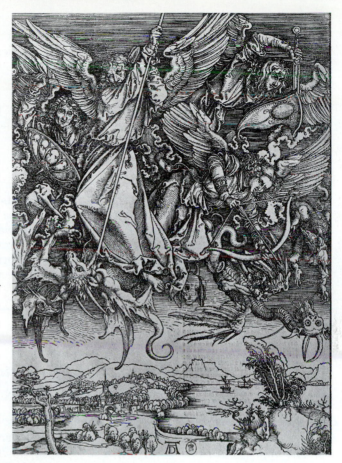

Figure 7–3 Albrecht Dürer, *Saint Michael's Fight against the Dragon* (1498) (Art Resource, N.Y.).

(1500). Dürer was the first artist to paint self-portraits and he did several of them at various points in his life. The one featured in this segment was finished at age 29 and the artist portrayed himself in a Christ-like pose. This was no blasphemy in Dürer's mind but, rather, the acknowledgment that artistic talent derives from God and that man was made in God's image. Thus, Albrecht Dürer served as a conduit through whom humanist ideas and Italian style flowed to the north. His creativity and innovative vision had a seminal impact on the Northern Renaissance.

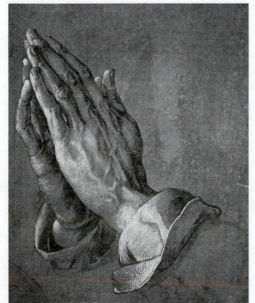

Figure 7–4 Albrecht Dürer, *Study of Praying Hands* (1508) (Art Resource, N.Y.).

The Garden of Earthly Delights (1500)
HIERONYMUS BOSCH

Hieronymus Bosch (ca. 1450–1516) was another great artist of the Northern Renaissance. Like Albrecht Dürer, he was a talented painter who possessed a deep understanding of human character and was one of the first artists to represent abstract concepts in his work. Bosch, in his early paintings, detailed humanity's ignorance, innocence, and vulnerability to evil. But these rather conventional depictions developed into a full-blown eruption of fantasy in mid-career, as evidenced in his impressive triptychs of the Hay Wain, *the* Temptation of Saint Anthony, *and the* Garden of Earthly Delights. *The latter, in particular, represents Bosch's mature style as he portrays the dreamlike world of paradise. It is a bizarre landscape with strange birds, monstrous creatures, cross-breeds, and cavorting animals. This painting demonstrates Bosch's link with the allegorical culture of the Middle Ages. At the same time, the organizational structures of the triptych and the detail focused on composition and color reveals a master storyteller and humorist, who presented complexities on a grand scale, often prompting unusual interpretations of esoteric meanings.*

Compare and Contrast:

- How would you describe Bosch's view of Paradise before the fall of man? Do you find this to be an enticing or rather disturbing world? Is this how you view Paradise?

- *The Garden of Earthly Delights* presents some rather bizarre figures. Compare Bosch's imaginings with Dürer's conception in St. Michael's fight to rid Heaven of the devil and his demons. Paradise seems a rather unstable place in the paintings of these northern artists. Why? How do they reflect the instability within the church at this time?

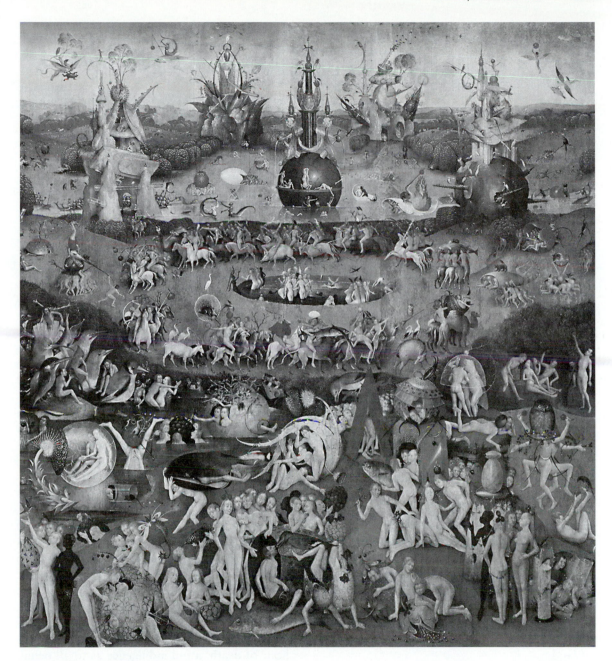

Figure 7–5 Hieronymus Bosch, *The Garden of Earthly Delights* (1500) (SuperStock, Inc.).

The Lutheran Reformation

By the late 15th century, the remission of sin dispersed to mortals from the pope's "infinite treasury of grace" was extended to both the living and the dead, and one could therefore liberate the soul of a relative "trapped" in Purgatory by purchasing an indulgence. The sale of indulgences became a routine affair of peddling forgiveness of purgatorial punishment, and the papacy came to rely on it as a necessary source of income. In 1507, Pope Julius II issued a plenary indulgence in order to obtain funds for the construction of Saint Peter's Basilica in Rome. Leo X renewed the indulgence in 1513, and subcommissioners actively began selling to the faithful. One of the most successful subcommissioners was Johann Tetzel, prior of the Dominican monastery at Leipzig. His oratorical ability is evident in the following passage.

"How Many Sins Are Committed in a Single Day?" (1517)
JOHANN TETZEL

Venerable Sir, I pray you that in your utterances you may be pleased to make use of such words as shall serve to open the eyes of the mind and cause your hearers to consider how great a grace and gift they have had and now have at their very doors. Blessed eyes indeed, which see what they see, because already they possess letters of safe conduct by which they are able to lead their souls through that valley of tears, through that sea of the mad world, where storms and tempests and dangers lie in wait, to the blessed land of Paradise. Know that the life of man upon earth is a constant struggle. We have to fight against the flesh, the world and the devil, who are always seeking to destroy the soul. In sin we are conceived,—alas! what bonds of sin encompass us, and how difficult and almost impossible it is to attain to the gate of salvation without divine aid; since He causes us to be saved, not by virtue of the good works which we accomplish, but through His divine mercy, it is necessary then to put on the armor of God.

You may obtain letters of safe conduct from the vicar of our Lord Jesus Christ, by means of which you are able to liberate your soul from the hands of the enemy, and convey it by means of contrition and confession, safe and secure from all pains of Purgatory, into the happy kingdom. For know that in these letters are stamped and engraven all the merits of Christ's passion there laid bare. Consider, that for each and every mortal sin it is necessary to undergo seven years of penitence after confession and contrition, either in this life or in Purgatory.

How many mortal sins are committed in a day, how many in a week, how many in a month, how many in a year, how many in the whole course of life! They are well-nigh numberless, and those that commit them must needs suffer endless punishment in the burning pains of Purgatory.

But with these confessional letters you will be able at any time in life to obtain full indulgence for all penalties imposed upon you, in all cases except the four reserved to the Apostolic See. Therefore throughout your whole life, whenever you wish to make confession, you may receive the same remission, except in cases reserved to the Pope, and afterwards, at the hour of death, a full indulgence as to all penalties and sins, and your share of all spiritual blessings that exist in the church militant and all its members.

Do you not know that when it is necessary for anyone to go to Rome, or undertake any

"How Many Sins Are Committed in a Single Day?" is from James H. Robinson, ed., *Translations and Reprints from the Original Sources of European History*, Vol. 2, no. 6 (Philadelphia: University of Pennsylvania, 1902), pp. 9–10.

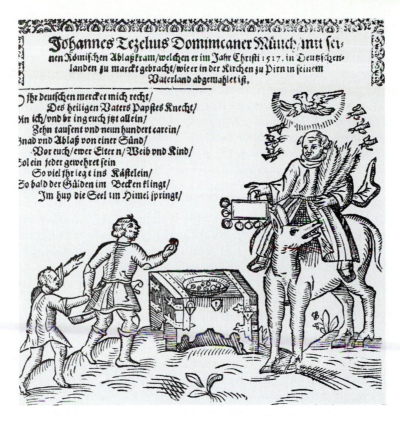

Figure 7–6 Caricature of Johann Tetzel, the indulgence preacher who spurred Luther to publish his *Ninety-five Theses*. The last line of the caption reads: "As soon as gold in the basin rings, right then the soul to heaven springs." (Library of Congress).

> "Are you not willing, then, for the fourth part of a florin, to obtain these letters, by virtue of which you may bring, not your money but your divine and immortal soul safe and sound into the land of Paradise?"
> —Johann Tetzel

other dangerous journey, he takes his money to a broker and gives a certain percent—five or six or ten—in order that at Rome or elsewhere he may receive again his funds intact, by means of the letter of this same broker? Are you not willing, then, for the fourth part of a florin, to obtain these letters, by virtue of which you may bring, not your money but your divine and immortal soul safe and sound into the land of Paradise?

Consider This:
- Why were indulgences so detested by critics of the church? Can you construct a logical argument in support of indulgences with which the church could have satisfactorily defended itself against criticism? Is the principle of indulgences at issue here, or just the manner in which they were sold?

Salvation Through Faith Alone

MARTIN LUTHER

It was in response to this sale of indulgences that a young monk named Martin Luther protested and nailed his Ninety-five Theses *to the door of the Wittenberg church.*

It is important to note that although Luther called into question the sale of indulgences, the main issue was salvation. Salvation, he reasoned, was cheap indeed if it could be purchased. Luther was tortured by the demands of God for perfection and worried that his own righteousness was insufficient for salvation in the sight of God. The church taught that in addition to winning grace through faith, one could also merit God's grace through good works or the remission of sin by indulgence. In fact, the purchase of an indulgence was considered a good work. But to Luther's mind, salvation required more, much more, and had nothing to do with deeds. While studying Saint Paul's Epistle to the Romans *(1:17), Luther achieved a breakthrough that freed him from his torment: By the grace of God alone could one be saved, and this salvation was obtained only through faith in Christ. Neither good works nor indulgences could have anything to do with salvation. This stand called into question the very foundation of established Christian belief. Was the pope the true Vicar of Christ who spoke the words of God? If so, why did he advocate indulgences as a means of salvation? Was he in fact infallible on such matters of faith? The corruption of the papacy was also troubling, yet Luther's objective was not to overthrow the church, but to reform it from within.*

Martin Luther's transformation from monk to reformer was not a preconceived act; it developed gradually not only as a result of corruption around him, but especially because of a spiritual awakening. Luther struggled with the need to imitate the perfection of Christ, which was important in the eyes of the church for salvation. Luther realized that because of his nature as a human, he was too sinful, and that no amount of prayer or good works could help him achieve the Kingdom of Heaven. After much study and pain, he concluded that salvation was a free gift of God and that a person was saved by faith in Christ alone. In the following selection, Luther explains his enlightenment. When Luther posted the Ninety-five Theses *on the church in Wittenberg, the Reformation began in earnest.*

I, Martin Luther, entered the monastery against the will of my father and lost favor with him, for he saw through the knavery of the monks very well. On the day on which I sang my first mass he said to me, "Son, don't you know that you ought to honor your father?" . . . Later when I stood there during the mass and began the canon, I was so frightened that I would have fled if I hadn't been admonished by the prior. . . .

When I was a monk I was unwilling to omit any of the prayers, but when I was busy with public lecturing and writing I often accumulated my appointed prayers for a whole week, or even two or three weeks. Then I would take a Saturday off, or shut myself in for as long as three days without food and drink, until I had said the prescribed prayers. This made my head split, and as a consequence I couldn't close my eyes for five nights, lay sick unto death, and went out of my senses. Even after I had quickly recovered and I tried again to read, my head went 'round and 'round. Thus our Lord God drew me, as if by force, from that torment of prayers. . . .

The words "righteous" and "righteousness of God" struck my conscience like lightning. When I heard them I was exceedingly terrified. If God is righteous [I thought], he must punish. But when by God's grace I pondered, in the tower and heated room of this building, over the words, "He who through faith is righteous shall live" [Rom. 1:17] and "the righteousness of God" [Rom. 3:21], I soon came to the conclusion that if we, as righteous men, ought to live from faith and if the righteousness of God should contribute to the salvation of all who believe, then salvation won't be our merit but God's mercy. My spirit

"Salvation Through Faith Alone" is from Theodore Tappert and H. Lehmann, eds., *Luther's Works,* Vol. 54: *Table Talk* (Philadelphia: Fortress Press, 1965), pp. 85, 193–194, 234, 264–265. Copyright © 1965 by Fortress Press. Reprinted by permission of Augsburg Fortress.

was thereby cheered. For it's by the righteousness of God that we're justified and saved through Christ. These words [which had before terrified me] now became more pleasing to me. The Holy Spirit unveiled the Scriptures for me in this tower.

God led us away from all this in a wonderful way; without my quite being aware of it he took me away from that game more than twenty years ago. How difficult it was at first when we journeyed toward Kemberg after All Saints' Day in the year 1517, when I first made up my mind to write against the crass errors of indulgences! Jerome Schurff advised against this: "You wish to write against the pope? What are you trying to do? It won't be tolerated!" I replied, "And if they have to tolerate it?" Presently Sylvester, master of the sacred palace, entered the arena, fulminating against me with this syllogism: "Whoever questions what the Roman church says and does is heretical. Luther questions what the Roman church says and does, and therefore [he is a heretic]." So it all began.

> **"You wish to write against the pope? What are you trying to do? It won't be tolerated!" I replied, "And if they have to tolerate it?"**
> **—Martin Luther**

Consider This:

- What would you identify as the underlying causes for the Reformation, and what was the "spark" that set things in motion? To what extent was Martin Luther's action directed against abuses within the church?

The Architectural Foundation

SAINT PETER'S BASILICA

Saint Peter's Basilica in Rome is one of the most celebrated edifices in the world. Its conception dates back to the reign of Pope Nicholas V (1447–1455), who was dismayed at the deterioration of the Old Saint Peter's Basilica. On April 18, 1506, Pope Julius II laid the first stone for the new cathedral and decided to finance the venture by proclaiming a Jubilee Indulgence. Julius hoped that this special sale of indulgences to the faithful for the remission of sins would provide an income stream to offset the significant cost of his visionary plans. Intended to be the largest cathedral in the world, it was first designed as a Greek cross and eventually evolved into a three-aisle Latin cross with an enormous dome (devised by Michelangelo) fitted directly above the high altar that covered the shrine of Saint Peter. This was the church of the popes, those Bishops of Rome who would be buried in the crypt below the altar.

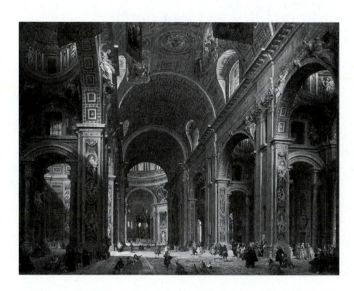

Figure 7–7 Giovanni Panini, *Interior of St. Peter's, Rome* (1754) (National Gallery of Art, Washington, D.C.).

Little expense was spared in this venture throughout the basilica's construction over the course of nearly 110 years from 1506 to its completion in 1615. The pope as the Vicar of Christ and spiritual heir to the authority of God, employed the most renowned architects, painters, and sculptors in the creation of this magnificent cathedral.

The interior of Saint Peter's Basilica is here depicted about 1754 by Giovanni Paolo Panini, the most celebrated painter of classical and contemporary views of Rome in the eighteenth century. His paintings were not idealized, but were accurate and objective portrayals designed to satisfy the growing popularity of Rome as a pilgrimage center and as a stop for foreign visitors on the Grand Tour of European capitals. Panini's painting gives us a sense of the almost overwhelming design of the cavernous interior.

The impressive bronze Baldachin or canopy over the altar and above the crypt, was completed in 1633 by Gian Lorenzo Bernini and is an unprecedented fusion of sculpture and architecture, the first truly Baroque monument.

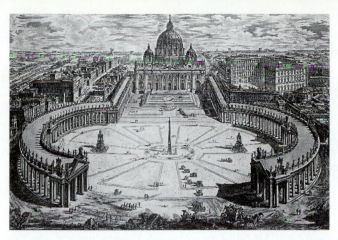

Bernini's greatest architectural achievement, however, remains the colonnade that encloses the piazza before Saint Peter's Basilica. The famous engraver, Giovanni Piranesi, provides us with an 18th-century view of the colonnade that offsets the enormous façade of the cathedral. Bernini created a series of free-standing columns designed to grant access to visitors as they gathered for the papal benediction on Easter and other special occasions. The encircling design of the colonnade symbolizes the enveloping arms of the church and directs the faithful into the cathedral.

Figure 7–8 Giovanni Piranesi, *Bernini's Colonnade, St. Peter's, Rome* (SuperStock, Inc.)

Instructions for the Sale of Indulgences (1517)

ARCHBISHOP ALBERT

The controversy over the sale of indulgences was the spark that set the Reformation in motion. In 1515, Pope Leo X made an agreement with Archbishop Albert to sell indulgences in Mainz and other areas of northern Germany, with half the proceeds going to support Leo's construction of Saint Peter's Basilica in Rome and half going to pay for the debts that Albert had incurred in securing his church offices. In the following selection, Archbishop Albert gives instructions to those subcommissioners who actually sold the indulgences in 1517.

Keep in Mind:
* What were the advantages of buying indulgences from the church?

In the matter of [indulgences] preachers shall take pains to commend each to believers with the greatest care, and, in-so-far as in their power lies, to explain the same.

The first grace is the complete remission of all sins; and nothing greater than this can be named, since man who lives in sin and forfeits the favor of God, obtains complete remission by these means and once more enjoys God's favor: moreover, through this remission of sins, the punishment which one is obliged to undergo in Purgatory on account of the affront to the divine Majesty, is all remitted, and the pains of Purgatory completely blotted out.

[A] most important grace is the participation in all the possessions of the church universal, which consists herein, that contributors toward the said building, together with their deceased relations, who have departed this world in a state of grace, shall from now and for eternity be partakers in all petitions, intercessions, alms, fasting, prayers, in each and every pilgrimage, even those to the Holy Land; furthermore, in the stations at Rome, in the masses, canonical hours, flagellations, and all other spiritual goods which have brought forth or which shall be brought forth by the universal most holy church militant or by any of its members. Believers who purchase confessional letters will become participants in all these things.

"Instructions for the Sale of Indulgences" is from James H. Robinson, ed., *Translations and Reprints from the Original Sources of European History*, Vol. 2, no. 6 (Philadelphia: University of Pennsylvania Press, 1902), pp. 4–9.

[Another] distinctive grace is for those souls which are in Purgatory, and is the complete remission of all sins, which remission the pope brings to pass through his intercession to the advantage of said souls. . . . Moreover, preachers shall exert themselves to give this grace the widest publicity, since through the same, help will surely come to departed souls, and the construction of the Church of St. Peter will be abundantly promoted at the same time.

Compare and Contrast:

- Compare these instructions given by the Archbishop of Mainz for the sale of indulgences with the actual process of selling them by Johann Tetzel on pages 280–281. What made Tetzel such a good "rainmaker" for the church? Was he doing exactly what the pope and archbishops expected of him?

- In the previous source, "Salvation Through Faith Alone," Martin Luther argued against the "crass errors of indulgences" and made his mind up to oppose the process actively. But the Archbishop of Mainz in these instructions advocates the sale of indulgences as helping "departed souls" come to Paradise while at the same time promoting the construction of Saint Peter's cathedral. Sounds like a win/win proposition. Why was Luther so upset?

The Broader Perspective:

- During the Golden Age of Classical Greece from about 480 to 404 B.C.E., the democracy of Athens established an empire that provided them with a continuous flow of tribute that they used to build the Parthenon and many other monuments that established Athenian cultural supremacy and defined artistic standards for centuries to come. But all this cultural progress was dependent on the maintenance of an empire held by force. Does the beauty and cultural worth of the monuments of a civilization justify the means of obtaining them?

- Similarly, through the sale of indulgences, the Roman church built Saint Peter's Basilica, a testament to the glory of God, the authority of the papacy, and the depository of artistic genius—of Raphael, Bramante, Michelangelo, and Bernini. What price civilization?

"Here I Stand":
Address at the Diet of Worms (1521)
MARTIN LUTHER

The church replied to Luther's challenge to its authority with what it considered swift and appropriate action. Luther was excommunicated and his writings were condemned as heretical. It became evident to Luther that his desire to reform the church could be achieved only by defying the authority of the pope and starting a new church. Supported by the Holy Roman Emperor Charles V, the church sought to eliminate the root of the controversy. However, Luther was hidden, protected by the secular princes in Germany who, because of their location and traditional independence, were willing to defy their emperor and promote a religion that to them served a secular purpose. Yet Luther's movement was spiritual in nature, and he decried such political connections even as he sought the aid of the princes and nobility.

After his excommunication by Leo X in June 1520, Luther was summoned to appear before a diet (assembly) of prelates and officials of the Holy Roman Empire in the city of Worms to

"'Here I Stand': Address at the Diet of Worms" is from J. Pelikan, ed., *Luther's Works,* Vol. 2: *Career of the Reformer* (Saint Louis: Concordia Publishing House, 1958), pp. 109–112. Copyright © 1958 by Concordia Publishing House. Used by permission of the publisher.

answer questions about his heretical writings. His safe conduct to the meeting was guaranteed by the Holy Roman Emperor Charles V, who presided over the Diet. Accompanied by his secular protector, Frederick the Wise, Elector of Saxony, Luther appeared on April 17, 1521. When asked whether he wished to defend all his writings or retract some, Luther delivered this famous speech. On April 23, Luther secretly left Worms and was hidden by friends at Wartburg castle. Charles V's edict against Luther is the second selection.

"Most serene emperor, most illustrious princes, most clement lords, obedient to the time set for me yesterday evening, I appear before you, beseeching you, by the mercy of God, that your most serene majesty and your most illustrious lordships may deign to listen graciously to this my cause—which is, as I hope, a cause of justice and truth. If through my inexperience I have either not given the proper titles to some, or have offended in some manner against court customs and etiquette, I beseech you to kindly pardon me, as a man accustomed not to courts but to the cells of monks. I can bear no other witness about myself but that I have taught and written up to this time with simplicity of heart, as I had in view only the glory of God and the sound instruction of Christ's faithful. . . .

"[A] group of my books attacks the papacy and the affairs of the papists as those who both

> "Through the decrees of the pope . . . the consciences of the faithful have been most miserably entangled, tortured, and torn to pieces."
> —Martin Luther

by their doctrines and very wicked examples have laid waste the Christian world with evil that affects the spirit and the body. For no one can deny or conceal this fact, when the experience of all and the complaints of everyone witness that through the decrees of the pope and the doctrines of men the consciences of the faithful have been most miserably entangled, tortured, and torn to pieces. Also, property and possessions, especially in this illustrious nation of Germany, have been devoured by an unbelievable tyranny and are being devoured to this time without letup and by unworthy means. [Yet the papists] by their own decrees . . . warn that the papal laws and doctrines which are

contrary to the gospel or the opinions of the fathers are to be regarded as erroneous and reprehensible. If, therefore, I should have retracted these writings, I should have done nothing other than to give strength to this [papal] tyranny and I should have opened not only windows but doors to such great godlessness. It would rage further and more freely than ever it has dared up to this time. Yes, from the proof of such a revocation on my part, their wholly lawless and unrestrained kingdom of wickedness would become still more intolerable for the already wretched people; and their rule would be further strengthened and established, especially if it should be reported that this evil deed had been done by me by virtue of the authority of your most serene majesty and the whole Roman Empire. Good God! What a cover for wickedness and tyranny I should have then become.

"I have written a third sort of book against some private and (as they say) distinguished individuals—those, namely, who strive to preserve the Roman tyranny and to destroy the godliness taught by me. Against these I confess I have been more violent than my religion or profession demands. But then, I do not set myself up as a saint; neither am I disputing about my life, but about the teachings of Christ. It is not proper for me to retract these works, because by this retraction it would again happen that tyranny and godlessness would, with my patronage, rule and rage among the people of God more violently than ever before.

"However, because I am a man and not God, I am not able to shield my books with any other protection than that which my Lord Jesus

> "I do not set myself up as a saint; neither am I disputing about my life, but about the teachings of Christ."
> —Martin Luther

Christ himself offered for his teaching. When questioned before Annas about his teaching and struck by a servant, he said: 'If I have spoken wrongly, bear witness to the wrong' [John 18:19–23]. If the Lord himself, who knew that he could not err, did not refuse to hear testimony against his teaching, even from the lowliest servant, how much more ought I, who am the lowest scum and able to do nothing except err, desire and expect that somebody should want to offer testimony against my teaching! Therefore, I ask by the mercy of God, may your most serene majesty, most illustrious lordships, or anyone at all who is able, either high or low, bear witness, expose my errors, overthrowing them by the writings of the prophets and the evangelists. Once I have been taught I shall be quite ready to renounce every error, and I shall be the first to cast my books into the fire.

"From these remarks I think it is clear that I have sufficiently considered and weighed the hazards and dangers, as well as the excitement and dissensions aroused in the world as a result of my teachings, things about which I was gravely and forcefully warned yesterday. To see excitement and dissension arise because of the Word of God is to me clearly the most joyful aspect of all in these matters. For this is the way, the opportunity, and the result of the Word of God, just as He [Christ] said, 'I have not come to bring peace, but a sword. For I have come to set a man against his father, etc.' [Matt. 10:34–35]. . . . Therefore we must fear God. I do not say these things because there is a need of either my teachings or my warnings for such leaders as you, but because I must not withhold the allegiance which I owe my Germany. With these words I commend myself to your most serene majesty and to your lordships, humbly asking that I not be allowed through the agitation of my enemies, without cause, to be made hateful to you. I have finished."

When I had finished, the speaker for the emperor said, as if in reproach that I had not answered the question, that I ought not call into question those things which had been condemned and defined in councils; therefore what was sought from me was not a horned response, but a simple one, whether or not I wished to retract.

Here I answered:

"Since then your serene majesty and your lordships seek a simple answer, I will give it in this manner, neither horned nor toothed: Unless I am convinced by the testimony of the Scriptures or by clear reason (for I do not trust either in the pope or in councils alone, since it is well known that they have often errored and contradicted themselves), I am bound by the Scriptures I have quoted and my conscience is captive to the Word of God. I cannot and I will not retract anything, since it is neither safe nor right to go against conscience. "I cannot do otherwise, here I stand, may God help me, Amen."

The Edict of Worms (1521)
EMPEROR CHARLES V

In view of . . . the fact that Martin Luther still persists obstinately and perversely in maintaining his heretical opinions, and consequently all pious and God-fearing persons abominate and abhor him as one mad or possessed by a demon . . . we have declared and made known that the said Martin Luther shall hereafter be held and esteemed by each and all of us as a limb cut off from the Church of God, an obstinate schismatic and manifest heretic. . . .

And we publicly attest by these letters that we order and command each and all of you, as you owe fidelity to us and the Holy Empire, and would escape the penalties of the crime of treason, and the ban and over-ban of the Empire, and the forfeiture of all regalia, fiefs, privileges,

> "We have declared . . . that the said Martin Luther shall hereafter be . . . cut off from the Church of God, an obstinate schismatic and manifest heretic."
> —Emperor Charles V

"The Edict of Worms" is from James H. Robinson, ed., *Readings in European History*, Vol. 2 (Boston: Ginn and Company, 1906), pp. 87–88.

and immunities, which up to this time you have in any way obtained from our predecessors, ourself, and the Holy Roman Empire—commanding, we say, in the name of the Roman and imperial majesty, we strictly order that immediately after the expiration of the appointed twenty days, terminating on the fourteenth day of May, you shall refuse to give the aforesaid Martin Luther hospitality, lodging, food, or drink; neither shall any one, by word or deed, secretly or openly, succor or assist him by counsel or help; but in whatever place you meet him, you shall proceed against him; if you have sufficient force, you shall take him prisoner and keep him in close custody; you shall deliver him, or cause him to be delivered, to us or at least let us know where he may be captured. In the meanwhile you shall keep him closely imprisoned until you receive notice from us what further to do, according to the direction of the laws. And for such holy and pious work we will indemnify you for your trouble and expense. . . .

And in order that all this may be done and credit given to this document we have sealed it with our imperial seal, which has been affixed in our imperial city of Worms, on the eighth day of May, after the birth of Christ 1521, in the second year of our reign over the Roman Empire, and over our other lands the sixth.

By our lord the emperor's own command.

Consider This:

- Edward Bulwer-Lytton once said, "A reform is a correction of abuses; a revolution is a transfer of power." Under this definition, would you consider the Protestant Reformation to be a revolution?

On Celibacy and Marriage
MARTIN LUTHER

The Lutheran Reformation was not simply spiritual or corrective in nature, for it had many political and social repercussions as well. In response to the celibacy demanded of priests by the church, Luther advocated that clergy be allowed to marry. He himself married a former nun. Such defiance in one sphere was confusing for certain elements of society that saw Luther as their champion as well.

First, not every priest can do without a woman, not only on account of the weakness of the flesh but much more because of the needs of the household. If, then, he is to keep a woman, and the pope grants him permission to do so, but he may not have her in marriage, what is this but leaving a man and a woman alone and forbidding them to fall? It is like putting fire and straw together and commanding that there shall be neither smoke nor fire. Secondly, the pope has as little power to give this command as he has to forbid eating, drinking, the natural process of bodily elimination or becoming fat. No one, therefore, is in duty bound to keep this commandment and the pope is responsible for all the sins that are committed against this ordinance, for all the souls lost thereby, and for all consciences thereby confused and tortured. Consequently, he undoubtedly has deserved long ago that

> "What is this but leaving a man and a woman alone and forbidding them to fall? It is like putting fire and straw together and commanding that there shall be neither smoke nor fire."
>
> —Martin Luther

someone should drive him out of the world, so many souls has he strangled with this devilish snare; although I hope that God has been more gracious to many of them at their end than the pope had been during their life. Nothing good has ever come out of the papacy and its laws, nor ever will.

Listen! In all my days I have not heard the confession of a nun, but in the light of Scripture I shall hit upon how matters fare with her and know I shall not be lying. If a girl is not sustained by great and exceptional grace, she can live without a man as little as she can without eating, drinking, sleeping, and other natural necessities. Nor, on the other hand, can a man dispense with a wife. The reason for this is that procreating children is an urge planted as deeply in human nature as eating and drinking. That is why God has given and put into the body the organs, arteries, fluxes, and everything that serves it. Therefore what is he doing who would check this process and keep nature from running its desired and intended course? He is attempting to keep nature from being nature, fire from burning, water from wetting, and a man from eating, drinking, and sleeping.

Whoever intends to enter married life should do so in faith and in God's name. He should pray that it may prosper according to His will and that marriage may not be treated as a matter of fun and folly. It is a hazardous matter and as serious as anything on earth can be. Therefore we should not rush into it as the world does, in keeping with its frivolousness and wantonness and in pursuit of its pleasure; but before taking this step we should consult God, so that we may lead our married life to His glory. Those who do not go about it in this way may certainly thank God if it turns out well. If it turns out badly, they should not be surprised; for they did not begin it in the name of God and did not ask for His blessing.

The Reformation in the Wake of Luther

John Calvin and the Genevan Reformation

Although Lutheranism formed the basis of the Reformation, by the mid-16th century it had lost much of its energy and was confined to Germany and Scandinavia. The movement was spread throughout Europe by other reformers, the most influential of whom was John Calvin (1509–1564).

A trained lawyer and classical scholar, Calvin had been a convert to Luther's ideas and was forced to leave France, eventually settling in Geneva in the 1530s. There in the 1540s, he established a very structured society that can best be described as a theocracy. Calvin's strict adherence to biblical authority and his singular strength of personality can be seen in his treatise, On the Necessity of Reforming the Church. In it he defines the church as "a society of all the saints, a society spread over the whole world, and existing in all ages, yet bound together by the one doctrine and the one Spirit of Christ." In the words of Saint Cyprian, which Calvin often quoted, "We cannot have God for our Father without having the Church for our mother." The importance of this idea cannot be overestimated in Calvin's understanding of doctrine and of the reform of the church. In the following excerpt from his famous treatise, which was addressed to the Holy Roman Emperor Charles V in 1544, Calvin expressed disgust that the church had become divorced from the society of saints it was supposed to serve. The continuity of the church as a universal embodiment of all believers had to be reestablished through clerical reform and a reconceptualization of Spirit.

On the Necessity of Reforming the Church (1544)

JOHN CALVIN

In the present condition of the empire, your Imperial Majesty, and you, Most Illustrious Princes, necessarily involved in various cares, and distracted by a multiplicity of business, are agitated, and in a manner tempest-tossed. . . . I feel what nerve, what earnestness, what urgency, what ardor, the treatment of this subject requires. . . . First, call to mind the fearful calamities of the Church, which might move to pity even minds of iron. Nay, set before your eyes her squalid and unsightly form, and the sad devastation which is everywhere beheld. How long, pray, will you allow the spouse of Christ, the mother of you all, to lie thus protracted and afflicted—thus, too, when she is imploring your protection, and when the means of relief are at hand? Next, consider how much worse calamities impend. Final destruction cannot be far off, unless you interpose with the utmost speed. Christ will, indeed, in the way which to him seems good, preserve his Church miraculously, and beyond human expectation; but this I say, that the consequence of a little longer delay on your part will be, that in Germany we shall not have even the form of a Church. Look round, and see how many indications threaten that ruin which it is your duty to prevent, and announce that it is actually at hand. These things speak loud enough, though I were silent. . . .

Divine worship being corrupted by so many false opinions, and perverted by so many impious and foul superstitions, the sacred Majesty of God is insulted with atrocious contempt, his holy name profaned, his glory only not trampled under foot. Nay, while the whole Christian world is openly polluted with idolatry, men adore, instead of Him, their own fictions. A thousand superstitions reign, superstitions which are just so many open insults to Him. The power of Christ is almost obliterated from the minds of men, the hope of salvation is transferred from him to empty, frivolous, and insignificant ceremonies, while there is a pollution of the Sacraments not less to be execrated. Baptism is deformed by numerous additions, the Holy Supper [communion] is prostituted to all kinds of ignominy, religion throughout has degenerated into an entirely different form. . . .

In the future, therefore, as often as you shall hear the croaking note–"The business of reforming the Church must be delayed for the present"—"there will be time enough to accomplish it after other matters are transacted"—remember, Most Invincible Emperor, that the matter on which you are to deliberate is, whether you are to leave to your posterity some empire or none. Yet, why do I speak of posterity? Even now, while your own eyes behold, it is half bent, and totters to its final ruin. . . .

But be the issue what it may, we will never repent of having begun, and of having proceeded thus far. The Holy Spirit is a faithful and unerring witness to our doctrine. We know, I say, that it is the eternal truth of God that we preach. We are, indeed, desirous, as we ought to be, that our ministry may prove salutary to the world; but to give it this effect belongs to God, not to us. If, to punish, partly the ingratitude, and partly the stubbornness of those to whom we desire to do good, success must prove desperate, and all things go to worse, I will say what it befits a Christian man to say, and what all who are true to this holy profession will subscribe: We will die, but in death even be conquerors, not only because through it we shall have a sure passage to a better life, but because we know that our blood will be as seed to propagate the Divine truth which men now despise.

> "The power of Christ is almost obliterated from the minds of men, the hope of salvation is transferred from him to empty, frivolous, and insignificant ceremonies."
> —John Calvin

"On the Necessity of Reforming the Church" is from John Calvin, *Tracts and Treatises on the Reformation of the Church*, Vol. 1, trans. Henry Beveridge (Edinburgh: Calvin Translation Society, 1844), pp. 231–234.

Consider This:

- In the treatise *On the Necessity of Reforming the Church*, what is John Calvin's primary message to the Holy Roman Emperor Charles V? Do you think Calvin was exaggerating when he reminded the Emperor that "the matter on which you are to deliberate is, whether you are to leave to your posterity some empire or none"?

Predestination: *Institutes of the Christian Religion* (1536)

JOHN CALVIN

Calvin's doctrines were primarily Lutheran in nature, but Calvin went a step beyond and stressed the doctrine of predestination: One's salvation had already been determined by God, and those elect who had been "chosen" gave evidence of their calling by living exemplary lives. Calvinism became popular in the Netherlands and Scotland and it formed the core of the Puritan belief that was to be so influential in the colonization of America. The following excerpt reveals Calvin's justification for reform, his concept of predestination, and his strict regulation of lives and beliefs in Geneva.

The covenant of life is not preached equally to all, and among those to whom it is preached, does not always meet with the same reception. This diversity displays the unsearchable depth of the divine judgment, and is without doubt subordinate to God's purpose of eternal election. But it is plainly owing to the mere pleasure of God that salvation is spontaneously offered to some, while others have no access to it, great and difficult questions immediately arise, questions which are inexplicable, when just views are not entertained concerning election and predestination. . . . By predestination we mean the eternal decree of God, by which he

> "All are not created on equal terms, but some are preordained to eternal life, others to eternal damnation."
> —John Calvin

determined with himself whatever he wished to happen with regard to every man. All are not created on equal terms, but some are preordained to eternal life, others to eternal damnation; and, accordingly, as each has been created for one or other of these ends, we say that he has been predestined to life or to death. . . .

We say, then, that Scripture clearly proves this much, that God by his eternal and immutable counsel determined once for all those whom it was his pleasure one day to admit to salvation, and those whom, on the other hand, it was his pleasure to doom to destruction. We maintain that this counsel, as regards the elect, is founded on his free mercy, without any respect to human worth, while those whom he dooms to destruction are excluded from access to life by a just and blameless, but at the same time incomprehensible judgment. In regard to the elect, we regard calling as the evidence of election, and justification as another symbol of its manifestation, until it is fully accomplished by the attainment of glory. But as the Lord seals his elect by calling and justification, so by excluding the reprobate either from the knowledge of his name or the sanctification of his Spirit, he by these marks in a manner discloses the judgment which awaits them. I will here omit many of the fictions which foolish men have devised to overthrow predestination. There is no need of refuting objections which the moment they are produced abundantly betray their hollowness. I will dwell only on those points which either form the subject of dispute among the learned, or may occasion any difficulty to the simple. . . .

"Predestination" is from John Calvin, *Institutes of the Christian Religion*, Vol. 2, trans. Henry Beveridge (Edinburgh: Calvin Translation Society, 1845), pp. 529, 534, 540.

Consider This:
- How would you define the concept of predestination and why is it so efficient as a device for controlling a congregation? What is the basis for the success of the Calvinist movement?

Spiritual Exercises for the Catholic Reformation (1548)
IGNATIUS LOYOLA

During the Protestant movement, the Catholic church was active in its own efforts to reform from within. The Society of Jesus (Jesuits) was a religious order founded by Ignatius Loyola in 1540. Loyola (1491–1556) was a soldier who had turned to religion while recovering from wounds. Under Loyola's firm leadership, the Jesuits became a disciplined organization that was dedicated to serving the pope with unquestioned loyalty. The next selection from the famous Spiritual Exercises of Loyola demonstrates the purity and determination of these Catholic reformers.

1. Always to be ready to obey with mind and heart, setting aside all judgement of one's own, the true spouse of Jesus Christ, our holy mother our infallible and orthodox mistress, the Catholic Church, whose authority is exercised over us by the hierarchy.

2. To commend the confession of sins to a priest as it is practised in the Church; the reception of the Holy Eucharist once a year, or better still every week, or at least every month, with the necessary preparation.

4. To have a great esteem for the religious orders, and to give the preference to celibacy or virginity over the married state.

5. To approve of the religious vows of chastity, poverty, perpetual obedience, as well as the other works of perfection and supererogation. Let us remark in passing, that we must never engage by vow to take a state (such e.g. as marriage) that would be an impediment to one more perfect.

6. To praise relics, the veneration and invocation of Saints: also the stations, and pious pilgrimages, indulgences, jubilees, the custom of lighting candles in the churches, and other such aids to piety and devotion.

9. To uphold especially all the precepts of the Church, and not censure them in any manner; but, on the contrary, to defend them promptly, with reasons drawn from all sources, against those who criticize them.

10. To be eager to commend the decrees, mandates, traditions, rites and conduct; although there may not always be the uprightness of conduct that there ought to be, yet to attack or revile them in private or in public tends to scandal and disorder. Such attacks set the people against their princes and pastors; we must avoid such reproaches and never attack superiors before inferiors. The best course is to make private approach to those who have power to remedy the evil.

The Tridentine Index of Books (1564)

The Council of Trent from 1545 to 1563 was an involved effort by the Catholic Church to clarify its doctrine and bring about internal reform. The church sought to make its own stand in the face of the Protestant threat, and thus its traditional doctrinal views are set forth with firmness and confidence. One of the most significant actions of Trent was its reorganization

"Spiritual Exercises" is from Henry Bettenson, ed., *Documents of the Christian Church*, 2nd ed. (London: Oxford University Press, 1963), pp. 364–365. Copyright © 1963 by Oxford University Press. Reprinted by permission of Oxford University Press.

"The Tridentine Index of Books" is from J. Barry Colman, ed., *Readings in Church History*, rev. ed., Vol. 2 (Westminster, Md.: Christian Classics, Inc., 1985), pp. 705–706, 708.

and codification of laws concerning censorship and the prohibition of books. The following selection, published after the Council closed, sets out some of the restrictions. These general rules were in force until they were replaced with new decrees in 1897.

The holy council in the second session, celebrated under our most holy Lord, Pius IV, commissioned some fathers to consider what ought to be done concerning various censures and books either suspected or pernicious and to report to this holy council. . . .

1. All books which have been condemned either by the supreme pontiffs or by ecumenical councils before the year 1515 and are not contained in this list, shall be considered condemned in the same manner as they were formerly condemned.

2. The books of those heresiarchs, who after the aforesaid year originated or revived heresies, as well as those who are or have been the heads or leaders of heretics, as Luther, Zwingli, Calvin, Balthasar Friedberg, Schwenkfeld, and others like these, whatever may be their name, title or nature or their heresy, are absolutely forbidden. The books of other heretics, moreover, which deal professedly with religion are absolutely condemned. Those on the other hand, which do not deal with religion and have by order of the bishops and inquisitors been examined by Catholic theologians and approved by them, are permitted. Likewise, Catholic books written by those who afterward fell into heresy, as well as by those who after their fall returned to the bosom of the Church, may be permitted if they have been approved by the theological faculty of a Catholic university or by the general inquisition.

3. The translations of writers, also ecclesiastical, which have till now been edited by condemned authors, are permitted provided they contain nothing contrary to sound doctrine. Translations of the books of the Old Testament may in the judgment of the bishop be permitted to learned and pious men only. . . . Translations of the New Testament made by authors of the first class of this list shall be permitted to no one, since great danger and little usefullness usually results to readers from their perusal. . . .

4. Since it is clear from experience that if the Sacred Books are permitted everywhere and without discrimination in the vernacular, there will by reason of the boldness of men arise therefrom more harm than good, the matter is in this respect left to the judgment of the bishop or inquisitor, who may with the advice of the pastor or confessor permit the reading of the Sacred Books translated into the vernacular by Catholic authors to those who they know will derive from such reading no harm but rather an increase of faith and piety, which permission they must have in writing. Those, however, who presume to read or possess them without such permission may not receive absolution from their sins until they have handed them over to the authorities. . . .

5. Those books which sometimes produce the works of heretical authors, in which these add little or nothing of their own but rather collect therein the sayings of others, as lexicons, concordances, apothegms, parables, tables of contents and such like, are permitted if whatever needs to be eliminated in the additions is removed and corrected in accordance with the suggestions of the bishop, the inquisitor and Catholic theologians.

7. Books which professedly deal with, narrate or teach things lascivious or obscene are absolutely prohibited, since not only the matter of faith but also that of morals, which are usually easily corrupted through the reading of such books, must be taken into consideration, and those who possess them are to be severely punished by the bishops. Ancient books written by heathens may by reason of their elegance and quality of style be permitted, but may by no means be read to children.

8. Books whose chief contents are good but in which things have incidentally been inserted which have reference to heresy, ungodliness, divination or superstition, may be permitted if by the authority of the general inquisition they have been purged by Catholic theologians. . . .

> "If anyone should read or possess books by heretics . . . he incurs immediately the sentence of excommunication."

Finally, all the faithful are commanded not to presume to read or possess any books contrary to the prescriptions of these rules or the prohibition of this list. And if anyone should read or possess books by heretics or writings by any author condemned and prohibited by reason of heresy or suspicion of false teaching, he incurs immediately the sentence of excommunication.

Consider This:

- A critical issue of the Reformation era centered on the diverse means of attaining salvation. How is this issue reflected in the sources? According to Luther, Calvin, Loyola, and the Catholic Church, how is one saved? Be specific in your documentation.

- One of the most important questions of this period that separated the reformers from the church centered on religious authority. In spiritual matters, did religious authority rest in the church (as dictated by the pope), in church councils (such as Trent), in scripture, or in individual conscience? How is this problem reflected in the sources?

Compare and Contrast:

- Read carefully the selection entitled "Spiritual Exercises for the Catholic Reformation." What specifically does Loyola demand from the Catholic faithful? Compare these guidelines to the dictates of the Tridentine Index of Books. Can faith be enforced in this manner? Some historians have called the Catholic reform movement the "Counter Reformation." What does this imply?

The Broader Perspective:

- Do you think a reformation of the church would have occurred without Martin Luther? How important was Luther in changing history?

The Artistic Vision

EL GRECO AND THE MANNERIST STYLE

Figure 7–9 El Greco, *Christ on the Cross Adored by Donors* (1585–1590) (Art Resource/Reunion des Musées Nationaux).

El Greco ("The Greek") remains one of the great enigmas of the art world. For nearly two and a half centuries after his death in 1614, he was regarded as a misguided eccentric, a lunatic by some counts, whose mystical spirituality was little understood outside of the confines of his adopted country, Spain. Then, about 1850, critics and artists began to rediscover and reevaluate the depth of his artistic vision. This was no lunatic, but a sophisticated humanist whose cultivated mind found compatible links to a highly developed sense of the spirit. El Greco has been accepted as one of the great painters of Western Civilization, a prophet of modern artistic vision.

Doméikos Theotokópoulos was born in Iráklion, Crete, in 1541. Because Crete was a possession of the Venetian Republic at the time, he decided to pursue his studies in Venice. About 1560, he entered the studio of Titian, who was the greatest painter of his day, and learned the sophisticated Italian style of the High Renaissance that emphasized the importance of imitation and architectural setting that was perfected in the astonishing paintings of Raphael. Yet many artists were moving beyond the limitations of harmonious classicism. Between about 1520 and 1590, a new style called Mannerism developed in reaction to the idealized vision of the Renaissance. Mannerism was characterized by graceful, but strangely elongated limbs, smaller heads, and stylized facial features. Exaggeration was a particular feature as constricted spatial arrangements, a dense composition and the use of intense colors in strange juxtapositions gave new energy to the relationships between artistic figures. Michelangelo's huge fresco, The Last Judgment *(1533–1541) in the Sistine Chapel demonstrates Mannerist tendencies with the tortured poses and exaggerated movements of the nude figures.*

El Greco was certainly influenced by this style during his Italian period before he arrived in Spain in the spring of 1577. Under the leadership of Philip II (1556–1598) and Philip III (1598–1621), Spain became increasingly overextended and financially exhausted as military adventures against the English and Dutch led to a greater dependency on the importation of

silver from its New World empire. This, in turn, eventually contributed to inflationary pressures on the Spanish economy.

This was a society hyperconcious of honor, caste, and status, whose king regarded himself as the temporal defender of the Catholic faith. The Spanish Inquisition had checked intellectual inquiry, although painting, theater, and literature continued to flourish as reflected in the success of Miguel de Cervantes's Don Quixote. *But religious orthodoxy was the watchword and El Greco worked within established boundaries supported by patronage from the local nobility and learned clergymen of the archdiocese of Toledo, the official center of Spanish Catholicism. El Greco's art became a conduit through which the policies of the Catholic Reformation might be promulgated. In his paintings, he emphasized the veneration of saints and the glorification of the Virgin Mary, the value of penance, and the spiritual evocation of God's presence that was so much a part of Spanish mysticism.*

The Burial of Count Orgaz *(1586–1588) is universally regarded as El Greco's masterpiece. It portrays Gonzalo de Ruiz, Count of Orgaz as he is laid to rest in his grave by Saints Stephen and Augustine. The count's soul ascends to Heaven which is densely populated with angels, saints, and even King Phillip II, if a bit prematurely. In life, the count was known for his generous charity, and this supported the church's policy, challenged by Luther, that good works played an important role in salvation. This painting displays some of the more typical Mannerist characteristics of elongated figures and the dense composition where all of the action takes place in the front plane. The yellows and reds in this work are particularly vibrant.*

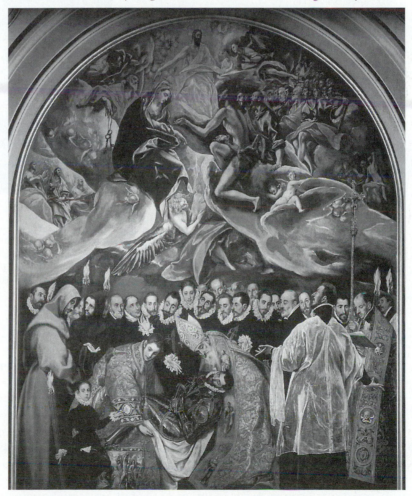

Figure 7–10 El Greco, *The Burial of Count Orgaz* (1586) (SuperStock, Inc.).

Another painting completed during this same period, Christ on the Cross Adored by Donors *(1585–1590) emphasizes the gentle sway of the elongated body of Christ set amidst an ominous sky that appears in many of his backgrounds. All pious eyes are on Christ as he extends their gaze to Heaven. In El Greco's later works, the Mannerist elongation and intense spirituality becomes more pronounced. In* The Adoration of the Shepherds *(1612–1614) painted at the end of El Greco's life, the supernatural glow that is focused on Christ and highlights the other swirling figures reflects that mystical dimension of Christ's presence within all believers.*

Figure 7–11 El Greco, *Adoration of the Shepherds* (1612–1614) (Art Resource, N.Y.).

Consider This:

- Why was El Greco's Mannerist style allowed to develop under the close scrutiny of the Spanish state and Catholic church? If Christ were Perfect, then why not demand perfection from artists in their depiction of Him and the Holy Family? Why was style less important than doctrine for the Catholic church?

- El Greco had a significant library and read widely from classical authors. Many art historians have referred to his humanist interests that had been developed in Italy. How could a humanist prosper in a nation so thoroughly dominated by the strictures of religious doctrine and proper behavior? What does this say about the values of humanism and El Greco's ability to find reconciliation between God and man?

The Mystical Experience of Saint Teresa
SAINT TERESA OF AVILA

The Catholic Reformation was advanced by those like Ignatius Loyola who advocated an active and disciplined resistance to Protestantism in the world at large. Others, like Saint Teresa of Avila, struggled in poverty behind convent walls to guide her nuns to a pureness of thought in order to achieve the "Way of Perfection." By writing her autobiography in 1565, she hoped to influence others to choose a simple life of faith and commitment to God.

Teresa was born in Avila, Spain, in 1515, but her family originated in Toledo. After entering a Carmelite convent at age 18, she had several transitory mystical experiences where she felt God's presence within her very soul as she describes in the following selection from her autobiography.

"The Mystical Experience of Saint Teresa," is from David Lewis, trans., *The Life of Saint Teresa of Avila* (London: Thomas Baker, 1854), 5.27 and 5.30.

At the end of two years that were spent in prayer by myself and by others for this end—namely, that our Lord would either lead me by another way or show me the truth of this (for now appearances of our Lord were extremely frequent)—this happened to me. I was in prayer one day. It was the feast of the glorious Saint Peter, and I saw Christ close to me; or to describe it more accurately, I felt Him. For I saw nothing with the eyes of the body, nor anything with the eyes of the soul. He seemed to me to be so close beside me. And I also believe I saw that He was speaking to me.

As I was completely ignorant that such a vision was possible, I was very much afraid at first, and did nothing but weep. However, He spoke to me with one word to assure me. I recovered myself, and was, as usual, calm and comforted without any fear at all. Jesus Christ seemed to be by my side continually. As the vision was not imaginary, I saw no form. But I had a most profound feeling that He was always on my right hand, as a witness of all that I did. Never at any time, unless I was too much distracted, could I be unconscious of His near presence.

In great distress, I went at once to see my confessor and tell him about it. He asked in what form I saw our Lord. I told him I saw no form. He then said: "How did you know that it was Christ?" I replied that I did not know how I knew it.

But I could not help knowing that Jesus Christ was close beside me, and that I saw Him distinctly, and felt His presence. . . . For someone who has experienced the mystical events I have, there can be no pleasure or comfort that equals that of meeting someone else whom the Lord had raised in the same way.

Linking the Humanities:

- This mystical element that Saint Teresa discusses, the personal engagement with God and spiritual evocation of God's presence, can be discerned in the divine glow that emanates from members of the Holy Family throughout El Greco's work. There really is no sun in his art, but the illumination in his religious work is always present. How were the experiences of Saint Teresa of Avila and the art of El Greco reflective of Spanish values during the turn of the 17th century?

Compare and Contrast:

- Compare Saint Teresa's complete commitment to faith with the stinging sarcastic criticism of the church by the northern humanist, Desiderius Erasmus, who had at one time taken holy vows. How do their two perspectives reflect the different posturings of the spirit during the 16th century?

- In this regard, compare the art of El Greco painted late in the 16th century with the visions of Albrecht Dürer and Hieronymus Bosch completed at the beginning of the century? How do they reflect a different spiritual outlook?

The Thought and Literature of the Age

Utopia

SIR THOMAS MORE

Sir Thomas More (1478–1535) became famous for his opposition to King Henry VIII of England. As Henry's Lord Chancellor, More was expected to support the king's divorce from Catherine of Aragon and his authority as head of the newly created Church of England. But More refused to take an oath impugning the pope's supremacy and paid the price when he was beheaded in 1535. More was made a saint of the Catholic church four hundred years later.

"Utopia" is from Thomas More, *Utopia*, trans. Paul Turner (Baltimore, Md., and Harmondsworth, Middlesex: Penguin Books, 1965), pp. 66–67, 76–77. Copyright © 1947 by Paul Turner. Reprinted by permission of Penguin Books, Ltd.

But long before this dramatic climax to his life, Thomas More cultivated his reputation for honesty and intellectual brilliance as a scholar and statesman. The Dutch humanist, Erasmus, was a good friend and described More as a very engaged and provocative thinker. Nowhere is this in better evidence than in More's most famous work, Utopia.

We spend a lot of time in our contemporary world thinking of the perfect society where all the complex problems surrounding us are resolved in harmonious balance. But this fantasy has long been contemplated over the centuries in the Sumerian epic of Gilgamesh and the Elysian fields of Homer, the celestial vision of Saint Augustine's City of God and the worker's utopia of Karl Marx. Thomas More, however, was the first to present a detailed literary description of the ideal society. He based his conception on Plato's Republic, *but chose to locate his utopia in the New World. This afforded him an opportunity to comment on the contemporary social and political problems of Europe in a less direct and perhaps safer way.*

In More's perfect society, there is a high regard for justice—a few simple laws, assiduously enforced without capital punishment and without lawyers. Utopia *is a witty exposition of possibilities where society offers material benefits for all, including food, clothing, housing, education, and medical treatment.*

All of these bare necessities of life are provided by the state in exchange for a short work day of six hours. However, one must exchange a significant measure of personal liberty for these benefits. There is no private property, but there is virtually no privacy either. In More's utopia, "Everyone has his eye on you so you're practically forced to get on with your job, and make proper use of your spare time." This also was a patriarchal society where each month women had to confess "all their sins of omission and commission, and ask to be forgiven." Yet, males were apparently exempt from this provision. In sexual matters, consequences were unforgiving. Premarital sex was punished by compulsory celibacy for life, and adultery by slavery and even death for repeated offenses. More's vision was of a moral landscape, free from want, attuned to need, but cognizant of moral obligation.

The following excerpt is a dialogue between Raphael Nonesenso, who had just returned from the New World, and Thomas More as they discuss the parameters of utopian society.

Raphael: Though to tell you the truth, my dear More, I don't see how you can ever get any real justice or prosperity, so long as there's private property, and everything's judged in terms of money—unless you consider it just for the worst sort of people to have the best living conditions, or unless you're prepared to call a country prosperous, in which all the wealth is owned by a tiny minority—who aren't entirely happy even so, while everyone else is simply miserable.

In fact, when I think of the fair and sensible arrangements in Utopia, where things are run so efficiently with so few laws, and recognition of individual merit is combined with equal prosperity for all—when I compare Utopia with a great many capitalist countries which are always making new regulations, but could never be called well-regulated, where dozens of laws are passed every day, and yet there are still not enough to ensure that one can either earn, or keep, or safely identify one's so-called private property—or why such an endless secession of never-ending lawsuits?—when I consider all this, I feel much more sympathy with Plato, and much less surprise at his refusal to legislate for a city that rejected egalitarian principles. It was evidently quite obvious to a powerful intellect like his that the one essential condition for a healthy society was equal distribution of goods—which I suspect is impossible under capitalism. For, when everyone's entitled to get as much for himself as he can, all available property, however much there is of it, is bound to fall into the hands of a small minority, which means that everyone else is poor. And wealth will tend to vary in inverse proportion to merit. The rich will be greedy, unscrupulous, and totally useless characters, while the poor will be simple, unassuming people whose daily work is far more profitable to the community than it is to them.

In other words, I'm quite convinced that you'll never get a fair distribution of goods, or a satisfactory organization of human life, until you abolish private property altogether. So long as it exists, the vast majority of the human race, and the vastly superior part of it, will inevitably go on laboring

under a burden of poverty, hardship, and worry. I don't say that the burden can't be reduced, but you'll never take it right off their shoulders. . . .

> "I'm quite convinced that you'll never get a fair distribution of goods, or a satisfactory organization of human life, until you abolish private property altogether."
> —Raphael Nonesenso

More: I disagree. I don't believe you'd ever have a reasonable standard of living under a communist system. There'd always tend to be shortages, because nobody would work hard enough. In the absence of a profit motive, everyone would become lazy, and rely on everyone else to do the work for him. Then, when things really got short, the inevitable result would be a series of murders and riots, since nobody would have any legal method of protecting the products of his own labor—especially as there wouldn't be any respect for authority, or I don't see how there could be, in a classless society.

Raphael: You're bound to take that view, for you simply can't imagine what it would be like—not accurately, at any rate. But if you'd been with me in Utopia, and seen it all for yourself, as I did—I lived there for more than five years, you know, and the only reason why I ever left was that I wanted to tell people about the New World—you'd be the first to admit that you'd never seen a country so well organized. . . .

In Utopia they have a six-hour working day—three hours in the morning, then lunch—then a two-hour break—then three more hours in the afternoon, followed by supper. They go to bed at 8 P.M., and sleep for eight hours. All the rest of the twenty-four they're free to do what they like—not to waste their time in idleness or self-indigence, but to make good use of it in some congenial activity. Most people spend these free periods on further education. . . .

But here's a point that requires special attention, or you're liable to get the wrong idea. Since they only work a six-hour day, you may think there must be a shortage of essential goods. On the contrary, those six hours are enough, and more than enough to produce plenty of everything that's needed for a comfortable life. And you'll understand why it is, if you reckon up how large a proportion of the population in other countries is totally unemployed. First you have practically all the women—that gives you nearly fifty per cent for a start. And in countries where the women *do* work, the men tend to lounge about instead. Then there are all the priests, and members of so-called religious orders—how much work do they do? Add all the rich, especially the landowners, popularly known as nobles and gentlemen. Include their domestic staffs—I mean those gangs of armed ruffians that I mentioned before. Finally, throw in all the beggars who are perfectly hale and hearty, but pretend to be ill as an excuse for being lazy. When you've counted them up, you'll be surprised to find how few people actually produce what the human race consumes. . . . But in Utopia, the facts speak for themselves. There, out of all the able-bodied men and women who live in a town, or in the country round it, five hundred at the most are exempted from ordinary work.

Consider This:

- In the dialogue, Raphael argues that "the one essential condition of a healthy society was the equal distribution of goods," which he believed was impossible under capitalism. Do you agree? How does More counter this argument?

- According to Raphael, why is a six-hour day sufficient to provide all that's needed for "a comfortable life." For Utopians, what is a comfortable life? How do they spend their free time? What assumptions does Raphael make about human beings that might make his vision of utopia problematic?

On Cannibals
MICHEL DE MONTAIGNE

Michel de Montaigne (1533–1592) was born the son of a lawyer and landowner in Bordeaux, France. He studied philosophy and law amid the general religious disorder that was ravaging France during the middle of the 16th century. The contending Huguenot and Catholic factions produced a barbaric chaos as justice was sought in extreme action, the slaughter of innocents, the execution by fire at the stake. Montaigne became skeptical of understanding the world, but sought to find balance through a personal quest for truth. He rejected easy theories and sought to test himself through a series of "trials" or "essays" that forced him to set out on a voyage of self-discovery without the protection of an egotistical spirit or fear of religious condemnation. Montaigne wrote on many subjects: cruelty, friendship, the imagination, repentance, and in the following selection, on cannibals.

As the exploration of the New World produced great wealth and opportunity, it also presented moral dilemmas about the horrors of conquest and the treatment of peoples from new and exotic lands with strange customs and social expectations. Were these "noble savages" or vicious barbarians? And could their barbaric acts of cannibalism compare with the atrocities that attended European religious rivalries? In the following selection, Montaigne struggles with the question of human depravity.

> **"We call barbarous anything that is contrary to our own habits."**
> **—Michel de Montaigne**

Now, to return to my argument, I do not believe, from what I have been told about this people, that there is anything barbarous or savage about them, except that we all call barbarous anything that is contrary to our own habits. Indeed, we seem to have no other criterion of truth and reason than the type and kind of opinions and customs current in the land where we live. There we always see the perfect religion, the perfect political system, the perfect and most accomplished way of doing everything. These people are wild in the same way as we say that fruits are wild, when nature has produced them by herself and in her ordinary way; whereas, in fact, it is those that we have artificially modified, and removed from the common order, that we ought to call wild. In the former, the true, most useful, and natural virtues and properties are alive and vigorous; in the latter we have bastardized them, and adapted them only to the gratification of our corrupt taste. . . .

These nations, then, seem to me barbarous in the sense that they have received very little molding from the human intelligence, and are still very close to their original simplicity. They are still governed by natural laws and very little corrupted by our own. They are in such a state of purity that it sometimes saddens me to think we did not learn of them earlier, at a time when there were men who were better able to appreciate them than we. . . .

This is a nation in which there is no kind of commerce, no knowledge of letters, no science of numbers, no title of magistrate or of political superior, no habit of service, riches or poverty, no contracts, no inheritance, no divisions of property, only leisurely occupations, no respect for any kinship but the common ties, no clothes, no agriculture, no metals, no use of corn or wine. The very words denoting lying, treason, deceit, greed, envy, slander, and forgiveness have never been heard. . . .

For the rest, they live in a land with a very pleasant and temperate climate, and consequently, as my witnesses inform me, a sick person is a rare sight; and they assure me that they never saw anyone palsied or blear-eyed, toothless or bent with age. These people inhabit the seashore, and are shut in on the landward side by a range of high mountains, which leave a strip about a

"On Cannibals" is from Michel de Montaigne, *Essays*, trans. J. M. Cohen (Baltimore, Md., and Harmondsworth, Middlesex: Penguin Books, 1958), pp. 108–113. Copyright © 1947 by J. M. Cohen. Reprinted by permission of Penguin Books, Ltd.

hundred leagues in depth between them and the sea. They have a great abundance of fish and meat which bear no resemblance to ours, and they eat them plainly cooked, without any other preparation. The first man who brought a horse there, although he had made friends with them on some earlier voyages, so terrified them when in the saddle that they shot him to death with arrows before recognizing him. . . .

They spend the whole day dancing. Their young men go hunting after wild beasts with bows and arrows. Some of their women employ themselves in the meantime with the warming of their drink, which is their principal duty. In the morning, before they begin to eat, one of their old men preaches to the whole barnful, walking from one end to the other, and repeating the same phrase many times, until he has completed the round—for the buildings are quite a hundred yards long. He enjoins only two things upon them: valor against the enemy and love for their wives. And he never fails to stress this obligation with the refrain that it is they who keep their drink warm and well-seasoned for them. . . .

They have their wars against the people who live further inland, on the other side of the mountains; and they go to them quite naked, with no other arms but their bows or their wooden swords, pointed at the end like the heads of our boar-spear. It is remarkable with what obstinacy they fight their battles, which never end without great slaughter and bloodshed. As for flight and terror, they do not know what they are. Every man brings home for a trophy the head of an enemy he has killed, and hangs it over the entrance of his dwelling. After treating a prisoner well for a long time, and giving him every attention he can think of, his captor assembles a great company of his acquaintances. He then ties a rope to one of the prisoner's arms, holding him by the other end, at some yards' distance for fear of being hit, and gives his best friend the man's other arm, to be held in the same way; and these two, in front of the whole assembly, despatch him with their swords. This done, they roast him, eat him all together, and send portions to their absent friends. They do not do this, as might be supposed, for nourishment, but as a measure of extreme vengeance. The proof of this is that when they saw the Portuguese, who had allied themselves with their enemies, inflicting a different sort of death on their prisoners—which was to bury them to the waist, to shoot the rest of their bodies full of arrows, and then to hang them—they concluded that these people from another world who had spread the knowledge of so many wickednesses among their neighbors, and were much more skilled than they in all sorts of evil, did not choose this form of revenge without a reason. So, thinking that it must be more painful than their own, they began to give up their old practice and follow this new one.

I am not so anxious that we should note the horrible savagery of these acts as concerned that, while judging their faults correctly, we should be so blind to our own. I consider it more barbarous to eat a man alive than to eat him dead; to tear by rack and torture a body still full of feeling, to roast it by degrees, and then give it to be trampled and eaten by dogs and swine—a practice which we have not only read about, but seen within recent memory not between ancient enemies, but between neighbors and fellow-citizens and, what is worse, under the cloak of piety and religion—than to roast and eat a man after he is dead.

Consider This:

- Montaigne describes these natives as "wild." What did he mean? What were Montaigne's criticisms of his contemporary European society?

- Why did the natives eat their enemies? Can a society that commits such an act truly have any civilized qualities? What are the standards of "civilization?" How did Montaigne's essay test his personal beliefs on the subject?

Compare and Contrast:

- What did the natives learn from the Portuguese treatment of their enemies? What point was Montaigne trying to make here? Were the natives "noble savages"?

- Compare Montaigne's description of the way the natives live with Thomas More's description of life in Utopia. How is the "natural environment" of the New World idealized? What were the drawbacks?

The Reflection in the Mirror

THE BLOODY WARS OF RELIGION

The Saint Bartholomew's Day Massacre (1572): "A Thousand Times More Terrible Than Death Itself"

THE DUKE OF SULLY

After the Council of Trent in 1563, Catholic forces, led by Jesuit-inspired activists, began an offensive against equally dogmatic and aggressive Calvinists, who were determined to secure full religious toleration. The wars of religion that followed were both internal conflicts and international struggles that engaged virtually every major European nation from the 1560s until the resolution of the Thirty Years' War in 1648.

The following selection is an eyewitness account of the Saint Bartholomew's Day Massacre in 1572. Catherine De Medici, as French regent for her son Charles IX, sought to maintain a precarious balance between Protestant and Catholic influence within her court. When it appeared that the scale was tilting in favor of the Protestants and that her position might be threatened, she convinced Charles that a Huguenot plot against the monarchy was afoot.

On the eve of Saint Bartholomew's Day in 1572, 3,000 Huguenots were butchered in Paris and over 20,000 died throughout France during the ensuing three-day massacre. After this, Protestant leaders became convinced that an international struggle to the death must be pursued against a brutal Catholic foe. The Duke of Sully (1560–1641), who later became ambassador and finance minister to King Henry IV, was only 12 when he viewed the massacre firsthand—but he never forgot it.

Keep in Mind:
• What adjectives does the Duke of Sully use to describe the death of the Huguenots (French Protestants) in this incident?

If I were inclined to increase the general horror inspired by an action so barbarous as that perpetrated on the 24th of August, 1572, and too well known by the name of the *massacre of St. Bartholomew*, I should in this place enlarge upon the number, the rank, the virtues, and great talents of those who were inhumanly murdered on that horrible day, as well in Paris as in every other part of the kingdom; I should mention at least the ignominious treatment, the fiend-like cruelty, and savage insults these miserable victims suffered from their butchers, whose conduct was a thousand times more terrible than death itself.

I have writings still in my hands which would confirm the report, of the court of France having made the most pressing solicitations to the courts of England and Germany, to the Swiss and the Genoese, to refuse an asylum to those Huguenots who might fly from France; but I prefer the honor of the nation to the satisfying of a malignant pleasure. . . .

"The Saint Bartholomew's Day Massacre" is from Bayle St. John, ed., *Memoirs of the Duke of Sully*, Vol. 1 (London: George Bell and Sons, 1877), pp. 85–87.

Intending on that day to wait upon the king my master [Henry of Navarre, who became King Henry IV of France], I went to bed early on the preceding evening; about three in the morning I was awakened by the cries of people, and the alarm-bells, which were everywhere ringing. . . . I was determined to escape to the College de Bourgogne, and to effect this I put on my scholar's gown, and taking a book under my arm, I set out. In the streets I met three parties of the Life-guards; the first of these, after handling me very roughly, seized my book, and, most fortunately for me, seeing it was a roman Catholic prayer-book, suffered me to proceed, and this served me as a passport with the two other parties. As I went along I saw the houses broken open and plundered, and men, women, and children butchered, while a constant cry was kept up of, "Kill! Kill! O you Huguenots! O you Huguenots!" This made me very impatient to gain the college, where, through God's assistance, I at length arrived, without suffering any other injury than a most dreadful fright.

Compare and Contrast:

- Why did the Saint Bartholomew's Day massacre take place? Why did Catholics feel so threatened? Were these Huguenots killed for political or religious reasons?

- Compare this example of destruction with that of the Crusades about 1100 on page 206. Why were the Crusades fought? Is intolerance a natural by-product of faith or a necessity of power?

The Broader Perspective:

- In Michel de Montaigne's essay *On Cannibals*, he discussed the acts of "horrible savagery" perpetrated by the natives, but chided that "we should not be so blind to our own." Would the Saint Bartholomew's Day massacre qualify as an act of barbarism? How thin is the line between civilization and barbarism?

"Tilting at Windmills": *Don Quixote*
MIGUEL DE CERVANTES

Don Quixote *by Miguel de Cervantes (1547–1615) was one of the first novels in Western literature and has maintained its popular appeal for generations. It is basically a satire or parody of the chivalric ideals that were so influential among the nobility in Spain during the late 16th century. Burdened by debt and in and out of prison, Cervantes gave up the life of a soldier and turned to writing in order to support his family. The success of* Don Quixote *in 1605 led to another volume of his adventures in 1615.*

In many ways, the characters and theme rather than the plot remain the most memorable aspects of the novel. Don Quixote, as the embodiment of a detached Spanish nobility, alive in his dreams, but devoid of any real authority or purpose in a declining Spain, is joined by the simple peasant, Sancho Panza. Sancho represents the burdened lower classes who live in a desperate world enslaved by the reality of exploitation and doomed to a future without hope.

The two characters set out together, one a complete romantic on a quest for glory to prove himself worthy of knighthood and the honor of his ideal Lady Dulcinea, and the other, the realist who only wants guarantees of safety and continuity in a world he can't change. Through their adventures, they grow together and discover that life without dreams cannot sustain the soul, though the dreams may come to nothing in the end.

"Tilting at Windmills" is from Miguel De Cervantes, *Don Quixote*, trans. J. M. Cohen (Baltimore, Md., and Harmondsworth, Middlesex: Penguin Books, 1950), pp. 108–113. Copyright © 1950 by J. M. Cohen, pp. 76–80. Reprinted by permission of Penguin Books, Ltd.

At that moment they caught sight of some thirty or forty windmills, which stand on that plain, and as soon as Don Quixote saw them he said to his squire: "Fortune is guiding our affairs better than we could have wished. Look over there, friend Sancho Panza, where more than thirty monstrous giants appear. I intend to do battle with them and take all their lives. With their spoils we will begin to get rich, for this is a fair war, and it is a great service to God to wipe such a wicked brood from the face of the earth."

"What giants?" asked Sancho Panza.

"Those you see there," replied his master, "with their long arms. Some giants have them about six miles long."

"Take care, your worship," said Sancho, "those things over there are not giants but windmills, and what seem to be their arms are the sails, which are whirled round in the wind and make the millstone turn."

"It is quite clear," replied Don Quixote, "that you are not experienced in these matter of adventures. They are giants, and if you are afraid, go away and say your prayers, whilst I advance and engage them in fierce and unequal battle."

As he spoke, he dug his spurs into his steed Rocinante, paying no attention to his squire's shouted warning that beyond all doubt they were windmills and not giants he was advancing to attack. But he went on, so positive that they were giants that he neither listened to Sancho's cries nor noticed what they were, even when he got near them. Instead, he went on shouting in a loud voice: "Do not fly, cowards, vile creatures, for it is one knight alone who assails you."

At that moment a slight wind arose, and the great sails began to move. At the sight of which Don Quixote shouted: "Though you wield more arms than the giant Brareus, you shall pay for it!" Saying this, he commended himself with all his soul to his Lady Dulcinea, beseeching her aid in his great peril. Then, covering himself with his shield and putting his lance in the rest, he urged Rocinante forward at a full gallop and attacked the nearest windmill, thrusting his lance into the sail. But the wind turned it with such violence that it shattered his weapon in pieces, dragging the horse and his rider with it, and sent the knight rolling badly injured across the plain. Sancho Panza rushed to his assistance as fast as his ass could trot, but when he came up he found that the knight could not stir. Such a shock had Rocinante given him in their fall.

"O my goodness!" cried Sancho. "Didn't I tell your worship to look what you were doing, for they were only windmills? Nobody could mistake them, unless he had windmills on the brain."

"Silence, friend Sancho," replied Don Quixote. "Matters of war are more subject than most to continual change. What is more, I think—and that is the truth—that the same sage Friston who robbed me of my room and my books has turned those giants into windmills, to cheat me of the glory of conquering them. Such is the enmity he bears me; but in the very end his black arts shall avail him little against the goodness of my sword."

"God send it as He will," replied Sancho Panza, helping the knight to get up and remount Rocinante, whose shoulders were half dislocated.

As they discussed the last adventure they followed the road to the pass of Lapice where, Don Quixote said, they could not fail to find many and various adventures, as many travelers passed that way. He was much concerned, however, at the loss of his lance, and, speaking of it to his squire, remarked: "I remember reading that a certain Spanish knight called Diego Perez de Vargas, having broken his sword in battle, tore a great bough or limb from an oak, and performed such deeds with it that day, and pounded so many Moors [Muslims], that he earned the surname of the Pounder, and thus he and his descendants from that day onwards have been called Vargas y Machuca. I mention this because I propose to tear down just such a limb from the first oak we meet, as big and as good as his, and I intend to do such deeds with it that you may consider yourself most fortunate to have won the right to see them. For you will witness things which will scarcely be credited."

"With God's help," replied Sancho, "and I believe it is as your worship says. But sit a bit more upright, sir, for you seem to be riding lop-sided. It must be from the bruises you got when you fell."

"That is the truth," replied Don Quixote. "And if I do not complain of the pain, it is because a knight errant is not allowed to complain of any wounds, even though his entrails may be dropping out through them."

"If that's so, I have nothing more to say," said Sancho, "but God knows I should be glad if your worship would complain if anything hurt you. I must say, for my part, that I have to cry out at the slightest twinge, unless this business of not complaining extends to knights errants' squires as well."

Don Quixote could not help smiling at his squire's simplicity and told him that he could certainly complain how and when he pleased, whether he had any cause or not, not up to that time he had never read anything to the contrary in the law of chivalry. . . .

They passed that night under some trees, from one of which our knight tore down a dead branch to serve him as some sort of lance, and stuck into it the iron head of the one that had been broken. And all night "Don Quixote did not sleep but thought about his Lady Dulcinea, to conform to what he had read in his books about knights errant spending many sleepless nights in woodland and desert dwelling on the memory of their ladies. Not so Sancho Panza; for, as his stomach was full, and not of chicory water, he slept right through till morning. And, if his master had not called him, neither the sunbeams, which struck him full on the face, nor the song of the birds, who in great number and very joyfully greeted the dawn of the new day, would have been enough to wake him. . . .

Don Quixote wanted no breakfast for, as we have said, he was determined to subsist on savory memories. Then they turned back on to the road they had been on before, towards the pass of Lapice, which they sighted about three in the afternoon.

> **"Here, brother Sancho Panza, we can steep our arms to the elbows in what they call adventures."**
>
> **—Don Quixote de la Mancha**

"Here," exclaimed Don Quixote on seeing it, "here, brother Sancho Panza, we can steep our arms to the elbows in what they call adventures. But take note that though you see me in the greatest danger in the world, you must not put your hand to your sword to defend me, unless you know that my assailants are rabble and common folk; in which case you may come to my aid. But should they be knights, on no account will it be legal or permissible, by the laws of chivalry, for you to assist me until you are yourself knighted."

"You may be sure, sir," replied Sancho, "that I shall obey your worship perfectly there. Especially as I am very peaceable by nature and all against shoving myself into brawls and quarrels. But as to defending myself, sir, I shan't take much notice of those rules, because divine law and human law allow everyone to defend himself against anyone who tries to harm him."

"I never said otherwise," replied Don Quixote, "but in the matter of aiding me against knights, you must restrain your natural impulses."

"I promise you I will," replied Sancho, "and I will observe this rule as strictly as the Sabbath."

Consider This:

- What are the primary themes contained in this excerpt from *Don Quixote*?

- Note how Don Quixote has an unlimited capacity to avoid the truth of reality by constantly reinterpreting Sancho's warnings in a manner consistent with his ideals. Do human beings often distort reality for their own benefit? Why? How is this sometimes important to motivate and sustain inspiration? Which pathway, however, is more rewarding in life? That of Sancho Panza or Don Quixote?

The Broader Perspective:

- Michel de Montaigne in his essays hoped to find personal truth and reality independent of what others argued. Would you find a bit of Don Quixote in his approach to the world—or more of Sancho Panza's reality? Why is Truth so elusive? Is there no absolute truth about anything? Are all truths relative?

"And Sure Brutus Is an Honorable Man": Antony's Funeral Oration

WILLIAM SHAKESPEARE

William Shakespeare (1564–1616) occupies a central position in world literature as arguably the greatest dramatist of all time. Born in Stratford, England, near the Avon River, Shakespeare's prodigious output of plays and poetry testifies to his reputation as a writer of great intellectual and psychological depth, vast emotional range, and poetic power. He was an astute observer of human behavior who in complex characterizations plumbed the depths of human motivation and explored the moral consequences of rash action and studied deceit. Shakespeare held a mirror to the human soul and reflected the tangled web of fear and betrayal, greed and revenge that articulated the "star crossed" dimensions of human tragedy. His was not a bookish or abstract presentation of stolid moralism; rather, Shakespeare entertained the crowd with vivid action, low comedy and sophisticated wit, complex plots, mistaken identities, the joy of lovers reconciled and the pain of love denied. He spoke directly with an eye to popular approval and obliquely with a whisper of intellectual insight. The "Bard of Avon" still continues to mesmerize those who are willing to engage his formidable mind and human vision. The prophecy of Shakespeare's contemporary, Ben Jonson, himself a great poet and dramatist, that the bard "was not of an age, but for all time," has certainly been fulfilled.

One of Shakespeare's most accessible and fascinating plays is Julius Caesar. *The Roman statesman, general, and dictator only appears in three scenes and is assassinated before the play is half-finished. Therefore, this has been called the tragedy of Brutus, an honorable man who was pressured to live his republican ideals by lending his support to a conspiracy fashioned by lesser men of ambition like Cassius and Casca. Brutus acquiesced to the assassination of his friend and colleague because Caesar presented a clear threat to the political freedom so dear to Brutus's sense of justice. Brutus could justify Caesar's murder as a practical necessity for the good of Rome but did not have the stomach to see the game to its conclusion and survive the moral hailstorm that would demand the immediate death of all those who might avenge Caesar. Brutus, therefore, fell victim to his own sense of honor—too good to steep himself in the bloodshed that would have provided personal security, too naive to forsake his political ideals in a dangerous world.*

Shakespeare's Julius Caesar *exhibits a sharp verbal edge and all the engaging elements of honor, conspiracy, political eloquence, naive idealism, lust for power, mob action, supernatural portents, battle, and violent death. The following excerpt comes from the most famous speech in the play, when Mark Antony, Caesar's chief lieutenant and friend, understanding the danger and opportunities created in the political vacuum following Caesar's death, moves to secure the upper hand. He was allowed by the conspirators to address the crowd after Brutus in his own stirring oration had justified Caesar's murder in the name of liberty. Antony's speech is a wonder of deft argument and controlled sarcasm as he inexorably portrays the "honorable" assassins as cowards who betrayed the trust and friendship of Caesar, the Colossus that "doth bestride the narrow world." In the end, it is Brutus whom Shakespeare describes as "the noblest Roman of them all."*

Mark Antony: Friends, Romans, countrymen, lend me your ears!
I come to bury Caesar, not to praise him.
The evil that men do lives after them,
The good is oft interred with their bones;
So let it be with Caesar. The noble Brutus
Hath told you Caesar was ambitious;

"And Sure Brutus Is an Honorable Man" is from William Shakespeare, *Julius Caesar*, Act III, Scene 2, lines 73–260 (First Folio Edition, 1623).

If it were so, it was a grievous fault,
And grievously hath Caesar answer'd it.
Here, under leave of Brutus and the rest
(For Brutus is an honorable man,
So are they all, all honorable men),
Come I to speak in Caesar's funeral.
He was my friend, faithful and just to me;
But Brutus says he was ambitious,
And Brutus is an honorable man.

He hath brought many captives home to Rome,
Whose ransoms did the general coffers fill;
Did this in Caesar seem ambitious?
When that the poor have cried, Caesar hath wept;
Ambition should be made of sterner stuff:
Yet Brutus says he was ambitious,
And Brutus is an honorable man.
You all did see that on the Lupercal
I thrice presented him a kingly crown,
Which he did thrice refuse. Was this ambition?
Yet Brutus says he was ambitious,
And sure he is an honorable man.
I speak not to disprove what Brutus spoke,
But here I am to speak what I do know.
You all did love him once, not without cause;
What cause withholds you then to mourn for him?
O judgment! Thou art fled to brutish beasts,
And men have lost their reason. Bear with me,
My heart is in the coffin there with Caesar,
And I must pause till it come back to me. . . .

 [*Antony pauses for reflection*]
But yesterday the word of Caesar might
Have stood against the world; now lies he there,
And none so poor to do him reverence.
O masters! If I were dispos'd to stir
Your hearts and minds to mutiny and rage,
I should do Brutus wrong, and Cassius wrong,
Who (you all know) are honorable men.
I will not do them wrong; I rather choose
To wrong the dead, to wrong myself and you,
Than I will wrong such honorable men.

But here's a parchment with the seal of Caesar,
I found it in his closet, 'tis his will.
Let but the commons hear this testament—
Which, pardon me, I do not mean to read—
And they would go and kiss dead Caesar's wounds,
And dip their napkins in his sacred blood;
Yea, beg a hair of him for memory,
And dying, mention it within their wills,
Bequeathing it as a rich legacy
Unto their issue.

Fourth Plebeian: We'll hear the will. Read it, Mark Antony.

All: The will, the will! We will hear Caesar's will.

Antony: Have patience, gentle friends, I must not read it.
It is not meet you know how Caesar lov'd you:
You are not wood, you are not stone, but men;
And, being men, hearing the will of Caesar,
It will inflame you, it will make you mad.
'Tis good you know not that you are his heirs,
For if you should, O, what would come of it?

Fourth Plebeian: Read the will, we'll hear it, Antony.
You shall read us the will, Caesar's will.

Antony: Will you be patient? Will you stay awhile?
I have o'ershot myself to tell you of it.
I fear I wrong the honorable men
Whose daggers have stabb'd Caesar; I do fear it.

Fourth Plebeian: They were traitors; honorable men!

All: The will! The testament!

Fourth Plebeian: They were villains, murderers. The will, read the will!

Antony: You will compel me then to read the will?
Then make a ring about the corpse of Caesar,
And let me show you him that made the will.
Shall I descend? And will you give me leave?

All: Come down. . . .

Antony: If you have tears, prepare to shed them now.
You all do know this mantle. I remember
The first time ever Caesar put it on;
'Twas on a summer's evening, in his tent,
That day he overcame the Nervii.
Look, in this place ran Cassius' dagger through;
See what a rent the envious Casca made;
Through this the well-beloved Brutus stabb'd,
And as he pluck'd his cursed steel away,
Mark how the blood of Caesar followed it,
As rushing out of doors to be resolv'd
If Brutus so unkindly knock'd or no;
For Brutus, as you know, was Caesar's angel.
Judge, O you gods, how dearly Caesar lov'd him!
This was the most unkindest cut of all;
For when the noble Caesar saw him stab,
Ingratitude, more strong than traitors' arms,

Quite vanquish'd him. Then burst his mighty heart,
And in his mantle muffling up his face,
Even at the base of Pompey's statue
(Which all the while ran blood) great Caesar fell.
O, what a fall was there, my countrymen!
Then I, and you, and all of us fell down,
Whilst bloody treason flourish'd over us.
O now you weep, and I perceive you feel
The dint of pity. These are gracious drops.
Kind soul, what weep you when you but behold
Our Caesar's vesture wounded? Look you here,
 [*Lifting Caesar's mantle*]
Here is himself, marr'd as you see with traitors. . . .
 [*Mournful cries and threats against the assassins from the crowd*]
Good friends, sweet friends, let me not stir you up
To such a sudden flood of mutiny.
They that have done this deed are honorable.
What private griefs they have, alas, I know not,
That made them do it. They are wise and honorable,
And will no doubt with reasons answer you.
I come not, friends, to steal away your hearts.
I am no orator, as Brutus is;
But (as you know me all) a plain blunt man
That love my friend, and that they know full well
That gave me public leave to speak of him.
For I have neither wit, nor words, nor worth,
Action, nor utterance, nor the power of speech
To stir men's blood; I only speak right on.
I tell you that which you yourselves do know,
Show you sweet Caesar's wounds, poor, poor, dumb mouths,
And bid them speak for me. But were I Brutus,
And Brutus Antony, there were an Antony
Would ruffle up your spirits, and put a tongue
In every wound of Caesar, that should move
The stones of Rome to rise and mutiny. . . .
 [*The crowd moves to disperse and hunt down the conspirators*]
Why, friends, you go to do you know not what.
Wherein hath Caesar thus deserv'd your loves?
Alas you know not! I must tell you then:
You have forgot the will I told you of.

All: Most true. The will! Let's stay and hear the will.

Antony: Here is the will, and under Caesar's seal:
To every Roman citizen he gives,
To every several man, seventy-five drachmaes.

Second Plebeian: Most noble Caesar! We'll revenge his death.

Third Plebeian: O royal Caesar!

Antony: Hear me with patience.

> "Great Caesar fell.
> O, what a fall was there, my
> countrymen!
> Then I, and you, and all of us
> fell down,
> Whilst bloody treason flour-
> ish'd over us."
>
> —Mark Antony

All: Peace ho!

Antony: Moreover, he hath left you all his walks,
His private arbors and new-planted orchards,
On this side Tiber; he hath left them you,
And to your heirs forever—common pleasures,
To walk abroad and recreate yourselves.
Here was a Caesar! When comes such another?

First Plebeian: Never, never! Come, away, away!
We'll burn his body in the holy place,
And with the brands fire the traitors' houses.
Take up the body.

Second Plebeian: Go fetch fire.

Third Plebeian: Pluck down benches.

Fourth Plebeian: Pluck down forms, windows, anything.
 [*Exit the Plebeians with the body*]

Antony: Now let it work. Mischief, thou art afoot,
Take thou what course thou wilt!

Consider This:
- Before Mark Antony delivered this speech, the crowd had been won over by Brutus who painted Caesar as a tyrant and his assassination a patriotic necessity, the salvation of liberty. How specifically did Antony persuade this hostile crowd to reverse its stance and then demand revenge for the murder of Caesar? What does this say about the fickle nature of democracy and the power of oratory? Are people easily manipulated because they truly want to believe whatever a leader says?

- What makes this an effective speech? How does Antony use the technique of "rhetorical irony" wherein he describes Brutus and the other conspirators as "honorable men," when in fact he means that they are nothing of the sort, but rather dishonorable traitors to Caesar and to Rome itself? Note how the meaning of "honorable" changes in tone and concept nearly every time Antony uses the word.

And How About This:
- Throughout the speech, Antony sets up the crowd by denying exactly what he intends. For example, he says that he would rather "wrong the dead, myself and you, than I will wrong such honorable men" when he absolutely intends to destroy the conspirators. Antony denies the crowd access to Caesar's will "because it will make you mad" when he is depending on their anger to give him the advantage over Brutus. Finally, Antony denies that he came to steal away the hearts of the crowd because "I am no orator as Brutus is; but as you all know me, a plain, blunt man that love my friend." Yet it is through his powerful oratory and these deceptive arguments that Antony becomes the embodiment of simple Roman virtues, the loyal and earnest friend, who by implication casts a long shadow on Brutus's intentions. Is this brilliant writing or what? Why has Shakespeare been called the greatest dramatist of all time?

- Antony's speech can be divided into two sections: setting up the crowd and then moving in for the kill when he says: "If you have tears, prepare to shed them now." How does Antony then drive home his assertion that these honorable men are traitors who should be destroyed? How do you interpret Antony's last line: "Now let it work. Mischief, thou art afoot, take thou what course thou wilt!" Is this confirmation that Antony has accomplished exactly what he set out to do?

To Be or Not to Be: Hamlet's Dilemma
WILLIAM SHAKESPEARE

Shakespeare's greatness is nowhere more evident than in his exposition of tragedy. Like the formidable Greek dramatists, Aeschylus, Sophocles, and Euripides, Shakespeare was fascinated with the complex dimensions of human character that grappled with spiritual turmoil in the struggle between moral flaw, personal sacrifice, and heroic resolve. In Shakespeare's greatest tragedies, Hamlet, Othello, Macbeth, and King Lear, we repeatedly confront characters on the edge of life, filled with ambition, greed, deceit, fear, and loathing; they are doomed to the inevitable confrontation between the vanities of desire and the resolution of justice. And among these outstanding examples of Shakespeare's genius, Hamlet remains his most successful and popular play.

This is the story of a man who could not make up his mind. Claudius seizes the Danish throne by poisoning his brother and marrying his widow Gertrude within a month after the crime. The protagonist is Hamlet, the young prince of Denmark whom Shakespeare portrays as a good man made weak through his inability to decide, once he discovers the awful truth, how or even whether to avenge his father's murder. Claudius is a formidable opponent, a strong bad man, a skilled politician, and hypocrite. In this moral sea of ambiguity, Hamlet opens his being, confronting his responsibilities to his deceived mother and betrayed father with the necessity of revenge and justice. For Hamlet, the challenge strains his very soul and in this famous soliloquy, he contemplates resolution in suicide—the ultimate abandonment of self.

Hamlet:

> To be, or not to be: that is the question:
> Whether 'tis nobler in the mind to suffer
> The slings and arrows of outrageous fortune,
> Or to take arms against a sea of troubles,
> And by opposing end them? To die: to sleep;
> No more; and by a sleep to say we end
> The heart-ache and the thousand natural shocks
> That flesh is heir to, 'tis a consummation
> Devoutly to be wish'd. To die, to sleep;
> To sleep: perchance to dream: ay, there's the rub;
> For in that sleep of death what dreams may come
> When we have shuffled off this mortal coil,
> Must give us pause: there's the respect
> That makes calamity of so long life;
> For who would bear the whips and scorn of time,
> The oppressor's wrong, the proud man's contumely,
> The pangs of despised love, the law's delay,
> The insolence of office and the spurns
> That patient merit of the unworthy takes,
> When he himself might his quietus make

"To Be or Not to Be" is from William Shakespeare, *Hamlet*, Act III, Scene 1, lines 55–86 (First Folio Edition, 1623).

With a bare bodkin [mere dagger]; who would fardels [burdens] bear,
To grunt and sweat under a weary life,
But that the dread of something after death,
The undiscover'd country from whose bourn [region]
No traveller returns, puzzles the will
And makes us rather bear those ills we have
Than fly to others that we know not of?
Thus conscience does make cowards of us all;
And thus the native hue of resolution
Is sicklied o'er with the pale cast of thought,
And enterprises of great pitch and moment
With this regard their currents turn awry,
And lose the name of action. . . .

Consider This:

- In this soliloquy, Hamlet contemplates suicide and likens it to sleep by which "we end the heart-ache and the thousand natural shocks that flesh is heir to." But what is the problem? What is "the rub"?

- Hamlet wonders why he should want to live, "to grunt and sweat under a weary life." So, why doesn't he commit suicide? Why not enter the "undiscover'd country" that is death? How does "conscience make cowards of us all"? Do you agree with him? How does this soliloquy point up Hamlet's weakness of indecision? But is this truly a human weakness and hesitation a strength that forces us to reevaluate and be resolute in molding our own lives without falling prey to doubt?

The Art of the Sonnet
WILLIAM SHAKESPEARE

William Shakespeare was not only a playwright of great renown, but also a poet whose sonnets in their variations of tone and mood present unique opportunities for self-discovery. The romantic poet, William Wordsworth noted that through this poetry Shakespeare "unlocked his heart." But Shakespeare the man remains elusive in the sonnets. Scholars have continued to debate their value in constructing a personal profile of the poet. On the whole, the sonnets are quieter and more reflective of actual human experience than are the plays. They are filled with expressions of doubt and estrangement, fear of failure and the unforgiving burden of time, of friendship and the inevitable triumph of death. They seem devoid of the storms of passion that often characterize his plays, but exhibit an artistic control over the texture of words and a refined understanding of the dimensions of sensation. The sheer density of thought and imagery that characterize the sonnets engages the mind and elevates our potential for appreciating the intimacy of human relationships and aspirations.

Sonnet 18

Shall I compare thee to a summer's day?
Thou art more lovely and more temperate:
Rough winds do shake the darling buds of May,
And summer's lease hath all too short a date;

"The Art of the Sonnet" is from William Shakespeare, *Sonnets*, nos. 18, 29, 130 (1609).

Sometime too hot the eye of heaven shines,
And often is his gold complexion dimmed,
And every fair from fair sometime declines,
By chance or nature's changing course untrimmed:
But thy eternal summer shall not fade,
Nor lose possession of that fair thou ow'st.
Nor shall Death brag thou wander'st in his shade,
When in eternal lines to time thou grow'st.
 So long as men can breathe, or eyes can see,
 So long lives this, and this gives life to thee.

Sonnet 29

When in disgrace with fortune and men's eyes
I all alone between my outcast state,
And trouble deaf heaven with my bootless cries,
And look upon myself and curse my fate,
Wishing me like to one more rich in hope,
Featured like him, like him with friends possessed,
Desiring this man's art, and that man's scope,
With what I most enjoy contented least;
Yet in these thoughts myself almost despising,
Haply I think on thee, and then my state
Like to the lark at break of day arising
From sullen earth, sings hymns at heaven's gate,
 For thy sweet love remembered such wealth brings,
 That then I scorn to change my state with kings.

Sonnet 130

My mistress' eyes are nothing like the sun;
Coral is far more red than her lips' red;
If snow be white, why then her breasts are dun;
If hairs be wires, black wires grown on her head.
I have seen roses damasked, red and white,
But no such roses see I in her cheeks,
And in some perfumes is there more delight
Than in the breath that from my mistress reeks.
I love to hear her speak. Yet well I know
That music hath a far more pleasing sound;
I grant I never saw a goddess go,
My mistress, when she walks, treads on the ground.
 And yet, by heaven, I think my love as rare
 As any she belied with false compare.

Compare and Contrast:

- Which of Shakespeare's sonnets presented in this section appeal to you the most? Why? What are the themes of these sonnets and how do they speak to human concerns?

- Compare Shakespeare's sonnets to those of the medieval Italian poet, Francesco Petrarch (see pages 225–227). Pay attention to the structure of the sonnet and the themes. How do they differ? Which do you prefer and why?

Illustration Credits

Figure 7–8 Giovanni Battista Piranesi (1720–1778, Italian), *St. Peter's Cathedral & St. Peter's Square, Rome.* © SuperStock

Figure 7–9 El Greco (1541–1614), *Christ on the Cross Adored by Two Donors,* oil on canvas. Photo: Gerard Blot. Louvre, Paris, France. © Reunion des Musees Nationaux Art Resource, N.Y.

Figure 7–10 Iglesia Santa Tome, Toledo, Spain/SuperStock

Figure 7–11 El Greco (Domenikos Theotokopulos) (1541–1614), *The Adoration of the Shepherds,* painted during El Greco's last period, between 1603–1614, canvas, 319 × 180 cm. Cat. 2988. Museo del Prado, Madrid Spain. © Erich Lessing / Art Resource, N.Y.